In a Cold Crater

WEIMAR AND NOW: GERMAN CULTURAL CRITICISM
Martin Jay and Anton Kaes, general editors

1. *Heritage of Our Times,* by Ernst Bloch
2. *The Nietzsche Legacy in Germany, 1890–1990,* by Steven E. Aschheim
3. *The Weimar Republic Sourcebook,* edited by Anton Kaes, Martin Jay, and Edward Dimendberg
4. *Batteries of Life: On the History of Things and Their Perception in Modernity,* by Christoph Asendorf
5. *Profane Illumination: Walter Benjamin and the Paris of Surrealist Revolution,* by Margaret Cohen
6. *Hollywood in Berlin: American Cinema and Weimar Germany,* by Thomas J. Saunders
7. *Walter Benjamin: An Aesthetic of Redemption,* by Richard Wolin
8. *The New Typography,* by Jan Tschichold, translated by Ruari McLean
9. *Rule of Law under Siege: Selected Essays of Franz L. Neumann and Otto Kirchheimer,* edited by William E. Scheuerman
10. *The Dialectical Imagination: A History of the Frankfurt School and the Institute of Social Research, 1923–1950,* by Martin Jay
11. *Women in the Metropolis: Gendered Urban Discourses of Weimar Germany,* by Katharina von Ankum
12. *Letters of Heinrich and Thomas Mann, 1900–1949,* edited by Hans Wysling, translated by Don Reneau
13. *Empire of Ecstasy: Nudity and Movement in German Body Culture, 1910–1935,* by Karl Toepfer
14. *In the Shadow of Catastrophe: German Intellectuals between Apocalypse and Enlightenment,* by Anson Rabinbach
15. *Walter Benjamin's Other History: Of Stones, Animals, Human Beings, and Angels,* by Beatrice Hanssen
16. *Exiled in Paradise: German Refugee Artists and Intellectuals in America from the 1930s to the Present,* by Anthony Heilbut
17. *Cool Conduct,* by Helmut Lethen, translated by Don Reneau
18. *In a Cold Crater: Cultural and Intellectual Life in Berlin, 1945–1948,* by Wolfgang Schivelbusch, translated by Kelly Barry

In a Cold Crater

Cultural and Intellectual Life in Berlin, 1945–1948

Wolfgang Schivelbusch

Translated by Kelly Barry

UNIVERSITY OF CALIFORNIA PRESS
Berkeley · Los Angeles · London

Research for this book was made possible through
grants of the John Simon Guggenheim Memorial
Foundation, New York, and the Stiftung Volkswagen-
werk, Hannover, Germany.

University of California Press
Berkeley and Los Angeles, California

University of California Press, Ltd.
London, England

© 1998 by
The Regents of the University of California

Library of Congress Cataloging-in-Publication Data

Schivelbusch, Wolfgang, 1941–
 In a cold crater : cultural and intellectual life
in Berlin, 1945–1948 / Wolfgang Schivelbusch;
translated by Kelly Barry.
 p. cm.—(Weimar and now; 18)
 Includes bibliographical references and index.
 ISBN 0-520-20366-6 (alk. paper)
 1. Berlin (Germany)—Intellectual life.
 2. Berlin (Germany)—Social life and customs.
 3. Intellectuals—Germany—Berlin—History—
 20th century. I. Title. II. Series.
 DD866.S34 1998
 943'.155—dc21 97-40067

Printed in the United States of America
9 8 7 6 5 4 3 2 1

Contents

Preface

When the victors of World War II decided to cut Germany into four zones, they also decided to leave the capital of the Reich undivided and govern it together. True, they did draw up four sectors and assigned each of those to one power. However, in the first three years after the victory, the sector lines were of only "platonic" significance. In administration, in everyday life, and last but not least in cultural matters, Berlin continued to be the "Great Berlin" (Gross-Berlin) it had officially been named in 1920. Thus, beyond the four zones (American, Soviet, British, French) into which Germany had been divided, Berlin formed what in the first years of postwar Germany some called the "Fifth Zone."

For three years after the collapse of 1945, Berlin in many ways remained what it had been in its "Periclean" period in the 1920s. Certainly its physical structure had suffered, and, more important, its intellectual and cultural resources had been decimated by the Nazi regime as early as the 1930s. Still, for three years artists, intellectuals, writers, composers, filmmakers, theater producers, and audiences acted as if nothing were more evident and more natural than another Weimar Berlin rising from the ruins and ashes. If there was a perceived difference, it was that while in the years after 1918 the capital had remained "provincial" or national in the sense that it was center stage for German institutions—governments, bureaucracies, corporations, theaters, academies, and so forth—now, in 1945, it was a truly international city. The

German government no longer existed. In its place the four most important world powers had taken over. Except for Jerusalem in the period of the crusaders' empire, and for Paris during the short period of its occupation after the fall of Napoleon, nothing like this had happened before.

The elements of ferment in Berlin during the years 1945–1948 were the avant-garde past of the 1920s, the international present, and an open future—all in all, a promising starting point, one would think. As cultural history records today, however, nothing memorable came of that unique constellation of circumstances. This book is an attempt to go back and understand why. It is not a comprehensive history of Berlin's post–World War II and pre–Cold War culture. The music world is absent, as is most of the academic world and the art world. And even though the index at the end includes several hundred names, many well-known members of Berlin's high-culture community go unmentioned and important events untold. But then the question in Berlin from 1945 to 1948 involved who and what was regarded as important. Nameless "cultural officers," as they were called, in the Allied bureaucracy, and equally anonymous types surfacing from the Berlin underground in the spring of 1945, worked both hand in hand with, and against, those figures left over from the high-culture scenes of 1918–1933 and 1933–1945. Cultural luminaries of the victorious powers (such as the poet Stephen Spender, the philosopher couple Sartre and Beauvoir, the film directors Rossellini and Wilder, and many more) visited for shorter or longer periods, either to observe what was happening or to work on their own Berlin projects. Theirs was a cultural-political tourism not wholly unlike the one conducted by Western intellectuals journeying to Moscow in the 1920s, or to Havana in the 1960s. Motivations and fantasies of course differed. The pilgrims to Moscow and Havana were eager to get a glance at the best of all worlds supposedly about to be realized in those places. Those going to postwar Berlin were after the thrill of witnessing the latest empire of evil brought to its fall. And yet, since curiosity is always the same, regardless of its object, and the idea of a perfect world seems to arouse an excitement similar to the horror of an exceptionally evil one, the postwar years of Berlin have become one episode in the string of great political romances of the twentieth century.

Abbreviations

BPRS Bund Proletarisch-Revolutionärer Schriftsteller (League of Proletarian and Revolutionary Writers). Communist organization in the 1920s.

CDU Christlich-Demokratische Union (Christian-Democratic Union). Confession-oriented party of the center, established in 1945 in all four occupational zones of Germany.

DDP Deutsche Demokratische Partei (German Democratic Party). Liberal party in the Weimar period representing the leftist bourgeoisie, as opposed to the more nationalist liberals of the Deutsche Volkspartei (DVP).

DDR Deutsche Demokratische Republik (German Democratic Republic). Established in 1949 as successor of the Russian zone, in response to the establishment of the Federal Republic, which was formed out of the three Western zones.

Defa Deutsche Film-Aktiengesellschaft (German Film Joint-Stock Company).

DIAS Drahtfunk im Amerikanischen Sektor (Wireless Radio in the American Sector).

KPD Kommunistische Partei Deutschlands (Communist Party

of Germany). Established in 1919, banned by the Nazis in 1933, reestablished in 1945. *See also* SED.

KPdSU German acronym for the Communist Party of the Soviet Union.

LDPD Liberal-Demokratische Partei Deutschlands (Liberal-Democratic Party of Germany). Established in and for the Russian zone. Its Western equivalent was the Freie Demokratische Partei/Free Democratic Party (FDP).

MPAA Motion Picture Association of America.

MPEA Motion Picture Export Association.

NEP New Economic Policy. The period in Russia following the so-called wartime Communism, allowing private enterprise and relative freedom of the arts.

NKVD Russian acronym for Narodnyn Kommissariat Vnutren-nykh Del (People's Commissariat of Internal Affairs— i.e., secret political police).

NSDAP National-Sozialistische Deutsche Arbeiterpartei (National-Socialist German Workers' Party).

NWDR Nordwestdeutscher Rundfunk (North-West German Radio). Radio station for the British zone, licensed and controlled by the British, and operated by German personnel.

OMGUS Office of Military Government in Germany—United States.

POLAD Political Administration (parallel branch to OMGUS).

PWD Psychological Warfare Department.

SBZ Sowjetisch Besetzte Zone (Soviet-Occupied Zone). Official name for the Russian zone and later German Democratic Republic.

SDS Schutzverband Deutscher Schriftsteller (Protective Association of German Writers). Professional association in the Weimar period. Reestablished in 1945 as the Schutzverband Deutscher Autoren (SDA; Protective Association of German Authors).

SED Sozialistische Einheitspartei Deutschlands (Socialist Unity Party of Germany). Product of the merger in 1946 of the Russian zone's KPD and SPD. *See also* KPD, SPD.

SMAD Sowjetische Militär-Administration in Deutschland (Soviet Military Administration in Germany). Russian equivalent of OMGUS.

SPD Sozialdemokratische Partei Deutschlands (Social-Democratic Party of Germany). The old traditional party reestablished in 1945 in all four occupational zones of Germany.

USPD Unabhängige Sozialdemokratische Partei Deutschlands (Independent Social-Democratic Party of Germany). Pacifist socialist party formed in 1916 by members of the SPD in protest against the old party's support for the war. Dissolved after the First World War, its members rejoining the SPD or entering into the Communist Party.

ZfV Zentralverwaltung für Volksbildung (Central Administration for Popular Education). Housed in the half-ruined former Ministry of Propaganda in Wilhelmstrasse, this was the quasi ministry of culture for the Russian zone. In 1949 it became the Ministry of Popular Education and Culture of the German Democratic Republic.

The Prize

Beneath the blanket bombings of its wars, the twentieth century has witnessed whole cities disappear. Their names have become metaphors of obliteration, standing for the techniques of destruction of the time and a readiness to employ those techniques against civilian targets. Guernica, lying on the periphery of Europe and at the perimeter of World War II, was the prelude. The bombardment of April 1937 transformed this previously unknown provincial Spanish city into a worldwide symbol of terror. In May 1940 Rotterdam became the first large well-known European city to find its name imbued with new meaning through its destruction. With the bombing of Coventry—and the German term derived from it, *coventrisieren,* "to coventrize"—a new technology of annihilation had developed to the point where the many cities wiped out in its wake remained nameless. Not until the end of the war, with the fall of the cultural center Dresden, did a city name with symbolic significance once again emerge. Dresden became the metaphor for the most advanced "conventional" techniques of destruction, as this military practice would henceforth be termed. It seems almost inevitable that atomic technology claimed as its first victim a place as obscure as Guernica had been in its time. Only in its destruction did Hiroshima assume international stature.

And as for Berlin? The capital of the German Reich absorbed more bombs and shells in World War II than any other metropolis. Of the scale of the wreckage, of that mass of resulting rubble, there are but

rough estimates, fluctuating between 55 and 100 million cubic meters. Assuming an average figure of 80 million cubic meters, and given a post-war population of 3 million, there were 26 cubic meters of debris for each Berliner. The title of a study published three decades later made clear the consequences this had on the city's appearance: *The Anthropogenically Conditioned Transformation of the Cityscape through Deposits of Debris in Berlin (West).*[1]

Though at the forefront of the European inferno, Berlin was never seen as a victim of bombing. The fact that surface bombings, having already become a matter of routine and deadening habit, reached their real peak in the years 1943–45 provides some explanation for this. Significant as well was the psychological fact that the capital of a state waging war is always considered apart from its cities of art, industry, and trade. In the first half of the twentieth century the adversaries were in full agreement with the idea that a capital city was less a civilian construct than the symbol of a nation's power.

They were equally united in the conclusion that the enemy whose defeat had in the past been symbolized by the seizure of his capital could now be crushed through the flattening of his capital. At the beginning of World War I, the destruction of London and Berlin by zeppelin bombardments was a fantasy equally and mutually popular in Great Britain and Germany. As the behavior of London's inhabitants demonstrated during the German air raids of 1940–41, this attitude was evident even in those directly affected: they reacted as soldiers in a warlike bulwark, not as defenseless victims. One could interpret Brecht's aphorism—"Berlin: an etching of Churchill's according to an idea of Hitler's"*—as the destruction of the capital in order to make an example of it. Or as the British Director of Bomber Operations put it on the eve of the last great wave of attacks on Berlin: "The complete devastation of the center of such an enormously large city as Berlin would lay before the entire world an irrefutable proof of the power of a modern military force armed with bombers. . . . Were Allied troops able to occupy Berlin, or were the city held by a neutral party, it would witness a lasting monument to the efficacy which strategic bombardment has made possible in this war and can, at any given time, repeat."[2]

The site of this efficacy became a principal stop on the grand tour that led Allied politicians and journalists to Germany in the years right

*Brecht's phrase operates on an untranslatable German pun. *Radierung*, "etching," also means "erasure."

after the war. However, the impression anticipated by the Allied bomber commando did not fully materialize. The power of destruction that had here performed its work proved less stirring than the sight itself of what had been destroyed. For the visitor passing through the still largely intact outlying districts and approaching the formerly pulsing city center between the Tiergarten and Alexanderplatz, it was, as Churchill's niece Clarissa wrote, "as if . . . reaching a different climatic zone, a mountain top where no living thing can survive and the vegetation gradually thins out and ceases."[3] From the plane carrying him from Nuremberg to Berlin in July 1947, Albert Speer, who at Hitler's request had planned and in part begun a massive reconstruction of this area, saw the edifice of the New Chancellery below. "It was still there, although damaged by several direct hits," he noted after his arrival at the prison in Spandau.[4] Others saw it differently, among them the English poet Stephen Spender, who the year before had visited what remained of the government quarter:

> The Reichstag and the Chancellery are already sights for sightseers, as they might well be in another five hundred years. They are scenes of a collapse so complete that it already has the remoteness of all final disasters which make a dramatic and ghostly impression whilst at the same time withdrawing their secrets and leaving everything to the imagination. The last days of Berlin are as much matters for speculation as the last days of an empire in some remote epoch: one goes to the ruins with the same sense of wonder, the same straining of the imagination, as one goes to the Colosseum at Rome.[5]

What Speer had attempted at the height of his architectural career was strangely subverted by what Stephen Spender and other visitors to Berlin saw. For Speer's "ruins theory" (at least as he explained it afterward in his memoirs) was nothing other than an architecture that anticipated its continuation in decay. Assuming that modern industrial materials and techniques would not produce buildings like those of the Ancients, which decayed in dignity, Speer chose the same heroic materials, such as granite and porphyry. ("By using special materials and by applying certain principles of statics, we should be able to build structures which even in the state of decay, after hundreds or [such was our reckoning] thousands of years would more or less resemble Roman models. To illustrate my ideas I had a romantic drawing prepared. It showed what the reviewing stand on the Zeppelin Field would look like after generations of neglect, overgrown by ivy, its columns fallen, the walls crumbling here and there, but the outlines still clearly recognizable.")[6]

The condition of the New Chancellery in 1945 revealed Speer's ruins theory as too traditional in its exclusive focus on a decay caused by time to account for a decay now accelerated by bombardment and artillery fire. On the other hand, statements like Spender's verify that it was possible to see the modern form of war ruins in a classical manner: as an image of fallen power, of shattered greatness and humbled arrogance, the image that had fascinated historians from Herodotus to Gibbon. However, not everyone saw Berlin's expanse of ruins in such neatly historical terms as Spender. For the American journalist William Shirer, who had last witnessed Berlin at the height of Nazi power, it possessed neither greatness nor tragedy. It was nothing more than a mass of "obscene ruins," in which the "indecency" of defeated power showed itself for a final time. "How can one find words to convey truthfully and accurately the picture of a great capital destroyed almost beyond recognition; of a once almighty nation that ceased to exist; of a conquering people who were so brutally arrogant and so blindly sure of their mission as the master race when I departed from here five years ago, and whom you now see poking about their ruins, broken, dazed, shivering, hungry human beings without will or purpose or direction."[7]

In visual terms, Berlin's fields of ruins offered a different sight than cities in the west of Germany that had experienced a similar devastation. The city was, as Isaac Deutscher said, "not 'leveled,' it stands upright in front of the observer to a truly astonishing degree."[8] It is inviting to see the image of the capital, confronting the observer almost defiantly even in its destruction, as a projection of the Reich. And yet there lay in the construction materials and techniques a real explanation for Berlin's uprightness. Because of their medieval—that is, largely wooden—structures, historic city centers in the west and south of Germany burned down to enormous heaps of ashes, leaving behind empty expanses. Berlin, however, was a product of the nineteenth and twentieth centuries, erected in large part by a method of construction using steel frames; even the conventionally built buildings from the baroque through Wilhelminian Germany were of such massiveness that, though burned out, they remained standing. Because of its technical modernity the capital of the Reich was never thought to have the historic, monumental, or aesthetic qualities of cities like Dresden, Munich, Cologne, and Nuremberg. To adherents of traditional artistic and architectural urban ideals, Berlin seemed ever less a city and increasingly an urban machine. Wilhelm Hausenstein in 1932 called it "baseless," "ground-

less," "a vacuum"—not because of any lack of architectonic substance ("Old Berlin, the Berlin of the palace area, has verdigris roofs as good as those of baroque Dresden"), but because its essence, its identity rested in something different. Berlin was a new kind of city; its technological modernity did not function as a superficial addition to what already existed but was the capital's very essence and substance. In the 1920s, any representative of *Neue Sachlichkeit* would have agreed with the traditionalist Hausenstein in calling Berlin "a nothingness elevated to quintessence," saying of it that "automobiles, traffic, and light bulbs in Berlin constitute a disproportionate and almost romantic addition . . . because the vacuum of Berlin is so large."[9] Berlin, the most technological, modern, and "American" metropolis in Europe of the 1920s, was also more "modern" in its destruction than the historical cities in western and southern Germany. That it was not seen as a victim like Dresden is attributable to the fact that here, so to speak, the most modern technologies of production and destruction collided, in a kind of self-destruction of technology, a duel it carried out with itself. In his first visit to the destroyed city, Alfred Döblin, who in *Berlin Alexanderplatz* described Franz Biberkopf's struggle against this urban machine, saw its ruins as the result of a struggle that the city and fleets of bombers had fought out with each other. "Images of a terrible devastation, of immeasurable boundless destruction," he noted. "It almost no longer has the character of reality. It is an improbable nightmare in broad daylight. The city must have gotten itself into a horrible struggle in the darkness."[10]

A struggle against Berlin, a struggle in Berlin, a struggle for Berlin: as a real warrior in this theater, and entering the fray at about the same time as the fictitious Franz Biberkopf, Joseph Goebbels also deserves mention. His book about the buildup of the Nazi organization in the city was titled *Ein Kampf um Berlin* (a struggle for Berlin). He remained personally bound to this city—to the very city considered the least Nazi of all German cities—until his death. He had a love-hate relationship with Berlin and learned to heed its lessons. "Till then [the mid-1920s] the city of Berlin," he wrote in *Ein Kampf um Berlin,*

> was for me a sealed book in terms of its politics and its population. I knew it only from occasional visits, and it always appeared as a dark, mysterious secret to me, as an urban monster of stone and asphalt that for the most part I would have preferred to leave rather than enter. You get to know Berlin only after living there for several years. Then that dark mysterious quality of

this sphinxlike city suddenly unfolds. . . . I came from the provinces and was still fully trapped in provincial thinking. The multitude was for me merely a dark monster, and I myself was not possessed of the will to conquer and master it. Without that one cannot last long in Berlin. . . . Whoever wants to become something here must speak the language the crowd understands. . . . Of necessity I developed an entirely new style of political speech under these rash impressions. . . . It was the same for all the agitators of the Berlin movement. . . . A new inflammatory language was spoken here that no longer had anything to do with antiquated, so-called *völkisch* forms of expression. The National Socialist agitation was tailored to the masses. The modern outlook of the party sought and found here a new style capable of sweeping people away.[11]

The irony of history: Was it this city, the most modern and technological, the least National Socialist city in Germany, which in every fiber embodied the "asphalt civilization" whose destruction was the goal of the Nazi party—was it this very city that modernized the party, thereby making possible its success and victory? Goebbels's book was called *Ein Kampf um Berlin* not only in reference to Hitler's *Mein Kampf*. The struggle, in Goebbels's terminology, for the submission of the "urban monster" Berlin and its transformation into a party-run machine was also intended. For the Nazis, Berlin was battlefield, enemy, prize, and booty in one. For a nation in civil war, the capital city always represents this; yet Berlin in the twentieth century was more than just the capital of a nation in civil war. If the more recent view that the two world wars begun by Germany were a single worldwide civil war is to be heeded, then Berlin was its capital, its enemy, the prize, and the spoils, within the compass not merely of a nation but of the entire world. The Allies' degree of concern over the capital of the Reich was manifest in their plans for its conquest and occupation.

The victor's entry into the capital, though not generally the closing act to the wars of the past, has always been considered the true consummation of victory. This question becomes more complex when a coalition, not a single victor, is concerned. Because coalitions often fall apart in less time than it takes their common enemy to collapse, each member tries—even as the final battle is being fought—to secure its booty, whether unilaterally or in new alliances, as changing circumstances dictate. None of the war alliances of the last two centuries resulted in the joint occupation and rule of an enemy capital. Even Paris, occupied in 1814–15 by English, Prussian, Austrian, and Russian troops, offered no exception: this was a short-term, strictly military occupation,

without the assumption of administrative or governmental functions. No thought was given to partitioning the city into sectors for the allied powers.

Jerusalem in the twelfth century stands as a more distant example of such a partitioning. Collectively conquered by the first Crusade coalition and declared the seat of the Latin Kingdom, it was without a doubt an "internationally" occupied and ruled city. However, there was no modern administration tidily divided into sectors according to nation; there arose instead a new ruling class composed of a disorderly mixture of medieval entourages living next to and with each other.

A third example of an international occupation is offered by the International Zone of Shanghai formed by France, Great Britain, and the United States in the nineteenth century. It was to this situation, in fact, that the one in Berlin has been often compared since 1945. But unjustly so, for the International Zone represented only a small part of Shanghai, being in essence nothing other than a European enclave, and in no way the result of a previous conquest.

The conquest, occupation, partition, and divided joint rule of Berlin by the Allies was historically unique, not comparable to any of these precedents, yet uniting essential elements of each. Like Paris in 1814–15, Berlin was the capital of the defeated world enemy. Like the International Zone in Shanghai, it was ruled internationally over an extended period of time. And like Jerusalem for the High Middle Ages, Berlin was of almost mythological significance for the twentieth century's idea of a world revolution and its real world wars. To have Berlin, and consequently Germany, was—according to the horizon of expectations opened with the October Revolution—to have Europe. The Russian Revolution was only an initial spark, a prelude to the real world revolution emanating out of—and unthinkable without—Berlin. In the years between 1917 and 1923, this idée fixe occupied so firm a position in the minds of the revolutionary generation that it most likely never fully disappeared until 1945. Stalin's salute to the German Communist Party (KPD) in 1923 was of course propaganda ("The victory of the German proletariat will undoubtedly transfer the center of the world revolution from Moscow to Berlin"),[12] but like all effective propaganda, it played upon a reality of the most fanciful ideas. The polarization of the world after 1945 stripped Berlin of both its position and its aura. This downfall, taking place in the three years of Allied postwar occupation, has the closed and self-referential quality of great drama. Berlin furnished the unities of time, place, and action.

The decision to occupy and rule Berlin jointly was made in London in the fall of 1944 by the Allied European Advisory Commission responsible for postwar planning. It was also decided that the city, partitioned into sectors, would lie in the middle of the future Russian zone of occupation, as would the American enclave of Bremen within the British zone. This arrangement, which at first glance appeared unnecessarily complicated, was the result of a careful weighing of Germany's economic, demographic, and geographical resources. Because the greatest concentration of population and economic power lay in the west, the Russian zone received a disproportionately large surface area. But this did not mean that Berlin would have to lie in the middle of this eastern zone. It was possible to draw a border that made the Reich's capital the border city of these zones. Roosevelt must have conceived of such a solution when he first studied the problem on the way to the Tehran Conference in 1943. He drew a borderline between the American and Russian zones running from Stettin (Szczecin) through Berlin to Leipzig, leaving no doubt that Berlin was to lie on the westward side of this line. ("We should go as far as Berlin. The Soviets could then take the territory to the east thereof. The United States should have Berlin.")[13] A similar suggestion was still under discussion in the deliberations of the European Advisory Commission. It came from James W. Riddleberger of the American State Department. According to this plan, Berlin was supposed to lie at the point of intersection of the three Allied zones (a French zone had not yet been thought of), at approximately the center of the German pie cut into three segments. Proceeding from Potsdamer Platz, the American, Russian, and British sectors of Berlin would have expanded outward in a funnel- or wedge-shaped manner, continuing into the hinterland of their respective zones. However, the cartographically clear and geometrically elegant solution had no chance of realization. Given the traditional administrative borders and economic and commercial spheres, it was utopian.

Whatever the details of the plans for partition, the fact that Berlin commanded the Allies' collective attention despite so many adverse circumstances showed that for them the capital of the Reich was a place that no one power was willing to relinquish entirely to any other. Berlin was clearly the trophy of World War II, and plans for its divided joint rule were an attempt to establish a balance of the victorious powers resulting from the suppression of the common enemy. Like heirs coming together in the house of the deceased warily to oversee the division of

goods, the victorious powers planned to convene in the capital, Germany's former center—and now vacuum—of power.

When these decisions were made in the fall of 1944, the end of the war was in sight, though it was not clear exactly how and when that would occur. As the circle tightened around Germany, the Allies were able to calculate their gains and losses for the last phase of the struggle. For the British and Americans in the west and the Russians in the east, there were two options. Either their own armies conquered all (or the greatest part) of Germany, with no consideration of casualties. Or, conversely, their allied counterparts would be given precedence.

In the latter case casualties (but likewise profits) in Germany would be minimized. The European Advisory Commission's plan for division represented a compromise. In the event that the Red Army reached the Rhine—considered probable in American military circles six months before the end of the war—the Western powers were guaranteed their portion of Germany and Berlin. And in the case of an advance of the Western powers toward the east—which in fact happened in the spring of 1945—the Russians were given the corresponding guarantee. Drawing borders was a measure of reciprocal security against extreme shifts of balance arising from the incalculable fortunes of war. It arose from the same sober weighing of interests and avoidance of unwageable risks, from the same conservative global politics with which the two world powers would assure and control each other during the decades of the Cold War. For forty-five years Berlin would serve as the needle on the scale of this balance. But in the spring of 1945, the city was briefly at the center of a calculation aimed at the imbalance of one side. This happened in the weeks of the unexpectedly rapid advance of the British and Americans and the still unexplained two-month standstill of the Red Army at the Oder. Suddenly what Roosevelt had hoped for two years before—the conquest of Germany up to the Oder and the occupation of Berlin by the Western powers—seemed palpably near. Churchill pressed Roosevelt to seize the opportunity. The decisive lines in the two telegrams he sent to Washington on March 31 and April 1 of 1945 read: "Why should we not cross the Elbe and advance as far eastward as possible? This has an important political bearing, as the Russian armies of the South seem certain to enter Vienna and overrun Austria. If we deliberately leave Berlin to them, even if it should be in our grasp, the double event may strengthen their conviction, already apparent, that they have done everything" (March 31, 1945). And, resuming

and intensifying his argument the next day: "If they [the Russians] . . . take Berlin, will not their impression that they have been the overwhelming contributor to our common victory be unduly imprinted in their minds, and may this not lead them into a mood which will raise grave and formidable difficulties in the future? I therefore consider that from a political standpoint we should march as far east into Germany as possible, and that should Berlin be in our grasp we should certainly take it."[14] Roosevelt, for whom Berlin was meanwhile no longer a political but a purely military goal, left the decision to General Eisenhower. The latter's refusal to conquer the capital of the Reich was characterized by Robert Murphy, an American diplomat later serving in Berlin, as "a decision of such international significance that no Army chief should have been required to make it."[15]

The global political consequences of Eisenhower's decision, however much they might invite speculation, can hardly be grasped. The consequences for Berlin, however, were clear: the Russians were the conquerors and sole masters of the city for two decisive months. They made the personnel and political decisions about the structuring of the administration, the admission of parties and unions, the arrangement of educational and judiciary systems, about the restimulation or dismantling of industry, the repair of transportation systems—in brief, about everything that started the urban machine going again. When the Allies entered Berlin after this two-month lapse to take possession of their sectors, their situation was that of guests received by the master of the house. To be sure, they had legal claims and a contractual assurance of quarters. The American advance unit that entered Berlin on July 1, 1945, found out how little that meant in practical terms, though. Its commander later offered a description of this arrival:

> With no billets to go to, we wound up in the Grunewald, that great forest park in the southwestern area of the city. We had to set up pup tents in the mud and rain, and crawl into them for the night . . . I had managed to avoid pup tents throughout World War II, yet here I was, with the war over and making a triumphal entry into Berlin, established in that dreaded form of shelter under most dreary and uncomfortable conditions. This was undoubtedly history's most unimpressive entry into the capital of a defeated nation by a conquering power.[16]

For the subsequent forces of the Western Allies the situation was no longer so extreme; yet soon they too noticed, and in a more far-reaching way, what it meant to move into a house appointed without their collaboration.

The house set up by the Russians also contained a floor for art and intellectual life. As in the other rooms, here too the accommodations consisted of what was available—that is, of what remained after the war and the collapse, and, going back even further, of what remained after the Nazi *Gleichschaltung* (razing or leveling) of culture. The question, then, is how much of the artistic and intellectual life of Berlin before 1933 had survived to the spring of 1945.

1930: YEAR OF CRISIS

The image of Berlin's physical destruction in 1945 is typically associated with the cultural destruction of the twelve previous years: what had begun with book burnings, prescriptions, banishment, imprisonment, and murder found its horrifying conclusion in the massive collective devastation of the city. According to this view, artistic and intellectual life was in full bloom when it was destroyed on January 30, 1933, as though by a sudden frost. In the theaters, Brecht, Piscator, Jessner, Fehling, and Gründgens had set the tone; in the concert halls, the avant-garde was represented by Schoenberg, Hindemith, Alban Berg, Kurt Weill, and Hanns Eisler, and classicism by Bruno Walter and Wilhelm Furtwängler. In the feuilleton sections of newspapers, Walter Benjamin, Siegfried Kracauer, Herbert Ihering, and other critics dissected cultural activity with razor-sharp precision; analysis of political events issued from the pens of Carl von Ossietzky, Leopold Schwarzschild, and Theodor Wolff. In Berlin's "red" district of Wedding, Ernst Busch blared poetic-proletarian battle songs in the streets. In Dahlem, Albert Einstein expanded the borders of modern physics. In their studios, Walter Gropius, Mies van der Rohe, Erich Mendelsohn, the Taut brothers, and others designed houses and housing developments that were soon to enter the textbooks of modern architecture and urban planning. Berlin was the laboratory of modernity, a city in which (according to a Brechtian poem) intellectuals eulogized oil tanks while writing sarcastic sonnets about intellectuals worshiping oil tanks.

Recently cultural historians have expressed doubt about the idea that this blooming culture perished—that is, was destroyed by the Nazis—instantaneously, as though submerged under a sudden deluge. The *Gleichschaltung* of the culture of the Weimar period was, of course, violent and sudden. Yet the scene that ended so abruptly in 1933 was no longer what it had been at the end of the 1920s. Truly modern intellectual life in Berlin, so open to experiment, and in art and spirit so radical, had

already changed in the years before 1933. The "international experi-
mental downturn" (H. D. Schäfer)[17] that became visible in the crisis
year of 1930 meant for Berlin revising the revolution of 1918–19. That
same year Herbert Ihering described the change, which he called a "cul-
tural reaction," as a fait accompli: "The turn occurred gradually. The
omens altered imperceptibly. Invisibly ideas were rearranged. It was
nothing other than a slow and cautious change of climate. A new sea-
son with all its seductive transitions was announced. It seeped pleasantly
into every pore. Resistance grew weaker and weaker. A tepid warmth.
An intellectual Capua."[18] Of course, not everyone partook in the new
mood of 1930. The situation was like that of half a century later when
another postmodern shift to "the new lethargy, the new sentimentality,
the new reaction" (Ihering) would also lead to polarization, antagonism,
and partisanship where before consent had ruled. Intellectual encamp-
ments, which were to find their continuation in the real camps built af-
ter 1933, had been set up by 1930.

 This development was not restricted to Berlin, but it was here that
it took its most decisive form. As, for example, in the writers' national
association Schutzverband Deutscher Schriftsteller, whose local Berlin
chapter was the largest in the Reich. Even before 1930, a majority had
formed here anxious to see in the Schutzverband not merely a forum
for professional representation but an organization vigorously engaged
in politics (though not party politics). It thereby stood in opposition to
the Schutzverband's national board of directors, also residing in Ber-
lin, which insisted on strict political abstinence. Disputes, confronta-
tions, and the expulsion of several members by the board resulted. In
1931, when the majority of the Berlin members declared solidarity with
those expelled, the board dissolved the Berlin chapter. It was a coup de
main that had its political counterpart in the deposition of the Prussian
state government in 1932 by Papen's national government. Openly sup-
ported by all liberal colleagues of note, the Berlin group could ignore its
dissolution and continue on as though nothing had happened. Conse-
quently, the board of directors established a rival organization in Berlin.
Up until the general *Gleichschaltung* in 1933, there were two national
writers' associations in Berlin. The first cultural fissure had occurred.
The second, between the liberal-democratic and conservative-national
members of the Literature Division of the Prussian Academy of the
Arts, transpired almost at the same time. Here the conservatives, who
found themselves in the minority, simply quit the field: they left the

academy. As is well known, the leftist-bourgeois group under the leadership of Heinrich Mann and Alfred Döblin did not last for long.

Such institutional polarizations were carried out more visibly than those in works of art. Writers personally in support of politicizing their association or the academy embraced Ihering's so-called change of climate in their work. If in the 1920s they had been fascinated by the metropolis, asphalt, oil tanks, and the soul in the age of its technical manipulability, they were now more interested in the past than in the present, more in myth than in technology. "Instead of 'scientists,' 'engineers,' or 'agitators,' writers now understood themselves as . . . 'prophet,' 'priest,' 'guide,' or 'adviser'"(H. D. Schäfer).[19]

The intellectual life in Berlin that passed into the Nazis' hands in 1933 was no longer the laboratory of modernity but merely the burned-out husk of the period 1918–29. One might imagine how Berlin of the Weimar period, without the violent disruption of the Nazis, might have entered cultural history.* Once exhausted, periods of cultural flowering in urban centers usually find a peaceful end. Like Paris and Petersburg in the nineteenth century or Paris, New York, and London in the decades after 1945, they quietly return to normality. Without the thunderclap of 1933, cultural life in Berlin, much of which had already withered, would have likewise undramatically faded away. But with it, that culture was transfixed as the dramatic image of the fall of an intellectual Pompeii. Since then, Berlin of the Weimar period (as American cultural history has it) has been the familiar metaphor for the culture of modernity poised, like Damocles, beneath the sword of reaction and barbarism. In this romanticizing and mythologizing of culture one might detect a variant of Speer's theory of ruins: ruined (despised, forbidden, banished, murdered) by the Nazis, the Berlin intelligentsia of 1933 continues to live on in intellectual mythology as the unique generation of intellectuals who were granted a duel with real power, and romantic defeat. This myth became international as Berlin's culture spread with the

*In addition to intellectual change of climate, there were signs around 1930 that Berlin's creative limits had also been reached. Several great artists and minds had left the city and the country for a longer period or for good, seeing more promise elsewhere. After 1929 Albert Einstein spent more time abroad than in Berlin, and in 1932 he accepted an invitation from the Institute for Advanced Study at Princeton. Hollywood lured away the top names in German film: Murnau, Lubitsch, Marlene Dietrich, Elisabeth Bergner. A small colony of Berlin intellectuals arose in Paris; its most prominent members included Tucholsky, Benjamin, and Rudolf Leonhard. George Grosz left Berlin in January 1933. It was not a general migration, but a noticeable trickle, as is often to be observed before the floodgates are lifted.

banishment from its native soil. Einstein, Grosz, Hindemith, Gropius, Schoenberg, Lang—all ceased to be names confined to Berlin or even Germany. They became international images, and with them Berlin became the global metaphor for modern high culture at the gates of barbarism.

That, however, was a later development. In the Berlin of 1945 there was no sense for such considerations. Berliners had as little historical distance from the period that had preceded the Third Reich as they had taste for their destroyed city as an antique field of ruins. The time before 1933 belonged indisputably to a past world, yet at the same time it also represented, as the last stop before the descent into barbarism, the only possible orientation for rebuilding. Progress had continued in New York and other places spared from fascism and Stalinism, and what had been modern at the beginning of the 1930s had meanwhile acquired a patina and given way to its replacement; but in the Berlin of 1945 any recourse to the period before 1933 meant opening a time capsule left untouched all those years. Nowhere was this more apparent than in the reconstruction of the city itself. For the architects and urban planners who in 1933 had had to shelve their plans for a modernized Berlin, the time had come.

"A MECHANICAL DECONGESTANT"

Destroyed, Berlin presented itself to the observer in two forms. One, as Isaac Deutscher noted, was vertical: the ruins projecting upward. But there was the horizontal, too: the open plain, the field, or, as was occasionally said after 1945, the steppe that had resulted from the destruction. "That steppe in the middle of Berlin" (Manuel Gasser)[20] was the center, approximately Potsdamer Platz, in which buildings and traffic had been at their most congested before the war and where now grass grew and wild rabbits lived. "On the sidewalks, nettles as tall as men, and where sleek lines of traffic used to move along, grass is secretly gathered at night for whatever livestock is hidden away at home," wrote the poet Gottfried Benn, calling the city "a Mongolian border town provisionally still called Berlin."

Urban planners saw it differently. They saw in the reversion of the metropolis into an open field not a relapse into barbarism but the successful creation of an open construction site they had long hoped for in vain. For representatives of modernity in the 1920s, the great obstacle

to the architectonic and structural modernization of Berlin was the existing city. In their eyes, clear and orderly plans had repeatedly been frustrated by the enormous, disorderly, unhealthy, and senseless urban heap. Thus the destruction of World War II could provoke a few dutiful tears for the ruined gems of architectural history, such as the Schloss and several Schinkel buildings. But beyond that, a feeling of liberation described more precisely the reaction of modern-minded architects and urban planners after 1945. Whether they had emigrated or remained in Germany, they were united on this point. "Berlin is no more! A decayed corpse!" noted Walter Gropius during his first visit in August 1947,[21] and recommended that the American military government construct a new capital in Frankfurt am Main. Martin Wagner at Harvard, who was not to revisit his former sphere of influence until the 1950s, suggested that Berlin's mounds of rubble not be rebuilt but that an entirely new city by this name, if possible in another place, be erected: "The very idea seems monstrous, even barbaric . . . to rebuild on German rubble what made it rubble: obsoleteness, outlived purpose, and an architecture of spent respect."[22]

From the 1920s until his banishment in 1933, Martin Wagner had been the head of planning on Berlin's Board of Works, initiator of, among other things, the redesign of Alexanderplatz and a pioneer of modern housing developments. A disciple of the technological utopia, he made it his life goal to organize residential and urban construction as Henry Ford had the manufacture of automobiles. Houses were no longer to be built of stone, and if possible also no longer in a cubic form, but produced, like the Model T, a million times over from light, cheap, nondurable materials. The city Wagner envisioned was no longer a historically and culturally groomed structure, but a machine that would break down with age, and whose breakdown informed its very conception. The lifetime of the houses planned by Wagner was twenty-five years, the period of amortization for the capital required for their production. Architectonic and urban planning vision went hand in hand with technological and economic calculation. His concept of the housing development was meant to initiate "a city-country culture in which urban dwellers close to the country and a rural population close to the city might join hands in a common ascent toward a better way of life."[23]

Wagner's ideal of a city close to the country, embedded in nature and abundantly verdant, was shared by the entire modern urban-planning movement. And in Wagner's Berlin of the 1920s, that ideal had been approximated more closely than anywhere else. Not in the center, to be

sure; on the periphery, though, arose developments considered exemplary in international regard—for example, Britz, Zehlendorf, Lindenhof, Eichkamp, and Frohnau. Thus in 1929 Bruno Taut could with a certain right speak of the "country character" that Berlin, in distinction to Paris, London, and New York, possessed and could not shake off, as innate a feature as the avenues in Paris or skyscrapers in New York.[24] That same year Wagner's colleague in the Berlin Magistrat (city administration), commissioner of transportation Ernst Reuter, announced as the objective of his department: "With all our resources, we hope to encourage the fusion of metropolis and countryside, the development of the metropolis into a green city out in the open, a city between lakes and forests."[25]

For those colleagues of Gropius and Wagner who had stayed in Berlin, the city in 1945 was the unexpected realization of this vision. The destruction, which they euphemistically called a "mechanical decongestant" (Hans Scharoun), had transformed what had once been a city back into nature, or, in Alfred Döblin's words, into "a scrap of earth through which the Spree flows." Here, all former impediments now swept away, their ideal garden metropolis of the future could be erected. In addition to the de-densification of the center, modern planners found further cause for gratification. Those outer districts of Berlin, in whose construction they had taken part and which they regarded with pride and satisfaction as the first actualization of modern urban planning, had remained essentially undestroyed. Like a "wreath of outlying municipalities [around] the extinguished crater" (Theodor Plivier), these districts stood ranged about the annihilated center, signaling in the sheer fact of their survival that they were more suitable to the modernity of the twentieth century than had been the historic center.

It was logical that plans for Berlin's reconstruction—or new construction—should proceed from the crater's periphery. Of the three most important designs, two bore the names of outlying districts: the Zehlendorf plan and the Hermsdorf plan. The third, the so-called Collective Plan developed by the Magistrat's planning group under the direction of Hans Scharoun, detailed most fully what the other two also attempted: the transformation of Greater Berlin into a diffuse and verdant garden city according to the principles of modern urban planning set down in the Athens Charter by the International Congress of Modern Architecture in 1933. "What the mechanical decongestant of bombings and the final battle have left behind," said Scharoun in 1946, "gives us the chance to create an 'urban countryside.' . . . This will make it

possible to organize all that is incomprehensible and immeasurable into comprehensible and measurable elements and to coordinate these elements in the way that forest, field, mountain, and lake come together in a beautiful countryside."[26] According to the Collective Plan, Berlin's urban countryside was supposed to stretch to the east and west, abandoning historical indices to follow more closely natural features, above all the valley of the Spree and Havel as carved out by receding glaciers many thousands of years before.

The Collective Plan remained as hypothetical as the Zehlendorf and Hermsdorf plans. In the end, the historic structure once again prevailed, modified by the political east-west division. Nevertheless, as a kind of monument of modern urbanism, the plan was significant because it could in fact have been realized. No other urban-planning utopia designed for a European metropolis in the twentieth century, not even Le Corbusier's visions of Paris, had anticipated the urban demolition or destruction necessary for so complete a reconstruction.

Berlin in 1945 came close to the realization of the modern ideal of urbanism not only in its theoretical planning but also, if in a somewhat uncanny way, as the city that it in fact was. The residential areas situated in the verdure of the periphery ceased to be purely residential areas and became autonomous municipal entities. In the summer of 1945, reference was made to the "independent republics" of which the formerly unified Greater Berlin now consisted. The old district offices were no longer subordinate to the central administration as dependent administrative units. They emerged as decentralized and autonomous organizations, like the free cities of the middle ages, in the way that utopian urban planners had always imagined ideal communal living. Cultural life, which had formerly played out in the center, now flourished throughout the garden city republics. The ensembles of bombed-out theaters, opera houses, and concert halls played in makeshift halls or, weather permitting, in gardens and parks. Everything that constituted life at the capital in its traditional center was now to be found at the periphery. There had never before been a Council for the Arts in Zehlendorf. In the summer of 1945, this newly created office numbered among Berlin's most important cultural institutions. The picture was completed by the new masters of the city, the Allies, ruling the city from their headquarters in the residential streets of American Dahlem, Russian Karlshorst, British Grunewald, and French Frohnau. In the summer of 1945, the ruined center seemed like a modern version of fourteenth-century Florence struck by the plague and abandoned by its residents; and, like the

party of the *Decameron* that had fled to the countryside, some of the residents in the outlying districts sensed the contrast between their comfortable normality and the world that began only a few miles away. In July of 1945, the German émigré and British press officer Peter de Mendelssohn described how Berlin appeared from the perspective of the Allied officers' club in Zehlendorf:

> Berlin is boiling in sweltering heat, and the stench and odour that arises from the canals and river arms of the inner city, still packed with thousands of rotting human bodies, that sweetish, nauseating odour that pervades everything, begins to make one really sick. For now it comes not only from the still waters—vast mosquito-breeding grounds and sources of pest and pollution—but also from the dead ruins where the heat of the sun has by now penetrated through the mountains and mounds of rubble and reawakens to foul life what is buried underneath. In a few days this town is going to be a cesspool. . . . Out here in lovely Zehlendorf, of course, the air is pure and clean and life is pleasant enough. A heavy golden summer heat has been hanging all afternoon over the large wild garden that stretches behind the house and over which I look from my desk. The big chestnut and slender lovely birch trees in the summer heat, slightly ruffled every once in a while by a breeze—they are the image of peaceful comfortable life in a large, well-appointed country mansion. The chairs and sofas are comfortable, the large French windows out to the terrace are open, there are drinks and coffee on the low table, American cigarettes, and the radiogramme playing the Mendelssohn violin concerto with Toscanini. The officers lounge around in deep chairs, smoking, chatting in low voices, it is getting slowly dark, the mosquitoes are beginning to come in, at the back of the room, along the walls are books by the hundred, a good and interesting library. Someone turns the light on, the records are changed—it is a perfect summer evening, hot, lazy, comfortable and a little drowsy.[27]

"DREAMLAND"

Dreams like that last but an instant, like the dream
of that moment when the Americans and the Russians
shook hands at the Elbe and every exhausted soul
seemed to heave a deep sigh of release: So be it!
 Ernst von Salomon, *Der Fragebogen*

There were two different, in fact contradictory images of Berlin's destruction and its ruins after 1945. To the historical-romantic gaze, it appeared as a field of wreckage of antique greatness, timeless like the Forum Romanum. Viewed in a modern-surrealistic way, on the other hand, one could see in the image of shattered houses and ruined streets

not eternal witnesses of transience, but the slain victims of a destruction
still recent and reeking. In the summer of 1945, the writer Johannes R.
Becher called such houses, their rooms proffered to the observer like
naturalistic stage scenery, "slaughtered and eviscerated." They were
ruins of uncanny life.

> A room cut in half sways at a height above the abyss of a courtyard filled
> with rubble; hopelessly isolated in the wasteland of rubble of an executed
> quarter, with a table, piano, sofa, chairs, and both walls hung with pictures:
> unaware that only a slight gust of wind would sweep it from its dizzying
> height into nothingness—ghostlike: from behind the curtains of this burned-
> out and deserted world, a woman emerges from an invisible backdoor on to
> the stage, holding a can in front of her, moving gropingly along the table; a
> balcony, too, above this empire of rubble, as though borne aloft for a mo-
> ment, and then tilting downward again in its suspension.[28]

Such scenery became a topos in the literature about postwar Germany.
A contributor to Sartre's magazine *Les temps modernes* called it the
"poésie du cauchemar"—the poetry of nightmares—and tried to pic-
ture for her Parisian readers the surreal reality of Berlin: "The surrealist
sewing machine placed at the base of the statue of Frederick the Great
on Unter den Linden would surprise no one."[29]

The people of Berlin who lived with and in the ruins and who had ex-
perienced the destruction of the city from 1943 to 1945 gave an im-
pression of psychic ruins to outsiders. The American journalist William
L. Shirer saw "broken, dazed, shivering, hungry human beings without
will or purpose or direction."

"Two months after the capitulation, Berliners still seemed stupe-
fied," stated the American special ambassador Robert Murphy.[30] A few
weeks after his return from Moscow, Johannes R. Becher, a hybrid of
observer and victim, described the situation in the first person plural:
"Haven't we grown ghostlike, too, aren't we all wandering about, shad-
ows and phantoms . . . ?"[31] Ernst Jünger compared the condition of
the Germans after the collapse with that of Charlie Chaplin "when he
has received a strong blow on his head and reels."[32] Jünger, who had
fought in World War I, knew what he was talking about. Chaplin's
condition of reeling, stupefaction, confusion, and loss of orientation
and reality was that of thousands of soldiers on the front lines: in psy-
chopathological terms, war neurosis or traumatic neurosis. The diagno-
sis of traumatically neurotic was made of those who, without bodily
injury, were psychically overwhelmed by a particularly violent event of

war (such as a grenade explosion, burial in rubble, or battle charge). If the suffering in World War I was restricted to the soldiers on the front, with the effacement of the distinction between the home and battle fronts in the total phase of World War II the suffering became universal. The traumatized soldiers returning home in 1918 had in 1945 turned into a traumatized general population.

Berlin, the theater of both German collapses, provokes the comparison between 1918 and 1945: just as the Spartacan Rebellion in January 1919 became a prelude to German civil war and finally to the east-west division of Germany and Europe, so did the battle line running through the center of Berlin and dividing the bourgeois west from the proletarian east anticipate, with astonishingly little error, the later line of demarcation between the Western sectors and the Eastern sector. Count Harry Kessler had a sense of epochal change, like Goethe at Valmy, when at the outbreak of this rebellion he noted in his diary on January 6, 1919: "All of Berlin is a bubbling cauldron whirling together violence and ideas. In fact world history is being made today . . . a decision between east and west, war and peace, ecstatic utopia and dull everyday life. Not since the great days of the French Revolution has there been so much at stake for mankind in a city's street battles."[33]

The battles of the winter 1918–19 took place in a physically intact Berlin, within an urban machine that, as Kessler and others noticed with astonishment, continued running as if nothing unusual were going on. "Little impact of the revolution on big-city life," Kessler noted on January 17, 1919. "Life here is so primary that even a historic revolution like this causes no fundamental disturbance. Only with the revolution have I realized how Babylonian, immeasurably deep, chaotic, and violent Berlin is, seeing how this colossal motion has caused only small, local disturbances in the even more colossal to-and-fro of Berlin."[34] Even small, local disturbances seemed strangely unreal, as Kessler observed with reference to a scene of street battle: "Up on the viaduct, a train moves right through the fiery battle."[35] The philosopher Ernst Troeltsch offered another example of this surreal simultaneity: "The theaters continue to operate and attract their audiences, which hustle past gunfire in the usual numbers, and above all, wherever possible, there's *dancing* [emphasis in original]."[36]

The difference, indeed the exact inversion, of the scenes in 1918 and 1945 is obvious. In 1945 the destruction of the urban machine was as fundamental as had been its continued functioning, despite all revolutionary turbulence, in 1918. And just as scenes of violence and destruc-

tion looked surreal in the intact city of 1918, so did the intact islands and niches that appeared in the ruined city of 1945. Whoever unexpectedly caught sight of an undestroyed house or house-lined street among the scenery of rubble found it, like the Berlin critic Karla Höcker, "almost comic: like scenery from the wrong play,"[37] or unreal, like Johannes R. Becher: "Everything is still here. Everything is still in the same spot, everything still seems as it always was. But there is something artificial about such preservation amid the general devastation, like something put together for an exhibition."[38] However fundamentally different, even contradictory, the realities from which they arose, the features of Berlin's appearance in 1918 and 1945 shared a common unreal, dreamlike, ghostlike quality and a common prerequisite: the defeat and collapse of the old system of power. But there comparisons end. The year 1918 had witnessed an active self-liberation through revolution and 1945 only a passively experienced defeat by a foe from the outside. It was from this essential difference that everything followed, from the intellectual and artistic flowering after 1918 to the barren expanse of the years after 1945. Recall the image of Charlie Chaplin knocked on the head; the scene that has him dizzily swaying and reeling is but one version. In others equally frequent in Chaplin films, such a blow puts him into a trance in which he lithely executes dances until a second blow brings him back to reality. Ernst Troeltsch, laying such great weight on the fact that in the Berlin of 1918 "above all . . . there's *dancing*," called the weeks and months following the signing of the armistice in November 1918 the "dreamland of the armistice period."[39] This referred to the state of mind of the Germans, who had not yet grasped the full extent of the defeat. The collective "I" was in a state of suspension; everything dreamed seemed possible, and everything real seemed dreamlike and unreal. Ideas like revolution and socialism proved stirring across classes and special-interest groups. Thirty-six years after Troeltsch's dreamland metaphor, Klemens von Klemperer commented, "In those few months of euphoria even the conservatives turned revolutionary."[40]

A similar state of suspension reigned at the end of World War II. In New York, Moscow, London, and Paris, the atmosphere was unchecked, enthusiastic, carnivalesque. Berlin was stricken, stupefied, dizzy—a "dreamland" under nightmare conditions, but undoubtedly a dreamland as after all great historical upheavals. If in 1945 the word *liberation* did not have the rousing effect in Germany that had issued from *revolution* in 1918, it was still more than merely an Allied propagandist

slogan. The liberation in collapse was experienced as a redemption, if
not by the entire population, then certainly by the greater part of the
German intelligentsia. The difference between 1918 and 1945 is per-
haps best elucidated with an image that Georg Lukács used in another
context. In 1918–19, Berlin's intelligentsia was able to pursue, ponder,
and fashion the collapse from the distance and safety of an intact "Ho-
tel Abyss." Now the hotel itself was destroyed, metaphorically and in
the most concrete of senses. Intellectuals found themselves in the abyss,
without distance from or defense against its reality. They felt it so di-
rectly and forcefully that words failed them, or—to borrow Karl Kraus's
phrase—they had nothing to add to it.

So, at least, did it seem in retrospect. Yet whoever experienced Berlin in
the summer of 1945 must have marveled at the speed with which the
cultural life of a city that had been struck so mightily found its voice
again. Only a few weeks, even days, after the capitulation, theaters and
opera houses recommenced rehearsals. Orchestras played. Hundreds of
cinemas and cabarets sprang up overnight, as would the pornography
and banana stands forty-five years later in collapsed East Germany, sat-
isfying a similarly elemental popular demand. Artistic and cultural so-
cieties were established and found a lively following. The founding of
newspapers and magazines, film-production companies and radio sta-
tions soon followed. Peter de Mendelssohn, formerly a literary figure in
Berlin, noted upon his arrival in July 1945, "Berlin is not dead, in many
ways it is more alive than Paris," and was reminded "of the inflation
period by the atmosphere of artificial amusement and hectic gaiety amid
towering ruins and depressing deadness."[41] Other observers also felt
reminded of the early 1920s—less, however, by the cultural scene than
by the appearance of the black market, prostitution, and crime, of ev-
erything that a British officer stationed in Berlin in 1945 termed the
"moral melting pot."[42] The 1920s were recognizable in the intellectual
and artistic scene merely as a fruitless attempt at conjuring spirits. "To-
tally *ideenlos* and unfortunately retrospective in their tastes and sensi-
bilities," Clarissa Churchill said of the intellectuals and artists whom
she met while writing an article on Berlin for the literary magazine *Ho-
rizon* in 1946. She added: "It is rare to find a self-assured and indepen-
dent thinking person among the German intellectuals, and the few that
exist are generally in the Communist camp. An example of this lack of
esprit nouveau is seen in the theatre, where both the choice of play and

the production reflect so thoroughly the now sterile and outmoded spirit of the twenties."[43] Fritz Kortner, the actor and director, wrote about his first reencounter with the Berlin theater in 1947: "The performance [at the Kurfürstendamm Theater], which I had to endure through to the end, was unbelievably wretched. Decorum kept me in my seat. In truth, I wanted to flee right after the curtain went up, all the way back to America. Impudent schmaltz, depraved humor, an alien gaiety on the stage, insulting eye, ear, heart, and mind. For days afterward I lost all mirth over this debased, miserable, depraved, disturbing comedy."[44] Empty activity in place of true productivity, fluff instead of substance—critical characterizations of Berlin's cultural life in the three years after 1945 revolved around this formula. Such verdicts were numerous. In a letter to Hermann Hesse in November 1947, Peter Suhrkamp spoke of "all those engaged in culture and art who crawled out of holes and onto the streets, immediately busy and active once again."[45] In January 1946 he wrote to Siegfried Kracauer: "Signs of the life here: everything transpires in an empty room. Nothing is conveyed. There is no movement nor a favorable atmosphere, and nothing issues as a result. You might best understand what I am trying to describe by imagining that nothing is happening in your house, truly nothing at all."[46] Wilhelm Furtwängler: "What is going on now is all passing, insignificant, meaningless. A reign of mediocrity in its truest sense, but which certainly cannot and will not last."[47] Elisabeth Langgässer: Berlin is "a vacuum filled with newspapers, magazines, amusements, and literary gatherings, a sheer collection of nonsense that cannot offer fertile ground for a real cultural life. . . . As grotesque as it sounds: over the last twelve years I had incomparably more time to produce real work than today." About the Congress of Writers in 1947, Langgässer wrote: "The whole thing went up like a great show of fireworks, and the following morning the parched brown grass was strewn with the charred remains." "Both culturally and materially, Berlin is one big mound of rubble. A dance of ghosts from 1928 . . . propels 'intellectual life' onward: Brecht, Toller, Tucholsky, Zweig, Becher, etc." Berlin—"an inward and outward Pompeii."[48] What Erich Kästner said about the younger generation did not refer specifically to Berlin—indeed, here it was probably less accurate than in the rest of Germany—but his words also defined the cultural atmosphere of Berlin: "The most intolerant, stupid, and vile remarks [about modern art and literature] originate almost without exception with students and young people. Youth who were always the

first and most enthusiastic partisans of the artistic vanguard today fill the ranks of the Philistines. The Germans have the aesthetic ideals of old women."[49] Herbert Ihering compared the cultural *niveau* after the collapse with the period after the Thirty Years' War, demanding, like Lessing, a new beginning.[50]

This is not to say that critics were of one mind as to what a new and contemporary culture meant. Belonging to camps of different orientations, they had already stood irreconcilably opposed to each other in the 1920s. Furtwängler, Langgässer, and Suhrkamp sadly felt the absence of the great achievements of traditional high culture after 1945; Ihering, Kortner, and Kästner missed everything modern and experimental with which they had identified in the 1920s. But in their contempt for the postwar cultural fluff they were of the same opinion. What escaped them is that such activity, if understood as a culture trying to catch up, was not so entirely empty and unproductive. What finally prevailed and defined the culture of the postwar period into the 1950s was not the attempt to resuscitate the 1920s, but the reception of what had taken place abroad during the twelve years of cultural isolation. German postwar culture eagerly soaked up the works of Sartre, Anouilh, Claudel, Vercors, Eliot, Hemingway, and Thornton Wilder. This new cultural system, its coordinates formed by Paris, London, and New York, held no place for Berlin, a fact demonstrated by the failed attempt, as quick as it was pitiful, to artificially achieve such a position by conjuring up the 1920s. It must have been obvious to everyone in 1945 that, in intellectual and artistic terms, Berlin no longer represented anything.

After the collapse, intellectuals pondered what this really meant for Berlin. And they came to conclusions that, even if merely sketched and never implemented, once again assigned to the city a metacultural or existential importance. These were in part the same intellectuals who disdained Berlin's cultural bustle as hot air. During visits to western Germany Peter Suhrkamp discerned "a certain innocuous unawareness" as the reigning attitude there: "It was clear that they had not faced the demons in the final act like everyone here in Berlin."[51] For Gottfried Benn, Berlin had lost through its destruction its formal unequivocality: "Its sobriety shows strains. Traces of the chaotic enter into its former clarity. Some wavering quality is introduced, an ambivalence out of which centaurs and amazons are born."[52] Likewise for Herbert Ihering: "The only thing missing in this bright, matter-of-fact city has now been

etched in: tragic features. To its characteristic reason and infallible judg-
ment was added a capacity for suffering and endurance its enemies would
never have believed the city capable of."[53] Contemporaries found this
transformation visually imprinted in the ruined state buildings, formerly
seen as ostentatious, brutal, and ugly. "One can see," writes an English
observer, "how the ruins of these colossal piles—the Schloss, Kaiser
Wilhelm Gedächtniskirche, the Air Ministry, the Kroll Opera House,
or the War Ministry can have a certain pathetic sense of wasted effort
and mutability about them."[54] A Janus-faced Berlin emerged from the
contradictory statements of its defenders and detractors. As though he
had never compared the postwar culture of this city to the wasteland
after the Thirty Years' War, Ihering wrote to Brecht: "Berlin still has
the potential of a true theater town. Precisely because so much has been
destroyed and so much of the old cleared away."[55] As though all mirth
had not left him in Berlin's theaters, Kortner wrote: "Slowly old Ber-
lin's great talent crawled out of the ruins."[56] Friedrich Wolf, who held
the Germans to be "hopelessly conceited and irremediable," believed
in the "great potential of Berlin again becoming an artistic and cultural
center of the first rank."[57] Fleeting moods and tactical considerations
(e.g., how an émigré might best be enticed back to Berlin) surely fig-
ured in this ambiguity. But what remained was the contradictory char-
acter of the city as the sowing ground of future cultural productivity.
The suggestive link between all of these statements led the philosopher
Gert H. Theunissen in 1947 to define Berlin's intellectual stature not in
terms of

> the works and achievements that musicians, poets, painters or directors, sci-
> entists and intellectuals, writers, politicians, or economists have produced.
> The word *stature* is merely aimed at the condition under which works and
> achievements can arise at all.Berlin's intellectual status exceeds the in-
> tellectual situation of every other city in Germany in the possibilities of in-
> tellectual experience and knowledge, though it is altogether a different mat-
> ter as to whether these unquestionable possibilities are actually perceived
> here, whether, in other words, Berlin is proliferating de facto with the many
> pounds that have been conferred upon it, not by its merit, but from develop-
> ments in global politics after the collapse.[58]

Understood as such, the most important element of Berlin's intel-
lectual status was that though the city had ceased to be the capital of
the German Reich, it remained so in a different form: as the seat of rule
of the Allied victors and present masters of Germany. Through this

internationalization, Berlin became, for a brief period and in a manner far removed from the Nazis' visions of world power, a kind of world capital more than ever before. Like a permanent Viennese Congress or a Vatican council stretching over years, it continued to draw global attention to itself. There were more foreign journalists covering Berlin in the three years after the war than there were in any other European metropolis. *The New York Times,* which had three correspondents in London, two in Paris, and one in Rome, engaged four in Berlin.[59] In the years 1945–48, arriving in Berlin's Tempelhof airport from London, Paris, Rome, or Frankfurt seemed like landing on a chessboard of global politics. Only after 1948, with the conclusive East-West confrontation—and the division of the world, Europe, Germany, and Berlin—did the city lose this aura and become the marginal exclave it continued to be until 1989.

One might object that Berlin's role as an international capital was as removed from the sphere of its inhabitants' everyday world as the governor's palace of a colonial power from the colonized population. Initially the Allied capital of Berlin was without doubt a control room for the victors, hermetically closed off from the Berlin of a defeated people. To the extent, however, that conflicts within this control room emerged and signs of disintegration began to appear, Berliners, at first merely looking on, became participants. Isaac Deutscher wrote in October 1946 that from Berlin

> Germany's political recovery has begun. It is a very strange type of recovery—almost exclusively the result of the rivalry between east and west. Berliners instinctively sense that their greatest opportunity lies in this rivalry. After Napoleon's fall, France had her Talleyrand who understood how to exploit the differences within the victorious coalition, raising himself from mouthpiece for the defeated to arbiter of the victors. There was no Talleyrand in Germany after the fall of the Nazis. But somehow the multitude of Berliners seemed to play the role of a collective Talleyrand.[60]

Talleyrand's policy of independence was possible in a France defeated but not partitioned among its victors. Berlin's "independence" was possible as long as the city remained the undivided object of the victorious powers and the goal of their "open" competition. When that division finally occurred in the fall of 1948, those who had played the collective Talleyrand in politics and culture lost their sphere of action. They ceased to act independently, and little remained for them but to identify with the powers for whom they now became functionaries and mouthpieces.

CULTURAL COMMANDO

The circumstances of the conquest, military occupation, and rule of Berlin after 1945 had an archaic quality. During the battles and their aftermath there were rapes and plundering, and when life went back to normal, it followed the oldest bylaws of victory and defeat. The Allies' quarters in the elegant parts of town were as isolated from the rest of the city as the European districts of Saigon, Algiers, New Delhi, and Léopoldville were from the native centers. Nonfraternization regulations governed dealings with the civilian population. Private relations were forbidden. During unavoidable official contact, it was verboten to shake hands with Germans. At the same time the fruits of victory were enjoyed, both material and symbolic, and often in undifferentiated combination. In the office of the head of American Information Control, a flag with the swastika was draped over the sofa, and a luxury edition in folio of *Mein Kampf* served as the guest book (the guests entered their names on the margins and empty spaces).[61] The theater critic Hilde Spiel mentioned another form of delighting in the trophy: "The ladies of the Allied occupation, apparently at ease and without noticeable consternation at the moral compromise entailed, now lay claim to the amenities—the hairstylists, manicurists, pedicurists, seamstresses, furriers, and servants—of the 'high ladies' of the Nazi elite who disappeared along with their executed or incarcerated husbands."[62] More than forty years later, Spiel in her memoirs showed no great consternation at having laid claim to such services herself. From her hairdresser ("Madame Sibylle") she heard "many a secret of the ruling class under Hitler." To the dependents of the victorious powers, the occupation period was a dream period of a singular kind—especially if they had American dollars at their disposal: "At that time there were parties you read about only in novels. There were enormous quantities of Manhattans and martinis, creme de menthe and old French cognac, Scotch whisky and the best French champagne. There was the best Russian caviar, there were oysters, there were enormous steaks. And for some fifty guests, with three servants engaged especially for the evening, and a bartender—the cook and maid were already there—all of this cost about ten dollars, that is, cigarettes in the amount of ten dollars. At that time in Berlin, with dollars, you could live as though it were not a mound of rubble, not a defeated city, but a paradise" (Curt Riess).[63] Not everyone shared in the good life of these "satraps" (Spiel) with equal lack of worry and consternation. Some found the behavior of the

"occupational establishment," as George F. Kennan called it, to be morally objectionable. Kennan said of it:

> This was an establishment for which I had an almost neurotic distaste. I had been twice in Germany since the termination of hostilities. Each time I had come away with a sense of sheer horror at the spectacle of this horde of my compatriots and their dependents camping in luxury amid the ruins of a shattered national community, ignorant of the past, oblivious to the abundant evidences of present tragedy all around them, inhabiting the very same sequestered villas that the Gestapo and SS had just abandoned, and enjoying all the same privileges. . . . a disparity in privilege and comfort between themselves and their German neighbors no smaller than those that had once divided lord and peasant in that feudal Germany which it had been our declared purpose in two world wars to destroy.[64]

In addition to their material well-being, intellectuals in the cultural departments of the military administration had another reason to consider the occupation period in Berlin the "richest, most varied, and exciting" (Spiel) of their lives. Young men (less frequently women) at the beginning of their professional careers who might never have never gotten beyond a midlevel position now found themselves in positions of power that Balzac's young heroes could only dream of. They became founders of newspapers instead of toiling away as editors, issued publishing licenses in lieu of merely reading manuscripts. Twenty-five-year-olds with no more experience in the theater than Wilhelm Meister or Felix Krull decided whether the famous director Jürgen Fehling was to receive a theater license. Berlin's cultural industry seemed to them a giant toy, or a new version of the Roman saturnalia. The old hierarchy was suspended. It was the cultural zero hour in which all seemed possible, including the phenomenon of a nameless young musician from Florida, now the cultural officer responsible for music, directing the Berlin Philharmonic and deciding whether Wilhelm Furtwängler would ever be allowed to lead it again.

So much for the archaism—or, more correctly, the archaic appearance—of the cultural occupation of Berlin. For what appeared as a recourse to antique and colonial practices of handling the defeated was in reality something new. In the past, military occupation of defeated nations had limited itself to physical control. The thought and culture of the occupied people were left untouched. Censorship measures ensued only to protect the military and political interests of the occupying power. In contrast, Allied policies for reeducating the defeated after World War II

sought to complete the foe's external subjugation through an inner one. Out of the psychological-warfare techniques developed during the war to demoralize the enemy emerged a postwar strategy of remoralization toward the ethical and political values of the victor.

Like everything new, this had its predecessors as well. The most immediate were Germany's cultural policies in occupied Paris from 1940 to 1944, which for their part drew upon the experiences of the German occupation of Belgium from 1914 to 1918. The Central Press Office of the Political Division of the General Government in Belgium, established in Brussels in 1915, might be called the first information control department of modern military history. Its sphere was partly traditional—censorship—and partly modern—propaganda. It did, however, fall short of the direct intervention into native cultural institutions and the media that occurred in Germany after 1945. The Brussels department's importance showed in the choice of its personnel. Wilhelm Hausenstein, Rudolf Alexander Schröder, and Otto Flake—all respected poets and writers in prewar Germany—were engaged as cultural officers in Brussels.[65] Germany's cultural policies in Paris after 1940 continued these first leanings toward propagandistic cultivation of the occupied country's intelligentsia. The most important tool, founded for this purpose, was the German Institute. What its leader, Karl Epting, said in December 1940 about the institute's objectives shows that a distinction between propaganda and reeducation was still discernible, though evaporating more and more. "French intellectuals must renounce their ideal of universalism. They must no longer speak in the name of general principles and should no longer try to spread these principles beyond France's borders."[66] These precepts could be interpreted loosely. Nazi ideologues in Berlin like Goebbels and Rosenberg attempted a Nazi reeducation of the French intelligentsia. More moderate circles were satisfied with the idea that the French intelligentsia were simply being denied the further export of their views. In German-occupied Paris there was in fact no noteworthy attempt at Nazi reeducation, because those who would have had to carry it out were not disposed to do so. The German cultural officers were in the main Francophiles of the educated middle class, characterized by what one of them (Gerhard Heller) once confessed: "For us, Paris was a second intellectual fatherland, the most complete embodiment of everything we sought to preserve of the culture of the past."[67] Distance was not the only factor permitting in Paris what was culturally unthinkable in Berlin in the years 1940–44. The cautious maneuvering of the cultural officers played an important part

as well. The comment of a German to Paul Léautaud—"In Paris we allow ourselves a liberalism completely unknown to us in the Reich"[68]—shows that events like the debut of Sartre's *Les mouches* and the publication of Camus's *L'étranger* in 1943, the year of Stalingrad, were not purely accidental.

The French, moving into their assigned sector of Berlin in the late summer of 1945, found it difficult to play the role of victor convincingly. The trauma of the defeat in 1940 and subsequent occupation and collaboration was still fresh, and their self-assurance was undercut by the memory that the Germans, now to be ruled and overseen, had less than a year before been the rulers in their own land. How little France counted in the circle of victorious powers had been made clear when the areas of occupation were first laid out. No thought had been given to a French zone. The fact that the French zone in western Germany and the French sector in Berlin were taken from the area originally intended for the British must have been seen in Paris as the granting of crumbs from the table of the mighty. And in the end, for the nation that for centuries had considered itself the cultural leader of Europe and the entire world, it was sheer humiliation to be assigned a sector in Berlin composed of two districts that were a cultural wasteland. In Reinickendorf and Wedding there was to be found no theater, no opera house, no museum, no publisher of note, no university, and, beyond a few public-library branches, no library worthy of the name. In view of these circumstances it is not surprising that the tone of the French occupation was subdued and full of resentment. The American correspondent Delbert Clark, himself anything but warmly disposed toward Germans, considered French occupation politics paranoid and petty, emanating from an "atmosphere of diseased pragmatism"—"like the behaviour of a squirrel on a treadmill: so long as he keeps it revolving he fancies he is going somewhere."[69] The behavior of her countrymen in Berlin reminded Simone de Beauvoir of the Germans in Paris during the occupation period. ("I felt we were as hateful as they had been . . . and you feel worse if you are on the occupating [sic] side.")[70]

The lack of cultural infrastructure in the French sector made it impossible for the French to institute cultural policies as the other Allies were doing. Restriction to cinemas, schools, and public libraries did not satisfy French claims on culture; and the only voice that carried beyond their sector, the daily newspaper *Der Kurier,* was also regarded as inadequate. A solution was sought in the Mission Culturelle, a creation of the foreign ministry in Paris, possibly inspired by the model of the Ger-

man Institute of the years 1940–44. Its task was in any case a similar one: contact with the local intelligentsia; organization of visits and speeches by prominent figures from France (e.g., Sartre and Vercors); liaison with other Allied cultural administrations. Established in the fall of 1946, the Mission Culturelle was the first organization of its type in which the Allies presented themselves to the Germans not as victors but as bearers of culture.[71] Its leader, Félix Lusset, maintained more cordial relations with Alexander Dymschitz, the chief cultural officer in the Soviet Military Administration in Germany (SMAD), than he did with his Western colleagues. When at the end of 1947 the Americans and English banned the organization Kulturbund zur demokratischen Erneuerung Deutschlands (Cultural League for the Democratic Revival of Germany), the French did not join them because, as Lusset's superior in the foreign ministry had said a year before, they saw in institutions like the Kulturbund the greatest possibility "for developing our influence in Berlin on cultural directives."[72] In his memoirs, Lusset reports discussions with Dymschitz about the possibilities and prospects of a cultural axis involving Paris, Berlin, and Leningrad.[73]

The English moved into their sector under completely different conditions. Their self-assurance as victors was unbroken. They belonged to the Big Three of the war conferences from Tehran and Casablanca to Yalta and Potsdam. And of all four Allies, they were the most experienced in the control of foreign peoples. Two centuries of empire had produced a colonial know-how and a well-trained administrative bureaucracy regarded with envy by their allies and respect by the Germans. Reeducation meant for the English something different than it did for the Americans. They were not guided by thoughts of an idealistic moral mission but by the conviction, confirmed through long experience, "that by educating the elite of their subject peoples into British ways, from cricket to the rule of law, they were able to maintain their rule by indirect control rather than by the more costly and troublesome overtly military-administrative direct methods of control."[74] The English historian Nicholas Pronay, author of this insight, finds evidence that the reeducation of South Africans by the English after the Boer War "contained practically all the basic ideas and techniques planned for the re-education of Germany."[75] English cultural policy in Berlin proceeded carefully and with reservation. They included an understanding that winning over the intelligentsia of a European country required different methods than those applied in Africa and India. The emphasis of English cultural policy fell less on artistic and intellectual production

than on the establishment of a culture of common sense in a country whose cultural elite (at least in English opinion) had let itself be too easily led astray by extremes.

The missionary zeal and moral rigor of American reeducation policies, like the behavior of the Red Army during the conquest of Berlin, belong to the commonplaces of German postwar history. They are correct, but upon careful examination they thwart certain common assumptions. Thus in Europe it has been little noted that the American treatment of postwar Germany presented in essential points a repetition of what eighty years previously the victorious Union had conferred upon the defeated South after the Civil War. What took place in Germany in the years after 1945 had taken place once before in postbellum America, from the idea of unconditional surrender to the military occupation, the installation of a military government, and the attempt through reeducation morally to improve the subject population.[76] Instead of slavery and racism, the ideas now to be rooted out were militarism and nationalism. The methods in both campaigns were alike insofar as the population to be reeducated was not believed capable of the strength required for self-purification. Salvation had to be forced upon it.

Not altogether absent were critical voices within the American military administration, like that of the Harvard political scientist Carl J. Friedrich, who stated retrospectively: "Indifferent to or unaware of the strength of anti-Nazism inside Germany, American policy makers imposed on the Germans a totalitarian regime, more benevolent, to be sure, than that of the Nazis but giving little consideration to the best in German tradition and to the legitimate wishes of those men and women who had not accepted totalitarian methods."[77] The head of the military government, General Lucius D. Clay, felt similarly: "I do not deem it necessary for a Ministry of Propaganda to be established for such controls," he informed his head of Information Control, General Robert McClure, who held a fundamentally different view of the Germans. ("The basic difference between General Clay and myself is . . . [my] disagreement with him that there are lots of good Germans just around the corner waiting for a chance to prove their democratic attitude.")[78] Perhaps it was not entirely coincidental that Clay was a southerner and McClure came from the North.

Given the difference of opinions at the highest level of American military government, it was significant that among the specialists em-

ployed in Information Control there were more German émigrés than Americans. McClure sought to rid himself of this bequest of the Psychological Warfare Division, out of whose personnel Information Control was formed in the summer of 1945, arguing that "in a country which has been as anti-Semitic as Germany the reaction to some of these people has not been favorable, while on the other hand, as with Americans of any religious faith, many are starry-eyed crusaders and in some cases, therefore, unreliable."[79] Given that McClure himself, in his heart of hearts, belonged to the "crusaders," the wish to be free of coworkers engaged toward this end did not seem very logical. Or did he, when speaking of starry-eyed crusaders, in fact mean an entirely different group of émigrés, people who thought more like General Clay and were, in McClure's eyes, irremediable starry-eyed optimists about the Germans' ability for self-purification?

In the Berlin division of Information Control, the émigrés were in the majority. Many of them had been born and grown up in Berlin. They encountered antifascist German intellectuals daily, resuming contact with old friends and former colleagues. And they soon came to acquire an understanding for the survivors of Nazism and a caution in criticizing and condemning far removed from McClure's rigor.

Of the four occupying powers in charge of rebuilding Berlin's culture, the Russians were first in every respect. In the two months of their undivided sovereignty in May and June of 1945, they laid the foundations and set the stage for all future activity. Their Allied partners arriving in July could question, accept, or undo what was done; but what was done, at any rate, would have to be dealt with.

The second reason for the success of Russian cultural policy was the liberalism and pragmatism with which they set about achieving it. Their strategy of "opening up instead of restricting" roused the soul— as Peter de Mendelssohn stated not without envy.[80]

A third factor was the close collaboration with the communist intelligentsia, both at the level of the party apparatus and with individual intellectuals and artists. Since the most active part of the intelligentsia in Berlin, as in all of Europe, inclined to communism in 1945, the Russians had at their disposal a circle of highly qualified collaborators, unlike any other occupying power.

Finally, in the concurrent judgment of all who dealt with them, Russian cultural officers were themselves highly qualified intellectuals. They

spoke fluent German and were frequently better acquainted with German literature and art than their German counterparts. Berlin memoirs are replete with anecdotes like that of a Russian officer shaming his German listeners with long citations from Heine's *Winterreise* and the *Nibelungenlied*.[81]

The question asked by Western Allies and Germans in 1945, and ever since by students of postwar history, is, of course: Why should the same power that under Stalin had visited upon its own country a *Gleichschaltung* of art and intellect so rigorous and without consideration of losses confer such generous treatment upon a subjugated foe? There is still no satisfactory answer to this. Given the poor state of provisions, did the Russians, as has been supposed, resort to the old motto circuses instead of bread? Did they hope to win over artists and intellectuals to their politics with a kind of Brechtian Tui breadbasket? Or was the cultural pluralism they fostered in Berlin perhaps the result of a quasi-conspiratorial activity of Russian intellectuals in uniform who, at a safe distance from Stalin, Zhdanov, and Beria, thought they could do what was unthinkable in Moscow? Was the situation of the Russian cultural officers in Berlin comparable to that of the German officers in Paris in the years 1940–44?

A statement from the head of SMAD's Information Administration, the Russian counterpart to American Information Control, suggests as much. Sergei Tulpanov,* looking back on the work of his department, wrote: "We knew . . . that the era we were supposed to help shape was long over in the Soviet Union—that is, Germany was going through a phase similar to the developments of the Soviet Union at the beginning

*Tulpanov was a scintillating figure who appears in the memoirs of many contemporaries and several historical accounts as the most superior of the "liberal" cultural officers. He controlled the Soviet Occupied Zone's political activities—of course not by himself, but in the relay of decisions made in Moscow. It remains largely unexplained which persons and groups in Moscow were behind these policies and against whom they were directed. According to a more recent interpretation, Tulpanov was more powerful than Vladimir Semjonov, also a political adviser to the SBZ, because the latter was subordinate to a merely state authority, the foreign ministry, whereas Tulpanov had a direct line to the party. This would explain his unusually self-confident, even imperious behavior with SMAD members of higher rank. According to this study, he had "high-placed protectors" in the party who supported him until 1949 against numerous attacks from other party circles. Bernd Bonwetsch and Gennadij Bordjugov, "Die Affäre Tjul'panov: Die Propagandaverwaltung der SMAD im Kreuzfeuer der Kritik, 1945–1949" (unpublished manuscript, which the authors kindly made available to me). There is much to suggest that Tulpanov was at the fore of the famous and much speculated constellation of both competing Soviet-German lines—the Stalinist line (Zhdanov, Ulbricht) and the laissez-faire–laissez-passer line (Beria, Malenkov).

of the 1920s: a *Sturm und Drang* period."[82] Written at the time of Brezhnev's neo-Stalinism (1967), this "officially" read: compared to the sociohistorical stage of development in the Soviet Union, which had long ago surmounted its *Sturm und Drang* period, Germany's development after 1945 was outdated and backward, and was to be considered only in terms of achieving socialist conditions as quickly as possible. Yet these sentences bear a different reading as well: as the expression of a secret nostalgia for an irrecoverable past, the period of Tulpanov's generation's artistic and intellectual freedom, which might now perhaps be recovered in occupied Germany.

East German liberal cultural historians tend toward the latter interpretation;[83] their West German counterparts, pointing to the unremitting political control over such "outposts," regard it as improbable.[84] To be sure, the fact that Tulpanov belonged to Zhdanov's inner circle did not exactly predestine him to be a cultural liberal working against Moscow's official cultural policies. The matter becomes entirely confusing in view of a recent "revisionist" assessment of Zhdanov. According to this, the Soviet Union's most famous *Gleichschalter* of culture was in reality a reformer fighting for greater openness whose cultural battle "appears to have been more a function of political maneuvering than an expression of ideological principle. . . . In fact, Zhdanov was neither as dogmatic nor as chauvinistic as his reputation suggests. He did not seek to impose narrow ideological constraints in fields such as philosophy and natural science, but in fact resisted dogmatism and encouraged creativity in these disciplines."[85] In this reading, cultural politics under Stalinism were not actually cultural politics, but a politics that availed itself of culture as a strategic means, being otherwise completely disinterested in its contents and forms. Culture was attacked and took the blow. The desired target was the opposing faction within the party. It was all part of the language of disguise and camouflage necessary in the Stalinist system. Certain artistic forms and intellectual orientations that came under attack, as in Zhdanov's campaign against formalism, were not aimed at as such; the target lay elsewhere—for example, the opposing Malenkov group in the politburo. Recently, Sheila Fitzpatrick has worked out the genesis and logic of this role of culture, thereby correcting the long-held image of Soviet culture brutally policed and razed. The enigma of liberal Russian cultural policies and highly educated Soviet cultural officers in postwar Berlin can be largely explained through her theory of Stalinist *Kulturnost*.

Contrary to the view that the bourgeois Russian intelligentsia under Stalin suffered a fate similar to that of the kulaks and the clergy, Fitzpatrick finds evidence that "the old intelligentsia came out of the Cultural Revolution in better shape than its members had probably expected or than Western historians have generally recognized."[86] What the Stalinist cultural revolution of the years 1928–32 destroyed was not the bourgeois cultural elite, but merely its self-confidence as an independent mandarin class, which after the upheaval of the revolution had been largely restored in the New Economic Policy period. The cultural revolution brought about the intelligentsia's great humiliation, a demonstration of its marginality by the all-powerful party and state. As the reward offered by Stalin after the flogging, the old privileges were restored without demanding any express political, ideological, or revolutionary avowal. Thus, in the same move in which the party castrated the intelligentsia, it established the very values and forms of bourgeois culture in the place of revolutionary ideology. The political-cultural complex *Kulturnost*—freely translated as "culture-ful lifestyle"—arose and would define late- and post-Stalinist society of the Soviet Union and its satellites. Neoclassicism in architecture, Stanislavsky on the stage, Tolstoy in literature—these were the new cultural dogmas that replaced the old proletarian-revolutionary ones. Given Fitzpatrick's interpretation, the behavior of Russian cultural officers in Berlin after 1945 no longer seems wayward, but follows precisely this line. The culture put forward—Thomas Mann, Gerhart Hauptmann, Wilhelm Furtwängler— was bourgeois and traditional like the Russian models of Tolstoy and Stanislavsky. For the experimental and avant-garde there was neither understanding nor support.

Fitzpatrick's interpretation of Stalinist cultural history also helps to explain the high intellectual level of Russian cultural officers so surprising to many observers. They were not the sons of peasants and workers, trained as "engineers of the soul," but children of the educated middle class. The typical SMAD cultural officer was of Jewish descent, was born between 1900 and 1910 in Petersburg, and had experienced the revolution as a boy and the NEP years as a young man. He had studied at one of Petersburg's old schools patronized by Lunatscharski. And at the end of the 1920s, he was about to enter cultural life when the cultural revolution changed everything. Alexander Dymschitz, the leader of SMAD's cultural division, and his childhood friend Grigori Weispapier, editor of the *Tägliche Rundschau* in 1945, were pure incar-

nations of this type. The furnishings of their family homes included a full library and a Steinway in the drawing room. Different languages— German, French, English—were spoken on different days of the week. They attended the German Reform School, the traditional elite school of Petersburg's educated class. Their dandyish posing—they wore white gloves in summer—was de rigueur, as was a rapturous enthusiasm for modern art. Petersburg's Institute for Art History, where Dymschitz and Weispapier studied in the late 1920s, was considered the "citadel of formalism," a fact that filled them with pride.[87]

In 1949, Dymschitz stood at the fore of the campaign against formalism. His about-face remains ultimately as inscrutable as those performed by other intellectuals of his generation who showed no visible discontinuity and apparently no resistance. It is unlikely that they considered culture as indifferently and instrumentally as did the members of the politburo, even if the cultural revolution had broken their moral backbone. The line between political and cultural loyalty surely blurred at some point.

This was a dilemma not just for the Russians but for the cultural officers of the other powers as well. In the three years of Berlin's openness, they all enjoyed a relative cultural independence and power. Their freedom was restricted as the once open scene in Berlin became increasingly closed off and finally bifurcated into hostile camps. They saw that they were not, as they had always assumed, knights but merely pawns on the board, those led first to the field, quickly sacrificed, and little lamented. And yet the process of narrowing and dividing the Berlin scene stretched over so long a period that the cultural officers' sense of power and their sense of impending powerlessness were strangely entwined. When the House Committee on Un-American Activities had already begun its witch-hunt in Washington and the battle cry against formalism and cosmopolitanism had been sounded in Moscow, Berlin appeared free of such hysteria. After all, it was, militarily speaking, a no-man's-land between the two advancing fronts, a world where things long declared impossible behind the lines were still permitted. The cultural departments of enemy powers meeting on this ground became "lost patrols," which because of their unique position and professionalism were closer to each other than to their respective general staffs. As Berlin was led into the Cold War, there were indeed indications of a frontline solidarity among the cultural officers. The American theater officer Benno Frank encouraged the staging of plays by authors already

blacklisted in America.[88] And when the Deutsches Theater presented a production of an anti-American Russian propaganda play in the spring of 1947, director Wolfgang Langhoff let Frank know in confidence that he and the Russian cultural officers were acting only by force of higher orders and personally would welcome an official American protest.[89] The late Wolfgang Harich has remarked that in their dealings, beyond political-ideological officialdom, Dymschitz and Frank got along well: "They had to dutifully discharge their class hatreds, but otherwise they spoke the same language."[90]

CHAPTER TWO

Kulturkammer

The conquest of Berlin lasted approximately ten days. Trams were still running in Charlottenburg when the Red Army seized the first outlying districts. Restaurants on the Kurfürstendamm were still serving lunch, and in the Café Schilling, as a Swiss businessman recalled, there was "very good cake with a layer of brown crème the thickness of your finger."[1] Now and again grenades fell and there were casualties. Within a few days, this situation witnessed a complete inversion. As the battle raged in the center, above all in the government quarter, the outlying districts already enjoyed peacetime conditions. Individuals or groups of Germans appointed (or at least tolerated) by the Russian commanders saw to it that life continued. It was the great period of the so-called Antifa groups, which assumed control of the abandoned administration or stripped it from the hands of the old system's remaining representatives. "An atmosphere prevailed that I had always associated with meetings during the October Revolution and civil war in Russia, and in fact had always wanted party meetings to have," Wolfgang Leonhard, who returned to Berlin with the Ulbricht Group,* wrote in his memoirs. "Clear, brief suggestions issued from all sides, were then discussed, sometimes elaborated on by counter-suggestions, and decided upon."[2]

*The top brass of the German Communist Party flown into Berlin from Moscow in late April 1945 to take over the administration of Berlin.

Positioned between the old center lying in rubble and the largely un-
damaged outlying districts, Charlottenburg, with its famous central ar-
tery of traffic and business, the Kurfürstendamm, belonged to the dis-
tricts of Berlin moderately affected by the war. Few street battles had
taken place here; the Kurfürstendamm itself at Olivaer Platz and the
surrounding side streets were mostly intact. The Russians had taken this
area largely without resistance. One of these side streets was Schlüter-
strasse. Between the Kurfürstendamm and Lietzenburger Strasse stood
No. 45—one of those bourgeois apartment houses built around 1900,
with a marble staircase, an elevator, high ornamental ceilings, spacious
rooms, and all the technical comforts of the time.

It had been years since the building was last used for residential pur-
poses. In the spring of 1945 it was the seat of the Reichskulturkammer
(Chamber for Arts and Culture), which had resided on Wilhelmstrasse
until it was bombed out. A few interior adjustments had been under-
taken for this move, such as the creation of a large head office out of
several smaller adjacent rooms. Inside stood the desk—a work of co-
lossal dimension modeled after Hitler's desk in the New Reich Chancel-
lery—of the head of this administrative authority, Hans Hinkel. Early
in May 1945, its old occupants vacated No. 45 Schlüterstrasse. In addi-
tion to its office equipment and furnishings, the building contained the
complete files on all of the members of the Reichskulturkammer—that
is, a file on every German who had been permitted artistic, literary, and
journalistic activity in the Third Reich—as well as a part of the painting
collection of Berlin's former Jüdische Gemeinde in the basement, includ-
ing paintings by Chagall, Liebermann, and Lesser Ury.

A week after the end of hostilities, this abandoned property of the
Reich was seized in the name of district mayor Kilian, newly appointed
by the Russian commandant. As was common in those days, this tran-
spired not as an official administrative act but in the form of a "wild"
occupation based on some form of unverifiable Russian authorization.
In this case, the occupier in question was Elisabeth Dilthey. The forty-
five-year-old widow of a high Prussian official passed herself off as the
niece of the philosopher Wilhelm Dilthey,[3] although there was no fam-
ily relation. She led the dance of dubious figures who seized the build-
ing in the following months to set up their operation.

"A lady of great social importance," as a Nazi informant referred to
her in 1933,[4] Dilthey moved in the circles of upper-level officials and
nobility. Until shortly after the death of her husband she lived in com-

fortable circumstances, with a domestic staff and a chauffeur. In May 1932 she joined the Nazi party, shifting her social connections to prominent party figures like Hanfstaengl, Rosenberg, and Dietrich. She had a particularly close personal connection to Gottfried Feder, the economic theoretician and author of the Nazi party's economic program. Author of the "Manifesto against Usury," Feder belonged to the anticapitalist wing of the Nazi party and shared its fate after the seizure of power. For a few months he served as state secretary in the Reich's economic ministry but was soon pushed aside to a post at Berlin's Technical University. This occurred in the summer of 1933, a period of particularly close contact between him and Elisabeth Dilthey. Already tense for some time, the relationship between Dilthey and Hans Hinkel (at the time state commissioner in the Prussian Ministry of Culture) broke out into open personal enmity that summer. Their feud moved from mutual accusations of antiparty behavior and personal slander to a secret report on Dilthey commissioned by Hinkel and finally to her temporary "protective custody." What underlay all of this can only be inferred from the few remaining pieces of correspondence in the Berlin Document Center. Hinkel apparently considered Dilthey a spy for political circles outside the party. The secret report he commissioned on her (now lost) bore the title "Jewish Spirit in German Minds." Whatever Elisabeth Dilthey's true political sympathies and possible intentions—whether she was a supporter of the left wing of the Nazi party or, as Hinkel believed, a reconnoiterer from some opposing camp—the fact that she confiscated Hinkel's headquarters in May 1945 could be seen only as an act of delayed revenge.

However, the ensuing satisfaction was not to last. Only a week later, a new figure appeared, armed with full authority from Bersarin, the Russian commandant of the city. Compared with Dilthey, Klemens Herzberg had more experience in artistic and cultural matters, having worked in the administration of Max Reinhardt's Deutsches Theater until 1933. His efforts to emigrate before the war began were unsuccessful, and after the deportation of Berlin's Jews began in 1942, he went underground. Supported by a hairdresser named Martin Gericke, he survived for three years in an apartment on Xantener Strasse, a few blocks away from Schlüterstrasse. Shortly after the end of the battle for Berlin, he called on the Russian commandant of the city and, because he spoke Russian well, was more successful than others who tried the same. In his own words:

I went to General Bersarin and told him that this was the Reichskulturkam-
mer building and would be suitable for the new authorities. General Bersarin
directed me to Colonel Yusenev at headquarters in Charlottenburg and told
me: "Have the building confiscated." A Russian lieutenant was put at my
disposal and the building was confiscated. Here I came upon Frau Dilthey
with a large staff of personnel. I took charge of the personnel, telling myself:
They will be valuable. I suggested to Frau Dilthey that she stay. She refused.
She refused all suggestions, and thus the misunderstanding came about that I
appropriated the house for myself.[5]

Russian authority declared Herzberg "Plenipotentiary of the City Com-
mandant of Berlin for Cultural Affairs." Yet Herzberg did not enjoy his
success much longer than had his predecessor. His reign lasted about
ten days, filled not with work but with "reunion parties" (Alexander
Peter Eismann) with old friends, to whom he promised, like a Sancho
Panza suddenly granted lofty office, heaven and earth. Herzberg's good
time—or, as Dilthey later put it, his "Köpenickiade"*—came to an end
when the Russsians' attention was drawn to these activities and he was
removed from his position.

Thus ended the first phase of the new beginning of Berlin's cultural
life. However incidental the two persons in question were, however ob-
scure their interests and motives and however minimal their actual cul-
tural contribution—in these four weeks the building on Schlüterstrasse
nevertheless became a vital gathering and meeting place for artists and
intellectuals. For this office came to oversee the classification and distri-
bution of ration cards. The Russian ordinance of May 13, 1945, estab-
lished four classes of ration cards. At the top was class I ("heavy labor-
ers and workers in hazardous trades"), and at the very bottom, class
IV/V, popularly known as the "dying class" ("children, nonworking fam-
ily members, and the remaining population"). Intellectuals and artists
might have reckoned that their daily bread lay somewhere in the mid-
dle—if not among "the remaining population"—had it not been for a
special stipulation according to which "qualified scholars, engineers,
and artists" were eligible for class I. Hence it was Schlüterstrasse that
decided one's artistic rank and corresponding ration status. Toward this
end, a categorization was established for every artistic profession. For
writers, it read:

*A reference to the episode in Wilhelmine Prussia when a jobless shoemaker who
donned a secondhand army uniform masqueraded as a Prussian captain and ordered the
mayor of Köpenick (then a Berlin suburb, now a district of the city) to hand over the cash
in the city hall. He became notorious as "the Captain of Köpenick" and was immortal-
ized in Carl Zuckmayer's epic play of the same title.

Leading writers and poets: class II
Freelance writers, according to submission and evaluation of samples: III

And for actors:

Leading rolls: I
Supporting rolls: II
Supporting rolls in smaller theaters: III
Permanently engaged extras and others: III.[6]

In short, conductors, soloists, producers, and directors made up class I; established and distinguished performers, along with intellectuals and fine artists, formed class II; the rest belonged to class III. In practical terms, a trip to Schlüterstrasse meant for the majority, who were neither directors nor internationally known artists, a struggle for a place in class II—that is, avoiding placement in class III. The artistic achievements publicly acknowledged and often handsomely rewarded during the twelve years of the Third Reich did not, after its collapse, meet with automatic approval. In other words, political evaluation went hand in hand with artistic assessment. And the building on Schlüterstrasse was particularly suited to this end, as the complete personal files and the entire correspondence of the Reichskulturkammer were stored here. The question of *who* was to control and make use of this archival cache had been decided by a group of individuals in the first days of the occupation, and in the same pragmatic way that Dilthey and Herzberg had occupied the building—that is, by simply assigning themselves this function. In distinction to Dilthey and Herzberg, however, this group was able to win official recognition and support. Its functions were at first carried out in an unstructured and improvised way; the group was later institutionalized as the Spruchkammer für Entnazifizierung (Office of Denazification) of Berlin's artists.

Its members came from the Berlin resistance, above all from the so-called Ernst Group, which had been active in the western districts. It was a loose, ideologically and politically diverse fusion of liberal bourgeois and communist members. These included the actor couple the de Kowas; the conductor (and temporary head of the Philharmonic in the spring and summer of 1945) Leo Borchardt and his companion, the writer Ruth Friedrich; a few doctors; a boxer; and the students Alexander Peter Eismann (who had gone underground) and Wolfgang Harich (who had deserted from the army). This loose agglomeration was held together by a certain Alex Vogel. The resistance activities of the Ernst Group had consisted in organizing desertions and falsifying identification cards and

other papers necessary for survival. A few days before the final battle, the group undertook the action undoubtedly truest to its spirit: they posted hundreds of handbills with the word *nein* on walls, shop windows, lampposts, and trees.

Thirty-seven years old and by profession a trade correspondent, Alex Vogel had been a communist since the age of eighteen, "a first-class organizer and man without scruples" (Wolfgang Harich). Temporarily arrested after the Nazis seized power, he afterward left the country, but returned in 1935, possibly at the behest of the party. Until his desertion and disappearance into the Berlin underground in 1944, he went through the war as a soldier, at first in the Wehrmacht and then in a penal battalion. It is characteristic of Vogel that all information about him, this included, is somewhat uncertain and difficult to verify. His membership in the KPD was the only thing that the other members of the Ernst Group knew about him. There were rumors of his connections to the Russians. It is certain that no one in the group knew about Alex Vogel's role as a go-between for the Gestapo. His assignments included reporting on certain persons in the Russian embassy.[7] Perhaps Alex Vogel was a double agent whom the Gestapo fell for, or an eccentric and independent Antifa fighter, a type of warlord not uncommon in Berlin's antifascist underground; perhaps he was both. He was at any rate a scintillating figure, not unlike Elisabeth Dilthey, whose move into the building on Schlüterstrasse roughly corresponded with his own.

The political scrutiny of Berlin's artists was for Vogel only one function among many, but another former member of the Ernst Group, Wolfgang Schmidt, gave himself over to this task with passionate and singular devotion. As an English officer recalled, Schmidt bore

> an almost uncanny likeness to Joseph Goebbels. Ironic it was, but in looks our Nazi-hating Spruchkammer secretary could have been the late unlamented Nazi leader's younger brother. Both had the same slight, slim bodies with disproportionately large heads, the same slicked-back dark hair, the same deep dark eyes, the same thin lips with the same misanthropic downturn at their corners. And when Schmidt got excited, then—just as with Goebbels when he worked himself up to an oratorical climax—strands of that neatly combed hair would shake loose, fall on to an unusually wide forehead, and thereby draw attention yet once again to a curious anatomical imbalance.[8]

As the building on Schlüterstrasse became a first central meeting point, an exchange for jobs and information among artists and intellectuals, the Ulbricht Group made its presence on the cultural scene felt in

other ways. The group—that is, those members entrusted with cultural missions—had arrived in Berlin on May 1. Rudolf Herrnstadt brought out the first newspaper, the *Berliner Zeitung*. In the Reich's former broadcasting center on Masurenallee, Hans Mahle organized the first postwar radio station. Fritz Erpenbeck, a former assistant to Erwin Piscator in the Theater am Nollendorfplatz and the only member of the group not charged with a specific task, linked old contacts with new and thereby also came into contact with the Kammer. "Lively, straightforward, curious, intelligent, he felt particularly good in this roving position" (Wolfgang Leonhard).[9] Erpenbeck became personal adviser to Otto Winzer, who for his part turned out to be the most important cultural functionary of the Ulbricht Group and one of the key figures in the rebuilding of Berlin's cultural life.

At the time of his return from exile in Moscow, Winzer was forty-three years old. The former typesetter had spent his entire adult life as a party functionary. Long before his emigration he had been privy to functionary conferences and training sessions in Moscow. However, the impression he made on his Western counterparts in the spring and summer of 1945 did not at all correspond to what his fellow Moscow émigré Wolfgang Leonhard later said about him after his break with the Socialist Unity Party (SED): "More than all the other members of the Ulbricht Group, Winzer represented the type of 'sharp' icy Stalinist functionary who executes every directive unconditionally, whose long involvement in the 'apparatus' has stripped him of all connections to the living workers' movement and the ideals of socialism and popular solidarity."[10] To Western officers, Winzer, like many of the communists returned from exile, seemed a competent manager. "They are all highly intelligent men," commented the British cultural officer E. M. Lindsay, professor of classics at Oxford in civil life, "passionately sincere and with a good idea of just what was wrong with National Socialism and how one should set about stamping it out. They have a considerably broader outlook than the average man who has been caged up in Germany for the last twelve years. . . . It would be ideal if Britain were in a position to produce intelligent émigrés of the type of Winzer."[11] Michael Josselson, an American cultural officer and later general secretary of the Congress of Cultural Freedom, characterized Winzer as "highly intelligent," adding that he "knows what matters, but also possesses a certain unusual modesty."[12] Wolfgang Harich remembers him as "a man of quality," "an excellent functionary," and, in distinction to the other leading KPD functionaries, someone who was "aware of his

limits" and surrounded himself with competent advisers like Erpen-beck.[13] In the Magistrat, the first central administration in Berlin formed by the Ulbricht Group, Winzer took over the department of Popular Education. Not limited to actual educational institutions, this agency covered all cultural domains in the stricter sense: art, literature, music, theater—in short, everything organized at Schlüterstrasse.

Given the multitude of former administrative officials, politicians, functionaries, and fortune hunters populating the house on Schlüter-strasse, one might ask what Berlin's artists—in whose name all of this was being carried out—were doing. Artists valued the place above all because of the ration cards distributed there. There was hardly time or interest for greater activity of a political, ideological, or even organiza-tional kind. Individual concerns with sheer personal survival and the ef-fort needed to restart a professional career were predominant. For those in the theater, this was a relatively easy matter. If the building in which they had formerly performed was still standing, they could continue. If it had been destroyed, a replacement needed to be located, an undertak-ing that succeeded or failed according to initiative, ingenuity, and con-nections. Gustaf Gründgens, whose Staatstheater at Gendarmenmarkt stood in ruins, was one of the first to assemble what remained of his en-semble and to continue where they had left off after the theaters were closed in 1944. He rehearsed Schiller's *The Parasite* in the Harnack House of the Kaiser-Wilhelm-Institute in Dahlem. Rudolf Platte was able with the help of colleagues to set himself up in the undamaged Theater am Schiffbauerdamm. Empowered by a staff plebiscite, Mich-ael Bohnen, until then a singer at the City Opera on Bismarckstrasse now lying in ruins, took over the Theater des Westens on Kantstrasse as a replacement and acted as its director. Ernst Legal, formerly at the now ruined Schiller Theater, moved into the intact Renaissance Theater on Hardenbergstrasse with part of his ensemble and rehearsed *The Rape of the Sabines*. Smaller theaters and cabarets sprang up in the cellars of ruins and half ruins. Everyone previously involved with the stage or now transfixed by the vision of a shining career set about planning and opening a theater. Jürgen Fehling, who hoped to crown his fame as a director with a position as the head of a theater, envisaged himself as the new *Intendant** of the Deutsches Theater. Fritz Wisten, president

*The *Intendant* of a German theater fulfills both the administrative functions of a man-ager and the creative functions of a director.

of the Jüdischer Kulturbund until 1938, assembled actors to realize his long-planned staging of *Nathan the Wise*. And Wolfgang Staudte, an unknown film director until then, sought the collaborators and means to realize his long-planned project under the working title *The Murderers*. During these weeks, Paul Wegener undertook comparatively little activity, which, given his age of seventy-one, was no surprise. He and his apartment on Binger Strasse in Friedenau, with its costly East Asian furnishings and famous pair of Buddha statues, had survived the bombs and the final battle and, after the Russians marched in, had the fortune of being recognized, protected, and touted by the victors. A sign in Russian on his garden fence mounted by order of the commandant read: "This is the house of the great artist Paul Wegener, loved and honored throughout the world." It was an angelic protective measure in those violent days.[14]

Wegener was not one of those artists who had withdrawn from the public light after 1933. He worked as a film director and actor, and also belonged to the ensemble of the Deutsches Theater under Heinz Hilpert; in short, he led the life of a star without, like his colleagues Emil Jannings, Werner Krauss, and Heinrich George, signaling to the public any express affinity to the regime. The American cultural officer Henry C. Alter offered an apt characterization of Wegener in the summer of 1945: "He is an uncompromising German of the kind you seldom come across. . . . His hatred of everything in any way connected to National Socialism is credible, but his exorbitant belief in the importance of art, theater, and the phrase 'The show must go on' can make dealing with him somewhat difficult. He believes that German art and Germany's more notable artists are the logical means through which the German nation can, must, and will be reeducated."[15]

Wegener was taken up into the network of dignitaries that began to form in these weeks through the efforts of his neighbor, Ernst Legal, who in a whirlwind of activity had already procured for himself a replacement theater and new contacts in Russian headquarters and resumed contact with numerous colleagues in the theater. The circle was made up of those heads of Berlin's artistic and cultural life who had not all too strongly identified with the Nazi regime. Among them were the general director of the Staatsoper, Heinz Tietjen (appointed the "Plenipotentiary for Opera" by the Russians for a few weeks); the directors Karl-Heinz Martin, Ernst Legal, de Kowa, and Michael Bohnen; as well as Gustaf Gründgens, who at this point had not yet been detained by

the Russians. Not included in this circle were those prevented only by absence—people like Wilhelm Furtwängler and Heinz Hilpert—or those who, like Jürgen Fehling, kept apart because of their temperament and disinclination to join any kind of group or collective organization.

This group—which today might be called a kind of cultural mafia—assumed contact with the Russian authorities in the second half of May. It is no longer certain whether the initiative came from the German or Russian side. The version most often circulated, according to which Bersarin invited all of Berlin's prominent cultural figures to a meeting in Karlshorst, would seem to correspond more to these artists' sense of self-worth than to a reality in which the Russian commandant, however great a student of the arts he might have been, had higher priorities than busying himself with art and artists. It is more probable that the group around Legal called on Bersarin to make him aware of Herzberg's incompetence as the "Plenipotentiary for Cultural Affairs" and to urge his dismissal. It followed that Herzberg's successor should be decided upon by this circle, and then confirmed and officially appointed by the Russians. It followed, too, that the group, composed of so many ambitious men potentially caught up in their pasts, agreed upon the one person who because of his age and political benignity must have appealed to everyone: Paul Wegener. At the beginning of June 1945, Wegener was appointed Herzberg's successor by Bersarin and moved into Hans Hinkel's former office. With this action, the piratelike seizure of this building ended. The more orderly occupation began. In addition to the plenipotentiary, a five-person board of directors was created, first named the Council of Five and then the Presidential Council, which Wegener presided over as the first among equals. Seven divisions were established for the various artistic fields. The melee of individuals, groups, and cliques (between eighty and ninety people) who had settled in at Schlüterstrasse in the preceding weeks were now subjected to a preliminary form of organization. The divisions were:

theater
opera/operetta
music
film
fine arts
literature
cabaret and variety shows

Administrative—above all, financial—matters were also organized, and the house on Schlüterstrasse became part of the Popular Education department in the Magistrat under Otto Winzer. From June 1945 onward those employed drew fixed salaries from the city government. And finally, in the course of the reorganization, the building received a new name—which, to be sure, was not all that new. What four weeks before had still been called the Reichskulturkammer was now the Kammer der Kunstschaffenden (chamber of artists).

This reorganization confirmed what until then had developed of its own accord. Personnel remained the same, including the retired Herzberg. And activities continued without change: the distribution of ration cards, the political scrutiny by the Vogel-Schmidt group, and the examination of Hinkel's archives. At the same time, with Wegener's appointment the old cultural establishment took over, where until then new men and women had done as they pleased. Conflict was unavoidable and would become the defining mark of the Kammer der Kunstschaffenden up to its not all too distant end. No. 45 Schlüterstrasse was the roof under which the cultural establishment tried to resume its old position while the forces against the establishment, striving to realize their own ideas and goals, tried to prevent precisely that. External influences also had to be reckoned with: Winzer's Popular Education department, the reestablished artists' unions, the Russians, and, soon afterward, the Western Allies.

The first to announce his claim was Erich Otto, president of the German Theater Guild until 1933 and the type of "mediocre actor who compensates for it in union work" (Wolfgang Harich). He was among the first occupants of No. 45 Schlüterstrasse and immediately set about his union work. With old friends and colleagues, he reestablished his former organization, which the Nazis had dissolved in 1933 and absorbed into the Reichskulturkammer. He regarded the building on Schlüterstrasse as union property because, as he argued, "it was bought with money stolen from the Theater Guild and German actors."[16] In addition to the property itself, Erich Otto laid claim to liquid assets in an amount between 1 and 2 million reichsmarks.[17] In order to carry these demands through, he had himself appointed executor of the property of the Reichskulturkammer by the municipal authorities.[18] In fact, he already occupied a not insignificant position in the Magistrat as Winzer's deputy and at the same time head of the Office for Theater, Radio, and

Music. And with the establishment of the Kammer der Kunstschaffen-
den, he also became a member of the Presidential Council. Otto pur-
sued his union interests vigorously, skillfully, and successfully, without
regard for the displeasure that the performance of so many offices and
functions in one person produced in many observers. The report of the
official in the Popular Education department responsible for the result-
ing complaints offers an impression of Erich Otto's omnipresence:

> Should you have a complaint about the German Theater Guild and its pres-
> ident, Herr Otto, then you must go to the head of the union, Herr Otto. He
> will then decide that the president of the guild, Herr Otto, acted properly.
> Should you still wish, you might see the municipal department chief, Herr
> Otto. And if you achieve nothing that way, then go to the head of the divi-
> sion, Herr Winzer. But he, as you yourself must admit, is completely over-
> burdened with work, for he runs one of the most important divisions. Ac-
> cordingly, you might at most speak to Herr Winzer's representative, and
> that would be, once again, Herr Otto.[19]

Already feeling like the real master at Schlüterstrasse, Otto suggested
the name Kammer der Kunstschaffenden and carried it through against
strong opposition and reservation, arguing that the Nazi concept of the
Kammer was a totalitarian perversion of an originally democratic union
concept that was now to be restored and accorded its old rights. The in-
tention was to kill two birds with one stone: if the Kammer der Kunst-
schaffenden, even in its name, was recognizable as the successor to the
Reichskulturkammer, the legal claim of Otto's Theater Guild would have
a stronger foothold; and the union definition of the word *Kammer* fur-
ther underpinned the union's claim to legal and material succession.

Erich Otto's preference for the Kammer concept understandably
cooled as the Kammer moved in an undesired direction. Paul Wegener
and those surrounding him were anything but friends of the union.
When Erich Otto noticed this, Schlüterstrasse 45 ceased forthwith to be
the site of the rebirth of a democratic union organization and became,
in Otto's eyes, simply an updated version of what it had been in the
Third Reich: "Today it is exactly like when the artist went to the Reichs-
kulturkammer or—it meant the same thing—to Schlüterstrasse during
the Hitler years. Just as before, artists still go to the Kammer, to Schlüter-
strasse. After the collapse of those twelve years, nothing has changed
for this whole circle. The Kammer is in the same building. Most of the
'artists' today speak once more of the Kulturkammer in the manner
customary then, so that specifically Nazi ideas are retained and rees-

tablished."[20] In other words, a union-controlled Kammer was good and
a non-union Kammer was bad. As Otto noted: "The Kammer I repre-
sented was laid to rest when in one meeting Wegener announced: 'As
long as I am at the head of this Kammer, neither guild nor union will
enter this building.'"[21]

Wegener, who knew Otto from the old times, could not stand him,
for both ideological and personal reasons. Even the slightest contact
("repulsive functionary type") was unbearable to the great man of the
theater. Defending the autonomy of the Kammer der Kunstschaffen-
den, as Wegener understood it, against Otto required the intervention
of a person suited to this task. Wegener found his man in that hair-
dresser with whom we were briefly acquainted as the aide and protector
of Klemens Herzberg during the Third Reich. Martin Gericke had ap-
peared with Herzberg at Schlüterstrasse in mid-May and during his short
reign became something like the unofficial managing director there. He
had not shared in the fall of his patron; on the contrary, he now suc-
ceeded in being officially confirmed in this position by Wegener.

Martin Gericke was fifty-eight years old and the proprietor of a bar-
ber shop in Wilmersdorf. His connection to the art world had been as a
makeup artist for Ufa film productions, a connection that automati-
cally made him a member of the Reichsfilmkammer, a subdivision of the
Reichskulturkammer. Those who knew Gericke at Schlüterstrasse in the
summer of 1945 remembered him, in contrast to the generally unloved
Erich Otto, as self-confident, perhaps a little too outspoken, but a not
unkindly, corpulent gentleman.[22] Gericke had finished only elementary
school. In the Kammer, however, he passed himself off as a student of
Friedrich Gundolf and an admirer of the poet Stefan George. As he put
it, he was a man of spirit "from those firmly rooted circles of art and
science that—grounded in the turn-of-the-century Georgean tradition—
everywhere reveal their influence on the artistic and particularly hu-
manistic mien of the last decade."[23] Martin Gericke was the type who
turns up in times of upheaval and transition, assuming some astonish-
ing position, only to disappear with equal swiftness and without a trace
once conditions have normalized again. He tried to secure his position
permanently, which meant making the Kammer into a lasting institu-
tion. This was where his and Wegener's interests met, for the latter
had precisely this in mind. Entering the first official position of his life
in old age, Wegener envisioned the transformation of this provisional
postcollapse organization into a kind of academy drawing together the

artistic and moral elite not only of Berlin but of all of Germany. Although in Wegener's eyes Gericke was not the man to lead such a serious undertaking responsibly (he once referred to him as "a chatterbox and out of the question at this time"[24]), Gericke seemed suited to the task of keeping Erich Otto in check, like a good watchdog. His other duties included parrying efforts by Winzer's department to strip the Kammer of its autonomy, and establishing good relations (or at least avoiding poor ones) with the Allies.

As far as the latter was concerned, the situation for the Kammer had meanwhile been complicated by the arrival of the Americans and English in early July. Neither the English, in whose sector Schlüterstrasse lay, nor the Americans, who had arrived with particularly rigorous ideas of denazification, objected in principle to the Kammer. There was nonetheless a certain mistrust of the institution and particularly its name, just as there was a healthy caution and reserve toward all of the institutions created during the two months of Russian occupation. In the opinion of the American military intelligence service, the Kammer was "neither fish nor fowl nor good red herring. It has no official status of any kind. It has no membership of any kind, it has no defined jurisdiction of any kind, it has simply a secretariat, which is paid by the Magistrat. Apart from this it has no funds whatsoever. . . . Its main functions at the moment seem to be a kind of exchange of artistic personalities and materials."[25] Another cause for worry was the Americans' realization that Germany's cultural mandarins of Wegener's type seemed to share a kindred conception of culture with the Russians. ("At the core of Russian politics is an almost fanatical worship of art and artists, paired with the belief that artistic activity is in itself good and necessary for the people in times of uncertainty and suffering.") The American military government believed that these views resulted in excessive leniency toward politically compromised artists. "It is characteristic of Russian 'the show must go on' politics that they have still not adopted a critical attitude toward the individuals involved. . . . It seems as though the Russians are inclined to forget a great deal when it comes to artists. They seem to consider them a different species who are hardly to be held accountable."[26] For American taste, there were too many prominent artists at Schlüterstrasse who had been active in the Third Reich. The film division in particular attracted attention. Heinz Rühmann and the producer Eberhard Klages were the first to be turned out. In this matter Martin Gericke made himself so useful that the Americans regarded and cultivated him as their

man ("Excellent man for the Chamber, with good judgment").[27] He
became a valuable informant for them on Berlin's cultural politics and
the art world during the time of the Russian occupation, on the situ-
ation in the Magistrat and in the Popular Education department, on the
status of union organization under Erich Otto, and on various cases of
Nazi-compromised or compromisable individuals in Berlin's cultural
scene. As long as the American cultural officers could not grasp the sit-
uation directly, Gericke played the role of scout for them. The more in-
sight and perspective they achieved in the course of the summer, the
more their enthusiasm for him dissipated. They opposed his plans to
make the Kammer into a suprazonal cultural institution.

Hence toward the end of the summer it did not look good for Ge-
ricke and the Kammer. Relations with the Magistrat and the Popular Ed-
ucation department had also cooled. To the extent that Otto Winzer's
office consolidated as the central cultural administration of Berlin, it
lost interest in the Kammer, which it began to see both as superfluous
because it was "completely up in the air"[28] and as a kind of damaging
competition. What no one had bothered about in the first weeks of May
now attracted notice and criticism: the allotment of positions among
prominent figures of Berlin's cultural scene; the "secret cabinet poli-
tics" of the circle around Wegener and Legal;[29] the unregulated appoint-
ment of other colleagues, mostly as personal favors, who were then paid
from municipal funds. There were also rumors of dark deeds and dubi-
ous intrigues, like the unexplained and possibly criminal appropriation
of paintings from the collection of the Jüdische Gemeinde by members
of the Kammer.

Erich Otto had meanwhile left the Kammer and entered into open
battle against it, using all of the influence he retained in his double
function as director in the Popular Education department and head of
the newly established Theater Guild. Winzer and Otto may not have
been able to stand each other personally and politically, but in this mat-
ter they had a confluence of interests that, it would soon bear out, was
by far more effective than that of Wegener and Gericke on the opposing
side. The final phase of the Kammer's history began in September 1945,
when Winzer had a plan for its reorganization drawn up. The central
points were:

1. the renaming of the Kammer as the Advisory Council for Artis-
tic Affairs to the Magistrate of Berlin;

2. the reduction of personnel to a third of its previous size;

3. Gericke's dismissal.

Decoded, this was nothing other than the liquidation of the Kammer as
an autonomous institution. The first step was taken with Gericke's dis-
missal, which Winzer—threatening for the first time to tighten the fi-
nancial screws—carried through against Wegener's only halfhearted op-
position. But Winzer again shrank before further steps when it became
clear that the Kammer had found unexpected support in the Berlin press.
The summer months saw a string of newspapers established, and many
of the young men who had been active at Schlüterstrasse in the spring
had become editors, critics, and reporters. In this capacity, they were
now prepared to support the institution in which they had begun their
careers: Wolfgang Harich at the French-licensed *Kurier,* Friedrich Luft
at the American *Allgemeine Zeitung,* and Hans Schwab-Felisch at the
American-licensed *Tagesspiegel.* After Gericke's removal, so much con-
fidence returned to Schlüterstrasse that the plans to make the Kammer
into a national institution were taken up again and elaborated. The
new managing director, theater director Herbert Maisch, himself a man
from the circle of the establishment, presented the Americans early in
1946 with a program that stated:

> The validity of our efforts is of significance for all of Germany, and even be-
> yond. That is why we are seeking connections to the intellectual forces out-
> side of Berlin; that is why we want to move beyond this restricted sphere to
> arrive at an intellectual exchange, at a circulation of new ideas that will ex-
> tend across all of Germany. These efforts have nothing to do with attempts
> at a new centralization. We do not wish to become a new center, we want to
> work together in absolute equality with artists in Munich, Dresden, Ham-
> burg, etc. We want to create bonds between art and the public, bonds within
> Germany and—what matters most to us—create intellectual bonds outside
> of Germany, with the entire democratic world. We want to bring together se-
> lected representatives of German artistic life in a council of the arts in order
> to create an exchange of ideas among them, and to present them to the Ger-
> man people as models and ideals, as an alternative to the bravado and war
> heroes of the past.[30]

The chances for realization were slim. The Americans showed even less
interest than Winzer. Moreover, an institution with the express objec-
tive of morally purifying German culture had been established in the
meantime. The Kulturbund zur demokratischen Erneuerung Deutsch-
lands resided in the same house on Schlüterstrasse. And within the ranks

of Berlin's cultural elite, the need for a moral institution had subsided to the extent that cultural figures had been absorbed into other newly established institutions.

Upon Allied order, on April 30, 1946, one year after the first occupation of No. 45 Schlüterstrasse, the Kammer der Kunstschaffenden ceased its activities. Both its functions and its bequest of personnel and possessions were divided up. Part of it moved to the newly created Council of the Arts in the Magistrat, part to the new District Council of the Arts of Charlottenburg. The Vogel-Schmidt group and the files of the Reichskulturkammer remained in the building and thenceforth formed the Spruchkammer für Entnazifizierung of Berlin's artists. With the permission of the Allies, this archive was put under Schmidt's leadership and made into an archive for all German *Spruchkammern*. Thus the building on Schlüterstrasse did become, though in a way other than what Wegener and Maisch had foreseen, an institution of national significance extending across zonal borders. It is worthwhile noting that the liquidation of the Kammer also meant a loss for Winzer. The duties of the new Council of the Arts were taken out of his Popular Education department, which became a strictly educational office.

The period in the Kammer's history truly significant for Berlin's cultural life—the three or four months in the spring and summer of 1945 when Schlüterstrasse became a gathering and meeting place for artists, intellectuals, and cultural politicians in Berlin who had come, often literally, crawling out of the rubble—was shorter than the period of its existence. Strictly speaking, the Kammer's significance concerned first and foremost the theater—the simple reason being that the most qualified and active individuals at Schlüterstrasse were theater actors and directors, or critics and writers attached to the theater. Also, the cultural public of the time regarded the theater as the central artistic genre. Arriving in Berlin from London in 1946, theater critic Hilde Spiel described how Berlin's postwar theater assumed this function:

> The Reich Chancellery has been swept away, but the theaters remain. In the middle of the most desolate metropolis in the world, still standing amid the gray washed-out skeletons of buildings, rising up again, they are of a magnificence Londoners can search for in vain at home. . . . Are they false facades, Potemkin villages, and behind them . . . the attempt to feign healthy bourgeois life? No, they are not. They are reality itself, the only one that remains. The set has replaced life. That gigantic nonsense of war has brought down with it the tables and beds, clothes and pots, pianos and tennis rackets, department stores and restaurants where people once enjoyed

themselves. What remains is the world of the theater. Only here do they continue to eat and drink, love without worry and die without cause, swagger, croon, charm, laugh. Only here do the porters still strut about and the candles still flicker in ornate chandeliers, only here do the cigars glimmer and the wines flow.[31]

In an altogether different way, the Berlin theater had functioned as a substitute in the Third Reich, a fact that, as always in times of transition, would lead to misunderstandings, miscalculations, and conflict.

Theater Battles

With one exception, the men in the Kammer der Kunstschaffenden who in the summer of 1945 deliberated upon how to fill the leading positions of Berlin's surviving theaters had been active in the Berlin theater during the Third Reich. In addition to Ernst Legal and Paul Wegener, this circle also included Karl-Heinz Martin and Jürgen Fehling, both known directors before 1933, and Boleslav Barlog, a young film director who emerged from obscurity in the spring of 1945. The sole exception was Gustav von Wangenheim, head of the former communist theater company Truppe 1931, who returned from Russian exile to Berlin in June 1945. Missing were the two men who had made "great theater" (K. H. Ruppel) in opposition to the official artistic policies in the years 1933–45: Heinz Hilpert, head of the Deutsches Theater; and Gustaf Gründgens, director of the Staatstheater at Gendarmenmarkt. Hilpert had left before the war ended. Gründgens was in Berlin during the collapse, and immediately afterward resumed rehearsals of his production of Schiller's *The Robbers,* the last play performed in the Staatstheater before the theaters were closed in September 1944. He had been present at those first meetings from which the Kammer soon after emerged. The same day the Kammer was officially founded at Schlüterstrasse, the sixth of June, he was arrested by the Russians—apparently not by military authorities but by the NKVD*—and brought to an internment camp

*The Narodyni Kommissariat Vnutrennykh Del (People's Commissariat of Internal Affairs), created in 1934, was the Soviet political police and counterintelligence organization. In 1943, it was divided into two commissariats, the NKVD and the NKGB.

near Berlin. Held there until March of the following year, he was absent for the decisive phase in the rebuilding of Berlin's theater life. The reasons for his arrest remain puzzling to this day. The conjecture usually offered, that the Russians had mistaken the title "General-Intendant" in Gründgens's passport or on the door of his office for a military rank, seems somewhat naive given the intelligence standards of the NKVD. Moreover, such a misunderstanding might have been quickly cleared up. There was enough opportunity to do so. For immediately after Gründgens's arrest, everyone of good standing and reputation in the Berlin theater or with any connection to the Russians, from Wegener to Wangenheim, sought his release. Furthermore, the treatment of his colleague Heinz Tietjen, general director of the Deutsche Staatsoper, showed how little the Russians made of such titles and positions of the Third Reich. Along with Klemens Herzberg, Tietjen had been appointed General Plenipotentiary for Berlin's Opera Theater by the Russian city commandant Bersarin in May 1945. His removal from this position shortly thereafter was an unpleasant surprise, but of no further consequence. Until his denazification, which went off without a hitch a little later, Tietjen was left alone.

Gründgens's absence was striking because his theater had been the only one taken seriously in the preceding years. It was considered an island in a sea of aesthetic and intellectual depravity, a "pier," as Wolfgang Harich wrote in 1946, "stretching along the arch of intellectual tradition toward a new shore in our time . . . in the service of an eminent political mission, in a daily struggle to defend intellectual labor against barbarism."[1]

The Staatstheater was now a ruin. Rehearsals of *The Robbers* ended with Gründgens's arrest, and the members of the ensemble who had remained in Berlin found ready reception at the still-standing Deutsches Theater on Schumannstrasse. Here, less than a kilometer's flight distance from the destroyed city center, the whim of bomber approach paths had spared a handful of theaters: the Theater am Schiffbauerdamm, which stood not far from the Deutsches Theater, and the Kammerspiele, located in the same building (the two old Max Reinhardt playhouses); the Admiralpalast on Friedrichstrasse (since the spring of 1945 the playhouse of the bombed-out Staatsoper ensemble); and the former Grosses Schauspielhaus (the "drip-stone cave"), where Max Reinhardt had also played and which would later open as the Friedrichstadtpalast.

In the summer of 1945, the Deutsches Theater became Berlin's most important theater, its rebirth trumpeted as the continuation of a great and untainted past in the very building from which the legendary Max Reinhardt had lifted the German stage to world acclaim. It was under this roof that Hilpert's and Gründgens's ensembles, the two islands of oppositional theater in the preceding twelve years, were now united.

The importance of Berlin's new "first stage" showed in the appointment of its director. While other theater positions were filled without further debate, the Deutsches Theater triggered a bitter competition. Jürgen Fehling made his entrance with the greatest and (in the eyes of many) the most pathological vigor. His claim was based on what he had achieved in the way of aesthetic-dramatic opposition during the Nazi period—and this was not insignificant. One need only recall his production of *Richard III* in 1937: the image of the great political criminal limping across the stage evoked in the mind of every spectator the figure of Goebbels. The enormous expanse of the entire stage, dwarfing the actors to antlike figures, offered an ingenious spatial metaphor for totalitarianism. "A distance, breadth, and dimension never before experienced on the stage. . . . In this space, men struggle—and their action is small and puny against the expansive void," wrote Paul Fechter about the premiere, adding: "Small, lost, helpless creatures in the icy reach of this cold space which monstrously encompasses their fate like a trifle, like something hardly worth considering."[2] All of this transpired in a lighting that, as K. H. Ruppel wrote, "is not favorable," that "instead . . . possesses a terrible brightness that cruelly unveils all that is concealed."[3] These were the images with which Fehling had made his impression on Berlin's theatergoing public during the Third Reich. Even a disposition more balanced than that of the manic-depressive Fehling might have had difficulty in resisting the temptation to demand a position in Berlin's postwar theater commensurate with such accomplishments. Yet the thought of giving the *Intendanz* of the most important theater to Fehling, a notorious bundle of nerves, made Wegener's hair—and that of all those responsible for the theater—stand on end. Left to themselves, they would have offered it to Gründgens, known as a deft diplomat and skilled politician, under whose *Intendanz*, after all, Fehling had been able to stage his production of *Richard III*. Fehling was offered a permanent position as tenured director at the Deutsches Theater under the administrative directorship of Ernst Legal. Negotiations ended with a tantrum from Fehling, who demanded all or nothing. He

departed Schlüterstrasse with the histrionic salvo "Once again the first German is driven into emigration,"⁴ and subsequently opened his own short-lived Jürgen Fehling Theater in the district of Zehlendorf. The reason for his unsuccessful attempt at a career as *Intendant* was undoubtedly his well-known administrative incompetence and his anarchic temperament. This had once before tripped up his career, when Goebbels's office had offered him the directorship of the Volksbühne in the fall of 1934.* Herbert Ihering's explanation a few years later of Fehling's failed move into the Deutsches Theater was correct: "The power of his stagings—the recklessness of pressing people, time, and everything around him into the service of this one work, and excluding all else or persecuting it with a fierce hatred . . .—[became] a weakness when it came to building up or holding together a whole theater."⁵ But by the summer of 1945 there was more to it than that. Theater in a totalitarian society is not just theater; it assumes functions that in a democracy are left to political journalism. If a Goebbels can be criticized neither on the front page nor from bar stools, a politicized staging of *Richard III* assumes a critical function: the director takes up the critic's pen, and his stage becomes a loaded editorial. Those in the theater thereby develop a particular type of self-assurance, as was more recently the case in the dramatic and literary life of Eastern European state socialism. After the fall of the totalitarian system, as for the celebrated war hero in peacetime, the return to normality is not easy. This was the position in which Fehling found himself in 1945. He "was raving about because the enemy he had faced up till then, National Socialism, no longer existed, his aggressive imagination had no target and therefore sought out victims" (Ihering).⁶

After the Fehling debate, and after a short period in which the actor Paul Bildt served as provisional head, Wangenheim, who had returned from Moscow, became director of the Deutsches Theater. According to his own account, the Kammer der Kunstschaffenden had first granted

*Goebbels sought in Fehling, whose political stance he was aware of, a counterpart to Gründgens, Göring's show horse. The relative importance of aesthetic quality assigned by the Nazi regime vis-à-vis an artist's political stance is evident in the appointment of party member Graf Solms to the Volksbühne. When it became clear that Solms could not be paraded about, he was dismissed and Fehling sought out as the solution. "Get rid of Solms soon! Settle things with Fehling!" Goebbels noted in the margin of the report from his theater administrator. Due to a "still undetermined so-called incident with Fehling, no contract was concluded." Jutta Wardetzky, *Theaterpolitik im faschistischen Deutschland* (East Berlin, 1983), 115–16.

him the Theater am Schiffbauerdamm, which until then had been oc-
cupied by Rudolf Platte. "Unburdened by all representative duties, my
job here was to build up an entirely new ensemble and create a pro-
gressive repertoire."[7] Wangenheim wanted to resume the experimen-
tal work of Truppe 1931 before his emigration. When the Theater am
Schiffbauerdamm was confiscated by the Russians for their own pur-
poses, Wangenheim—still according to his own account—applied for
the *Intendanz* of the Deutsches Theater. It was unanimously granted
to him by the Kammer der Kunstschaffenden. A year later Wolfgang
Harich, one of the best-informed observers of Berlin's theater scene at
the time, presented the matter differently. He claimed that Wangen-
heim "[had] his eye on the Deutsches Theater from the very first day of
his return" and that "the way Wangenheim soared up to the director-
ship of the Deutsches Theater was nothing other than a base intrigue."
Wangenheim supposedly appeared one day at Schlüterstrasse with a let-
ter from Winzer "according to which the Schiffbauerdamm Theater was
closed on a special order [and Wangenheim] wanted him to become di-
rector of the Deutsches Theater. If the theater board had denied Wan-
genheim the Deutsches Theater at that time, no one in Russian head-
quarters would have thought of insisting on it."[8]

If the truth lay somewhere between these two versions, Wangenheim
owed his post less to the enthusiasm the theater people in the Kam-
mer had for his work than to the influence of his party friends and
the Kammer's obedience with respect to the presumed wishes of the
SMAD. However, the appointment of a party communist remains as-
tonishing, contradicting as it did the KPD's policy at the time of filling
representative positions with bourgeois dignitaries. Were the returning
émigrés not aware of the significance the Deutsches Theater possessed
as the first stage and new state theater of Berlin? Or did they consider
Wangenheim suitable to head up Reinhardt's theater because he, the
son of Eduard von Winterstein, the oldest Reinhardt actor still alive,
had himself once belonged to Reinhardt's world as a student of the
Reinhardt school and young aficionado at the Deutsches Theater? Per-
haps the party figured that Wangenheim would now reclaim his per-
sonal "bourgeois heritage," abandoned when he left Reinhardt's the-
ater and established his Truppe 1931. Perhaps Wangenheim's bourgeois
youth was intentionally invoked to make him into a convincing repre-
sentative of the new "national" and "nonpartisan" party line of the new
Germany and the new German theater. Wangenheim's appointment was

as contradictory as the political stance on the theater developed in Sep-
tember 1944 at a Moscow conference of party intellectuals on the re-
construction of postwar theater. There were two competing lines. One
argued a policy of reserve, restricting party members to key political
positions and surrendering artistic positions to prominent bourgeois
figures. Another voiced the demand from party intellectuals and artists
to be taken more seriously by the party than in the past and thenceforth
to be appointed to leading cultural positions. Maxim Vallentin, the most
prominent representative of agitprop theater before 1933, formulated
this line most clearly:

> With our union and cadre policies, we underestimated or completely ig-
> nored the artistic significance of both our best comrades and progressive
> (and in some cases sympathetic) stage artists. We did not recognize that
> strengthening and increasing the artistic significance of our comrades should
> have been an important—if not the decisive—step for us in establishing
> strong authority. Instead of operating with artistic authority, we almost al-
> ways ignored it and thereby left progressive figures prey to resignation and
> despair, or the demagogy of the enemy. We made them into so-called *simple
> party soldiers* when, viewed correctly, we should have made them and many
> sympathetic prominent figures into *generals on the cultural front*, which—in
> my opinion—must be one of our future tasks [emphasis in original].[9]

Wangenheim's appointment as head of the Deutsches Theater would
show whether the conclusion drawn from the mistakes of the past
proved the correct path. But who was Gustav von Wangenheim? What
had the man who was now a general on the cultural front done as a
simple party soldier?

In the Weimar period, the founder of Truppe 1931 belonged, to-
gether with Piscator, Brecht, and Maxim Vallentin, to the stars of leftist
political theater. Truppe 1931 was composed of unemployed actors. It
was not aimed at a proletarian public like Vallentin's agitprop theater;
instead, it tried to flush out the illusions of independence, individuality,
and honor of a petit bourgeois audience. Wangenheim wrote and pro-
duced plays, in which similarities to Brecht's *Saint Joan of the Stock-
yards* are unmistakable. The parodic, high classical form—including ci-
tations from and allusions to *Hamlet* and *Faust*—were meant to jolt the
spectator out of a false consciousness. The whole thing was bawdy and
impudent, drawing less on the KPD platform than on Siegfried Kra-
cauer's essay "Die Angestellten." In 1931–32, *The Mousetrap* was a
great success in Berlin; even Alfred Kerr numbered among its bour-

geois admirers. Wangenheim's personal lifestyle was that of the dandy-communist type. In his spacious apartment in the west of Berlin, clad in a velvet dressing gown and sporting a monocle, he received astonished party comrades who knew nothing of this side of his life. He earned his money as a silent-film actor (e.g., in the role of the assistant broker in Murnau's *Nosferatu*).

Wangenheim's relationship to modern experimental art, like that of so many of his generation and party comrades, had been ruptured. In the so-called Expressionism Debate during his Moscow exile he represented the position—a precarious one under the conditions at that time—of not rashly dismissing modern art and literature along with late bourgeois decadence, but instead of taking it seriously as a symptom of crisis. Decoded, this was an effort to preserve for socialist realism a variety of aesthetic forms and techniques. "Stramm [i.e., the poet August Stramm] is a dead end," wrote Wangenheim in an article in 1938, "but something can be going on even in a dead end: Real! Intense!"[10] The courage he had shown in artistic-political debates seems to have failed him in the reality of Stalin's terror. He was one of the very few, if not the only one, of his exile troupe Deutsches Theater—Linke Kolonne to survive. As a witness for the prosecution he took part, possibly as an informant, in Carola Neher's arrest.[11] In the spring of 1945, he was among the émigrés in Moscow who tried to return to Berlin as quickly as possible. An almost beseeching letter to Pieck suggests that Wangenheim took a far greater interest in his return and employment than the party leadership did. ("Should I once again unfortunately not be able to choose this often underestimated task [winning over bourgeois intellectuals and artists as party comrades], then I request the command of some other party work.")[12] This urgency was perhaps the reason why Gustav von Wangenheim arrived in Berlin in June 1945 with no kind of experimental plans akin to his earlier dramatic work. Abandoning the class struggle for the present, he now fully adopted the party line of attending to the classical inheritance, of Lukácsian realism, of rebuilding a new national German culture. As he explained in July 1945, his dramatic work in the future would no longer "advance as the avant-garde in the fight against decadence, dissolution, and reactionism" but instead serve as part of the "broad democratic front of the German revival."[13]

Deutsches Theater mounted ten productions under Wangenheim's leadership in the 1945–46 season—three classics (Lessing's *Nathan the*

Wise, Molière's *School for Wives*, and *Hamlet*), three modern classics
(by Chekov, Hauptmann, and Sternheim), and four contemporary pieces
(by Julius Hay, Friedrich Wolf, Friedrich Denger, and Rachmanov).
Four of these Wangenheim produced himself: *Hamlet* and three of the
contemporary pieces. To heed the reception of Berlin's critics, it was
theater of mediocre quality: no exceptional achievement, no great event,
but acceptable under the conditions. Critics noted with approval Wan-
genheim's efforts to fill the decimated ensembles of the Deutsches The-
ater and the Staatstheater with suitable replacements. Most favorably
disposed to Wangenheim were the three tone-setting critics of the older
generation (Paul Rilla at the *Berliner Zeitung,* Paul Wiegler at the
Nacht-Express, and Fritz Erpenbeck at *Theater der Zeit*). The reviews
today read as though their authors had internalized the kind of *Kunst-
betrachtung* demanded of them over the previous twelve years. Two
critics of the younger generation disagreed. Walther Karsch at the *Ta-
gesspiegel* and Wolfgang Harich at the *Kurier* found Wangenheim's the-
ater conventional, boring, and stuffy, a kind of betrayal of all that
Wangenheim had once stood for. Karsch wrote: "With horror the spec-
tator turns away—back to 1931, when *The Mousetrap* and the name
Gustav von Wangenheim were a promise for us twenty-five-year-olds.
This should have been made good on. And what has resulted? A 'court
theater' in which stars are allowed to behave like unruly children, and
dull mediocrity struts about."[14] Harich, who said of one Wangenheim
production that "only shocking embarrassments jolt you out of the fa-
tigue,"[15] asked whether the former revolutionary of the theater, "who
15 years ago, in protest against the pompous revue hubbub of the late
Reinhardt, founded the political avant-garde Truppe 1931 . . . has mean-
while grown so experienced and been so strongly influenced by Stanis-
lavsky's tyranny in Moscow that he now knows nothing beyond a pious
eclecticism. We hoped for something unheard of and new from Wan-
genheim and were disappointed again and again by a stuffy conven-
tionality."[16] In private Harich expressed himself to Herbert Ihering even
more scathingly. Ihering had formerly provided dramaturgic advice for
Truppe 1931. After Wangenheim's appointment at the Deutsches The-
ater he had become the chief dramaturge there. Harich now reproached
him for the same forfeiture and betrayal of earlier standards as he did
Wangenheim:

> It is unbelievable that a theater critic of your caliber remains the drama-
> turge at a theater where productions like *Gerichtstag,* a trivial *Hamlet,*

Beaumarchais, Wir heissen euch hoffen, and *Sturmischer Lebensabend* were possible. . . . If you really are the same honored and admired Herbert Ihering who was the antipode to Alfred Kerr before 1933 and author of *Regie,* then you should have imprinted your stylistic will at the Deutsches Theater or have pointedly refused all further collaboration. Or you should have prevented the Deutsches Theater from being handed over to Wangenheim in the summer of 1945.

Harich held Ihering responsible for the fact "that the Deutsches Theater was reduced to the bleakest and most boring stage in Berlin." There occurred "unheard-of nonsense" under a "bewildered and unfocused *Intendant*" leading it to "artistic ruin." All this was "grotesque, even ghostly."[17]

Harich publicly demanded Wangenheim's dismissal and his replacement with the one director in Berlin, indeed in all of Germany, whom Harich, Karsch, and other young intellectuals considered capable of creating great theater. "Without Jürgen Fehling?" headed the retrospective review that Harich published at the end of Wangenheim's season. Walther Karsch added with somewhat more discretion: "Will there soon be a theater in Berlin to accommodate Jürgen Fehling?"[18]

At the end of August 1946, Harich's goal was achieved. Wangenheim stepped down "for health reasons" and "in order to devote himself to other matters," as it was officially stated. In fact it was greatly against his will and—most rare for a party communist—amid voiced protest to the party leadership. "I am most outraged by the entire thing," he wrote to Wilhelm Pieck.[19] And after an inquiry made to the SMAD by Ulbricht in the name of the SED secretary's office as to whether "the change in the leadership of the Deutsches Theater can still be prevented"[20] found no reply, he wrote to the Russian city commandant Bokov:

Suddenly, at the start of a new season, I was—a *novum* in the history of the theater—requested to step down for health reasons. Without any valid reason. Without any discussion with the ensemble, which must be as surprised by me being dropped as I am. Without conferring with any superior authorities, the Magistrat or the central administration. Without any discussion in the SED central office of the enclosed report on my activities in 1945–46. The central office refused all such discussion because the matter was already presented as a fait accompli. I cannot timidly and shamefully abandon the office entrusted to me, abandon my own dignity and existence as an artist. . . . Herr General Lieutenant! If I am not to protest, you yourself must indeed be of the opinion that I am ill-suited for the position of *Intendant*

in a progressive sense. I thereby submit to you my protest against the self-annihilation demanded of me as a serious comrade and artist.[21]

Wangenheim's dismissal is one of the puzzling episodes of Berlin's postwar cultural politics. It was strange enough that an event so unexpected for both Wangenheim and the public should have been announced, but not commented on, by all the newspapers. Even Wangenheim's two chief critics remained silent. German journalists, as long as they offered no direct criticism of the victorious powers, were relatively free in their opinions. Would any commentary on Wangenheim's dismissal perhaps have been a commentary on the SMAD? Wangenheim, Pieck, and Ulbricht knew why they appealed in protest to the Russian representative to urge reconsideration. The decision against Wangenheim was made in the SMAD central office in Karlshorst. Under the agenda item "Change of the Intendatur [sic!] of the Deutsches Theater" for its meeting of August 21, the SED's central office confirmed resignedly "that it was not debated beforehand but presented as already decided."[22] Given the evenhandedness, civility, and constant attempt to avoid unnecessary attention characteristic of Russian cultural politics, Wangenheim's treatment was unusual. What had he been guilty of? The explanation passed down through Wangenheim's family is too obliging to be believed: Wangenheim had supposedly stepped on the Russians' toes when he refused to engage the daughter of Anton Chekov's niece Olga Chekova as an actress at the Deutsches Theater, not knowing that her mother's lover was no less than Marshal Schukov, who felt personally insulted by the refusal.[23]

A more obvious explanation would be that Wangenheim was overtaken by a fate not infrequent in times of transitions of power: he was placed in a leadership position by his own party only to be thrown out of it as soon as he proved inadequate to the choice. Graf Solms, too, had found that after the Nazis seized power, a profession of political loyalty alone was insufficient. The same had been true of Franz Ulrich, named head of the Staatstheater at Gendarmenmarkt by Göring in 1933 only to be replaced soon afterward by a theater star unaffiliated with the party, Gustaf Gründgens.

But Wangenheim's fall cannot be explained as simply the correction of a politically motivated miscasting, either. For Wangenheim was not the type of failure merely pushed along under party protection. His work was comparable in quality to that of the heads of Berlin's other theaters—for example, Barlog, von Biel, de Kowa, Karl-Heinz Martin, Fritz

Wisten, and Ernst Legal. They were all, perhaps with the exception of Martin, average talents. No one expected of them spectacular achievements—but their stages also had no great names to lose. On the other hand, particular demands were made of the head of the Deutsches Theater. And Harich's and Karsch's reviews aside, Wangenheim satisfied them in the eyes of most Berlin critics. Even if there had been a general disappointment and discontent with his theatrical productions, his dismissal would have been a matter for the German theater world. It would have been slowly set up and prepared. Pro and contra would have been debated at length and many a commentary written without drawing the interest of the Russian authorities. It is difficult to imagine that Wangenheim was so abruptly ousted merely for making "bad theater,"[24] as Arseni Gulyga, a cultural officer at the time in Berlin, recalled—even if the SMAD understood by *bad theater* something different than Berlin's theatergoers and critics in August 1946. There are reasons to assume that one particular production proved fatal for Wangenheim. It was the last of the 1945–46 season and his last ever.

Stürmischer Lebensabend (*The Stormy Evening of Life*), by Russian playwright Leonid Rachmanov, was a schmaltzy revolution play fulfilling all the demands and criteria of high Stalinism. Its performance at the Deutsches Theater was requested of Wangenheim by SMAD officers Dymschitz and Fradkin. The Russians' concern with this production was manifest in the many articles preceding the event and a much-heralded interview with Rachmanov in the official SMAD newspaper, *Tägliche Rundschau*. The premiere at the end of May 1946 was, as the critic Werner Fiedler expressed it, a flop "bravely endured" by the audience.[25] Whereas the older critics engaged at Russian-licensed papers (Wiegler, Rilla) avoided the embarrassment with their usual pacifying *Kunstbetrachtung*, Harich and Karsch let their sarcasm flow freely. They attacked the sentimental character of the piece and, above all, Paul Wegener's portrayal of the lead role, a bourgeois-liberal professor led to communism by the October revolution. "He loads his role with mimic flourishes and flounces, tugging at them and getting caught up until a comic-strip character emerges, a grunting, tittering, shrieking, senile little man, as unconvincing as the honorary doctor from Cambridge he is supposed to be as his sudden resolve in the moment of political truth" (Harich).[26] The criticism in *Neues Deutschland,* the SED's central mouthpiece, took the same line: in his performance, Wegener had "reduced" the heroic professor "to a ridiculous figure who could convince no one . . . he killed the whole play. . . . A truly great actor would have

played Poleshajev [the professor] and not a 75-year-old idiot."[27] The production scandalized the SED reviewer, and he called by name the person whose ultimate responsibility it was to have prevented it: "The director, Gustav von Wangenheim, should not have allowed any of this."

The *Tägliche Rundschau,* which as the mouthpiece of the SMAD had taken such an interest in the play and the production, seemed on the contrary richly satisfied with the performance. Whoever read the review must have thought it referred to another play, another production, another lead actor. Wegener had shown great dramatic talent, "adding to the series of his great characters a new, unforgettable one. Every word and gesture hit the mark, and one sensed behind the routine skill, which as always spoke in every nuance of the performance, an engaged heart."[28] It was praise worse than any sympathetic critique might have been. *Stürmischer Lebensabend* represented too much Russian prestige for the performance to be acknowledged as a complete flop and embarrassing blunder. The Stalinist code of honor did not permit such a loss of face. Instead form, facade, and appearance were maintained, regardless of the number of independent observers bearing witness to the contrary. What was declared a great event would be a great event, whatever the cost. The principle of the political show trial—the moral depravity of the accused claimed against all probability, all appearance, all evident reality, and carried out as a merciless ritual—was inverted: in the harmless case of *Stürmischer Lebensabend,* the fiasco was declared a shining success. What happened after the performance and after the critical reviews was of course another matter. With his firsthand knowledge of the psychology behind the show trial, Wangenheim might well have read the eulogy in the *Tägliche Rundschau* with horror and suspected what lay ahead.

If the failure of *Stürmischer Lebensabend,* the Russians' indignation, and Wangenheim's fall were the result of Wegener's pulp performance, then doesn't this entire sequence ultimately point back to him? Gustav von Wangenheim seems to have implied something of this sort. "The rehearsals with Wegener were agonizing," he wrote after the premiere. "I had to ignore the most upsetting political comments to avoid an all-out break. I found Wegener's acting style, the coughing and clearing of his throat and countless absurdities, extremely disturbing, but because I could not let it come to a break, I was unfortunately, I repeat, not in a position to do anything about it."[29] Wangenheim could not let it come to a break because the Russians wanted the stars Wegener,

Gründgens, and Gerda Müller for their state performance. Müller, according to the reviews, had laden her role with the same schmaltz as Wegener. Wangenheim thus found himself between two fronts. On one side were the Russians' demands, which began with the choice of the play forced upon him ("My only all-too-justified doubts about the chances of success for *Stürmischer Lebensabend* [were] inexplicably interpreted as antagonism in Karlshorst"), and on the other, the unwillingness of his own actors to take the play seriously. ("I was against Paul Wegener, because I already knew what kind of a naturalistic spell he would cast on this role, which for ideological reasons he approached with the utmost antipathy and antagonism. As a passionate supporter of the Soviet Union, I was now in a very difficult position.")[30]

Paul Wegener and Gerda Müller were not the only members of the ensemble at the Deutsches Theater who played against their director and his production, nor was *Stürmischer Lebensabend* the only incident of this kind for Wangenheim, but it was the one most fateful for him. His production of *Hamlet* and its interpretation of the hero as a man of action was equally sabotaged by the actors' antagonistic performance. Twenty-six years later this incident was recorded into the official history of the East German theater: "This made it impossible for Wangenheim to give his conception—to work out the conflictual social situation in *Hamlet*—full scenic realization."[31] But what prompted the ensemble of the Deutsches Theater to such behavior? Was it simply the esprit de corps of an ensemble that had played together for years? Wangenheim was not the only one to sense this. A young actress he had engaged, Angelica Hurwitz, had the impression of "a static, closed-off atmosphere. It was as though everything that was still to be worked through at rehearsal was already complete. All the rehearsals proceeded in an almost rarefied intellectual atmosphere. Aribert Wäscher and Paul Bildt seemed to communicate with half words."[32] Or was this the emergence (as it would later be termed) of "ideologically sharply diverging forces in the collective of the actors," who tried to rid themselves of the disliked outsider forced upon them by using their work to compromise him?

The real reason was Gustaf Gründgens. For the actors, he represented the opposite of Wangenheim. He was not an outsider, stranger, or intruder but the master, the father and protector in those years when the Staatstheater at Gendarmenmarkt had been an island of aesthetic autonomy. He had been the creator and ruler of the realm of

that "rarefied intellectual atmosphere" in which half-words and ges-
tures outweighed heavy scripts and momentous historical interpreta-
tions. Gründgens, honored by his ensemble as the man who had cre-
ated this protected aesthetic space and repeatedly defended it, possessed
what Wangenheim did not: authority. This he retained despite his ab-
sence (in a Russian camp) and subsequent loss of power (he was demoted
to simple membership of the Deutsches Theater's ensemble). Would it be
misguided to conclude from this that Wangenheim ultimately failed in
welding together the ensemble because of Gründgens and his past work?
That would indeed be a great irony, for it was precisely in the field of
organizing people—or, as Wangenheim termed it, of "apparatus"—
that he had thought to have surpassed Gründgens. When Klaus Mann's
roman à clef *Mephisto* was published in the 1930s, Wangenheim, who
had worked with Gründgens in Hamburg, confirmed the depiction of
the ambitious and opportunistic Höfgen-Gründgens: "Someone like that
runs the apparatus like its lord and master—a stolen apparatus. We
will strip it from his hands. This he knows and fears. But we will create
art without an apparatus, and of this he knows nothing, understands
nothing. . . . When art springs up from the nature of the people, the men
of Gründgens's type will lose not only their positions but their talent as
well."[33] The irony was that precisely the opposite occurred. Gründgens
did indeed lose his post as Intendant and Wangenheim assumed it. But
it then proved that Wangenheim did not command the apparatus upon
which the theater rested. An art "springing up from nature" did not
emerge to assume the place of the apparatus; the apparatus he thought
sentenced to extinction persevered. Wangenheim, the romantic commu-
nist of the theater who had been at his best in his independent the-
ater group in the 1920s and 1930s, regarding it as the model of a fu-
ture society, failed to understand why the apparatus would continue to
thrive.

Wangenheim's successor and the head of the Deutsches Theater for the
next sixteen years was Wolfgang Langhoff.[34] Several years Wangen-
heim's junior, he had gone through the same stations along his profes-
sional and political career. He came from the upper middle class, en-
tered the KPD after World War I, led a theatrical double existence as
youthful hero in the bourgeois theater and as agitprop group leader in
the proletarian theater, meanwhile retaining, as had Wangenheim his
monocle, certain unproletarian preferences for tennis and horseback rid-
ing, as well as an almost dandyish pleasure in socializing. These charac-

teristics had earned him the nickname "Prince of Wales" in his youth.[35] That, however, exhausts the similarities and common features between the two. If Wangenheim was more of a romantic dreamer type, Langhoff has always been seen as a realist and man of action. "He is representative of a new type of actor who is right in the center of action, face to face with all professional issues and politics. . . . Wolfgang Langhoff shows that the actor today is not a dreamer or actor in quotation marks. . . . Wolfgang Langhoff could be just as good a politician or engineer or mechanic as he is actor" (Herbert Ihering).[36] Langhoff had proved himself as a political organizer in exile in Switzerland. There he established and led the local National Committee for Free Germany. He held together with diplomatic skill the Swiss exile group of the German Stage Guild made up of communists and noncommunists and headed the KPD cell at the Zurich Schauspielhaus (a duty not to be taken all too seriously, as the company there consisted almost exclusively of salon comrades like Theo Otto, Wolfgang Heinz, Karl Paryla, and Erwin Parker).

Wolfgang Langhoff was the communist version of Gustaf Gründgens, a man whose artistic and organizational talents worked in harmony with one another, and who with the right mix of patience and strictness knew how to lead people, commit himself, and make good on those commitments. Shortly after his appointment, he solved the main problem of the Berlin theater once and for all. He hired Jürgen Fehling and, at Fehling's first escapade, promptly got rid of him, thereby demonstrating both his goodwill and his skill in the politics of the theater world.

Langhoff's leadership transformed the ensemble of the Deutsches Theater, influenced until then by Hilpert and Gründgens, into something new: the national theater of the emerging GDR. A few years later there would be no trace any longer of the "rarefied intellectual atmosphere" that had so impressed the young Angelica Hurwitz and left Gustav von Wangenheim short of breath. Or rather, another atmosphere soon reigned, equally rarefied and equally intellectual in its way, another elliptical style of communication through half-words and allusions. Like Gründgens in the Third Reich, Langhoff was to create his island of theater in the GDR.[37]

Kulturbund

In the final years of the Weimar Republic, No. 14–16 Cäcilienallee (to-day Pacelli-Allee) in Dahlem had been a gathering place for leaders of German high finance and the Nazi Party (NSDAP). Emil Georg von Stauss, director of the Deutsche Bank, was one of the first to overcome an initial reservation toward the party. His home came to serve as a leisurely gentlemen's club where political and financial leaders got to know each other and learned to appreciate their shared interests. The Stauss villa was not the place, as is often rumored, where German financiers saved the NSDAP from bankruptcy, although the social atmosphere offered by its master did create the necessary conditions for this.[1] After World War II, the Stauss villa became the residence of the American commandant of Berlin for the next forty years. And according to the plans of the Foreign Office, the Foreign Minister of the Federal Republic is to have his residence here in the coming years. The villa, built in *Landhausstil* in 1914 by the architects Wilhelm Cremer and Richard Wolkenstein, is among the most beautiful in a residential district replete with upscale homes.

Two families from the circle of émigrés returning from Moscow lived here temporarily in June and July of 1945: the couples Fritz Erpenbeck and Hedda Zinner, and Johannes R. and Lilly Becher. Erpenbeck, a member of the Ulbricht Group, was the first to arrive, in late April. Becher followed six weeks later, on June 10. With him came Heinz Willmann, a colleague from Moscow and the editor of the magazine *Inter-*

nationale Literatur/Deutsche Hefte, published by Becher. The Red Army lodged Becher and Willmann (Lilly Becher joined them a few weeks later) in a confiscated house in the district of Karlshorst, in direct proximity to Russian headquarters, for the first days after their arrival in Berlin. The move to a bourgeois residential district in the west and accommodation on Cäcilienallee came about at Becher's request, though it was already clear that once the Americans assumed control of this district a few weeks later the situation would fundamentally change. But location was precisely what mattered: Becher and Willmann's plans could be better carried out from Dahlem than from Karlshorst. Dahlem and the adjoining districts of Friedenau, Steglitz, Wilmersdorf, and Schmargendorf were preferred by financiers as well as artists and intellectuals. Few people who held a position of even minor importance in Berlin's cultural life lived in the districts now belonging to the Russian sector, with the exception, at most, of Treptow. Actors, singers, editors, and writers who worked in the old cultural center of Berlin-Mitte lived in Dahlem in a villa, a single family home, a large apartment, or—at the bottom of the economic ladder—one of the small flats in the so-called artists' block at Barnayplatz, a guild-union establishment of the 1920s.

At Cäcilienallee, Becher and Willmann undertook a range of activities in many ways comparable to those at Schlüterstrasse. They assumed contact with comrades living in the area who had hibernated through the Nazi period there or recently returned from camps and prisons. Among them was the thirty-three-year-old publisher Klaus Gysi, who had survived in semi-legality and was now working in the provisionally established district office of Zehlendorf. He was very likely the source of the tip that the Stauss villa was available. Other contacts and comrades included the artist Herbert Sandberg, returned from prison; Robert Havemann, a physicist at the neighboring Kaiser-Wilhelm-Institute; Enno Kind, a journalist formerly active in the Münzenberg group and a future theater critic for *Neues Deutschland;* and Wolfgang Harich, who lived around the corner on Miquelallee. Contact was also made with members of the Kammer der Kunstschaffenden who, in private life, were now neighbors in Dahlem. Paul Wegener, Ernst Legal, and Herbert Ihering soon numbered among the more or less regular visitors to Cäcilienallee. Politicians from the bourgeois camp also turned up: the former DDP and future CDU man Ferdinand Friedensburg, Gustav Dahrendorf of the SPD, and the unaffiliated mayor of Zehlendorf, Wittgenstein. Figures from academic circles like the philosopher Eduard Spranger, the art historian Edwin Redslob, the Slavicist Max Vasmer, and the musicologist

Hans Bennedik appeared there. The pastors Niemöller and Dilschneider from the German Confessional Church frequented Cäcilienallee, as did the successful novelist of the 1920s Bernhard Kellermann, the radio man Franz Wallner-Basté, and others.

After many individual meetings and discussions, a kind of plenary session took place in the drawing room of the Stauss villa on June 26, 1945. The participants resolved to do what Paul Wegener and his supporters in the Kammer already had in mind: establish a cultural, moral, and intellectual organization for (as the phrase later became) "overcoming the past." Becher and Willmann were empowered in the name of those assembled to apply for a license for this organization from the Russian commandant. Further steps followed quickly. The very next day, on June 27, the application was filed. One week later, on July 3, the official inaugural meeting took place in the great hall of the broadcasting center on Masurenallee. Given the generally chaotic conditions at the time, the tempo was astonishing, almost suspicious. For on July 4, as expected, the Americans and English entered Berlin and moved into their sectors. Was the Kulturbund zur Demokratischen Erneuerung Deutschlands (Cultural Alliance for the Democratic Revival of Germany), as the new association was called, supposed to be a fait accompli *before* this new order was established? Both the swiftness of the inaugural proceedings and the date on the Russian license suggest as much. It was issued on June 25—that is, one day before the assembly at Cäcilienallee voted to establish the Kulturbund and entrusted Becher with obtaining the Russians' approval. It is unlikely that an official document of this sort contained a printing error. Had the Russians sanctioned the Kulturbund before its own founding fathers knew they would create it?[2] Had the whole thing already been settled in Moscow, and the figures necessary for implementation in Berlin simply sought out afterward?

Of course there was a history to Becher's undertaking. For years the intelligentsia exiled in Moscow, like the circles of exiles in the West and the Allies' postwar planning divisions, had pondered how the intellectual and cultural infrastructure of National Socialism was to be done away with after its defeat. When victory seemed close at hand, these considerations and plans became more and more realistic. In September 1944, Moscow was the scene of a cultural conference to set the course. It involved the party leadership and prominent representatives of the party intelligentsia—Becher, Friedrich Wolf, Erich Weinert, Willi Bredel, Gustav von Wangenheim, Hans Rodenberg, Fritz Erpenbeck, Theodor Plivier, Maxim Vallentin. Becher held a talk titled "The Reeducation of

the German People," summarizing what in the preceding years had
been established as the party line. In Becher's words, the situation re-
quired a "national liberation and reconstruction of the greatest kind in
the ideological and moral sphere. . . . It is a matter of liberating the Ger-
man people from all the reactionary filth of its history, which emerged
in its most extreme form with Hitler, and of giving to the German peo-
ple all the positive forces from its history and the history of other peo-
ples that can sustain it and prevent it from slipping back into imperial-
ist adventures."[3] Becher listed the groups within the intelligentsia to be
won over and reeducated for this undertaking:

1. Educators, from village schoolteachers to university professors;
2. Pastors and the clergy;
3. Literature in a broad sense (including film, the press, radio, theater).

The technical and organizational details of how this plan was to be set
in motion were not discussed. But it was clear that the "party as an in-
tellectual power of order" stood behind—or rather, above—all activi-
ties of this kind.

There were no further discussions or initiatives regarding the intel-
ligentsia and reeducation until May 1945. On June 6, the very day when
the Kammer der Kunstschaffenden was established in Berlin, Wilhelm
Pieck in Moscow drew up his plan for the (as it was now already
termed) Kulturbund zur Demokratischen Erneuerung. Its program was
in no way more concretely formulated than it had been the previous fall
by Becher. ("Active production in the area of literature, science, and art
toward the intellectual and moral destruction of Nazism, participation
in the intellectual rebirth of the German people toward democracy and
progress, encouragement of free scientific research and of all cultural
life, popularization of the classical inheritance of German intellectual
life.")[4] However, the observations that Winzer, Erpenbeck, and others
had meanwhile made from within Berlin's intellectual circles were clearly
reflected in the list of names of the organization's possible members at-
tached to the report. From the environs of Schlüterstrasse, Eduard von
Winterstein, Michael Bohnen, Klemens Herzberg, Heinz Rühmann, and
Viktor de Kowa were earmarked as possible members. But they repre-
sented, if one considers the entire list, a minority. Church and union
representatives, officials in the Magistrat, and former KPD and SPD del-
egates to the Reichstag (including Walter Ulbricht and Wilhelm Pieck)
formed the majority. This list, compared with the participants at the
inaugural meeting in the Stauss villa and the board of directors of the

Kulturbund eventually formed in August, shows a clear retreat of polit-
ical figures in favor of intellectual and cultural ones. Ulbricht, Pieck, and
Winzer (whose name was also on Pieck's list) no longer appeared in the
circle Becher had gathered about him. Compared with the scientists, art-
ists, literary figures, actors, and so forth, representatives of political par-
ties now formed only a small minority. They also no longer participated
as party representatives, but as cultural dignitaries who only inciden-
tally had party affiliations. A politician was a member of the Kulturbund
just as any doctor, engineer, or office worker with an interest in cultural
affairs might be. Presenting itself to the Berlin public on July 3 in the
broadcasting center, the Kulturbund emphasized its nonpartisanship as
well as its (nonpartisan) political, enlightenmentlike activism. There was
no logical contradiction between nonpartisanship and cultural and po-
litical activism in the conception of the Kulturbund. The seven program
points Becher presented at the inaugural meeting[5] were completely in
line with the directives planned in the Soviet-occupied zone for all areas
of state, economic, social, and cultural life concerning the "antifascist
democratic reconstruction" and "antifascist democratic unified front."
To overstate the case a bit, one might say that the KPD, officially re-
vived on June 11, 1945, had itself become nonpartisan, renouncing al-
most all of its revolutionary social demands of the period prior to 1933.
There was no more talk of a dictatorship of the proletariat. On the
contrary, citizens' rights and freedoms were openly praised and private
property guaranteed; private enterprise was not only tolerated but even
encouraged. Freedom of the press and freedom of the arts and sciences
were deemed necessary and worth preserving, and finally expressly se-
cured. There was no talk of transposing the Soviet social model to
Germany.

It harked back to the Popular Front period ten years earlier. The
KPD had once before presented itself to potential noncommunist allies
first and foremost as an antifascist party, and not as a revolutionary
and communist organization. Even the persons in question were the
same. Johannes R. Becher had been involved in organizing the first big
popular-front meeting of intellectuals, the Congress for the Defense of
Culture, in Paris in 1935. He continued and broadened his party expe-
rience both in the subsequent activities of the International Organiza-
tion for the Defense of Culture and in his work with *Internationale
Literatur/Deutsche Hefte,* for which he was able to win the collabora-
tion of everyone of standing and reputation, from Romain Rolland to
the Mann brothers. At the time, there was no reason to conceal one's

party membership—the Moscow show trials were still to come—but the party demanded extreme reservation and the strictest discretion in the conspiratorial assumption of being able to exercise more influence this way. This game of hide-and-seek, laughed at by outsiders as both obvious and naive, was taken very seriously by Becher. When his comrade Gustav Regler was carried away by communist sentiments during the Paris congress in front of the plenum and began singing the Internationale, Becher reproached him sharply and stipulated for further popular-front work: "It must be avoided at all cost that the Congress, along with the organization formed there, could be denounced as communist."[6] Exactly ten years later, at the founding of the Kulturbund, a similar mishap befell Becher. The party line and Walter Ulbricht's demand for a democratic appearance despite tight KPD control should have resulted in a Kulturbund structured like Berlin's municipal government: a bourgeois representative as its formal head, and communists in all key positions. Becher and the party planned to make the internationally known author Bernhard Kellermann the president and figurehead of the organization and Becher its true head and motor. The bourgeois majority upset these plans by selecting Becher himself at the inaugural meeting—most likely in the not misguided assumption that he, the apparent initiator of this undertaking, had earned the position. "It was a defeat, not a victory," Anton Ackermann declared, as had Becher ten years earlier in Paris.[7] Becher, however, could not be held responsible for his election, whereas Ackermann had been guilty for the same failure in the eyes of the Russians because he "had slept through the past three months."[8]

Although in the eyes of the party the Kulturbund was marked by this birth defect, the circles it strove to win over seemed not to notice it at all, regarding their choice as absolutely correct and appropriate. (It is, of course, theoretically possible that Becher's election might have been a conscious torpedoing of the communists' strategy, which any halfway intelligent observer of the scene in the summer of 1945 must have seen through; but given the fairly unrefined political sense of the participants, this is not likely.) Criticism of Becher within the party was unfounded: the election was forced on him by his bourgeois followers against his will (he resisted, almost comically, accepting it at the last moment); moreover, it soon became clear that he filled the position superbly and successfully, even by the party's standards.

If there was one member of the KPD whom the bourgeois members of the Kulturbund considered not a stranger but one of their own,

it was Johannes R. Becher. He played the role of the "integrating and seducing figure" (Gerd Dietrich)[9] so perfectly that one might wonder who was really seducing whom. As the party's liaison to the bourgeois intelligentsia, Becher was as successful in the postwar years as Willi Münzenberg had been in the 1920s and 1930s. Both functioned as a contact for intellectuals, with the difference, given the times, that Münzenberg "played the salon proletarian successfully" (Bruno Frei)[10] whereas Becher portrayed with equal aplomb the bourgeois son (which he in fact was) who, in the eyes of his bourgeois contacts, only incidentally belonged to the KPD. If Münzenberg's trademark had been his firm worker's handshake with which he was able to pull in sensitive leftist intellectuals of the Weimar and emigration periods (Bruno Frei), it was to some extent Becher's bourgeois respectability and sensitivity, the delicacy of his handshake, that made him irresistible to the educated middle class after 1945. His involvement with the KPD seemed not a threat but an encouragement, assuring them that one of their own would work alongside and make his influence known to the new rulers. In this respect, Becher fulfilled an integrative function similar to the Popular Commissioner for Culture in the Soviet Union in the 1920s, Anatoli Lunatscharski.

Becher not only played this role but seemed to merge with it entirely. His whole life and artistic development had consisted in changing from one role to the next, living out each to the fullest—from sensitive symbolist to aggressive expressionist, from expressionist to proletarian-revolutionary agitation poet, finally from agitator to national classicist. This last oscillation had taken place during his exile in the Soviet Union, both in reaction to the political defeat of 1933 and the loss of *Heimat,* and as a witness to the Stalinist rediscovery of patriotism during the Great War. In 1948 young Alfred Andersch asked him how he would explain his transformation from left revolutionary to *Heimat*-bound national poet. In response Becher pointed to the realization "that we were already living in exile in Germany before we went into outward emigration. Leftist literature was 'avant-garde' and isolated from national problems, and we left the shaping of fundamental historical problems to 'rightist' literature, which presented them in its reactionary way. . . . I discovered Germany in emigration . . . discovered the German countryside, the German people, and the great German poetry that I had before dismissed with a wave of the hand."[11]

Becher's biographical trajectory from rebellion against his father, suicide attempt, drug dependency, and identification with the party as a

substitute father revealed the same pattern again and again: rebellion followed by submission, with regular suicide attempts as the hinge between the two. Becher was not only a "divided poet"—as the title of a collection of texts issued after the opening of the archives in 1989 referred to him[12]—but a divided man and political masochist, who after attempts at breaking free always submitted again to an "almost voluptuous discipline."[13] He was unsteady in his personal relationships as well. His letters reveal the odd habit of addressing the same friends, alternately and arbitrarily, in the formal *Sie* and the informal *Du*. His humor was just as volatile. Heinz Willmann mentioned Becher's lack of self-irony and his constant readiness to unleash torrents of irony at the expense of others.[14] Hans Mayer speaks of his readiness to laugh, which was, however, often "the expression of a brutal Bavarian humor." "There were also traits of an evil person in him," Mayer continues, "an evil one, not a bad one. He could cause suffering, just to enjoy it."[15] Others saw another side, like Theodor Plivier, on whose behalf Becher supposedly came up against Ulbricht and Pieck in Moscow. But even here an internal split was unmistakable. "He dried many tears, and he did it alone and secretly, as though ashamed of his compassion and the monstrous crimes of a regime he could not free himself from."[16] Becher could be the "nasty *Geheimrat*" and the "Becher we have to drain to the dregs."[17]* He also could be—as the young student Elisabeth Noelle-Neumann, who visited him in 1946, found—a man who "having no more than the first impression of someone would make the first step to overcome distance, not with suspicious caution, not skeptical about what sort of person it might be."[18]

The three years in Berlin after his return from Moscow became for Becher a unique period in his life, without oscillation, without inner conflict, without anything more than the absolutely necessary measure of vicious humor. It seemed the fulfillment of a wish that his mistress from his Moscow years, José Boss, once expressed to him—"that only the poet in you remains and everything else was slowly done away with—all the 'Jobs.'"[19] Of course, Becher did not enter the Kulturbund as a poet but as an organizer, initiator, and mediator. In contrast to his previous and subsequent political activities he dedicated himself to this undertaking with the seriousness, energy, purposiveness, and evenhandedness of a person whose interest was provoked not merely by the desire to escape from something else. As long as his interests and the

*This is a pun on Becher's name, which means "cup."

party line were in harmony, Becher's peak lasted. When the dreamland
of the interregnum period between the war's end and the Cold War was
over, his personal dream period would also end.

The very visible communist leadership of the Kulturbund (beyond Becher
and Willmann, this included Alexander Abusch and Klaus Gysi) was, as
we have already seen, not nearly as disadvantageous as the party had
feared. The majority of Berlin's theater heads, museum directors, pro-
fessors, actors, writers, and artists who had participated in some form
in the Kammer der Kunstschaffenden now became members of the Kul-
turbund. There was even a spatial motivation for this once the Kultur-
bund took up quarters in the building on Schlüterstrasse.[20] The two
institutions could be clearly distinguished in terms of program and or-
ganization: from the very beginning the Kulturbund understood itself as
a suprazonal and ultimately national organization, whereas the Kam-
mer, despite high-flying schemes, always remained a Berlin concern. Un-
officially, however, the Kulturbund became an informational exchange
as the Kammer der Kunstschaffenden had been by bringing together in
its board the most important figures of Berlin's universities, theaters, or-
chestras, museums, radio stations, publishers, and newspapers. After the
dissolution of the Kammer in the spring of 1946, the Kulturbund ab-
sorbed these functions entirely.

The Kulturbund, however, did not consist only of a board of direc-
tors. Unlike the Kammer, it was conceived of as a organization for the
masses, an objective achieved within the first months. At the end of
1945, there were four thousand members in Berlin, and the number
reached nine thousand six months later. Socially, the educated classes
were dominant: 27 percent were writers and artists, 11 percent scien-
tists, 9 percent teachers, 11 percent engineers, 24 percent civil employ-
ees and officials, 14 percent individuals of independent means. Workers
formed the smallest group with 7 percent.[21]

The chord the Kulturbund struck in the middle class despite its com-
munist leadership rested on the specific disposition of this class after the
collapse. Joining culture to politics, or better yet, replacing politics with
culture, could not have been a more welcome offer. As a cultural orga-
nization, the Kulturbund corresponded exactly to the needs of a social
class that traditionally mistrusted politics and wanted nothing more to
do with it after the most recent events. At the same time, as a political
and moral institution, it promised to promote a catharsis of the moral
discontent undoubtedly present in the bourgeoisie in the wake of Na-

zism. Compared to the occupying powers' reeducation plans, carried out with the greatest naïveté and force by the Americans, the Kulturbund possessed the great attraction of a "house cleaning" (as it was called at the time) carried out without external interference. Membership meant allegiance to a moral, nonpartisan party. Culture, invoked like a magic word, would overcome the burden of the past and promised moral redemption. In this sense the Kulturbund was not merely a communist undertaking to win over and integrate bourgeois "useful idiots" into the communist-controlled Popular Front—as it has gone down in Western journalism and history—but mutually benefited both parties. Communists secured the prestige of the educated bourgeoisie for their popular-front politics, and the bourgeoisie received its desired moral exoneration. In the simplest terms, morally tainted culture was exchanged for morality lacking cultural prestige. Adherents of the bourgeois *political* class, people like Ferdinand von Friedensburg, Gustav Dahrendorf, and Ernst Lemmer, valued the Kulturbund as a substitute political forum at a time when real political life in Germany was not possible. Lemmer compared his task with that of the German National Association in the nineteenth century.[22] For Friedensburg, a former Prussian government official and alongside Becher probably the most active founding member until 1948, the Kulturbund represented "our own German position between the occupying powers."[23]

The Kulturbund guaranteed its success by satisfying tangible material requirements in addition to moral and political needs. For bourgeois intellectuals who did not want to be seen as too close to the new rulers in the SMAD and the KPD/SED, it was a welcome trading place to accept material advantages without being politically compromised—without any taint of collaboration at all. The perks offered included the Club of Artists on Jägerstrasse, location of the former upper-class Club of Berlin. Here, moving across the parquet floor of Speer's New Chancellery—which in the course of the building's restoration was disassembled there and laid afresh here—members could enjoy the central heating lacking at home and unrationed meals, read foreign newspapers not available elsewhere, and learn about cultural life abroad through lectures, discussions, and film presentations. Through its close connections to émigré circles and good contacts to all of the Allied cultural posts, the Kulturbund was undoubtedly the most international cultural institution in Berlin in the first year after the capitulation. Other amenities offered to members of the Kulturbund included summer vacations at the Baltic Sea resort of Ahrenshoop (confiscated by the SMAD

specifically for the Kulturbund). All of these goods, foodstuffs, and luxuries, as well as the greatest part of its budget, were bestowed upon the Kulturbund by virtue of an SMAD ordinance.[24] Johannes R. Becher's correspondence bears witness to how seriously the leadership of the Kulturbund regarded the coordination of moral and material needs and how much had been learned from the Russians in securing the sympathy of the hungry bourgeois intelligentsia through special rations ("pajoks," the legendary food packages). Shipments of foodstuffs from émigré comrades in America had the same persuasive force as plans for founding new magazines. If friends offered help in the form of food packages and inquired of Becher which of their colleagues or comrades was most needy and deserving, Becher suggested a name, indicating, as in a letter to F. C. Weiskopf in New York in May 1947: "It would be very good if you see to it that a note is included with each package indicating that the name was recommended by us, that is, by the Kulturbund."[25] But even relations between the Kulturbund and émigrés, whatever the personal connections and political sympathies, were marked by a principle of exchange. Both sides tried to capitalize on what the other needed. Hence letters from America that reached Becher often contained not only offers for care packages but also inquiries as to what professional opportunities and positions awaited the potential reimmigrant. A representative number of such letters in the archives of Becher's correspondence reveals a repeated schematic structure:

First paragraph: praise of Becher's writing.

Second paragraph: request for a copy of Becher's latest work.

Third paragraph: request for support upon return to Germany.

The third paragraph of a letter from Hanns Eisler, for example, of November 24, 1946, reads: "I would be very pleased if I could be of use, even a destroyed Berlin is still Berlin for me. Above all, I am thinking of the chairmanship of a music department."[26] Alfred Kantorowicz, who on February 3, 1946, likewise declared interest in an academic post, received the following reply from a beleaguered Becher: "This still seems to present certain difficulties."[27]

The repatriation and reintegration of émigrés into German cultural life, which curiously was given no mention at all in the programmatic principles at the Kulturbund's founding, became a central focus and probably stands as its most important contribution to German postwar culture. In this respect, it did internationally what the Kammer der

Kunstschaffenden had done on the local Berlin level; that is, it acted not as an employer but as a source of communication and mediation. People seeking to fill available positions were almost all members of the Kulturbund and could be contacted through Becher: Otto Winzer in the Magistrat; Gustav von Wangenheim and later Wolfgang Langhoff at the Deutsches Theater; Ernst Legal at the Staatsoper; Klaus Gysi at the Aufbau-Verlag; Paul Wandel, Erich Weinert, and Herbert Volkmann in the Soviet zone central administration's department of Popular Education. For many if not most of the émigrés returning to Berlin between 1946 and 1948, the Kulturbund served as an information and travel agent and employment and housing office in one. Compared with the system of privileges that later developed and the luxury offered to the great old men of bourgeois culture like Arnold Zweig and Heinrich Mann, the support of the party intelligentsia at the time proved modest. In distinction to the leading political cadres, who from the very beginning were taken into the SMAD's distribution system and received lodgings and provisions, even prominent intellectuals like Becher, Alexander Abusch, Friedrich Wolf, Erich Weinert, and Willi Bredel cherished every care package. Nor could the subsequent assignment of accommodations, after the first returnees were generously provided for by the Red Army (as in the Stauss villa), have been called privileged treatment. First-class intellectuals and functionaries like Abusch, Willmann, and Erich Wendt lived for months as subtenants.[28] On the other hand Heinrich Mann, the "Hindenburg of German exile" (Ludwig Marcuse),[29] whose return the Kulturbund had attempted to arrange beginning in 1946, was offered "a modern house with central heating, nice bath, and five rooms of pleasant proportion with garage, terrace, and winter garden, already pleasantly warmed and furnished. It was—this will amuse you—built . . . for an SS officer." The description is contained in a letter from Arnold Zweig to Heinrich Mann.[30] Zweig himself had shortly before been allocated a similarly appointed house, as had Hanns Eisler, who lived on the property bordering Mann's house. Mann's death prevented his return; it was one of the Kulturbund's few unsuccessful reimmigration attempts.

As importantly as the émigrés figured, they were not the principal group targeted by the Kulturbund. The call for a "democratic revival" really had another aim. The artists, intellectuals, and scientists who had not emigrated from the Third Reich fell into three groups: Nazi sympathizers; apolitical Germans who remained professionally active after

1933 without compromising themselves, and who occasionally even voiced camouflaged criticism; and those who ceased all artistic and literary work, or at least forwent publication, and turned to other occupations. Originally only those who expressed their refusal with total silence claimed the term "inward emigration" for themselves. From the personal point of view of Becher and other émigrés in the Kulturbund, the fact that Germans who had blithely continued to publish within the Third Reich also suddenly emerged as 'inward émigrés' after the collapse must have seemed sheer hypocrisy and opportunism. At the same time, the idea of reunifying German culture depended upon exactly this kind of comprehensive notion of inward emigration—a kind of general amnesty permitting all those who had not actively sympathized with the Nazis to return to the cultural community. There was another not entirely remote motivation for reimmigrants from Moscow to redefine emigration this way. If all those who had remained in Germany and not compromised themselves were now integrated under the label of inward émigrés, perhaps all who had gone into exile—into Stalin's Russia or Roosevelt's America—could (might, must) be seen and judged part of one undivided outward emigration.

In order to rejoin the branchings of German culture after 1933, the Kulturbund needed a figurehead whom everyone entering the organization could acknowledge and identify with. With the loss of Becher after his election to the presidency, someone else had to be sought. Becher's first concern after the founding of the Kulturbund was to find a patron, an honorary president to decorate the organization and give it respectability and an integrating force.

His first choice was Thomas Mann.[31] But before he could take steps toward winning him over, the matter was already decided. A controversy provoked by Walter von Molo and Frank Thiess spoiled the chances for Thomas Mann's return to Germany, if he had ever truly entertained such thoughts. Mann's polite refusal of Molo's request to return to Germany had drawn a caustic commentary from Frank Thiess. It was his open letter to Mann that contained the phrase that émigrés had followed the German drama "from their comfortable box seats" abroad. Becher must have swallowed his anger and bitterness over seeing his own plans for the great writer thwarted so clumsily when he wrote *privately* to Thiess. A grinding of teeth over the wasted chance is still somewhat audible in his lengthy letter of January 26, 1946: "Your first open letter to Thomas Mann [was] inappropriate in terms of tim-

ing, content, and tone. It would have been advisable if you had before-hand been in touch with Germans more familiar with the attitude abroad toward Germany, and who could have presented you plainly with the attitude toward emigration and in particular Thomas Mann's emigra-tion within it." But then the tone changes. Becher moves from the ac-cusatory *you* to the cooperative *we*, leaving no doubt that he consid-ered Thiess a comrade in matters of German culture despite his lack of diplomacy and his brutality in the case of Thomas Mann: "*We* could have been spared this refusal, equally regrettable for *us* and Thomas Mann, if *we* had in timely fashion considered and thought through to-gether if, how, and when *we* wanted to approach Thomas Mann [em-phasis added]." Becher assured Thiess it was his "sole effort to serve the cause that you and I are equally bound to: the revival of our people. Long before the return to Germany it was clear to me that in the inter-est of this cause, an end must be brought to the distinction between 'in-ward emigrant' and 'outward emigrant.'"[32]

After Thomas Mann, Becher's attention turned to another great writer of the older generation. Given his objectives, the choice was not an ob-vious one. Nothing about Gerhart Hauptmann seemed to embody the present circumstances, and not only because of his eighty-three years. Almost everything about him was unreal, especially the long stretch be-tween his productive youth and his spent old age. This had drawn com-ment from Becher, then of another mind, on the occasion of Haupt-mann's seventieth birthday in 1932: "A man remains, seventy years old, who is no longer of interest. May he rest in the peace he has made with the ruling powers."[33] His existence during the Third Reich was also unreal, keeping silent, but not forgoing official honor. Hauptmann was a living anachronism, a dead man waiting for release from life. His only connection to the present of 1945 was his surreal surroundings in Si-lesia, which was now undergoing the expulsion of the German pop-ulation and seizure by the Poles. Provisionally supported by the Red Army in the summer and fall of 1945, he continued on as lord of the manor of Wiesenstein House—a strange and unreal state given the trag-edy playing out just beyond the boundaries of his property's extensive grounds.

Becher's attention was brought to this situation in the summer of 1945 by Gerhart Pohl, a former literary friend and now Hauptmann's neighbor. In October he undertook what has gone down in postwar lit-erary history as the "expedition" to Hauptmann. In two motor vehicles,

and accompanied by a journalist from the *Tägliche Rundschau* and two
SMAD officers (the task of one of whom was to photograph the events),
Becher made his way to Silesia. Soon after his arrival he realized that
the aim of bringing back Hauptmann in person was impossible. The old
man shuffled between bed, sofa, and armchair and had no thoughts of
leaving his familiar surroundings. He wished only to die in peace. Even
his spirits seemed cut down after having witnessed the doom of Dres-
den in February 1945. "My head is as fuzzy as if I were wearing a
dozen woolen caps. I fade out of consciousness so often that I think,
now is the end—and I would thank God for it" (notebook of Marga-
rethe Hauptmann).[34] For the meeting with Becher and his entourage,
Hauptmann was moved from his bed by his attendant and seated in an
armchair. In a bathrobe, sunken in, he let pass before him what, to fol-
low the reports of it, must have been a strange scene of pitiful pathos,
wooden staging, and businesslike brevity.

> Becher: "Today millions of people are looking to you, Gerhart Hauptmann!
> They await a word, a word of encouragement! We all need your strength to
> raise up and strengthen Germany. We must rebuild under difficult condi-
> tions. It is our firm belief that we will succeed from the best sources of hu-
> manism. But this will take your word, Gerhart Hauptmann, and this is
> what we ask of you!"
>
> Hauptmann: "I am at your disposal. You do indeed charge me with an
> enormous task, though I am already—on the brink . . . I am a German, and
> it is absolutely clear that I will remain so. What we are discussing here is a
> matter that concerns Germany."[35]

The expedition did result in securing Gerhart Hauptmann's name for
the Kulturbund—that is, the title of honorary president. That Haupt-
mann himself, or the part of him still living, could not be brought back
to Berlin[36] was of no great weight by comparison and in fact proved an
advantage, as did his actual death the following year. Only the name on
his work remained, and now this could be more easily made to identify
with the progressive early period. But the question remains how Becher
lighted upon precisely the man who for so many years was practically
the symbol of numbed artistic potency, an image of sterility and oppor-
tunism. The expedition met with disbelief and rejection from Becher's
ideological friends. "Sympathy for efforts to win widespread partici-
pation in the rebuilding of cultural life," said F. C. Weiskopf, "must have
its limits. In the case of Hauptmann, these limits have been crossed,
in an undignified way and, as it may prove, to no effect. As far as the

'world public' itself is concerned, when it looks on Hauptmann (if at all), it looks with contempt and repulsion at this man who has outlived himself, a dancing puppet always making himself available to everyone."[37]

Becher, who thirteen years earlier had used similar words, did not need such hints. People like Weiskopf who judged the German scene from the distance of America, he could reply, were unfamiliar with the real situation; the situation dictated that Gerhart Hauptmann was unfortunately the right figure to reintegrate German culture. His appointment as honorary president may be viewed as an olive branch to the bourgeois members of the Kulturbund who had also acted opportunistically during the Third Reich. Becher's deployment of Hauptmann as a representative figure served as more than a trick popular-front strategy. Hauptmann was presented as a model of catharsis with whom many other fellow travelers should be able to identify. "The great intellectual power Gerhart Hauptmann represents has all too often been declared apolitical and neutral, and stripped of its own power," Becher wrote in the *Tägliche Rundschau* after his return from Silesia,[38] remarking: "The path to humanity, which the best part of his work called out for . . . [was] barely visible in much of what the writer failed to do against the spirit of barbarism . . . and in the darkness of the confusing and tumultuous times, he came close to the abyss and wanted to lose himself in fruitless resignation and isolation." The unspoken but clearly implicit conclusion of this statement: the Kulturbund offered the catharsis that would save German culture from such dangers.

To see in Becher's strategy only a Machiavellian calculation to pull discredited artists and intellectuals into his own sphere of influence would be mistaken. His twelve years of exile in Moscow must have made him only all too familiar with the reaction of intellectuals who closed their eyes and ears to the terror around them. Becher could not approach Hauptmann as an innocent man approaches a guilty one, as he might have done in 1932; they were, even if he could not admit it to himself, accomplices and partners in suffering. In writings published after Becher's death there is a note of deeper sympathy, tolerance, and complicity akin to Brecht's "An die Nachgeborenen" ("To Those Born After"): "Let us not be unjust to Gerhart Hauptmann's work, or led astray and embittered because Gerhart Hauptmann has adopted an attitude in the past years that—precisely because of our agreement with and interest in his work—we object to. . . . No, we do not want

to make his mistake our own and muddy our clear view of Gerhart Hauptmann. We bend in reverence even before a confused and often broken will, if it began as purely and passionately as his did."[39] In 1945–46 Becher could not have guessed that a few years later literary and intellectual contemporaries would judge him as he had judged and condemned Hauptmann in the past—in Johannes Bobrowski's merciless words, as "the greatest dead writer of his time, whom nobody listens to and reads, though he lives and writes on."[40] The experiences of Becher's exile, his feelings of transgression and cowardice, had followed him to Berlin and Silesia. In his later years, he would reflect on that period in autobiographical notes and poems. "Burned Child," a poem written down hastily like a diary entry, signals even in its title that it deals with his personal experiences.

A backbone broken once
Can hardly be persuaded
To stand upright again,
For the memory
Of the broken backbone
Is frightening.
Remaining so even
When the break has long since healed
And the reasons for it
No longer exist.[41]

Hauptmann was the most prominent member of the fellow-traveling silent majority of inward émigrés whom Becher set out to woo. As a rule, émigrés won over by the Kulturbund belonged to the enlightened political left wing of German culture before 1933; but the Kulturbund worked with at least the same energy for members of the conservative-apolitical right wing who had remained in the Third Reich, well-known figures like Wilhelm Furtwängler, Ernst Wiechert, Ricarda Huch, Hans Carossa, and Reinhold Schneider. Though not in the spectacular style of pursuit Hauptmann had elicited, Becher went to Bavaria and personally sought out Wiechert, probably the most prominent representative of the inward emigration in 1945, to gain his collaboration on a magazine project. Called *Die Tradition,* the publication was designed to bring together authors of the inward emigration and serve as a conservative counterpart to the leftist liberal monthly magazine *Aufbau* published by the Kulturbund.[42] Although the encroaching East-West polarization

brought an end to these efforts before they could take root, the very be-
ginnings in 1945–46 were enough to sound the alarm in his own camp.
Weiskopf's cautionary voice was joined by others, who moved beyond
criticism to strident protest. The outrage was greatest among Becher's
former supporters in the Bund proletarisch-revolutionärer Schriftsteller
(League of Proletarian Revolutionary Writers), most of whom had mostly
spent the Nazi period in Germany, in concentration camps or prisons,
and who now condemned the new roles given to Hauptmann, Wiechert,
Carossa, and Fallada. "The gentlemen have already assumed their posi-
tions," Hans Lorbeer wrote to Becher: "They will set the tone, pick the
text. I would not be surprised if Herr Pohl, Herr Barthel, Herr Bind-
ing, and Herr von der Vring found similar ones. Herr Fallada is already
there. Herr Heinrich Mann, who once knew to speak such generous
words to the 'democratic' rubber truncheon police back in lovely Prus-
sia, and Herr Hauptmann, and whatever their names are. One day,
when the politician has been put aside [Lorbeer was at this time the
mayor of Wittenberg] to pick up the poet's pen again, there will be no
mercy."[43] This was not only an expression of political and moral indig-
nation, but a fear of being left empty-handed in future cultural life. Kurt
Huhn, a writer and member of the BPRS in the 1920s, remarked: "The
noose is tighter than in my time in the camp. Yes! Silence in the cultural
office. Silence in the party newspaper. Excluded, ousted, superfluous, you
get there and stare into cold faces, what the hell kind of world is this?"[44]

Like Becher an émigré in Russia, Erich Weinert had returned to Ber-
lin three-quarters of a year later and belonged to the party intellectuals
who were pointedly *not* members of the Kulturbund. In his opinion,
Becher was too lenient with Hauptmann, Fallada, and the others. "We
don't wish to be pharisees, but we won't let the boundaries be effaced
that separate us from the people with whom we no longer share any
common ground. They should be thankful if nothing more happens to
them than being granted the right to rehabilitation."[45] Adam Scharrer,
another writer from Mecklenburg, was, as his friend Willi Bredel let
Becher know after Scharrer's fatal heart attack, "extraordinarily bitter
over the Kulturbund's policies in Berlin," because it slighted "proven
antifascists" in favor of "bourgeois nitwits" and threw the former "on
the scrap pile."[46] At an SED party conference on current questions of
cultural policy in January 1947, a member of the Kulturbund com-
plained "that we in the Kulturbund are now required to procure a
farm, a seaside villa, or whatever, for a well-known intellectual, a for-
mer member of the NSDAP, just so he doesn't go over to the English

zone . . . or make sure to provide every possible economic advantage
for people in whose literary production we have not the slightest inter-
est, just so their books aren't published in other zones."[47]

However, it was not only Becher's communist confederates from
the old times who complained about the Kulturbund. Its original tar-
get group, the bourgeois intellectuals, also launched a critique, different
from the protest coming from the left but touching on what had limited
the Kulturbund's appeal from the very beginning. Walther Karsch, co-
publisher of the American-licensed newspaper *Tagesspiegel* since the fall
of 1945, was initially cautious about the organization but not averse
to it. Only later did he become an outspoken opponent, seeing too many
ideologically irreconcilable forces at work for Becher's goal of a "great
union" of German culture to be achieved with such speed. "It can-
not be done if opposing fronts are effaced for the sake of an external
unity," Karsch warned. "On the contrary: only by working out these
fronts, proceeding sharply and ruthlessly with oneself and others, can
an external unity become an internal and genuine one."[48] Karsch never
joined the Kulturbund. Even a completely different type, a conservative
liberal of the older generation like Ferdinand Friedensburg, formerly a
high Prussian official and cofounder of the Berlin CDU in 1945, who
became one of the four vice presidents of the Kulturbund and its most
active bourgeois member, announced similar discontent at a meeting of
the board in early 1946: "There is a lack of . . . intellectual confron-
tation and struggle."[49] Jürgen Fehling, who was nearly elected to the
board in late 1946, made only a single appearance there. He opened
with the observation that the "the greatest danger of this meeting seems
to me to be that you're all so deadly serious. You speak as if you were
all union secretaries," and ended with an address to Becher:

> I think the methods in Russia, first quelling the revolution in art for twenty
> years so that there is peace after this horrible bloodbath and then creating a
> so-called unstormy youth, are absolutely wrong. Herr Becher, this is your
> great task as I see it. I believe that you, as a German writer, should acquaint
> those Russian gentlemen with the conception that Germans are completely
> unrevolutionary and never do well in intellectual revolutions. Only a genius
> can do that, and the genius never notices how revolutionary he is. To those
> who go on believing that a Marx, Trotsky, Lenin, or Kropotkin was as dan-
> gerous and revolutionary as Goethe when he wrote something as harm-
> less as *Elective Affinities* or even something infamously dangerous like the
> "Walpurgisnacht" or the second part of *Faust*, let it be said that in compari-
> son everything in politics is a harmless horse trade between parties.[50]

Sarcastic analyses and tongue-lashings like these were rare in the Kulturbund, on the board as well as the committees and discussion sessions. The organization typically provided a forum for serious discussions between representatives of different ideological and political views, like the debate between Anton Ackermann and Ferdinand Friedensburg about Germany's status within the political aims of the victorious powers on February 21, 1947. This took place in an uncompromising and controversial yet civilized and tolerant way, if perhaps somewhat insipidly for Jürgen Fehling's taste.[51] Even a topic like Ernst Jünger could be thoroughly debated in 1946 by members of the Literature Committee, including Karl Korn and Ilse Langer, free of the taboos typical of the time.

Regarding the culture of music, the Kulturbund distinguished itself by setting up a concert and lecture series titled "Contemporary Music" (organized by Hans-Heinz Stuckenschmidt) that provided exposure to new musical production. And the personal dealings between communist and bourgeois intellectuals apparently acquired the relaxed atmosphere of a gentlemen's club. Becher the communist, and the educated bourgeois Friedensburg (who as a young man in World War I made an adventurous escape from a British prison camp on Gibraltar), were on excellent terms personally. They saw each other privately as well, not restricting their interaction to the official sphere of the Kulturbund.[52] Their mutual attempt to use the Kulturbund for their own ideological and political goals—that is, as a means of influencing adherents of the "opposing" camp—was apparently conducive to their relationship and led to a mutual respect, evidenced in Heinz Willmann's expression of professional admiration for Friedensburg: "Friedensburg knew how to use music to personally bind a circle of influential people to himself—outside of the Kulturbund. His intention was to assemble a circle around him (and to influence it) that was set apart from the Kulturbund and everything involving it."[53] Their personal dealings also seem to have been marked by a certain degree of (self-) irony. Willmann's remark to Friedensburg—"You would even consider joining the KPD if you could save German capitalism by doing so"[54]—was, as both were aware, no less true for the communist Willmann, who, in order to serve his party, had become the director of a cultural association composed mostly of the educated bourgeoisie. It was also one of the oddities of their interaction that communists in the Kulturbund, maintaining bourgeois form, addressed each other formally, whereas several communist and

bourgeois members—who, like Friedensburg and Heinrich Deiters, had
been students together—used informal address.[55]

The Kulturbund could produce open and controversial discussions,
put on experimental and avant-garde cultural events, and foster per-
sonal relations among its members of a sharp-tongued but cordial tone;
but all of this was only one side of the "culture" of the Kulturbund, and
indeed the one that hardly appeared publicly. Its projected and gener-
ally perceived political physiognomy looked different. The Kulturbund
was an organization that represented traditional culture—that is, non-
avant-garde bourgeois culture before 1933—where representatives of
the tradition set the scene and tone, and where the dissonances that
had defined pre-1933 culture were smoothed out in the interest of cul-
tivating the greatest possible harmony. As long as the trauma of the
Third Reich and its collapse fed the intelligentsia's need for harmony
and their disinclination toward renewed politicization, the Kulturbund's
gentle contemplative course for the most part suited precisely the wants
and needs of the intelligentsia.

And the first year did pass in peace and harmony. Even the political
conflict stirred up by the forced merger of the KPD and SPD, leading to
the first polarization of communists and anticommunists, did not im-
pact the Kulturbund. There were few SPD members in its ranks, and
the public considered the controversy over the merger solely a party af-
fair at the time. The atmosphere changed only after the Magistrat elec-
tions in October 1946—that is, after the independent SPD triumphed
over the SED. The administration of Greater Berlin set up by the Ul-
bricht Group in May 1945 was dissolved. Communists who had occu-
pied decisive positions up till then were replaced by social democrats. In
the department of Popular Education, the SPD's Siegfried Nestriepke
assumed the post held by Winzer. The SED did everything in its power
to keep the Social Democrats out. "You cannot desert your work,"
Winzer declared on October 22 in a meeting with colleagues. "No one
leaves his post voluntarily. We must find a way, using all our means, to
remain in the apparatus. . . . We must now undertake all measures to
prevent our people from being thrown out."[56] Becher adopted a more
courteous stance. Before a selected circle of Russian journalists, he re-
marked self-critically about the election defeat: "The SED is known ev-
erywhere as the party of Quislings, as the party of the Soviet occupying
power. It is not right for the *Tägliche Rundschau* to cover up the SED's
blunders. It prevents the SED from practicing self-criticism, and it cre-
ates the impression that the SED and the occupying power are one and

the same. The occupying power must not orient itself to one party. That would be too risky. The occupying power must not identify itself with the defeats and blunders of a party. It will lose all possibility of maneuvering if it supports only the SED. We have to work together with the Social Democrats, there is no other way."[57] But the Social Democrats, who had toiled in vain during the one and a half years of the communist power monopoly, now came out more vigorously and "revanchist" against their former tormentors than was politically necessary. Friedensburg, a disinterested observer of this confrontation, thought the SPD was following "to some degree in the steps of their predecessors with their 48% majority . . . and is succumbing to certain totalizing cravings."[58]

The Kulturbund registered the new climate in the form of the SPD's sudden interest in its activities, members, and organization. Since Gustav Dahrendorf, one of the founding members, had moved to Hamburg, not a single distinguished representative of the SPD had joined the Kulturbund. So the organization was now criticized for lacking a legitimate democratic basis; that is, its failure to hold elections had resulted in the SED's excessive (and the SPD's lack of) influence on the organization. A change in power comparable to the shake-up of the municipal government was called for. Friedensburg and Becher, of one mind in this matter, replied that the board had never been conceived of as democratically representative, but was oriented to models like the Council of Immortals of the Académie Française. At the same time, they had to admit that the board, "with a few laudable exceptions, has not shown such a great spirit of reform that we might perhaps imagine that our work is so splendid it could not be done better some other way."[59] Demands for democratic legitimation could not be ignored, and elections were scheduled. They took place as part of the First Federal Congress on May 20–21, 1947. Social Democratic hopes for a political landslide like the margin in the Magistrat elections were disappointed. The board expanded to thirty members, none of whom were members of the SPD. As before, communist and bourgeois members dominated, for the simple reason that there were almost no organized SPD adherents in the Kulturbund's membership. This was not the result of a systematic policy of scaring off and excluding SPD members; the underlying reason for the lack of Social Democrats was likely that the SPD was not a party of intellectuals. After its betrayal of the 1918 revolution, the SPD had become a party of functionaries. Since 1919, rebellious bourgeois intellectuals rejecting their own class and seeking a new political home

had turned to the KPD, which through no effort of its own—and despite the animosity toward intellectuals soon rampant there—became the party of the intellectuals. A curious alignment of antipathies and sympathies among party functionaries and intellectuals developed across party lines. Despite all political enmity, an SPD functionary like Nestriepke, who had only scorn for the (in his view) fictitious nonpartisanship of the Kulturbund ("I do not value very highly people who are only nonpartisan. I prefer an avowed party man"),[60] was closer to an uninspired KPD functionary like Ulbricht than to Becher, an intellectual of his own party. And Becher connected better with the bourgeois Friedensburg than with the apparatchiks of his own party. The real front, not adhering to party allegiances, established itself between those seeking to subordinate politics to culture and those seeking to subordinate culture to politics.

After the board election, the SPD still made sporadic attempts to gain control of the Kulturbund on the district level. The most resolute attempt was undertaken in Wilmersdorf, the unit with the largest membership and greatest number of prominent figures and activities. After the election, several prominent Social Democrats joined the group and briskly took action against the district. This culminated in July 1947 with a vote of no confidence against the chairman, Hans Schomburgk, a famous explorer. An independent figure like Friedensburg, Schomburgk professed no party affiliation and belonged to the Kulturbund's bourgeois majority of dignitaries. There were fierce disputes between SPD and SED adherents at the meeting, in the course of which the writer and SED member Alexander von Stenbock-Fermor struck an SPD representative when the latter remarked: "In a discussion of human dignity and freedom, an SED speaker has no say."[61] The Wilmersdorf fistfight represents only one of numerous dissonances in the course of 1947 jolting the Kulturbund out of its peaceful meditation. As the political polarization spread across the city, assurances from its communist organizers that they were acting not as party communists but as critical humanists allied to the Kulturbund's goals met with skepticism. Walther Karsch, a critical observer of the Kulturbund since fall 1945, now considered it nothing more than a front for the SED for the purpose of winning over, manipulating, and infiltrating noncommunist circles. Forces were at work, he wrote in a lengthy article a few days after the Kulturbund's congress and board elections, that sought to "make up for the defeat in the political realm [the elections] by securing and (if must be) conquering all those positions from which it would be possible to align

intellectual currents with their own, or at least—in the truest sense of the word—not let them be crossed."[62]

Karsch and the Social Democratic critics of the Kulturbund were not wrong. Internal communications reveal what was behind the much-vaunted nonpartisanship. A memo from Willmann on relations with the SED reads:

> We find it only natural that the Kulturbund should collaborate particularly closely with the SED; this party is after all the bearer of progressive, liberal ideas. Within the specific spheres of both organizations' work, all issues will be discussed and carried out jointly, and in most district groups, the director or secretary is active as a functionary in the SED. Messrs. Otto Winzer and Anton Ackermann provide a connection between the board and the SED central committee and ensure a common tact in approaching political aims. . . . We will maintain all connections to the other parties as well, since we have set ourselves the task of gathering all democratic forces. Of course internal ties there are rare, with the exception of a few district groups whose leadership includes members of the CDU and LDP.[63]

Karsch himself, as copublisher of a newspaper that labeled itself independent and nonpartisan but was an American licensed and controlled mouthpiece, launched his attacks from the precarious position of his own partisanship and dependence. This hypocritical casting of stones came increasingly to characterize each of the confrontations that occurred as the political polarization increased.

Of course in 1945 the KPD had its specific intent in establishing the Kulturbund. But intentions are one thing, and existing conditions and subsequent developments are another. From the beginning, the Kulturbund developed a unique dynamic, which in many respects was "nonpartisan" and evaded the control of the KPD/SED. For a time it became a generally accepted authority in the broad field of "moral" culture, as the Kammer der Kunstschaffenden had been in more specific cultural matters. And just as the Kammer der Kunstschaffenden gradually lost its footing and justification when other cultural institutions were founded, political developments after 1946 began to undercut the Kulturbund's political and moral premises and legitimation. It could no longer claim to unify moral and political culture in the face of a clear segregation of communist and anticommunist moral politics and moral culture. The Berlin intelligentsia considered these developments from their own point of view. During the communist monopoly of political power in Berlin in 1945–46, many had seen in the Kulturbund the greatest chance for a *relative* degree of independence and nonpartisanship. Now that the SPD

election victory had broken that monopoly and crystallized as an alternative to communism, they shifted their hopes in this direction, especially once this alternative soon found the same generous support from the Americans as the KPD/SED had previously from the Russians.

The Kulturbund's bourgeois members began withdrawing in the first months after the Magistrat elections. Soon afterward two of them— the art historian and copublisher of the *Tagesspiegel* (and later the first rector of the Free University) Edwin Redslob, and the Humboldt University professor of Slavic studies Max Vasmer—created the Society for the Friends of the Natural Sciences and Humanities in Berlin-Wannsee, that is, in the American sector. This new organization was given little publicity and elicited little public interest. There was no mention of the Kulturbund as a possible motivation, or of the society as an alternative to it. The separation was the silent expression of a difference of opinions, as faint and imperceptible as Redslob and Vasmer's participation in the Kulturbund had been until then. Friedensburg, whose social position and outlook would have predestined him to membership in the new organization, remained in the Kulturbund. He remarked at a board meeting that "he was initially a little concerned, but in his opinion such concern was unnecessary. In refusing every political objective that organization marks itself as completely different from ours. We are engaged in a political struggle, they are a social club."[64] But Friedensburg was not as unconcerned as he appeared. A few days earlier he cautioned against ignoring the ever louder critique of the Kulturbund's irksome involvement with the SED. ("We will have to make a great effort and use a great deal of caution and selflessness to overcome this criticism, by recognizing the tensions in their mutual justification and reconciling them.")[65]

Western occupation authorities, in the first year of the Kulturbund's existence, did not object to its activities; in fact, its program of democratic revival corresponded exactly to ideas (especially the Americans' plans) for reeducating the German people. Even in 1947, the Kulturbund's lectures and events organized or assisted by the Americans, English, and French still outweighed Russian involvement.[66] The only thing arousing distrust at this time, particularly in the eyes of the Americans, was the excessive leniency the Kulturbund practiced in dealing with politically and morally tainted figures like Gerhart Hauptmann and Wilhelm Furtwängler. The organization's communist leadership, as long as

the KPD/SED was part of the political mainstream, was even less objectionable given that a number of American intellectuals serving as cultural officers were liberal-minded men of the New Deal who considered communists the most courageous and active of antifascists. This stance, too, began to change in the course of 1946. The New Deal generation of cultural officers was demobilized and sent back to America. New officers, selected according to different political criteria and marked by the Cold War atmosphere already advancing back home, took their places. Despite this gradual change in climate, the Kulturbund was still regarded with cautious reservation. Its bourgeois-communist mélange proved a ticklish problem; in antagonizing the communists, the Americans risked losing the leading bourgeois figures they hoped to ultimately win over to their side. A man like Friedensburg, an internal American memo stated, was "very precious . . . because the presence of this strong personality within the Kulturbund is very expedient to confirm the impression that the Kulturbund is a politically neutral organization."[67] This was nothing other than a paraphrase of the difficulty any American anti-Kulturbund policy faced. The British officer in charge also assumed that the Kulturbund was "a communist dominated organization" but did not advocate ignoring, isolating, or disbanding it, rather of turning the tables and using it as a means for the West to exert its influence: "It might well provide one of those points where we can meet communism in Germany and make some real effort towards infiltrating into German communism what we consider democratic ideas. I always feel that to do this rather than blankly oppose communism is the right British answer to the German communist move and I am quite convinced from experience that there is a large body of German communists who only belong to the SED because it is the most left-wing party, and would in fact, with a little education, be very much closer to the ideals of British democracy than to Marxism."[68] Friedensburg had similar ideas, but his hopes of influence from within the Kulturbund were ultimately as ineffective as those of the Western powers. ("Until now I fancied opposing the possible influence of our communist colleagues, insofar as communist ideology appears at all, of at least having a chance at the same effectiveness on the other side. . . . Of course the fear of communist influence on other segments of the population is very widespread in Germany. But it corresponds to a bourgeois inferiority complex, of which I am completely free.")[69]

Before 1947 came to a close, the Kulturbund had to cease its activities in the British and American sectors and vacate Schlüterstrasse. What

SED propaganda and later East German historiography termed the *Verbot* (ban) on the Kulturbund was the result of a complicated process desired and staged not only by the two Western powers.[70] The ban was a lesson taught by the Americans and English, but also by the Russians. Of course their political motives for this varied, but their actions were synchronized in a manner akin to an image coined by Alfred Kantorowicz at the time: the smooth coordination of a pair of parted scissor blades about to snap together and tear to pieces whatever is between them.

The ban followed Allied command order BK/o (47)16 to the letter. Issued in January 1947, it stated that political organizations in each of the four sectors of Greater Berlin had to be individually approved. The purpose, of course, was for the four powers to keep all political activity in their respective spheres under their control. Excluded from the regulation were political parties and unions licensed by the Russians before the Western Allies had arrived. How the order impacted the Kulturbund, which was neither a party nor a union, was soon the subject of divergent interpretations. The Americans considered it a political organization and argued that a license should be applied for in the American sector. The Russians declared it a cultural organization, insisting that according to Allied Order no. 1 (regarding the assumption of the Russian decrees issued in May and June 1945 by the Western Allies), the license of June 25, 1945, was still valid for the whole of Berlin. The Kulturbund itself was ready to file the petition demanded by the Americans, but had already applied for a quadripartite license the year before, in May 1946. At the time, without indicating their reasons, the Americans and British had refused their formal permission, but declared themselves willing to silently tolerate the Kulturbund in their sectors.[71]

In 1947, the Kulturbund found itself in a dilemma. If it filed for a license as the Western powers demanded, it offended the Russians, who had made it clear that this issue was a matter of prestige for them. Not filing a petition meant that after November 1, 1947, the deadline set by the Americans, the Kulturbund would no longer be considered legal in the American and British sectors. In Becher's words, it was "an international conflict in which we Germans have no chance of intervening."[72] Nevertheless, efforts to intervene were undertaken, most vigorously by Friedensburg. In talks with the Americans and Russians (Howley and Tulpanov) he sounded out their intentions. Certain that no one was concerned with the Kulturbund's well-being or even survival, Friedensburg tried to win time by turning the decision back on the Allies through what

a British cultural officer termed "an ingenious tactical move."[73] In a letter written two days before the American ultimatum expired, Friedensburg declared the Kulturbund's neutrality in this matter: since the Allies "represent diverging views with respect to its legal status, the board [of the Kulturbund] does not see itself in a position to reach a final decision in this matter and must leave it to the Allied command. To this end, the Berlin board asks the Allied command to reach a unified decision very soon, so that the Kulturbund can continue its activities in the Berlin area as it has until now."[74]

The letter was written on October 30 and passed on to headquarters along the usual official channels—that is, through the office of the SPD mayor, Luise Schröder. Two weeks passed before it arrived. The deadline of November 1 had expired, and the ban on activities in the American sector came into effect at midnight. The British authorities followed suit on November 12. (In the French sector the Kulturbund remained legal.) It is possible that the American-British ban resulted from the delayed delivery of Friedensburg's letter, perhaps deliberately caused by an SPD functionary in the Magistrat unsympathetic to the Kulturbund. But the letter could not have secured more than a temporary postponement anyway. The Americans' resolve at this time to end the problem of the Kulturbund in their sector was evident from their inquiries in a few district groups, where they assumed that noncommunist majorities were to be found or could be created. The director of the Neukölln group, a member of the SPD, was asked "why he did not himself register the Kulturbund and file for a license. It could do no damage at all if a decentralization were to take place here. The petition would probably have been approved immediately."[75]

For completely different reasons, the Western ban on the Kulturbund was not unwelcome to the Russians. In the heightening Cold War atmosphere, the Western powers' ban on the Kulturbund must, in terms of propaganda, have seemed more valuable to them than the organization itself was. Friedensburg noted from a conversation with Tulpanov that the latter had said, "The current situation is perhaps not at all so damaging. The Kulturbund developed with complete success, and with this incident the world public will wake up to the undemocratic behavior of the Western powers."[76] From the very beginning, despite all material and moral support, the Russians had had reservations about what they considered the Kulturbund's elitist structure. In September 1946, the head of the SMAD cultural division, Alexander Dymschitz, stated to a control commission of the party's central committee arrived

from Moscow: "The Kulturbund is not an organization concerned with mass political work. We have many differences of opinion with Becher" making it necessary "to radically improve the work of the Kulturbund, which has not become a mass organization, nor clearly defined its position as an SED organization."[77] Tulpanov, Dymschitz's boss, was even clearer with respect to Becher:

> We have now arrived at the firm conviction that Becher must be replaced. It is impossible to bear him any longer. For some time I have opposed this and we have had serious misgivings, but now . . . with the political struggle intensifying, the Kulturbund cannot simply be transformed into a mishmash of the entire intelligentsia. . . . In all of his intellectual views Becher is not a Marxist, but is directly oriented toward England and America, toward Western European democracy. He is embarrassed to say that he is a member of the SED Central Committee. He conceals it in every imaginable way. He does not even allow us to call him comrade but insists on "Herr Becher," and he fears any strong confrontation within the Kulturbund. . . . He approaches party work with disgust. . . . He is accommodating, never on the offensive; still, he is more familiar with the psyche of the German intellectual than we are.[78]

But the Russians' criticism of Becher was not unanimous. Two months after Dymschitz's and Tulpanov's accusations, a thorough evaluation of Becher's performance was made by Vladimir Semjonov, the head of the political division of the SMAD, a representative of the Foreign Ministry in the Soviet Zone and adherent of a different party faction in Moscow than Tulpanov. Semjonov found Becher to be "under a certain influence of bourgeois-thinking intellectuals," but also found that "subjectively Becher is on our side and openly pursues, from his standpoint, the best methods for our work in Germany. Removing Becher from the Kulturbund is not advisable at this time."[79] Divergent judgments of Becher and the Kulturbund, like the divergent political lines of Soviet policy on Germany, had their source in the competing groups in the Moscow party and its mesh of interests, aptly termed "cryptopolitics" (Borck). Plans and intrigues launched in the Politburo and the Central Committee in Moscow were faithfully reflected in the SMAD, its personnel, its attitudes, and its practices.[80]

If the Russians' actually intended to provoke the American-British ban on the Kulturbund and make propagandistic use of it, they could boast short-term success. The ban reunited the various groups and figures within the Kulturbund that had already begun to drift apart. A large protest meeting was held. Friedensburg, Ernst Lemmer, Günther Birkenfeld, and Gert H. Theunissen, who had all frequently expressed

their discontent with the organization's political tendency before, now put aside reproaches and showed solidarity with their organization and its communist leading trio. But this unity did not last long, and it ended in bitter disappointment—even in the leadership—over the Russians' behavior. Both bourgeois and communist members had expected something else from the protective power supposedly so sympathetic to their cause. Herbert Sandberg, the communist artist and caricaturist, thought "the Soviet command must be persuaded that filing a petition is technically correct, especially since Colonel Howley will presumably grant his approval."[81] The bourgeois art historian Adolf Behne remarked: "We have found so much understanding from the Russians that we can hope they will also do us the service of ending American intrigues and for our sake not oppose the petition simply in order to oust the Americans." Friedensburg added: "This behavior [the Russians' negative attitude] cannot be reconciled to our friendly relations up to now if it is their purpose to help the Kulturbund build on the foundations they have given us."

After this episode, the Kulturbund faced the unpleasant reality of no longer being recognized and supported as an important cultural institution but used as a pawn on the chessboard of the East-West conflict. The solidarity against the ban was the final, short-lived unity the Kulturbund mustered before dissolving the following year. It suffered the same division that gripped the city in 1947 and was completed in 1948 with the currency reform, the blockade, and the split of the Magistrat. Its bourgeois members, insofar as they did not decide in favor of the Eastern side, kept silently apart from its activities and retreated into private and professional life. Many left Berlin and headed for western Germany. Some of those who stayed and wanted to continue their political activities settled in the Eastern "camp," as it was thereafter called, others in the Western camp. These were migrations in a literal geographic sense. The period when artists and intellectuals traditionally lived in the Western districts of Berlin and worked in Berlin-Mitte was over. Members of the Eastern camp living in Wilmersdorf or Dahlem now moved to Pankow, Niederschönhausen, or Treptow. As a rule, those who switched over to the Western camp kept their residences. Half a year after the Kulturbund was banned and moved from Schlüterstrasse to Jägerstrasse in the Russian sector, a "Free Kulturbund" was established in the American sector. Its founders included the former board members Birkenfeld, Redslob, and Theunissen, and a former opponent of the Kulturbund, Walther Karsch. Unlike the original Kulturbund three

years earlier, the new organization (soon renamed the League for In-
tellectual Freedom) could not pull in big names from Berlin's artistic
and intellectual life. The list of its founding members reads like a who's
who of the mediocrity that would dominate the next twenty years of
provincial West Berlin culture: Fritz Äckerle, Werner Hadank, Karla
Höcker, Hanns Korngiebel, Siegfried Nestriepke, Josef Rufer, Karl Lud-
wig Skutsch, Joachim Tibertius, Friedrich Weigelt. Birkenfeld, for whom
such company was probably too shabby from the very start, had to
wait two years before a more resplendent intellectual forum for anti-
communism turned up. In 1950, he became the head of the Berlin of-
fice of the Congress for Cultural Freedom, an international association
(supported in later years by the American CIA) that set about organiz-
ing the anticommunist intelligentsia with the methods it had gleaned
from the Kulturbund and the communist congresses of the 1930s.

And as for the old Kulturbund? It went the way of all organizations
that had been founded with such hope in 1945 and ended up *gleich-
geschaltete* shadows of themselves with the Stalinization of the GDR.
The fates of some people caught up in this process suggest that it was
not carried out as smoothly and easily as it was regarded by the West
during the Cold War and is sometimes presented still today.

Among the noncommunists, Ferdinand Friedensburg fought most
persistently to defend the original conception of nonpartisanship against
political polarization. He wanted nothing to do with the Free Kultur-
bund. He repeatedly sought dialogue with the Americans to revoke the
ban of November 1947, not knowing, or deliberately ignoring, the fact
that the contra-Kulturbund was "an American baby,"[82] as an English
officer put it. At the same time, he adopted a stance within the Kul-
turbund against its increasing political orientation toward the East. Of-
ficial statements made by Willmann and Gysi in the name of the Kul-
turbund were, in Friedensburg's opinion, excessively marked "by the
vocabulary of political confrontation." He accorded the growing num-
ber of resignations from the board "a certain justification" and asked
"whether the Kulturbund had not been unsteadied by the departure of
the aforementioned men and women."[83] Such critical and self-critical
tones were perhaps typical of the board in the past, but six weeks af-
ter this statement Friedensburg discovered that the one-sidedness was
more advanced than he had assumed. On September 14, 1948, the Kul-
turbund expelled him for "anti-Soviet statements" supposedly made in
a public speech. Surprised by this move, Friedensburg declared indig-

nantly to Becher that the expulsion took place "in violation of the basic rules of any sailing club."[84] As a member of the board elected by the delegate assembly of the Federal Congress, Friedensburg could not be simply shut out. In fact, the initiative for his expulsion seems to have come not from the board but from the chapter of Greater Berlin, which had meanwhile become dominated by communists. The board was presented with a fait accompli; the Kulturbund's Greater Berlin chapter had made its decision without consulting the press at all. It is known that at least one member of the board (Krummacher) protested[85]—not publicly, but behind the scenes, ineffectually and finally cowardly, as would become the rule from now on. Friedensburg, the last of the noncommunist founding members of the Kulturbund, had to recognize that the period of relative openness and gentlemen's club rules was over.*

Recent studies offer two views of how the Kulturbund's communist initiators judged its course. The first, assuming that the Kulturbund was an unambiguously communist camouflage organization, grants Becher and his circle a certain disappointment because their plans—to win over "useful idiots"—failed. But this was supposedly only a tactical failure, after which the communists could proceed with the agenda they had always had in mind: the socialist-Stalinist *Gleichschaltung* of the GDR. David Pike has recently represented this argument in detail. He does give Becher credit for not being an enthusiastic advocate of Stalinism, of perhaps returning to Germany in 1945 with the goal of creating something other than what he and his comrades had witnessed in Russia in the 1930s. However, such hopes, if they existed at all, were from the very start as illusory as the underlying premise "that a new Germany could be built upon the basic principles of Marxism-Leninism, be inextricably linked to the Soviet Union, bow down to Stalin, and never engage in patterns of repression even remotely comparable with their experience in Soviet exile."[86] Accordingly, Pike judges the Kulturbund a

*One could imagine an anthology of "farewell letters"—the written pages with which the men who had until then worked jointly, and who from then on found themselves on opposite sides of the front, took leave of each other in 1948. Becher was the recipient and author of such letters many times over. For example, Kulturbund member Rudolf Pechel, publisher of *Deutsche Rundschau*, wrote on July 26, 1948: "I now consider it hopeless that in present-day Berlin intellectuals can still find a common ground that preserves some final bind. . . . I will tell you openly that it is painful and disappointing to find the community that existed during the Hitler years destroyed. But I can change nothing, and now I can only step down. . . . Let me hope that despite everything at least we both can maintain a feeling of human connection." Bundesarchiv Koblenz, Estate of R. Pechel II, vol. 1.

contradiction in itself: "The very notion of a genuine non-partisan or-
ganization sponsored and overseen by a Marxist-Leninist party . . . was
patently absurd."[87]

The contrary view, most recently argued by Gerd Dietrich,[88] sees in
the Kulturbund a genuine attempt, not merely a tactical party move, by
communists to create a forum for a "dialogue of dissidents."[89] Though
thwarted by the Cold War and the politics of the SED and SMAD, it
was a serious attempt whose failure represented a genuine defeat for its
founders, especially Becher.

Both views have their logic, and once again the truth falls unimagi-
natively somewhere in between. Becher surely did not hope to make
Germany a Soviet satellite state, as Pike thinks, but rather, being the
cross between nationalist-patriot and communist that he was, had ideas
of German-Russian relations that approached Friedensburg's "Rapallo"
mentality, or the version of the "German path to socialism" his com-
rade Ackermann proposed in 1946. German communists who had wit-
nessed the Stalin terror of the 1930s had every reason after their return
to Germany to secretly infuse the party's official popular-front direc-
tives with a different meaning and purpose. The Popular Front, as Ul-
bricht and his circle understood it (and as it actually operated), was
meant to encourage submission to Stalinism. The cultural popular front
attempted by Becher and his circle, initiated and organized by party in-
tellectuals who sought out the help of bourgeois partners, was more of
a popular front against Stalinism, trying to overturn the patterns of the
1930s and keep their own apparatus in check and Moscow at a safe
distance.[90] On the other hand, party intellectuals like Becher were them-
selves too deep in the party, too mixed up in its apparatus and psy-
chology, to be consciously and consistently capable of such a policy.
They could manage only momentary emotional longings for insurrec-
tion. Becher, who had alternated between rebellion and self-discipline,
accepted the responsibility of the Kulturbund in 1945 to serve his party,
but also to satisfy certain tendencies toward independence from this
power base. While the balance between his striving for independence
and his party superego lasted—for the two to three years of the open
political situation in Berlin—it functioned brilliantly. They were produc-
tive, energetic, and happy years for Becher, as exhilarating as his Ex-
pressionist youth and his conversion to communism after World War I.
He had the pleasure of playing two different roles, without either au-
dience being fully aware of the duplicity. To the party, he was a some-
what mysterious liaison to the bourgeois camp. In the bourgeois camp,

he was surrounded by the aura of a man who belonged to the new power elite. Becher would have been the last person to end this dream-like state, because he would have been the first to lose by it. The end came from behind his back, from above, against his will—and after a predictable self-subjugation to the party. He did not lift a finger as Friedensburg's case was decided. As always in such situations (like earlier in Moscow, and later in the Harich and Janka cases), he simply absented himself for reasons presumably related to his experience in Moscow in the 1930s: "fear and cowardice" (Pike).[91]

But rebellion followed this acquiescence as well, or resulted from it, according to his familiar cycle. A few weeks after the American ban on the Kulturbund (for which, in Becher's opinion, the Russians were also guilty because of their obstinate attitude) he stated: "The character of nonpartisanship in the Kulturbund was not always carried out as we understood it."[92] Nor was his own party innocent. Becher felt it had abandoned, if not betrayed, him, its interference and bungling destroying the carefully created nonpartisan ranks. This of course could not be said openly, for fear of suggesting that Becher was more interested in "his" Kulturbund than in party politics. An emotional outburst a few weeks later showed that he had only temporarily suppressed his anger. His vehemence, out of all proportion with the actual occasion (the supposed discrimination against the Kulturbund when the German Popular Congress was formed), points to his reserves of anger. Becher's letter to the party leadership was a settling of accounts in the broadest terms: "The recent behavior toward the Kulturbund seems to me no accidental oversight. Many similar instances could be mentioned that in my opinion reveal a considerable underestimation, on the side of the leading comrades of intellectual work, viz. an undue arrogance of leading comrades toward comrades working in the cultural sphere."[93] Even party intellectuals more hard-boiled than Becher suffered from their treatment at the hands of the party. Unlike Becher, his collaborator Alexander Abusch had emigrated to the West and returned to later become one of the most smoothly functioning wheels in the Stalinized cultural bureaucracy of the GDR. He noted down the following remarks for a report he was to deliver in early 1948 before the Ideological Commission of the SED:

> The comrades in charge of the Kulturbund have long had the feeling that we do not receive sufficient feedback on our work from the party because the general political significance of our work is underestimated. . . . This work is considered *unpolitical* or the *musings* of a few intellectuals in the party. . . .

Some strains of the anti-intellectualism in the German workers' movement
are clearly still at work here, contrary to all Latin countries, CSR, Yugo-
slavia, etc. The party shies away from esteeming and promoting leading in-
tellectuals in accordance with their specific value. . . . The Kulturbund is
responsible for helping to foster the atmosphere and openness necessary to
create intellectual resources for the party. But given the tendencies indicated
above, the party does not have the ideological attractiveness it needs for
these classes. It does not have the ideological offensive power right now to
approach issues like the *Freedom of Personality,* the *Concept of Freedom* as
a historical concept, existentialist philosophy, etc., as a *general German* dis-
cussion, as a large-scale, visible, and offensive confrontation in the Western
zones, in Berlin, and last but not least (make no mistake) in the Eastern
zone as well [emphasis in original].[94]

The intellectuals' scolding directed at their party seems not to have
fallen on deaf ears. On February 11, 1948, a resolution from the party
leadership labeled "Intellectuals and Party" pointed to "very serious
deficiencies, mistakes, and neglect in the work of the party itself," and
with respect to the Kulturbund promised "to safeguard under all cir-
cumstances the nonpartisanship of the organization and resist all at-
tempts to make the Kulturbund into a mere appendage of the party
organization."[95] But none of this came to pass. On the contrary, as
Friedensburg's expulsion showed, the *Gleichschaltung* only increased
in tempo. It is perhaps a balancing irony that communist intellectuals
reproached by the West for treating their bourgeois colleagues in the
Kulturbund as "useful idiots" were treated in a similar manner by their
own party and, having served their purpose, were ultimately pushed
aside in the same way.

Radio

In May 1945 workers at the Psychological Warfare Division (PWD) in Bad Homburg responsible for monitoring foreign radio stations came across a station in Berlin whose programming, in light of the most recent military and political developments, puzzled them. On the frequency of the former Reichsrundfunk could be heard not only announcers familiar from years past, concerts of classical and folk (especially Slavic) music, and readings and radio plays by German authors, but also political commentaries that—as an internal PWD communication sheet stated on May 31 under the heading "The Bear Purrs"—gave the impression that "the Soviet Union is presented as a friend, and almost a defender, of all good Germans."[1] Surveys of the population in the American zone revealed that these broadcasts from Berlin did not fail to leave their mark:

> Although these reports are the result of limited investigation and do not contain much detailed evidence, they do indicate the beginnings of a sharp change in German attitude toward the Russians and the possibility that this new attitude may be regarded as a political weapon by the Germans. The difference between U.S. policy announcements and the conditions in the American zone contrast sharply with the announcements that have emanated from Soviet sources. The contrast of tone is even sharper: no Allied station has ever entitled its early-morning concert program "Let's Start the Day with a Gay Heart" or advised listeners that for greater pleasure "you should listen on your balcony amid flowers." It is quite natural that the

Germans should attempt to use these contrasts as a lever for manipulating
their relationships with occupying authorities in the U.S. zone.[2]

American worries about on-air fraternization were not unfounded. A
radio program, German and Russian in content and personnel, had been
created a few days after the German capitulation in the former Reichs-
rundfunk building on Masurenallee in the north of Charlottenburg.
This development had much to do with the building complex itself: de-
signed by Hans Poelzig and built in the early 1930s, the largest and most
modern facility of its kind in Europe, it had survived the final battle al-
most completely intact—for several reasons. The station was located
outside the heavily shelled city center; the German staff had sabotaged
the order to destroy it; and the Russians were careful to spare the com-
plex in their artillery fire.[3] The building also housed a large part of the
original staff. Only a few days lapsed before broadcasting resumed and
soon began disconcerting the Americans in Bad Homburg. The Russians
laid a temporary cable to provide a connection to the transmitter in
Tegel and provided technical assistance, but limited themselves to the
control of German-produced programs. The actual broadcasting work,
the programming, and the organization of the staff were in the hands of
two members of the Ulbricht Group.[4] Matthäus Klein, a former pastor
and soldier in the Wehrmacht, had become a member of the National
Committee for Free Germany while in a Russian POW camp; in this
capacity he had been brought to Berlin to win over bourgeois popular-
front sympathizers. The man responsible for the broadcasting was Hans
Mahle. At thirty-four, he was the second-youngest member (after Wolf-
gang Leonhard) of the Ulbricht Group and in no way the functionary
type to Ulbricht's liking, as Leonhard attested even after his break with
the party: "He could still laugh, be happy, enjoy the company of 'aver-
age people' and, apart from the party jargon, found words that testified
to his own thoughts and feelings. . . . He always reacted to events and
people spontaneously, and that's why he remained—within the given
sphere, of course—capable of his own initiative and ideas."[5] According
to Mahle's later account, the first phase of the rebuilding of Radio
Berlin was pure improvisation. There was no preparatory planning for
the station; the responsibility fell to Mahle when the existence of the
undamaged broadcast center was discovered. The Russians simply pro-
vided technical assistance and secured the building with a military guard.
Supposedly only several weeks after broadcasting resumed did Western
inquiries alert the political command in Karlshorst to the fact that a

German radio station was in operation, and only then did Russian control officers appear in the building.[6] The version offered from the American side based on interrogations of former employees at Radio Berlin and other "fairly reliable sources" seems more plausible. Apparently the station's management initially consisted of ten Russian officers and seven German communists. Leading positions "were filled from the German resistance movement." The Russians did not permit live broadcasts; even news reports had to be recorded beforehand. "All texts were subject to strict Soviet censorship."[7]

However strict or lenient Russian censorship might have been, the German communists seem to have been in charge of programming but not—with the exception of political news and commentaries—production. Twenty-year-old Markus Wolf (later the chief of the East German secret service), sent back to Berlin as a soldier in the Red Army and now a reporter at Mahle's station, was one of the exceptions. Fritz Erpenbeck, also in the station's management, involved himself in so many other activities that he had little time for any real work there. In May and June of 1945, Radio Berlin was not, as Mahle recalled years later, a completely new broadcasting creation conjured up by resistance fighters and communists. In fact, it was remarkably familiar, for not only the building but also its old staff had been taken over intact. "There are six of our men and one officer, and 600 of 'them,'" Markus Wolf reported to his parents in Moscow on June 4, regretting that "sifting out the chaff is possible only to a small degree, since many, really most, are needed."[8] However, it was not only a lack of the Russians' "own" suitable radio people that necessitated recourse to the old personnel. It is more likely that the station's programming was meant to find a middle path between the previous broadcasting patterns and established audience habits, and political and programmatic reforms. In their work with German war prisoners for the National Committee for Free Germany, Mahle and Klein had had sufficient opportunity to acquaint themselves with the psyche of the average German in the Third Reich and to develop adequate propagandistic techniques. They could now apply their experience directly at Radio Berlin, and the furrowed brows in the Psychological Warfare Division in Bad Homburg confirmed their success. The continuity of listener habits depended on popular programming and, above all, on voices grown long familiar to the radio audience. Only announcers directly identifiable with the Nazi system—like those who had announced military victories—were silenced. The rest—in fact, the entire station—now followed the new motto: Reeducate but Don't Intimidate.[9]

"In international relations possession—physical possession—is no less important than in common law. It was on this basis that the first round of the contest for control of Radio Berlin was concluded in favor of the Soviets."[10] Radio Berlin's fate after the Western Allies arrived in the summer of 1945 could not be stated more accurately and succinctly than in these two sentences from an internal study conducted by the American military government (OMGUS) five years later.

When the Americans and British arrived in Berlin in early July to take possession of their sectors, they had specific ideas about the rebuilding, organization, and control of Berlin's future mass media. The city ruled jointly by the victorious powers was supposed to have a harmonious publicized opinion, in order to prevent the Germans from judging their victors.[11] The situation that confronted them soon prompted a revision of their strategy; in the two preceding months the Russians had established three daily papers, and the other Allies now began to plan their own newspapers. But as far as radio was concerned, they held to their original idea: this was a medium that cut across all sector borders. The very logic of its technology not only predestined it for joint operation but actually demanded it. Immediately after their arrival in Berlin none of the Allied radio officers thought of making the Russians surrender the broadcast center to the English, in whose sector it lay. Even less so since the Russians, as they assured their allies in one of their first meetings,[12] also favored quadripartite control of this medium. To be sure, their motives in offering such cooperation were different than the Americans and English suspected. As the Russian radio officer formulated it a year later, the Russians knew full well that they "had no legal claim whatsoever on this broadcast center except that they were the first to march into Berlin."[13] Thoughtful tacticians that they were, they nevertheless tried to get the best out of the situation. Anticipating that the English would carry through with their claim, and ready to comply with it, the Russians had made preparations to set up a new station in their own sector, and to this end had already disassembled and removed technical equipment from the building on Masurenallee. But at the first sign that the opposing side had no thoughts of insisting on its legal right, they jumped at the chance. Their willingness to operate the station jointly followed the old Russian wisdom according to which exchanging an apple for a fruit garden benefits the owner of the apple.

Several months would pass before this dawned on the Western military governments. Assuming that a quadripartite station was only a matter of time, they declared themselves in agreement with a temporary

preservation of the status quo—that is, the Russians' control. Their only demand was that the Americans, the English, and (after their arrival in Berlin) the French each had the right to one hour of airtime every day.[14] The tables had been turned within two weeks. The presence of the Western powers, legally the masters of the broadcast center, was now merely tolerated, and their involvement, in terms of airtime, was peripheral. The Russians had been confirmed and recognized as the actual masters, and they did not hesitate to strike again while the iron was hot. Two weeks after the agreement over airtime was reached, the Russians interpreted it to the effect that all three Western powers received one *joint* hour of airtime daily. Once again the Western powers conceded, keeping their eyes on the larger goal. ("The subject of a quadripartite zonal station was considered more important and the chances of success in this direction might be prejudiced by simultaneous pressure for time on Radio Berlin.")[15] When the Russians finally pulled the bottom out from all Western expectations by declaring the building on Masurenallee the station for the entire Russian *zone* (just as Frankfurt, Hamburg, and Baden-Baden were the stations for the Western zones), accountable only to SMAD and not subordinate to headquarters in Berlin, it was too late for any Western intervention. Even hinting that the broadcast center lay in the British sector no longer had any effect. When in the first half of 1946 a British representative presented this argument in one of their fruitless discussions, his Russian counterpart reacted indignantly. The protocol noted: "Such an attitude, the Soviet delegate interjected, radically changed the substance of the question under discussion. One could draw the conclusion that the British authorities' intention was to force the Soviet Administration to abandon use of the studios. Such a decision would be just as rash and unbelievable as if, by decision of any commanding officer, entry to Berlin, situated in his zone, were prohibited!"[16]

For a year and a half, until late 1946, negotiations continued. After Leipzig Radio was set up, the Western powers thought they saw another opportunity. Indicating that the Russian zone now had use of a station comparable to those in the Western zones, they again claimed Berlin Radio for quadripartite control. The Russians were unmoved by this reminder. The Western powers were left to face what the English officer responsible for radio affairs (confirming what his Russian colleague had before presumed with well-acted indignation) stated at the end of the year: "Fact is that unless the Russians move out voluntarily . . . nothing short of violence will eject them."[17]

As hopeless as it seemed, the English and Americans were not quite at the mercy of the Russians' refusal. While negotiations were in progress, they tended to their own interests. An American station went on the air in February 1946 and an English station (an extension of the NWDR zonal Radio in Hamburg) in August. The technical capacity of the American DIAS (Drahtfunk in the American Sector) was of lesser quality. It reached households only by telephone connections (hence the name Drahtfunk, meaning "wired"), and this was only a fraction of the 170,000 radios registered in the American sector. Its seven hours of daily programming was modest in comparison to Radio Berlin's nineteen hours of airtime. Yet DIAS fulfilled its purpose, really a double one. The first round lost, the station was supposed to strengthen (or simply generate) the Americans' negotiating position. DIAS was originally intended to cease its operation as soon as a quadripartite radio was created. At the same time, in the event that no agreement was reached, DIAS could be developed into a permanent broadcasting alternative. From the very beginning, especially among the English, there were skeptics who considered the idea of a quadripartite control of radio unrealizable.[18] They saw as a goal what the advocates of quadripartite radio took to be the means to an end. The Russians had now resolved not to trade back their unexpected booty for uncertain compensation, and the attempt at a unified and jointly operated Radio Berlin did end in three Berlin radio stations. The Americans began to develop their station into one of equal capacity. Half a year after DIAS was set up, all-day programming was established, broadcasting converted from wired to wireless, and the name changed to RIAS (Radio in the American Sector).

In the Cold War period, RIAS would become a landmark in Western anticommunist propaganda. In the first two years of operation, though, there were no signs of such tendencies. Whoever assumed that the American station, created as a counterpoint to Russian-controlled Radio Berlin, would now exclusively represent the American position was mistaken. Until 1947–48, RIAS kept above the increasing political polarization. In distinction to the Western-licensed newspapers (*Tagesspiegel, Telegraf*), which offered themselves as a journalistic forum for the anticommunist movement developing under the leadership of the SPD, RIAS consistently, almost fussily, pursued the "old" policy of Allied harmony— which the new pro-Western stance might easily perceive as communist-friendly, procommunist, or communist. As adherents of the old and new policies were equally represented in American Information Control, it

is not surprising that RIAS became the battleground and object of their confrontation.

DIAS had barely begun operating when the first clash occurred. It was the winter and spring of 1946, the weeks when the controversy over the merger of the SPD and KPD arose. Anti-merger circles within the SPD issued the demand that DIAS provide a journalistic venue for their cause as the dissident voice to procommunist Radio Berlin.* Some members of OMGUS with ties to the SPD, like Ralph Brown in the Political Division, supported such partisanship. ("His opinion was that the radio odds are so terrifically weighted against the SPD by Radio Berlin that, if the Drahtfunk were to be fair and provide equal time for both parties, the anti-merger position in the campaign would not be advanced. He suggested that the Drahtfunk indicate in its handling of speeches that since Radio Berlin projects the case for the merger, the Drahtfunk presents the anti-merger case.")[19] Information Control and RIAS decided to remain impartial: "Such handling would be detrimental to our long term aims, that it is not worth the risk of a short term fight on this issue . . . for the Drahtfunk to depart from its announced intention of factual, fair, and objective treatment of the news." Thus Ulbricht, Pieck, and Grotewohl—like their less prominent opponents in the independent SPD—all had their say in RIAS. After the forced merger, the nonpartisan policy was maintained, as in the regular discussion program "Parties at the Round Table." Debates in the Municipal Council, which Radio Berlin carried only in excerpts, were broadcast live by RIAS. Its cultural programming was as open as that of the early Kulturbund, with which RIAS frequently collaborated. Concerts of contemporary music organized by Hans-Heinz Stuckenschmidt, an employee

*There were few doubts about Radio Berlin's pro-KPD/SED tendencies in the spring of 1946. The connection was only all too apparent once the station was made subordinate to the KPD-dominated Central Administration for Popular Culture in the fall of 1945. The speed and rigor with which the KPD used the station for its own ends is evident in a document ("strictly confidential") from the head of the radio division in the Central Administration, Wilhelm Girnus, addressed to a Dr. Weigt at Radio Berlin and dated February 1, 1946, which reads: "I had a very important discussion with those in charge concerning the *Tagesspiegel*. The destructive activity of this mouthpiece must be forcefully and strongly repelled. I therefore ask you to arrange it that, in a daily program, the station take a position on this issue in the most pointed way. We will protect you in every regard, and the stance to be immediately adopted is this." What follows is a characterization of the American-licensed newspaper as "reactionary," "fascist," "an unjustified existence," and so forth. The letter closes with the line: "We ask the editorial staff of the press division at the station to carry out this order as expediently as possible and establish an ongoing campaign in this matter." Bundesarchiv Potsdam, R2/629.

at RIAS and member of the Kulturbund, were broadcast and in part financed by the station. Studio discussions like the live "Round Table" series brought together intellectuals who no longer shared space in Berlin's other media, from Walther Karsch and Erik Reger to Johannes R. Becher and Friedrich Wolf. There were programs on modern and contemporary literature and art, and shows commemorating historical events, like the anniversary of the murder of Rosa Luxemburg and Karl Liebknecht. Compared with Radio Berlin, the programming at RIAS was not only politically more neutral, open, and independent, but also culturally more innovative and demanding—in other words, more elite and intellectual.[20]

The *Indendant* at RIAS in charge of programming was Franz Wallner-Basté. Forty-two years old at the end of the war, he had headed the Council of the Arts in Zehlendorf and had made his mark by organizing open-air concerts by the Berlin Philharmonic before the Americans engaged him in December 1945 for this new assignment. On the American "white" list—that is, among the group of "uncompromised" Germans qualified for responsible positions—he had arrived on the recommendation of a former Berlin colleague, the screenwriter John Kafka, whom he had helped emigrate to America. In the 1920s, Wallner-Basté had been a music, theater, and literature critic for several Berlin newspapers and, in the last years before the Third Reich, head of the literature division for Southwest German Radio in Frankfurt am Main. After he lost his position in the summer of 1933, he earned his keep as a translator and screenwriter. His colleagues at RIAS remember him as an aesthete, liberal minded and highly educated, but without much talent in organization and leadership.[21] Wallner-Basté was also a passionate amateur photographer, and the albums he left behind are notable for the number of attractive young women who always seemed to surround him. Was it a coincidence that even at RIAS the circle of his closest collaborators consisted mostly of women? RIAS was called "Frauenfunk" (women's radio) in the jargon of Berlin's radio trade because women assumed a disproportionate number of the leading positions there: Ruth Gambke (Director of Programming), Elsa Schiller (Music Division), von Gleis (Literature Division), Engelbrecht (Women's Programs), Regler-Bahr (Youth Programs), and the most important of all: Ruth Norden, the American director ("Chief of Station"). Some of them were certainly more bluestockings than the "sweet girls" of Wallner-Basté's private circle in the 1920s. Ruth Gambke, who had been in charge of programming at Central German Radio in Leipzig before

1933[22] and possessed greater organizational and leadership talent than Wallner-Basté, displayed a managerlike severity even in the most courteous interaction and would be "the ideal of a program director even today" (Wolfgang Geiseler). She was apparently accepted and respected on all fronts as an emancipated professional in her field. Not only had she the full trust of Ruth Norden, but she was, at least in the eyes of Franz Wallner-Basté, her confidante.

Ruth Norden was thirty-nine years old when she arrived in Berlin in late 1945. Of German descent but born in London, she was not one of the émigrés in the American military administration. She knew Berlin from the pre-Nazi period, when she worked as an assistant to Hans Rothe, dramaturge at the Deutsches Theater, and later at S. Fischer Verlag under the direction of Peter Suhrkamp. Her friendship with the writer Hermann Broch dates from this period. She helped him obtain his travel visa to America in 1938 by winning over Thomas Mann and Albert Einstein as sponsors. "Some days your thinking borders on missionary work," Broch wrote to her on July 30, 1938, from London. After Broch's arrival in America, where Ruth Norden had worked on the editorial staff of various magazines since her return from Germany in 1935, their platonic relationship turned into an affair. Her role as a practical-minded savior in a foreign country remained unchanged. She wrote a grant proposal for Broch to the Guggenheim Foundation for his *Death of Virgil*. The relationship lasted for several years. In the fall of 1945, disagreements began. Broch wrote on September 14: "I no longer have the energy for an extramarital relationship, and for a marital one (which, in and of itself, I would urgently need) I lack the emotional strength." They agreed to let the matter be decided by geographical distance. Norden, who had last worked for the government radio station Voice of America, entered the service of the OMGUS and traveled to Germany in December 1945. Broch began psychoanalytic treatment.[23] Letters passed between Princeton and Berlin over the next two years, but in ever-decreasing intervals. There was never a reconciliation.

Ruth Norden's subordinates in Berlin remember her as cool and distanced in her dealings, a judgment she confirmed. ("I am not chummy with anyone.")[24] Broch noted her tendency "to respond to emotional impulses from her rational side, that is, from the place which always produces false images,"[25] and explained her masculine behavior as her unconscious wish, born of envy and competition with her brother Heinz,[26] to be a man.

Initially, relations between Norden and Wallner-Basté were as friendly and collegial as they had been between Wallner-Basté and Norden's predecessor, Edmund Schechter, with whom he had been on the best of terms both personally and politically. Wallner-Basté saw Norden privately, as he had Schechter, often inviting her to join his family. In Wallner's notebook from 1946 she appears throughout as "Ruth." This changed in 1947. "Ruth" became "Miss Norden" and "RN," and their friendly and familiar dealings turned to cool, written business interactions within the radio station on Winterfeldstrasse.

Both parties gave the same reason for the cooling off: the professional inability and dilettantism of the other. Even while relations were still friendly, Norden referred to Wallner-Basté as "a cultured man, a musician, but he gets on my nerves because he . . . is incapable of really getting anything done."[27] Wallner-Basté for his part held Norden responsible for the chaotic situation that had developed at RIAS in 1946–47 after a reorganization (a complete bureaucratization in Wallner-Basté's eyes) carried out by the Americans. Bills went unpaid because the most necessary funds were not authorized; contractors ceased their deliveries; important supplies were lacking; work morale at the station plummeted. "Ask myself whether continuing on at this station can be justified," Wallner-Basté noted in his diary on June 4, 1947. His answer? "Hardly."[28] Of course Wallner-Basté knew that the American military bureaucracy, which had finally submitted RIAS to its regulations after an initial period of autonomy, was to blame, not Ruth Norden.[29] He considered her incompetent because she did not try to solve the station's problems by conferring with him, instead going behind his back and over his head. He felt she had outmaneuvered him in his position in favor of his subordinate Ruth Gambke, whom he openly declared the ringleader of "a foolish office bohème" responsible for the "increasing unruliness" at the station. "Those who speak of RIAS's programming dismissively as 'women's radio' and 'a gossip atmosphere' must not be proven right," Wallner-Basté told Norden in a detailed memorandum, continuing:

> You have—excuse me if I say bluntly what is an open secret here—you have fallen under the influence of your program director to an excessive degree, of which you yourself are probably not aware. The program director finds my dutiful supervision, the relief measures executed and announced against the aforementioned troubles, an encroachment on her excessive totalitarian efforts. She is therefore systematically trying to keep from me being informed of important operational matters, to cut off my direct contact

to colleagues, to declare joint programming discussions unfeasible and prevent them. The impression that the program director had your support in such matters must have been widespread.[30]

What Wallner-Basté viewed as an intrigue against him and what Ruth Norden presumably saw as an outburst of offended masculine self-confidence was probably both. And given the background of the Berlin political scene in 1947, something else influenced their perceptions and behavior. In his first year at DIAS/RIAS, Wallner-Basté had become an opponent of the SED and an adherent—possibly also a member—of the SPD.[31] After the SPD's attempts in the spring of 1946 to gain RIAS's support in the merger dispute had failed because of the Americans' insistence on neutrality, the party reappeared with self-confidence after its victory at the polls in the fall of 1946. Hans Werner Kersten, editor in chief at RIAS and close to the SPD, was given "a list of comrades . . . who are in a position to offer commentary on the most diverse political issues." The SPD wanted to begin delivering a weekly commentary that would "represent the perspective of the party leadership on political events . . . but be aired by the American station as its own commentary."[32] According to Kersten, the SPD systematically collected "material against Mr. Mathieu [an American control officer at RIAS] and Miss Norden" and repeatedly demanded that Kersten provide "a judgment of Mr. Mathieu's political views and the political work of RIAS, in order to invite intervention from a higher American level and change RIAS's political line in favor of the three democratic parties in Berlin."[33] Kersten was dismissed in March 1947 when it came out that he had hushed up his membership in the Nazi party. Ernst Reuter later complained about the (in his opinion) excessively pro-SED stance in newscasts, calling RIAS "the second Communist station in Berlin" and noting: "We have been gathering evidence in this direction now for some time in order to present it to the American Military Government."[34] By 1947, SPD sympathizers in the American military government had already grown in number. But the neutrality that the year before had prompted a refusal of the SPD's request for political support still mattered to the Americans responsible at RIAS—namely, Ruth Norden and three other control officers. They refuted criticism like Reuter's as "a broadside attack in order to get some kind of control over RIAS. . . . The SPD objects to our objectivity and seems to be aiming at making the station one-sidedly SPD."[35]

Wallner-Basté, whose political sympathies and connections must have

been known to Ruth Norden, did not exactly recommend himself as a confidant in the delicate matter of the station's political neutrality and objectivity. It seemed logical, though certainly not conducive to her personal relationship with Wallner-Basté, to seek more support from the politically uncommitted program director, Ruth Gambke, than from the pro-SPD *Intendant*. Wallner-Basté's notes from the spring and summer of 1947 reveal how rapidly their relationship worsened. In a separate notebook that he began keeping alongside his diary, he recorded all the changes that Ruth Norden proposed on political radio manuscripts—which passages critical of the Soviets were stricken and which pro-Soviet additions were made.[36]

In August 1947, barely half a year after Kersten's dismissal, Wallner-Basté suffered the same fate. Officially, "personal reasons"[37] were cited. The real explanation for his dismissal was that "a stricter political leadership" would be attempted at RIAS than he had offered and had promised to deliver.[38] To Wallner-Basté this was the successful conclusion to an intrigue by the opposing side that in his view now no longer stemmed from the personal motives of Gambke and Norden but had a clear political background. He saw himself as a victim of the procommunist clique of American control officers at RIAS. Among the members of this group he numbered, in addition to Ruth Norden, Gustave Mathieu and Harry Frohman, both former German émigrés.[39] In discussion with an American of a politically more sympathetic standpoint, Wallner-Basté described the political line followed by Norden, Frohman, and Mathieu like this:

> They wanted commentaries to have a Soviet-friendly tint, news to be either falsified as pro-Soviet or suppressed. They wanted investigations into their news policy immediately suspended and those responsible to continue on unhindered. They wanted elaborate celebrations for communists returning from America. They wanted a communist American woman with three years of training in Moscow at the RIAS microphone to describe the political activities of communist film stars in Hollywood [i.e., Chaplin and Katherine Hepburn] with enthusiasm. They wanted RIAS control officers to give speeches on Radio Berlin. They wanted the top communist at Radio Berlin to pay house calls on RIAS control officers. They wanted a smug engineer from the Red Army to thoroughly inspect the wretched facilities of the newly completed American station.[40]

An investigation into RIAS's programming policies three years later—carried out in the middle of the Cold War and hardly to be suspected of communist sympathies—presented another image of RIAS in 1946–47. RIAS was never one-sided in its coverage, but always presented the

counter position as well. Precisely for this reason, according to Western standards of objectivity, RIAS distinguished itself positively from Radio Berlin.[41] In 1984, the historian Harold Hurwitz, also unsuspected of pro-communist tendencies, judged RIAS's news policy in the election battle of 1946 "objective, balanced, and very successful." He offered an explanation for the impression of RIAS's procommunist attitude so frequent in those years: "This impression . . . could arise among politically restless and active Berliners in the year after the October elections even when an American station reported impartially on Berlin's struggle for self-determination."[42] Norden, Frohman, and Mathieu adhered to the conciliatory policy toward the Soviet Union. Ruth Norden's letters from Berlin to Hermann Broch mention the increasing difficulties, inconveniences, irritations, and dangers that arose for the adherents of this increasingly untimely stance.[43] The jungle of personal intrigues in which RIAS operated during 1947 was the result of the transition from the old policy of alliance to a new one of confrontation. The political transition was also a generational shift. Those already active in Information Control in 1945 and perhaps even earlier in the Psychological Warfare Division (from whose personnel Information Control was formed) were mostly aligned with the older line. As a rule, whoever had joined on since 1946 already spoke the new language—officially condoned back in the States much earlier than in Berlin—of anticommunism. Of course, this generational shift did not happen overnight. The pace slackened as it moved eastward. The new policy was first established in Washington, where representatives of the old policy were the first shown the door. The process was slower in the American-occupied zone, but compared with the American sector in Berlin, moved along quickly: in 1946—after several voluntary resignations and involuntary dismissals of German collaborators and American control officers—Radio Frankfurt and Radio Munich were already toeing the new line.[44] And yet in 1947 representatives of the old policy at RIAS still had so much influence that they could dismiss leading German employees like Wallner-Basté and Kersten. But here, too, "reform" stood at the door or, more correctly, slowly crept in as the symptomatic intrigues and reorganizations increasingly prevalent at RIAS.

By 1947 power relations at RIAS and in the division of Information Control responsible for its management had produced a situation of dual sovereignty. On one side were Norden, Frohman, Mathieu, and the officers in the Radio Control Office of the central OMGUS who supported them, Charles Lewis and Hans B. Mayer. On the other side, of

ever increasing number and influence, were the anticommunist Information Control officers, none of whom was actually responsible for RIAS according to their function at OMGUS. This group included Bert Fielden (control officer for the *Tagesspiegel*), Fred Bleistein (Publishing Division), and Nicholas Nabokov and Ralph Brown (Political Division). When the forced merger of the SPD and KPD took place in early 1946, Brown had, it is recalled, undertaken the futile attempt (warded off by Lewis and Meyer) to bring RIAS in line with the SPD. The group around Brown operating in close contact with the SPD leadership tried to make their influence at RIAS prevail in various ways. Nabokov suggested a political investigation into Norden's relationship to the Communist Party. The officer in charge rejected this as inappropriate, explaining: "My impression is that at least some of those accused have simply not caught up to August 1947 where four-power developments are concerned. They are floundering in an effort to reconcile what many had hoped might be possible under four-power government of Germany, with some of the harder realities."[45] Brown got right to work. With no word beforehand to Norden, Frohman, or Mathieu, indeed apparently deliberately in their absence, he appeared at RIAS on October 6, 1946, and held a talk with Kersten and other German employees close to the SPD. Kersten later described this in a memo to OMGUS:

> Mr. Brown was thoroughly informed of the nature of the political programs up to now and had brought with him written records on the basis of which he criticized the so-called "parity" and "objectivity" of the political and election broadcasts. . . . Mr. Brown explained that while we were talking, discussions were underway in Buggestrasse as to whether these three control officers would remain here. He instructed me to take orders on our work only from him in the future; he would provide me with more specific instructions later that day. However, in the afternoon Miss Norden, Mr. Mathieu and Mr. Frohman returned and questioned me exhaustively about Mr. Brown's visit to the station, reproaching me for discussing the internal situation at RIAS with someone else without their express permission. I had to relate the conversation with Mr. Brown in a lengthy protocol, but I did not consider it opportune to report on this in complete detail to Miss Norden and Mr. Mathieu. For their part, the control officers avoided discussing this incident with me; Mr. Mathieu simply told me that it was a "cowardly surprise attack by Mr. Fielden, Mr. Bleistein and Mr. Brown" on them, but they—Miss Norden, Mr. Mathieu—would nonetheless never abandon their political convictions.[46]

With Wallner-Basté's dismissal in August 1947, the old RIAS leadership stood its ground for the last time against the new policy. A month

later the Brown-Bleistein-Fielden-Nabokov group could chalk up its first conquest with the appointment of one of their own (Charles Leven) as control officer at RIAS. The final victory came a quarter of a year later. In December 1947, Norden and Frohman left RIAS and returned to America. Technically, it was not a dismissal, since in both cases their contracts had expired. An extension, which would have been a matter of routine in other circumstances, was no longer in question.[47] The conditions already prevailing in the West a year before had finally caught up to RIAS. What was said about the retreat of the old New Deal guard at the Munich and Frankfurt stations also applied to Frohman and Norden: "Because of their political stance, in the short or long run they could no longer have held on to their positions of responsibility."[48]

Appointed in February 1948, Ruth Norden's successor was William Heimlich, the man who a few months earlier, as the ban of the Kulturbund loomed, had encouraged Western members of the Kulturbund to found an alternative, American-oriented Kulturbund. Before the appointment to his new post, Heimlich had held a leading position in the military intelligence service. In civil life the manager of a radio station in the Midwest, he undoubtedly possessed more experience in radio than Norden, Frohman, and Mathieu. On the other hand, he lacked any sense for the oddities and sensitivities of European artists and intellectuals. According to the memoirs of German employees at RIAS and Heimlich's own account, it was a Captain America style takeover of RIAS's leadership. Heimlich dismissed Wilhelm Ehlers, the provisional *Intendant* ("You *were* Intendant, Dr. Ehlers. As of this moment, I am in charge"); drove Ruth Gambke from her office ("I looked around for the very best office in the building . . . and that belonged to Frau Dr. Gambke, so I took her office. This was immediately establishing my turf"); and fired RIAS employees he suspected of spying for the Eastern side or who simply lived in the Russian sector of Berlin ("I had long since had a list of those who were Soviet agents in RIAS . . . so I had no hesitancy in immediately chopping off all people that we knew, or almost all of them, who were working for the Soviets, or who were living in the Soviet sector"). When these measures met with resistance from the staff, Heimlich dismissed the protesters. ("Before they could open their mouths I told them once more they were fired, now, on the spot, that was it, out, and I didn't want them back in RIAS under any circumstances.")[49]

Such were Heimlich's memories thirty-three years later in an interview. In fact, he did not proceed with such fury. He did try to dismiss the *Intendant* in office, Ehlers, but had to reappoint him again soon

afterward. And as far as the mass firing of the rebellious personnel was concerned, in reality a larger group of RIAS employees threatened with their own resignations. Offered in solidarity with Ehlers, the gesture did not fail in its effect, since Heimlich could not afford the sudden departure of so many workers necessary for the station's operation. Hence Ehlers, Gambke, and the other "troublemakers," "malcontents," and "ringleaders," as Heimlich's assistant Charles Leven called them, remained in their positions.[50] The iron broom with which Heimlich had entered soon softened up. On the whole, and above all at the level of division heads, there were no essential changes in the personnel. The German employees who had followed the policy of objectivity and reconciliation toward the East under Ruth Norden—if at times grudgingly—wheeled around to the new line effortlessly and, in some cases, enthusiastically.

Heimlich was not in charge of the actual political reorganization of RIAS; detailed for this responsibility was Boris Shub, a member of the Political Division of OMGUS. Like Brown, Bleistein, Fielden, and Nabokov, he belonged to those who had sought out connections to the anticommunist SPD early on and supported it in its struggle against the SED. Shub claimed he could smell a communist "100 miles away."[51] In the following months he made sure that the principles of anticommunist propaganda announced by General Clay on October 28, 1947, under the name Operation Back-Talk were carried out at RIAS. The last traces of the old policy of objectivity were stamped out. The cleanup extended not only to everything suspected of being communist or fellow-traveling, but also to noncommunists who did not declare themselves decidedly pro-Western. In September 1948, Shub thwarted the broadcast of a speech by Ferdinand Friedensburg.[52] The literature editor, Annemarie Auer, was asked to introduce a program on John Steinbeck's *Grapes of Wrath* with the comment that this kind of social criticism was possible only in the free West. She declared herself unwilling to do so, and the broadcast was not permitted. Auer resigned and moved to Radio Berlin, along with a few of her other younger colleagues with leftist tendencies.[53]

Long overdue, political battle lines now established themselves quickly. As polarization had already taken place in the Berlin press and many other cultural institutions, the old RIAS remained like a piece of old scenery on Berlin's already cleared stage. Heimlich and Shub simply cleared away the remains.

The general changes in programming, beyond the explicitly politi-
cal reforms RIAS experienced under Heimlich, present another picture.
Heimlich obviously had in mind the kind of station with which he had
grown up and was familiar: commercial, profitable, and popular, an en-
tertainment station unlike the original RIAS with its emphasis on pro-
gramming of education and higher culture. Profitability calculations were
drawn up in which RIAS fared miserably against the American stations:
the music division of the New York station NBC with its ten employees
produced 70 percent more airtime than the corresponding division in
RIAS with 51 employees. Even more flagrant was the disproportion of
revenues: "Our last symphony concert took 6,000 RM, whereas our
last revue took 45,000!"[54] On the basis of these numbers Heimlich de-
cided to reduce cultural programming and expand entertainment, in-
cluding advertising.[55] The model was unmistakably American radio, and
the success of the reorganization—in audience shares—undoubted and
impressive. In late 1948 the station, which had always been second in
comparison to Radio Berlin, became the most listened to station in Ber-
lin.[56] To be sure, the enormous increase was largely due to the dramati-
cally increasing gravity of the situation in Berlin during the blockade
period, but the shift from elite to mass programming did its part; RIAS
would have had difficulty in fulfilling its new propagandistic leading role
with a program of atonal music and readings of highbrow literature.
Heimlich's strategy of propaganda by entertainment ("Make this whole
propaganda effort totally plausible through laughter and fun")[57] was
apparently the right one.

However, it met with resistance as soon as it began to threaten the
cultural *niveau*. This included the music division. Led by one of the
RIAS women, Elsa Schiller, and developed with colleagues along Hans-
Heinz Stuckenschmidt's format, RIAS had achieved a respectable posi-
tion in Berlin's musical life in the first two years of its existence. It pro-
vided not only the typical classical-music fare, but high musical culture
and active musical politics. Berlin's elite musical world therefore took
it as a slap in the face when, a few weeks after his move to the RIAS
building, Heimlich appointed as head of the musical division a man
who in all respects embodied the opposite of this kind of musical taste.
Friedrich Schröder, thirty-seven years old, had made himself a popular
name in the entertainment industry of the Third Reich as a composer of
operettas with titles like *Wedding Night in Paradise, Shanghai Nights,*
and *Chanel no. 5*. His appointment to RIAS was initially viewed as a

"belated April fool's joke,"[58] then noted with sarcasm and finally with indignant outrage. Both American-licensed newspapers, which had always shown reserve toward RIAS's political line under Ruth Norden, now found the loss of quality in programming under the new (and politically much more sympathetic) RIAS leadership considerable. Under the title "Music or Musique?" the *Tagesspiegel* examined the status of artistic and intellectual quality under the new conditions of the Cold War. Though RIAS's new position as a political counterweight to Radio Berlin was welcomed, the article continued:

> What possibilities would be wasted if only the news is of interest in RIAS, and Radio Berlin had to be tuned in for musical offerings. . . . A misunderstood effort at "loosening up" has already produced a preponderance of entertainment music, which seems to go hand in hand with the decreasing number and quality of serious concerts. . . . This is the risk taken with Schröder's appointment. If the new head of the music division sees his first goal as ascertaining Berlin's best dance bands, that might satisfy part of the audience, but it does not satisfy a station's musical obligations.[59]

People like Karsch and Reger now realized that for consistent and effective anticommunist propaganda, high cultural standards would have to be abandoned. Educated bourgeois anticommunists, as Reger's and Karsch's experience with the *Tagesspiegel* had already shown, did not have it easy in this matter: since a considerable portion of the intelligentsia stood on the other side of the political trench, the basis for an elite anticommunist culture was small. RIAS's drop in quality made painfully clear to anticommunist intellectuals the dilemma of developing a popular propaganda campaign that was also of some artistic and intellectual distinction. It was no consolation—if the fact was registered at all—that colleagues on the other side were faced with the same dilemma.

To everyone's relief, RIAS's evolution rendered such concerns at least in this case unfounded. Their duties discharged, Heimlich and Shub were recalled and replaced by less outspoken successors. Because of the political reparceling already carried out, they could operate in a more liberal, familiar, and cultivated way, fostering what Heimlich had threatened to cut away. The contract with Schröder was silently annulled, and Elsa Schiller—who had de facto but never formally been responsible for music programming until Heimlich and Schröder appeared—was officially appointed head of the music division. A certain balance was struck between elitist and popular programming. The concerns of

Karsch, Reger, and a few intellectuals in the American military govern-
ment and elsewhere had not fallen on deaf ears. This was evident in
the founding of a journalistic mouthpiece that raised the connection be-
tween anticommunism and intellectual, artistic standing to a program-
matic level like no other. The first edition of a cultural monthly, *Monat,*
appeared as the struggle, and then the compromise, between culture
and entertainment ensued at RIAS. In the hands of the anticommunist
intellectual Melvin Lasky, the magazine became *the* organ for winning
over and cultivating an intelligentsia both anticommunist in its political
views and concerned with cultural quality.

And as for Radio Berlin? The sponsorship and supervision of the com-
munists did not guarantee it a smooth transition from the "anti-fascist
democratic order" to the Cold War without resistance or changes in the
personnel. By 1946 it was obvious that the station's entanglement with
the SED did not please everyone who had taken part in its founding.
According to statements by colleagues, Hans Mahle, the pragmatic, un-
orthodox boss of the first hour, was fairly reserved and conciliatory in
political matters. ("Please proceed such that I am kept clear of political
inconveniences.")[60] The same was true of his successor Max Seydewitz
(1946–47), a former SPD politician who had joined the KPD in Swedish
exile and for whom the position in Berlin was only a stop on his way to-
ward the office of the prime minister of Saxony. The political line was
pushed through by Wilhelm Girnus, something of a Boris Shub for Ra-
dio Berlin. He did not work at the station itself but in the Central Ad-
ministration for Popular Education on Wilhelmstrasse, where he led the
"Cultural Enlightenment" division. Already in the winter of 1946, when
political discourse in Berlin still moved along a relatively civilized path,
he used a vocabulary that would not become standard until 1948.[61]
 The situation changed in the late summer of 1947 when Heinz
Schmidt returned to Berlin from English exile to succeed Seydewitz.
Girnus lost his influence; the programming at Radio Berlin underwent
notable changes. Obligatory political programs like the reading out of
lengthy Moscow declarations were broadcast after midnight and no
longer during prime airtime. Representatives of noncommunist views
had their say; the station even invited an unabashed anticommunist like
Erik Reger, coeditor of the *Tagesspiegel,* to speak. (He declined for the
reason that his participation "would encourage the false impression you
hope to create, that Radio Berlin is an unobjectionable instrument in

informing the public.")[62] Reports, interviews, and live broadcasts sud-
denly sounded more "Western"—not in their political content, but cer-
tainly in their journalistic form. In fact, under Heinz Schmidt the build-
ing on Masurenallee became a reservoir for two generations of Western
émigrés: emigrants who had fled the Nazis and returned from exile in the
West (in addition to Heinz Schmidt, they included Maximilian Scheer
and Leo Bauer), and a number of intellectuals from the Western zones
who because of leftist—certainly not always communist—views had lost
their posts in the media there or voluntarily given them up. These in-
cluded Herbert Gessner and Karl-Georg Egel from Radio Munich, Karl-
Eduard von Schnitzler and Max Burghardt from NWDR in Cologne,
and Stefan Hermlin from Radio Frankfurt. Their Western "style" made
Radio Berlin more appealing and successful in the competition for Ber-
lin's radio audience than it had been under Girnus's severe management.
It is one of the ironies of the late 1940s that this reaction to RIAS's lib-
eralism and pluralism took place precisely at the moment when RIAS
abandoned this stance. Given the advancing East-West freeze, the im-
pending blockade, and the division of the municipal government, the
opening up Schmidt attempted was short-lived. A year and a half after
Ruth Norden's departure, he shared the same fate. Unlike both of his
predecessors, who were called up to higher positions, his activity in ra-
dio ended in political degradation and internal exile. Not that he had
stood for politically neutral programming like Ruth Norden: Schmidt
was a communist who thought to serve his cause most effectively by
leading it to the field openly and rationally in the tradition of Western
Marxism. It was his misfortune that when the Berlin scene closed and
the curtain fell, there was as little need for this kind of political journal-
ism in his camp as there was for Ruth Norden on the Western side. The
future of the following decades belonged to the Heimlichs, Shubs, and
Girnuses.

CHAPTER 6

Film

The general collapse in the spring of 1945, which impacted all branches
of Berlin's industry and culture, seemed to strangely pass over the film
industry. Perhaps it had to do with the old escapist tendency of the film
medium itself. There was something unreal in how, up until the last
gasp of the Third Reich, the studios in Babelsberg, Tempelhof, and Jo-
hannisthal continued to turn out light entertainment, and equally un-
real how after the collapse, business continued without production. The
directors and studio executives, financial and legal advisers of the three
large production firms in Berlin—Ufa, Tobis, and Terra—went on with
their usual activities, pursuing old directives and making new plans as
though nothing or nothing essential had happened. True, the state hold-
ing company Ufi had disappeared along with the Third Reich,* but this
signaled less a defeat than the promise of new opportunities. The Ger-
man film industry, centralized and disciplined under the Nazis, now
required complete reorganization. Based on his initial inquiries in July
1945, the American officer in charge of film, Vienna-born Henry C.

*Ufi was created by Reich Commissioner Winkler in 1942. He had worked for years
to consolidate the film companies nationalized in the late 1930s into a single state-run en-
terprise. The resulting holding company united the formerly independent studios of Ufa,
Tobis, Terra, Bavaria, and Wien-Film and would keep the German film industry profitable.
Ufi (an abbreviation for Ufa-Film), borrowing the name of its largest subsidiary, became an
umbrella organization for all activities with the exception of production; Ufa remained a
gigantic production company.

Alter, described the situation like this: "The individual film compa-
nies [of the former Ufi conglomerate] are still there, very uncertain,
and are trying to deal one another a blow, each one hoping to emerge
from this confusion at the top."[1] While the old studio heads in Berlin-
Mitte built their castles in the air, the studios and technical facilities
located in other districts of Berlin and outside of the city had become
independent.[2]

The spring and summer months also witnessed a profusion of new
film companies. There was less illusory denial of the situation in these
efforts; their founders had for the most part worked for the old compa-
nies as managers, directors, or technicians, and were aware of the un-
certainty, risk, and adventurousness of their undertaking. The motives
for setting up a new film company ranged from artistic or moral frenzy
to political opportunism and purely financial interests.

The director Wolfgang Staudte, who belonged to the first category,
had first tried his luck with a manager of one of the old firms, Wal-
ter Reitzel at Tobis. Reitzel appointed Staudte "artistic director" of his
shadow company on June 5, 1945. Four days later Staudte presented
the Russian control officer Colonel Ratkin with a proposal for a film
project under the working title *Die letzten Tage* (*The Final Days*), the
story of a young couple who survived the final trials of the Nazi period
and were liberated by the Red Army.[3] This met with as little success as
his attempts to obtain an American, and later an English, license for his
later to be famous project, *Die Mörder sind unter uns* (*The Murderers
Are among Us*).[4]

Demo Film was one of the firms set up by members of the resistance
in the spirit of the new antifascist beginning. The partners in this ven-
ture were Franz Graf Treuberg, dramaturge at the Hebbel Theater and
soon afterward head of the artists' club Die Möwe, a central figure
on the Berlin cultural scene between 1945 and 1948 who has fallen into
obscurity now; Werner Hochbaum, a director expelled from the Reichs-
filmkammer in 1939 because of the insufficiently veiled antipathy to-
ward National Socialism in his films; and Günther Weisenborn, a resis-
tance fighter freed from prison and the author of the play *Die Illegalen*.
Weisenborn and Treuberg wrote the script for a film set in the resistance
milieu (*Der Weg im Dunkeln*), which Hochbaum was to produce. This
project, too, remained a plan.[5] Projects like Heinz Rühmann's and Eb-
erhard Klagemann's were of a more opportunistic bent. With their com-
pany, Pax, they hoped to start producing again as quickly as possible.
The same was true of the former head of production at Terra, Alf

Teichs, who made two or three attempts to reestablish himself. We find him among the founders of Studio 45, Inc. (along with Hans Tost, also a former member of Terra), as a partner in Demo Film, and finally in 1947 collaborating with Rühmann as a founder and member of Comedia Film.

All of these firms were frustrated in their goal of producing feature films—not only because they did not have the necessary capital, but because production was not permitted without an Allied license. And in the summer of 1945, none of the powers issued production licenses. However carefully set up according to commercial laws, or lively and ingenious in their proposed projects, these new companies remained in the end as illusory as the old firms. Their founders, to earn their keep, had to pick up side jobs, which as a rule meant assisting in the dubbing of Allied films into German as authors, announcers, directors, and technicians. Before he could shoot his postwar classic *The Murderers Are among Us,* Staudte had to do the same, assisting in the dubbing of Eisenstein's *Ivan the Terrible.*[6]

There was a third theater for Berlin's imaginary postwar cinema. The film division of the Kammer der Kunstschaffenden seemed to be even more caught up in illusions about Germany's postwar film industry than the existing and newly founded film companies. Two groups were at work at Schlüterstrasse: those who were already involved in the new firms and saw in the Kammer a welcome source for information and communication; and those who had not yet found a position and now set their hopes on the Kammer's film division. The latter included the head of the division, Wolf von Gordon, a dramaturge at the Terra film studios until 1945. Like the other film people at Schlüterstrasse, he seemed to have in mind making the Kammer into a vehicle for the overhaul, supervision, and management of the entire German film industry. Though not meant to be directly involved in production, the Kammer would select and supervise all of those who wished to be active in film. This is how Gordon presented the situation to Billy Wilder, who served as a film officer in Berlin in the summer of 1945: "The Kammer would check the political reliability of all persons of the film branch, regardless of whether they are technicians or actors, directors or financiers. It would also oversee all film projects, which would of course then be brought before a board of the Allies before being released for production."[7] Finally, according to these plans, the Kammer would also take over the distribution of German films. Production would shift into the hands of private producers while the means of production remained

in possession of the state—the legal successor to Ufi—from whom the producers could lease, rent, or borrow them as needed. Presumably the film division in the Kammer also wanted to have its say in this restructuring. The plan envisioned (depending on one's political stance) the creation of a giant conglomerate to succeed the Reichsfilmkammer and Ufi, or a democratically supervised and guildlike self-management of film production. It is unknown who else besides Gordon supported this plan and what benefits were hoped for, but such considerations were clearly not restricted to the personal wishes and fantasies of members of the Kammer.

In the summer of 1945, before relations between the Kammer and Winzer's Popular Education department in the Magistrat had cooled, there were similar thoughts there as well. Theodor Baensch, the Magistrat's deputy for film, proposed that the Magistrat assume the Ufi legacy and reorganize it into a city undertaking, entrusting artistic control to the Kammer der Kunstschaffenden.[8] As there is no more than a draft of the Magistrat's plans, it can be assumed that they were either just personal speculations or abandoned by orders from above. The immediate reason why Gordon's and Baensch's intentions came to nothing was the arrival of the Americans in Berlin. They regarded the film people at Schlüterstrasse at worst as Goebbels's accomplices, at best as fellow travelers and opportunists who were to be treated with utmost suspicion and under no conditions entrusted with the powerful medium of film. And as Schlüterstrasse came under Western control, the Kammer also ceased to be a reliable basis (if it had ever been one) for Winzer. Winzer's and his party's plans for new German film production had to seek another venue.

While Theodor Baensch pursued his plans for the Magistrat's own film company less with the intention of building up new German film production than seizing the resources of the old, a group of functionaries and intellectuals in the leadership of the KPD set about implementing a resolution made in Moscow. In September 1944 the party leadership had decided that new German cinema should become "a means of artistically reflecting real life and creating conditions worthy of man."[9] Anton Ackermann, the functionary in charge of film affairs, seems to have taken the first decisive steps toward this goal by entrusting the matter to the Zentralverwaltung für Volksbildung (ZfV, Central Administration for Popular Education). Set up in August 1945, the ZfV was responsible for the cultural matters of the entire Russian zone, a fore-

runner to the later Popular Education and Culture Ministry of the GDR. It had its seat on Wilhelmstrasse, in the half-ruined former Prussian Ministry of Culture (which had later become Goebbels's Propaganda Ministry). The ZfV's "Art and Literature" division was ordered to assess the film situation, to draw up a proposal for the conception, organization, and personnel for future film production, and—as soon as this had been done—to transfer matters into the proper expert hands for implementation. Herbert Volkmann, the head of the division, took care of the matter personally.

Unlike his boss in the ZfV, the forty-four-year-old Volkmann was not a party functionary who had ended up in the cultural administration. Of middle-class background, he was a trained sociologist and political scientist, an educated and cultured man with a particular interest in the modern media of photography and film. He had spent the Nazi period in Berlin, for a time as head of the United Press news agency's Berlin office. In 1945 he was one of the few survivors of the Harnack-Schulze-Boysen resistance and espionage group ("Red Chapel"). Immediately after the ZfV was founded, Volkmann concentrated his attention on the film industry, and he quickly brought together a group of six experts. The group was dubbed the Filmaktiv in the ZfV. Its members, in one way or another, had all been involved in the leftist film and theater scene before 1933: the set designers Adolf Fischer (known from his work on *Mutter Krausens Fahrt ins Glück*) and Willi Schiller; the assistant director Kurt Maetzig; the actors Adolf Fischer (from the Piscator ensemble and *Kuhle Wampe*) and Hans Klering (from several Russian films from the 1930s); and Alfred Lindemann, a blend of actor, organizer, and factotum. As half of the Filmaktiv's members (Schiller, Fischer, and a certain Haacke) remained passive, the group came to consist only of the three active members: Maetzig, Klering, and Lindemann. Kurt Maetzig, whose film career was broken off in 1933 after he had barely begun it as an aspiring young cameraman, was primarily interested in producing and directing his own films. Klering became the nominal boss, his Moscow background foreordaining him to what would become his chief task, acting as a liaison to the party leadership. A reliable party man, he had little entrepreneurial and organizational talent, and the actual management was left to the only remaining member, Alfred Lindemann.

A few simple facts suggest the energy that drove Lindemann. Returning from an American P.O.W. camp, he arrived in Berlin on November

12, 1945. On the 13th he became a member of the Filmaktiv.[10] Three
weeks later the Filmaktiv moved into Ufa's former, half-destroyed ad-
ministrative building on Krausenstrasse. In four weeks' time there were
60 members, and a month after that 127 people[11] were involved in pro-
ducing newsreels and preparing the first feature film (Staudte's *The Mur-
derers Are among Us*). The Filmaktiv predated Lindemann's arrival, but
only his involvement put it in action and transformed it into the film
company Defa. ("In the first few meetings I proposed an immediate ini-
tiative, which was accepted and implemented right away.")[12]

Alfred Lindemann was one year Volkmann's junior, and his exact
opposite in terms of background, education, and professional develop-
ment: a blend of adventurer, organizational genius, and braggart, also
a communist with a passion and devotion seldom found among func-
tionaries—in short, a kind of postwar version of Willi Münzenberg.
Having joined the KPD during the Spartacus Rebellion as a seventeen-
year-old, he considered the party a substitute family, without ever hav-
ing been tempted by—or capable of—entering upon a functionary career.
His whole life he remained an outsider who placed his unconventional
talents in the service of the party that needed such abilities so greatly
yet at the same time so decisively refused and stifled them. In the 1920s,
Lindemann got along by taking various jobs in the film industry, as a
camera assistant to Joe May, projectionist, lighting technician, and pro-
duction manager. He acted in the Piscator ensemble and put his great
organizational talent to work in Wangenheim's Truppe 1931. He spent
part of the Nazi period imprisoned, part as a lighting technician for
Ufa. For a short time he was manager of the Theater am Schiffbauer-
damm, a position that he apparently used to gather information about
the NSDAP for his resistance group, Friends of the Soviet Union.[13] In
the 1930s he organized a series of small-scale embezzlements from Nazi
state funds to provide support for needy members of the group, and paid
for it with a prison sentence.

The situation in 1945 could not have been more favorable to a nature
like Lindemann's. The rapid development of the small Filmaktiv orga-
nization into the larger company Defa was due in large part to his tal-
ent for organization and improvisation. His later claim of having fi-
nanced the first phase of the Filmaktiv by selling personal possessions (a
camera, a watch, a telephoto lens) revealed an exaggeration typical of
the man himself.[14] At no time was there a lack of money. Funding came
in sufficient quantity from the ZfV. Of course in 1945 money alone was

not sufficient to create a production company. Greater management skill was required to push forward with his plans, including procuring materials on the black market not otherwise available. Not an easy undertaking even for private firms, this seemed a sheer impossibility for an enterprise subordinate to the ZfV. Yet Lindemann found ways, very much in his element navigating the gray and black zones of the economy, carrying out what would today be called money-laundering schemes. Film-production materials like wardrobe supplies and technical equipment, additional foodstuffs, and the cigarettes so stimulating to morale were procured through a "Special Account Lindemann" under his control. The salary demands of former Ufa stars were so high that they could not be officially submitted to the ZfV and revenue office. But Lindemann considered the glitter of big names imperative for Defa productions, and he found a solution in what he called a "system of premiums." In addition to their nominal salaries, big stars received a sum paid in cash. These premiums did not appear on the books, or rather, they turned up under other names as bills that the German revenue authorities never laid eyes on, preferably under the cover of productions commissioned by the Russians. The "winning over of bourgeois film people," which Lindemann later stated was the principal motivation and justification for his premium system,[15] was not his only goal. His party also profited. For the SED's campaign for the Berlin Magistrat elections in 1946, Defa produced fifty-two films gratis, the costs for which—150,000 RM by Lindemann's count—were hidden in other productions—for instance, in a film commissioned by the International Red Cross.[16]

This management style rested on two prerequisites: first, Lindemann's own ability and eagerness for such balancing acts; and second, the fact that Defa itself represented an adventuresome undertaking. As long as the Filmaktiv remained a subdivision of the ZfV, relations between the two were clear and simple. This changed when it was renamed Defa and became an independent business venture. On May 17, 1946, the company received a Russian license for feature-film production, but it existed legally neither as a joint-stock company (which it pretended to be) nor as a limited-liability company or limited partnership.[17] Defa did not really exist at all. It was merely a name under which the men who had formed the Filmaktiv now began actual film production, remaining so for the next two years. In November 1947 it was transformed into a joint-stock company, but this was simply a fiction of another order. Defa stocks were not traded on any exchange. Neither its owners nor

the amount of its capital were public knowledge. Defa was not a true joint-stock company but a type of "Soviet joint-stock company" (SAG) not uncommon at the time. What leaked out in the course of the years before it was transformed into an East German state-owned company in the 1950s was never made publicly known: its capital amounted to 10 million reichsmarks, 55 percent in the hands of the Russians, 45 percent in the hands of the (SED) Germans.

Russian interest in the German film industry was there from the very beginning. Only a few days after the capitulation, the state distributor Sojusintorg took control of Berlin's entire film distribution.[18] When the Filmaktiv came into existence a few months later, its members might not have known what was agreed upon by those who had stood behind this initiative: the production company was to be a joint venture, the capital and supervision Russian, the technical and artistic personnel German.[19] Presumably differences within the Russian camp caused the long delay in carrying these plans out—that is, differences of opinion between the SMAD, in charge of political and administrative affairs, and the financially oriented state companies Sojusintorg and Sovexport.[20] The same sureness of instinct guided Lindemann here as it did in his fictitious bookkeeping. He was on such good standing with Tulpanov and other members of the SMAD's information division that colleagues at Defa considered him Tulpanov's protégé.[21] Perhaps he knew or believed he knew that he had in Tulpanov a potential ally against any excessive economic influence from Sovexport and Sojusintorg on Defa.

Though a communist and Soviet sympathizer, Lindemann undertook actions as the head of Defa that were "patriotic" to the extent this was possible in the circumstances. The sale and distribution of Defa films were in the hands of Sovexport and Sojusintorg, whose monopoly allowed them to dictate prices[22] and, when films like *The Murderers Are among Us* and *Ehe im Schatten* (*Marriage in the Shadows*) became international successes, keep foreign-currency revenues entirely for themselves. Lindemann applied his unconventional tactics to counteract this situation. Bypassing Sovexport, he contacted an American film representative, apparently hoping for more favorable results through direct negotiation.

In the fall of 1947, Defa offered a model of successful postwar reconstruction. It was the second-largest film production company in Europe (after Mosfilm), commanding over a thousand employees and the use of the Ufa studios in Babelsberg and the Tobis studios in Johannisthal. Defa produced the first German feature films after the war and

made them into artistic successes. Its management could now broach broader aims with confidence, like moving beyond the restriction of the Russian zone to become a suprazonal national company. Lindemann took the first steps in this direction when he instructed the agent Paul M. Bünger in Munich to persuade key figures of German cinema stranded in southern Germany and the Tirol at the end of the war to return to Berlin.[23]

The transformation of Defa into a joint-stock company in November 1947 marked both the end of its "wild" phase and of the reign of Lindemann. No match for the circumstances that had confronted them, his colleagues in management had all too willingly left the direction to him. Now they reproached him for disregarding the principle of collective leadership and making himself the "dictator of Defa."[24] Lindemann had run-ins with Klering and Maetzig and with Karl-Hans Bergmann, who had later joined the company as a financial adviser. A situation arose in which his talents, his aplomb and ingenuity, and not least of all his charismatic effect on his coworkers were of little use. Obliged to him for so many special rations and cigarettes, the staff remained loyally devoted to him once the rift within management became clear. The SED party cell of Defa also stood behind him, testifying to the party leadership that Lindemann was the "true engine of Defa, enjoying an extraordinary trust from the entire staff and esteemed as a companion and comrade,"[25] whereas Bergmann was "conscientious . . . but too bureaucratic and narrow-minded" and "unpopular" and "related poorly to the staff." (The only comment about Klering was that he was active in the party group.) But it was of no avail. Even to those who had protected him so far Lindemann no longer seemed the person who belonged in the picture. He was relieved of his post in March 1948. Only Volkmann remained by his side, and fell with him. ("Because of their [i.e., Klering and Bergmann's] failure, Lindemann was the man in Defa into whose hands practically all the threads ran together and who did all the work.")[26]

Half a year later Lindemann was also expelled from the party. The official grounds were mismanagement and embezzling. When a Western newspaper dug up the old story of the "embezzlement" of Nazi state funds,[27] the party added this to his list of sins as well. The fate of the adventurer and communist Lindemann, who did everything for the party only to find himself repaid in such a manner, distantly echoed the Moscow trials of the 1930s. Lindemann himself described the expulsion from the party in these terms:

I saw it as my principal task to make Defa serve the goals of the party in every way possible, without ever demanding funds for this from the party. I was the one who . . . delivered up Defa to the party in the end. I am embittered that the party should now consider me a parasite. Since 1945 I have deferred all personal interests; I built up Defa. . . . I have utilized all the resources at Defa for important party work. Until recently, 22% of party comrades within Defa were placed in important positions. Through Defa assistance has been offered to many émigrés. Not because I wanted to waste Defa's funds by doing so, but because I saw this as a political and party duty. . . . I have been in political life for 30 years, was an active fighter and leading functionary in the great strikes in the film industry, was on the industry's blacklist, worked illegally during the Nazi period, was arrested by the Gestapo several times, and despite everything continued working right to the end. In 1945 I immediately placed myself at the disposal of the reconstruction and have allowed myself not a single day off in the past three years. Today I am without livelihood, nor do I possess private means. On the contrary, I am leaving Defa with a debt of 9,000 RM . . . I would at least like to request that I be given the opportunity to remain active as a party comrade and be allowed to work for the party on a new footing.[28]

HOLLYWOOD—BERLIN

In its moral and pedagogic impulses, American film politics in Berlin was hardly distinguishable from its Russian counterpart: new German cinema was to be the medium of reeducation. However, the victors parted ways over the appropriate business structure for the film industry. A new version of the state-run Ufi was out of the question, likewise all other forms of centralization or conglomeration. The Americans wanted to see film production in the hands of Germans, operating on a basis of private capital as broadly distributed as possible. This stance explains the sympathy that several American cultural officers, despite their fundamental political mistrust, showed toward the Kammer for Wolf von Gordon's plans to place all of Ufi's production assets and facilities in trust and rent out the facilities as needed to individual producers. Like editors and publishers in the press and publishing industries, film producers would be selected by Information Control on the basis of their political past and the suitability of their projects for the official goal of reeducation.

So much for the general course set for the control officers of the "Film-Theater-Music" department of Information Control in the summer of 1945. However, unlike in the press and publishing industries, where this plan could be implemented without great interruption or

impediment, there were considerable delays in the film division. Washington's plans were one thing, the interests of the American film industry another. The scale and shape of the conflicts and confrontations that resulted—given Hollywood's economic influence and power of intimidation—were worthy of an adventure or spy film.

Slightly simplified, Hollywood's attitude at the end of World War II can be summarized in one sentence: war had been waged to win back the European film market. Acting on this belief, the eight largest film companies formed a kind of cartel in the summer of 1945. The Motion Picture Export Association (MPEA) was supposed to coordinate exports and, in particular, prevent the thousands of American films that had amassed during the years of exclusion from the European market from ruining the industry in a wild competition with one another and leading to the collapse of the market only just regained. Prudent self-control and self-imposed quotas would guarantee the American film industry an orderly return to its previous status in Europe. In early 1946 there were MPEA offices in all of the European capitals considered important, including Warsaw, Prague, Budapest, Bucharest, and Sofia.

This strategy assigned the most important European market, Germany, particular significance, not only because the defeated enemy was lying at the American industry's feet, but also because the German film industry had been Hollywood's most prominent and dangerous competitor in the prewar international market. The opportunity seemed favorable not only for winning back the Americans' old share of the market (or perhaps gaining a larger one), but also once and for all of getting rid of the German competition. Visions of a cinematic Morgenthau plan occupied Hollywood moguls like Jack Warner, who stated plainly in August 1945, "If it is true as Field Marshall Montgomery stated that 'He who controls the cinema, controls Germany,' and if it is true, as others have stated that 'films are as strong as bullets,' and if the Allies will not permit Germans to rebuild the munitions industry, they should not be permitted for any reason, even if temporary, to rebuild a motion picture industry."[29] When the American military government invited the heads of the big studios, including Jack Warner, on an informational trip to Germany in June 1945, they all had reason to be optimistic. Hollywood was already in Washington's good graces because of its exemplary support of the war effort through numerous films made to boost morale. And now further help was requested in the form of American feature films the military government could show to the German public in their zone of occupation. It was not a very lucrative business proposition for

Hollywood. Revenues in Germany could not be exchanged into dollars and pocketed as actual profit. On the other hand, there existed the possibility of investing these revenues within Germany, into the German film industry, and thereby establishing a foothold and perhaps ultimately gaining control over the German industry. The stumbling block here was that American investment in Germany was not yet officially permitted; but this might change, if necessary by applying gentle pressure, like cutting off the supply of feature films to the American zone so important to OMGUS. At any rate, the result of the visit to Germany looked promising for the MPEA-member studios, and literally drew them into the military government: the MPEA representative in Berlin received an office in the building of the division of Information Control responsible for film, theater, and music. He was treated as an associated member of this department and, as the representative of the owners of the films shown to Germans by OMGUS, worked closely with it.

However, none of this meant a revision of the original American decision to have the new German production of feature films built up by Germans. The cultural officers in charge deliberated on which American experts could be pulled in to guide and supervise this build-up phase. Yet they were unable to escape entirely the lure that the tabula rasa of German cinema exerted on foreign film interests. They showed a strong inclination to dedicate themselves in equal measure to discharging their official duties and pursuing their own projects. Germans alert to such tendencies, like Munich's municipal film delegate in the city's studios in Geiselgasteig, saw clear signs of this: "The Americans do not proceed according to official and prescribed channels, their private interests are right in the foreground. They are for the most part American officers and soldiers who were insignificant in American cinema and unable to obtain important positions there, and now, because of their power with the occupation authorities, are trying to lord it over German cinema and bring it under their wings."[30] There is no evidence of such practices in Berlin, which was perhaps due to the fact that the incentive here was slight: the big studios were not in the American sector. But even here some officers found more appeal in forging their own film plans than pushing along the official plans for German production all too vigorously. Billy Wilder, who back home had just had a great success with *The Lost Weekend,* was certainly not one of those Americans "insignificant" back in Hollywood and therefore hoping for success on the German side-stage. Arriving in Berlin that summer as an American film officer, Wilder found the atmosphere there simply too seductive a cine-

matic cache to go unused. ("I saw a crazed, ruined and starving city, fascinating for the back drop of a film. My notebooks are full of fresh impressions.")[31] He wrote the treatment for a feature film ("the very simple story of a GI stationed here with the occupation troops and a young German woman") and counted on the approval of his superiors in OMGUS to carry though the project as a Paramount production. Perhaps nothing came of this because the other Hollywood studios protested against giving preference to one of their own. (Wilder's Berlin comedy *A Foreign Affair* came out only three years later.)

The example of Billy Wilder shows how difficult it was to draw a clear dividing line between personal advantage and artistic interest. Given OMGUS's interest in good entertainment films with a reeducational function (the phrase Wilder used was "propaganda though entertainment") and the Americans' conviction that such films would be made better by Americans than Germans, film projects like Wilder's (or Preston Sturges's plan for a Berlin film)[32] seem less a deviation from the official policy of reestablishing German film production than a variation of, or perhaps a propaedeutic to, new German cinema. If the goal was to have American experts educate future German producers, exemplary American-produced films could be seen as a part of the new German film production, which would then build on and follow them. OMGUS's objectives were motivated by aesthetic and moral, not commercial, concerns, but in all else they differed very little from Hollywood's plans. Both shared the conviction that the methods and achievements of American cinema were precisely what the Germans needed.

What explained the wavering course of American film policy in the first year after the war? The fact that it took into consideration so many possibilities and acted on none, that it did not distinguish clearly between German films for Germans, American films for Germans, and American films for the world market that would also be shown in Germany, and finally the fact that nothing concrete was accomplished in this year—was this all the result, as contemporary observers and historians later believed, of the Americans' distrust of the Germans, whom they wanted to deny the use of film for as long as possible? Or was there something different behind this behavior?

A shared awareness of belonging to the world-power American cinema drew together the OMGUS officers in charge of film and the American film industry. The MPEA was acutely aware of its economic advantage ("The most important advantage enjoyed by American motion pictures in the world market is the simple fact that people everywhere

like them"),[33] and the American film officers acted on this assumption with the sovereign indolence of one who knows that his incontestable superiority requires no displays of proof. The Americans took the Film-aktiv's activities in the fall of 1945 no more seriously than an English industrialist in the early 1800s would have regarded the competition of a Prussian manufacturer: "We should not be worried about the Rus-sians' film activities. . . . time is the factor we have on our side. We have a lot of time, at least ten years."[34] This reassuring statement made by the American film officer Robert Joseph on December 8, 1945, in his weekly report reflected less the actual situation than an attempt to jus-tify the indolence, aimlessness, and inactivity of the film policy until that point. By December 1945 it must have been evident to every OMGUS officer that a serious film enterprise was developing on the other side. A few weeks earlier the Filmaktiv had introduced itself to the public with a reception that attracted general attention and was attended by numer-ous figures prominent in the Berlin cinema. As anyone could figure out who knew that all the important film production sites lay in the Rus-sian sector and in the Russian zone around Berlin, this was no empty demonstration on the Russians' part.

But Joseph's report reveals in itself how little he himself believed in the decade at the disposal of the Americans to reconstruct the German motion-picture industry. The report states that Information Control ur-gently required an expert from the States "to get the matter in hand and underway." The job description, listing the requirements for this position, suggests an increased urgency: "Born in Germany, speaks German like a native; has a precise knowledge of the German film industry and the per-sons active in it up to at least 1937 or 1939. First-hand knowledge of all stages of film production, preferably a recognized producer or director from Hollywood."[35] An attached list of "suitable candidates" included Henry Blanke, Curtis Bernhardt, Erich Pommer, William Dieterle, E. A. Dupont, John Brahm, and Seymour Nebenzahl.

Joseph's report suggests either a miscommunication within Infor-mational Control or that an already concluded search was presented as still open. For, three months earlier, in September, one of the candi-dates named on the list had already received—and answered affirma-tively—an inquiry from the head of the film department as to whether he was prepared to head up new German film production in the Amer-ican zone.[36] Information Control's effort to present as still open the decision already made had to do with the candidate selected. It was thought advisable to defer announcing the name for as long as possible.

The name was Erich Pommer. He had had great repute in the German film industry and cinematic art from 1918 to 1933. Pommer's leadership as a producer at Ufa generated films that have since become legendary: *The Cabinet of Dr. Caligari, The Testament of Dr. Mabuse, Der müde Tod (Destiny), Der letzte Mann (The Last Laugh), Metropolis, Die Nibelungen (The Nibelungs), The Blue Angel*—to name only the most popular. If an industrial and collective artistic form like film can be reduced to one person, then Erich Pommer had been the person above all responsible for the quality of German cinema in this period. With matchless skill he brought together talents—for the most part already "discovered"—into the combinations whose creative concentration proved their success. His talent for production was in pulling together "the true export item of the German cinema in these years: manuscript, lighting, design, actors, sets" (Wolfgang Jacobsen)[37] into the totality (or in Hollywood's terms, the package) that brought worldwide admiration to German cinema. His creative and organizational talent was complemented by a "political" prowess regarding the international position of German film. As the head of production for Ufa, the largest film company in Europe, he attempted to challenge American domination of the world film market, or at least provide competition for the U.S. market on its own soil. In retrospect, his strategy in the 1920s seems like a carefully thought-out plan not unworthy of Dr. Mabuse. Developing the German trademark product, the "chamber film," was the first step. Then, building on this success, the move into the American domain of elaborate, large-scale productions was to follow. The production costs of *Metropolis, Die Nibelungen,* and *Der Kongress tanzt (The Congress Dances)* surpassed by far the typical budget for previous European films. The attempt failed. "American moviegoers were not interested in a Pan-Germanic epic like *The Nibelungs*."[38] Ufa's unsuccessful expansionist policies brought the company to the edge of bankruptcy, from which only several million dollars from the American film industry saved it. Cosmetically packaged into the Parufamet joint-distribution agreement of 1925, Ufa itself now guaranteed its American competitors a share of the German film market greater than before.[39]

Hence there was already a history to Pommer's relationship to Hollywood when he emigrated to America in 1939 and settled down in Los Angeles. Even the fact that he had spent his first six years of emigration in Paris and London showed his reluctance toward California. This was unusual, since many of his former colleagues had settled there and begun careers that surpassed anything they had achieved in Berlin. If

Pommer's hesitation stemmed from a fear that the American nemesis
would persecute him again on its own soil, he was not entirely wrong.
In his best years in Berlin, he had produced twenty films a year. Even in
the final year before his emigration, despite all impediments, he made six
films, and in the six years of his European exile he brought out eight.
For the whole length of his emigration in Hollywood, he produced only
three films, working for the RKO company.[40] When he suffered a heart
attack in 1941, RKO dismissed him. At age fifty-two, Pommer was un-
employed, in forced early retirement, and suffering—if not materially,
at least psychically—from Hollywood's disinterest. His numerous friends
and colleagues from the Berlin years were his only contacts. This circle
also included Billy Wilder, who had worked under Pommer in Berlin as
a screenwriter (for *Ein Mann sucht seinen Mörder* [*A Man in Search of
His Murderer*]). Apparently Wilder suggested Pommer for the Berlin post
of OMGUS's film deputy.[41]

The Berlin offer was a kind of consolation prize for Pommer, or as
his wife, Gertrud, stated, "a great satisfaction . . . after the Louis B.
Mayers and the Darryl Zanucks turned him down. Still, he would re-
fuse to go if something better were available here in the near future. Un-
fortunately this is not the case."[42] At first it seemed that even the few
illusions Pommer allowed himself when he accepted the offer in Sep-
tember 1945 were unfounded. The whole matter came to a standstill
before it really got started. For weeks he heard nothing; then he was
informed that "for a variety of reasons" further delays were to be an-
ticipated.[43] Pommer thought he recognized behind this the resistance
of the American film industry toward plans for rebuilding German film
production.[44] When General McClure, the head of Information Control
in Germany, returned to the States in October to discuss function and
prerequisites required of OMGUS's future film officer with government
officials and representatives of the film industry, Pommer assumed that
McClure "got the works from the representatives of the industry."[45] Al-
though there is no documented evidence of this, the subsequent prog-
ress—or rather, the standstill—of the affair suggests that Pommer's sus-
picions were not entirely unfounded. The matter viewed as so urgent in
September 1945 did not budge for half a year, only to be decided all at
once in Pommer's favor and against Hollywood's interests within a mat-
ter of weeks the following spring. In this six-month period the Filmak-
tiv had developed into a serious film enterprise. Staudte began shooting
The Murderers Are among Us, and Paul M. Bünger began working for
Defa in Munich. Lindemann looked increasingly worthy of compari-

son with classical founding figures and pioneers like Pommer. The situ-
ation required quick action and counteraction. Commercial interests,
however influential they may have been under normal conditions, had
to take the backseat to the general political and diplomatic task. The
American military government's judgment of how critical the situation
was is evident in the catalog of duties for the film officer (his official
title was Film Production Control Officer) given to Pommer in April
1946. It reads as though in a moment of crisis the Roman senate had
appointed a dictator for the film industry. Pommer's duties and powers
were listed as follows:

1. Advises the Director of Information Control in connection with the
 policy to be followed for the reconstruction of the German motion
 picture industry.

2. Drafts policy for the guidance of the German motion picture pro-
 ducers, German motion picture studios and all others concerned with
 the production of motion pictures.

3. Advises the Director of Information Control on policy to be fol-
 lowed in the Quadripartite discussions involving German motion pic-
 ture production.

4. Screens and guides directly those Germans who intend to become
 motion picture producers.

5. Supervises directly all activities in the Information Control Division
 of the various Länder of the US-Zone, pertaining to motion picture
 production. . . .

6. Fully responsible for approval of all shooting scripts to be produced.

7. Fully responsible for policy supervision of motion picture production.

8. Fully responsible for censoring new productions.

9. Fully responsible for policy supervision of studio operations.

10. Supervises all financial arrangements made by motion picture pro-
 ducers, film studios and film distributors. . . .

11. Fully responsible for approval of all major contracts made by motion
 picture producers, film studios, etc.

12. Directly responsible for supervision of new productions to insure
 that only acceptable actors, directors, etc., are employed and that
 new productions conform with the desires of the Military Govern-
 ment.[46]

Pommer arrived in Germany in early July 1946. His impression that
this was celebrated in German film circles "like the coming of the Mes-
siah"[47] was not exaggerated. Given the advanced progress in the Rus-
sian zone and noticeable first steps in the English zone, both the French

and American zones were trailing behind. "German film experts," commented Erich Kästner on Pommer's arrival, "above all in the American zone, looked to him as sailors look to the polestar. Directors and lighting technicians, stagehands and actors, set designers and divas, sound men and screenwriters, cinematographers, and makeup artists—an entire, huge, lamed industry has been waiting for this man and this name."[48] Pommer's return was for the German film world what Thomas Mann's return would have been for the literary world. Even those who opposed him soon began to feel the consequences of his presence. On September 7, Paul M. Bünger reported from Munich to the Defa central office in Berlin: "After the much discussed buildup of Pommer production in the press here, film people have become somewhat more reserved toward us." Some of them, including Erich Kästner, who shortly before had listened with interest to offers from Berlin, now politely declined.[49]

Even before Pommer's arrival, Germans in the film industry in the Russian and American zones used the vigilance and apparent progress of the other side as an argument to win more support for their own efforts from their respective occupying power. This mode of argumentation now became a component of the rhetoric on both sides, as though there existed some kind of secret accord between them. Pommer also availed himself of this argument regularly and with success. "They build a powerful industry along the lines of the old Ufa," he wrote in his report about Defa. "If the zonal boundaries are ever dropped, they will be in a perfect position to absorb the weak, decentralized industry in the US Zone. The final result may well be a Russian-dominated industry."[50] The analogous argument came from Alfred Lindemann, who wrote to Dymschitz to request more support for Defa, pointing to "the most important event of recent days, the appearance of Erich Pommer. . . . If we cannot hold our lead now, there is a danger that film production capacities will go over to the Americans." Even if the authenticity of this letter is doubtful,[51] its logic is authentic. Deploying the enemy as an argument in order to win more support from one's own leadership did not preclude personally good relations between the opponents. As Kurt Maetzig recalls, Pommer had "no aversion to us and was happy to be seen as a guest at the premiere of the first Defa feature film, *The Murderers Are among Us.*"[52]

Two rooms in a villa in Dahlem made up Pommer's residence in Berlin. Among the Allied cultural officers, he was probably the only one to employ a personal servant, or rather reemploy one, for Bruno Pahlow

had worked in his villa on Winklerstrasse in Grunewald prior to 1933. Pahlow prepared dinner parties for Pommer and his old colleagues and friends—including Hans Tost, Günther Rittau, Robert Herlt, and Fritz Thiery—who soon afforded him a better understanding of those who had remained in Germany. Pommer quickly recovered his old friendly relationship from the pre-Nazi period with Eberhard Klagemann, whom he initially considered an opportunist and treated coolly.[53] Less empathetic émigrés like William Dieterle and his wife, who visited Pommer in Berlin in the fall of 1946, took offense at this and circulated rumors that Pommer wanted to remain in Germany after his official duties ended to begin his own film production. Gertrud Pommer saw reason to bid her husband to be cautious in all statements to third parties: "How easy it is to be misunderstood by people and how careful one has to be not to be misinterpreted!"[54]

The plans for the new German motion-picture industry Pommer presented at several press conferences after his arrival recalled in a clear, unambiguous, and express manner the period of his former prominence. Like German cinema after 1918, postwar German cinema would be defined by the "rich tradition of poverty and ingenuity." Hence a renunciation of everything that was economically unfeasible and better left to American and French cinema anyway: "No pompous stage magic. No offerings to the masses. No cinematic luxury. No stardom. Instead a focus on artistic ingenuity. The undistorted image of people in our time. . . . The reality of our ruins is dearer to us than a film castle on the moon . . . the fate of a single, helpless veteran caught between nothing and starting over again is dearer to us than the cinematic deployment of every revolutionary summons to arms. Our refugees, our bombed-out population, the future of our youth—these are themes in plenty."[55] In addition to post-1918 German cinema, the Italian postwar film à la Rossellini was evidently the second model toward which Pommer wanted to direct new German production. In concrete terms, this meant that he had to select and grant licenses to German producers and directors who shared these ideas and were capable of realizing them. This soon proved to be the problem. While Rossellini, collaborating with Defa in Berlin, was shooting another of his neorealistic contemporary films of postwar Europe (*Germany Year Zero*), Pommer licensed producers and directors in the Ufa tradition: Eberhard Klagemann and Karl-Heinz Stroux in Berlin, von Baky, Thiery, and Harald Braun in Munich—men as unlikely to serve up the gritty realism of the rubble-filled streets in the "rich tradition of poverty and ingenuity" as David

O. Selznick might a documentary social critique. Those familiar with Pommer's work were not surprised by this move. For at the bottom of his heart, the greatest German producer of the interwar period was a studio producer. Concentrating production in Munich, where the large and intact studio facilities of the former Bavaria film company in Gei-selgasteig were available, was a clear sign of this. Had Pommer seri-ously tried to realize his plans for realistic and contemporary low-budget films, Berlin, despite its comparatively modest studio facilities in Tem-pelhof, would have been the more appropriate site for production. As Staudte's and Lamprecht's films at Defa demonstrated convincingly, Ber-lin offered an on-site location like no other for visualizing the German present.

Apparently Pommer no longer fit into the Berlin of 1946 as he had during the period from 1918 to 1933. His failure to appreciate *The Murderers Are among Us*[56] shows that he in fact did not recognize an aesthetic of "poverty and ingenuity" when he encountered it. Perhaps his tragedy was geographical; he was responsible for building up new film production in the part of Germany whose most important film stu-dios lay in the provinces, and not in the ruin-filled metropolis. Would Pommer have been better able to draw on—not to mention continue— his work from the interwar period if Berlin-Mitte and the studio city of Babelsberg had been his domain? Did he become, like so many other returning exiled urban intellectuals of Weimar culture, a victim of Ger-many's postwar provincialization?

The American film industry remained remarkably calm during Pom-mer's first six months of activity in Germany. In the fall and winter of 1946, a series of articles appeared in the film press containing astonish-ing statements. Pommer was reportedly working in Germany "with a long-range view of building politically-important friendliness toward this country [i.e., the United States] and opening up a tremendous new mar-ket for American films."[57] "Pommer has laid the ground work for ac-ceptance and appreciation of US films by the Germans."[58] "Pommer expected to represent US interests."[59] Given that Pommer's actual task was well known in the film industry's press, the reasoning behind this media policy was curious. Was it perhaps Hollywood's attempt to now win over and entreat the man whose appointment it had been unable to prevent?

If this was the strategy, it was abandoned as soon as it became clear that such expectations would not be fulfilled. This moment came in De-

cember 1946 when Pommer issued the first licenses to German produc-
ers. Hollywood's reaction was swift. Through their spokesman Irving
Maas, the MPEA went public in January 1947, declaring that American
film policy in Germany had taken a fundamentally wrong course. The
New York Times reported on January 18 that in the MPEA's opinion,
the German film industry "was being revived too quickly and on too
broad a scale." Its reconstruction should have taken place more slowly,
or better yet, not at all, for the Germans were better off being "fed
heavy doses of all pictures except those of their own making."

In Berlin these statements were regarded by the military government
for what they were—the attack of a private interest group against a
government policy it disagreed with—and expressly repelled. The event
was regarded as important enough to send a statement to Washington
signed by both the head of Information Control, General McClure, and
the head of the military government, General Clay.[60] At the same time
the MPEA representative in Berlin was instructed that, if he favored
further profitable collaboration with OMGUS's film division, he had
better make sure that attacks like Maas's did not occur in the future.

The MPEA representative, we recall, had his office under the same
roof as Pommer's film division and worked closely with it as a "special
consultant." He served as a liaison between the MPEA and OMGUS in
organizing the distribution of American films in Germany. In January
1947 distribution was still entirely in the hands of OMGUS, and the
MPEA made attempts to transfer it to their own management as soon
as possible. The MPEA representative, who had only recently taken
up his post, on January 1, 1947, was named Robert E. Vining. Pommer
took him aside in several "private discussions" (as he reported home)
and presumed "that he [Vining] has now understood the situation as it
really is. At any rate, he has assured me that he will deliver the most
vigorous reports to the industry with the intention of preventing future
attacks."[61] He could not suspect that the man who to him seemed so
understanding would merely add fuel to the fire. Eight days before Pom-
mer wrote this to his family, Vining had sent his boss in New York the
protocol of an alleged conversation with Pommer—or rather less a con-
versation than Vining's four-page account of Pommer's presumed mono-
logue. It read:

Dear Mr. Maas,

I arrived in Berlin one month ago today. Without comment, I want to record
to you the exact conversation I had with Eric Pommer, when at his repeated

request I went to lunch with him in the Truman Hall on Saturday, February
1, just prior to my departure for Wiesbaden. I am sorry not to have been able
to get this off to you sooner, but after making notes of Pommer's statements
I just had time to catch the train. Here they are and verbatim:

I [Pommer] have observed you closely and I think the time has come for
me to talk to you very frankly. You seem to consider only the American point
of view, whereas I try to see both the German and the American viewpoints.
After all, I am German born and bred and I am only over here because of sen-
timental reasons. Pommer was the German motion picture business once and
Pommer is again. Pommer wants to see the German film business back in its
former position. Here are 60,000,000 people of the highest culture and attain-
ments located in the very heart of Europe. Do you and Hollywood want to
see these millions of good Germans live in a vacuum? As Germany goes in
the next ten years, so will all of Europe, and how stupid the American indus-
try has been about me. When I arrived back here in Germany on July 4, 1946,
I was suspected as being a spy for Hollywood. They would not come to my se-
cret meetings, they would not tell me so little because they suspected me. Then
Zanuck and the others began to blast me in America, and nothing could have
helped me more as every time someone of Hollywood said anything about or
against Pommer all my old German friends flocked to me in droves. I only
get in really good licks at night when all of the important men of the German
business come to my house and we talk business sometimes until two and
after. Not only Germans come, I have the decartelization boys, the economic
boys [from OMGUS], other key people of OMGUS come to dinner. And let
me tell you frankly your real enemies are these boys because I have convinced
them that in rebuilding the German industry I can get them millions in export
credits. They had overlooked the film business until I came.

I am not a young man any more and this is taking a lot out of me, but I
loved the German film business and I want to see it back on its feet once more.
I am 57 and am only getting ten thousand and working like a dog. I did not
ask to come here, they pleaded with me to come. My contract is up in the
early summer and I may not even be able to go back to Hollywood, without
being pointed out as a traitor. Do you seriously believe I am not a friend of
the American industry? My only child is a son, who is working in Hollywood,
happy with the American film business. My wife is living on the coast. I am
not saying I will not return to live in Germany because no man knows his
future. . . .

I built up the German industry once and I would like to do it again be-
cause if I don't the Russians will take what should be German markets away.
Doesn't Hollywood recognize this fact? At my secret meetings I hear all my
old friends have to say and let me tell you this for your own good, if there is
one thing they are united on it is a determination that the old days and con-
ditions when Ike Blumenthal, Al Aronson and all the rest of the boys rode
roughshod over this German market are gone forever, they will never come
back, even if I have to lick them again as I did once. I am a famous producer,
but production is not what I really enjoy it is getting into foreign markets. I

was the Ufa man who was continuously on the road. It was Pommer who was always in London, in Paris, in Prague and all over the Continent. I was smart because I only allowed three, four, five, six of Ufa's best pictures to go out of Germany annually, the ones I knew would be box office abroad. Look what my *Blue Angel* did in addition to sending Marlene to Hollywood. And I am now grooming another girl [Hildegard Knef] Hollywood is going to want to grab. . . . Every day I get mail from Turkey, from Egypt, from all over South America, from Mexico, yes, and from the USA, asking me for German product. I've got the German film business right in my pocket, and there it is going to remain. The Near and Middle east will become a wonderful market for German pictures, this is the game I like to play. All my friends in Hollywood, who were forced to flee Germany, write me asking how much money I need. My former German friends now in New York, Philadelphia, Chicago, and all over America write and beg me to allow them to invest money in my new German productions. . . .

I am a well hated man. Hollywood hates me because they fear the competition of my German pictures. The Russians hate me because I am beating them at their own game, and they know I am keeping the best directors, producers and technicians here in the American zone. The British hate me because they know I have absolute control of all studio facilities. . . . Berlin is going to be the new center of the new Europe. And Pommer would enjoy being the foreign sales manager for German product. . . .

What right has Zanuck to say things against me and against German films? He's just a Nebraska boy and he certainly doesn't have a world outlook. I have great respect for Zanuck and wish I had been half as successful in Hollywood, but when it comes to German productions, past, present or future he talks through his hat. I watch over the dubbing of Hollywood features like a mother with a baby. . . . Where would Hollywood be without Pommer supervising the dubbing for Germany. Every dubbed picture I put through is competition for German films and it means building up not only box office but star values. Yet they point the finger of scorn at Pommer and say he is an enemy. . . . I tried to protect Hollywood until I found I was attacked, now Hollywood can protect itself and I'm not going to stick my neck out any more. I am going to tell you what is my conviction—the American industry has dug its own grave in Germany by its stupid and repeated mistakes. MPEA has even gone to the State Dept. to have me removed from Germany.

I realize that there are those, yourself included, who look with suspicion on my boys like Nilson, Hirsch, Van Eyke [i.e., Van Eyck], and Carl Winston [Pommer's colleagues in the OMGUS film division], and feel they will eventually have big jobs in the German industry. Hirsch and Nilson are just simple boys, Van Eyck is an actor, and Carl Winston is just an old idealist. I am not saying I would not like to have some smart Americans associated in the German film business whether or not they were ever identified with Military Government. . . . Now Hollywood wants to say to Pommer, you can't have Nilson, you can't have Hirsch because they were in Germany as Military Government officers. The pot is calling the kettle black.

Now comes Irving Maas who blasts me in the New York Times. I just
don't understand it as I personally took Irving out to the studios here in Ber-
lin, showed him everything and told him exactly what we were doing. . . .
I know every move the industry is making against me and I'm telling you
frankly this business of Hollywood constantly blasting away at Pommer has
got to stop. . . . I'm damned by everyone and getting no thanks from Military
Government for the job I'm trying to do. . . . And you will be a failure here in
Germany if you don't stop looking for the ghosts under the bed.[62]

This report, which soon became publicly known, was to play an impor-
tant role in the disputes between the MPEA and OMGUS. In many
ways it is puzzling. The original apparently no longer exists. The only
existing copy is in the Erich Pommer Archive in the Manuscript De-
partment of the University of South California in Los Angeles.[63] Erich
Pommer himself called the statements attributed to him "sheer fakery"
and "a series of misquotations and malicious lies."[64] His son John con-
siders them "totally fictitious and concocted by Vining," and in a lan-
guage unlike his father's: "I have never seen or heard my father talk
about himself as 'Pommer' or call industry executives 'the boys.'"[65] Erich
Pommer never would have made any mention of the name Vining, and
certainly not as someone with whom he had had an intimate talk. ("It
is beyond belief that my father would repeatedly request a luncheon
with Vining. It probably was the other way round.")[66] Two of Pom-
mer's colleagues in Berlin at the time, Kurt Hirsch and Eric Pleskow, con-
firm this. In Pommer's private and official correspondence from the years
1946–47, there is no trace of the slang that dominates Vining's proto-
col. Pommer spoke and wrote an émigré's awkward English. In all of
his statements, as in the testimony of others about him, he appears as a
person who behaved loyally to his new homeland and correctly carried
out in letter and spirit the policy of the American military government
in Germany.

Who, then, was the man who put these words in his mouth? No more
is known about Vining than appeared in a brief obituary notice in the
New York Times after his early death (at age forty-eight) in October
1949. He was born in Massachusetts in 1901; worked for several years
as a journalist; took on several public-relations jobs, including one for
Eleanor Roosevelt during the war; entered active duty in the Marines
in 1941; built up the South Pacific division of Psychological Warfare
under General MacArthur in 1943; and from 1946 to 1948 was Eric
Johnston's assistant in the MPAA and MPEA. Vining died "after a brief

illness" in October 1949 in Palo Alto, California, where he had accepted another P.R. job. Though not improbable, it is no longer certain whether his departure from the MPEA was the result of the stir around his report on Pommer. Presumably a man who had once worked for Eleanor Roosevelt (her correspondence, however, offers no mention of him) had certain professional and moral standards. It is astonishing that he would call "verbatim" the words of a meeting that he could not possibly have recorded on tape. His report was at most a recollection of Pommer's statements. Were they—however much Vining distorted them—a true expression of Pommer's thought?

Consider Gertrud Pommer's warning that her husband be on his guard when talking to outsiders and not make statements that could be misunderstood. Coming from his wife, who knew well his tendency to pronounce his opinions spontaneously and make momentary exaggerations, this warning might have been a plea for reservation. Someone who did not know Pommer and bore him ill will had a relatively easy game of provoking the harmless statements Pommer made in annoyance or self-confidence. And as letters to his family show, Pommer did not exactly hold back from such pronouncements. "It looks as if the American film industry will need my good will and help much earlier than I ever expected" (July 29, 1946). "Everyone here from General McClure on down places decisive weight on my opinion." "Overnight my stature with the film industry has soared to an astounding degree. All speeches are made exclusively for my benefit" (August 10, 1946). Taken out of context and maliciously edited, such statements could easily produce the blather in Vining's report. And what Pommer's alleged monologue contained was not entirely false. Given the history of his relationship with Hollywood and Pommer's frequently aired sentiments on this subject, it is possible that with all his distorting malice, Vining had put into words Pommer's unconscious thoughts.

Whatever the truth content of the protocol, its explosive power was obvious. The time bomb ticking beneath Pommer's chair was triggered when OMGUS announced its decision not only to build up German film production but also to release for export German productions from the years 1933–45 and use the profits to finance film stock. The decision was purely economic, made by financial advisers from the now collaborating American and English zones. Neither Pommer nor the film division of Information Control were consulted, and both, as it later

proved, opposed the plan.[67] The films scheduled for export were the apo-
litical entertainment films which had made up the larger part of the pro-
ductions during the Third Reich.

There could not have been a better occasion for the MPEA to once
again strike out against American film policy in Germany, and this time
the industry was not representing its own interests and could count on
popular support. Leading representatives in Hollywood turned in en-
flamed protest to Washington and appealed to the public. In their opin-
ion, allowing films produced in Nazi Germany—that is, Nazi films—to
flood the global motion-picture market and even appear in American
theaters practically amounted to a postwar propaganda victory for the
Nazis. The plan for export, they said, "foreshadows an early restora-
tion of the German propaganda machine and constitutes a threat of the
first magnitude, politically, socially and economically."[68] Unlike previ-
ous attacks, this was no longer a head-on attack against OMGUS, but
an attack against its representative, Erich Pommer. ("The whole film pro-
duction and export program was worked out by the control authorities
in Berlin apparently under Eric Pommer's guidance.") The Vining pro-
tocol was now pressed into service. The pithiest passages appeared in the
press and very quickly transformed Pommer's image. The Jewish émigré
and victim of National Socialism was turned into a power-hungry Teu-
tonic monster, like a figure from one of Pommer's own movies from the
1920s, who had set about continuing and completing Nazi conquest
policies with the help of unsuspecting American officials. Articles con-
cerning the "Pommer case" bore the titles "Secret Anglo-US Plan to Re-
Establish Reich Film Industry Bared" and "'Germany Film Industry Is
in My Pocket' Says Pommer."[69]

However, even this campaign, launched with cinematic melodrama,
ended anticlimactically. OMGUS decided that Vining's protocol was a
fiction and stood behind Pommer. Under the guidance of the acting Sec-
retary of War Petersen in Washington, an agreement was reached be-
tween OMGUS and the MPEA in the summer of 1947. The American
military government would forgo the export of German films, and the
MPEA promised not to interfere with American film policy in Ger-
many in the future. The man who now spoke for Hollywood made a
guarantee that this promise would be kept. Eric Johnston, president of
the umbrella organization MPAA, was judged even by Pommer to be a
person who saw things not only "from the perspective of a 'high pres-
sure salesman' but has the vision to give consideration to the political
conditions as they really exist."[70] Johnston was the kind of business-

man who behaved in accordance with the political leadership, voluntarily renouncing short-term gains in order to better attain long-term goals. He later came up with the motto Partnership Capitalism, which marshaled the American economy into the politics of the Cold War. Johnston corresponded so precisely to the new exigencies of the emerging East-West conflict, it seems astonishing that a campaign against OMGUS and Pommer could ever have occurred during his tenure at MPAA/MPEA.

From the summer of 1947 onward, Hollywood recovered the harmony with government policies it had enjoyed during World War II. A new opponent had been defined—the East—and a new task entrusted to the film world: to lead the charge in this global dispute through its worldwide medium. The remains of the antagonism with Germany were pushed aside. Hollywood declared itself ready to renounce its grand postwar plans by accepting Germany—that is, the part of it that now belonged to the free world—into Partnership Capitalism. "I believe," Johnston announced in Berlin on August 6, 1947, "that the German film industry must be set on its feet again and the Germans should re-emerge as fellow rivals on the motion picture world market."[71] The use of the friendly term "fellow rivals" in place of "competitors" signaled the changed relationship between the old victors and losers as new allies against a common enemy. Erich Pommer's demonization in the spring of 1947 embodied this transition. For a final time Hollywood had pulled out all the stops of the anti-Nazi propaganda of the past. From now on it would direct all of its power and skill of demonization at the new global enemy.

Writers at Large

The demarcation line between the Russian and American sectors neatly divided the part of Berlin's center usually referred to as the newspaper district—Kochstrasse, Zimmerstrasse, Jerusalemer Strasse, Schützenstrasse. This, the material inheritance of Berlin's press industry, fell into the hands of the two main victorious powers in equal parts; Great Britain and France, with not a rotary press between them in their respective sectors, came out empty-handed.

The newspaper district, like the city center as a whole, had been heavily bombed during the war. Yet the destroyed buildings, cellars, and machine rooms housed some functioning machinery that could be reassembled for new purposes. This piecemeal principle of repairs soon put at the Russians' disposal a respectable metropolitan print capacity. Two months after the conquest of Berlin, four daily newspapers with a total circulation of approximately 400,000 copies had been established: the *Tägliche Rundschau*, published by the Red Army; the *Berliner Zeitung*, under the leadership of the returned exile Rudolf Herrnstadt (its official publisher was the Magistrat); the KPD's *Deutsche Volkszeitung* (Paul Wandel and Fritz Erpenbeck); and the SPD newspaper *Das Volk* (Karl Germer and Otto Meier). All four had their seat in the Russian sector, although a considerable portion of their technical facilities had been dismantled in and transported from the neighboring American part of the press district.

When the press division of American Information Control moved

into their offices on Milinowskistrasse in Zehlendorf to confront this discouraging situation, they also found reason to celebrate. In the middle of the American sector, in the Tempelhof district, stood the printing facilities of the former Ullstein Verlag, built in the 1920s. Though damaged by bombings and prey to postwar Russian raids, the building was sturdy enough for reassembly and repairs to produce a satisfactory print capacity with relative speed.

Reassembling the intact parts of Berlin's journalistic personnel proved a more difficult and slower process, a fact the press officer in charge of establishing the first newspaper in the American sector confirmed. Peter de Mendelssohn numbered among the émigrés from the 1930s who returned to their homeland with the Allied armies. He was thirty-seven years old in 1945. In 1930, at age twenty-two, he had published his first novel, *Fertig mit Berlin* (*Finished with Berlin*), which appeared with some success, as the reviews and the fact of a second edition show. His career as a journalist in Berlin before 1933 had begun with promise: at eighteen he had begun in the editorial department of the respected *Berliner Tageblatt*, then worked in the Berlin office of the United Press news agency, eventually serving as a correspondent in London and Paris for the *Berliner Tageblatt* and other newspapers. Then came 1933 and emigration, leading Mendelssohn to Paris and Vienna on his way to London. In 1944 he joined the British-American division of psychological warfare, and in this position he was charged with seeking out German journalists for the first of the American-licensed newspapers in Berlin.

For a young man like Mendelssohn, who lived with and within literature, the situation must have seemed the fulfillment of a Rastignac-like fantasy: half of the newspaper district now lay at the feet of a man who twelve years before had been but a small cog in the great wheel of Berlin's press industry. In 1945, when many a lieutenant in the Allied occupation army was entrusted with decisions usually left only to business moguls and state secretaries, this was not an exceptional occurrence. During these years another exiled writer three years Mendelssohn's junior, Hans Habe, ruled over, as he later said with more accuracy than modesty, the "greatest newspaper empire in the world" (i.e., the entirety of the U.S. Army division's published newspapers for the German population: a circulation of 4.6 million).[1] The meeting between Habe and Mendelssohn in Berlin in the summer of 1945, at least in Peter de Mendelssohn's view, also bore traces of a certain romanticism. They had met in Vienna as young men. Habe, known at the time as the scandalous

rake Hans Bekessy, had been involved with a literary-minded young woman named Hilde Spiel,[2] who was later to marry Peter de Mendelssohn. In July 1945 Mendelssohn described to his wife Habe's arrival in Berlin as "a complete circus" carried out "in full prima-donna style."[3] Habe came to Berlin to establish the last of his army newspapers. When the erstwhile youthful friends and rivals met again as newspaper founders, the feeling of competition between them rose to a new level. "I am quite determined," Mendelssohn wrote to his wife, "to show him what a newspaper is and what it isn't. It is too funny and absurd that we should finally meet for the great contest in the same field on equal terms. The whole thing makes me laugh when I think how it all started."[4]

Habe's newspaper—which was really run by his collaborator Hans Wallenberg[5]—started appearing soon after under the title *Allgemeine Zeitung* and was a great success. Even Mendelssohn joined in the general praise: "His [i.e., Habe's] circus has really performed extremely well, they have done a superb job. . . . Everybody is simply green with envy."[6] The format and intellectual quality of the *Allgemeine Zeitung* recalled bourgeois intellectual papers like the *Vossische Zeitung* and the *Berliner Tageblatt*. Anyone not apprised of the fact that it was an American military newspaper might not have noticed. However, the army newspapers were meant to be only a transitional phase toward a German-run press industry, and their duration was limited from the outset. Mendelssohn, with a commission to establish a permanent German newspaper, had the upper hand over Habe this time.

Ten days after his arrival in Berlin and ten days *before* Habe arrived, Mendelssohn had already completed his proposal for a newspaper and formulated it in a memo. It anticipated the *Allgemeine Zeitung* by several weeks. References to German precedents like the *Frankfurter Zeitung, Vossische Zeitung,* and *Berliner Tageblatt* were unmistakable. The paper to be established was supposed to address an educated, bourgeois audience and, as Mendelssohn wrote in his memo to General McClure, was to be "of the highest standards and highest possible quality." It was presumed that this kind of journalistic venue would provide the most expedient means of influencing public opinion. Mendelssohn's hopes increased when Berlin's reading public—having endured twelve years of the *gleichgeschaltete* Nazi press, indeed sensitized by this very experience—showed little trust in the four newspapers published in the Russian sector because of their pro-Soviet stance. There was a readership in Berlin, Mendelssohn continued, "from the pre-Hitler period which was accustomed to a well-rounded, polished press of high intel-

lectual standards." Mendelssohn's plan was modeled after, indeed envisioned a resumption of, newspaper culture prior to 1933. This held true in personnel matters as well. "The group to be licensed. . . . on the basis of the democratic tradition it represented in the pre-Hitler period . . . should be accorded respect and authority in the journalistic field. It should not be a collection of completely unknown men, however good and honorable their intentions might be."[7]

When he presented his memorandum to McClure and the latter accepted it despite resistance within Information Control,* Mendelssohn had already contacted media figures from the Weimar period. Two days after his arrival in Berlin he held his first discussion with Heinz Ullstein, the only member of the Ullstein press and publishing dynasty who had remained in Berlin during the Third Reich. To Mendelssohn, this "calm, modest, unassuming man [with] a balanced cosmopolitan outlook and, for a German, remarkably clear grasp of the present world situation"[8] seemed to offer an ideal link to the pre-1933 newspaper world. The Ullstein name stood for liberal and democratic traditions in Germany, and issuing the first newspaper license to the last Berlin representative of a family dispossessed and banished by the Nazis[9] would be something of an "act of reparation and clear moral justice" (Mendelssohn). Negotiations with Heinz Ullstein stretched over several weeks, and it looked as though the reestablishment of the Ullstein house were only a matter of time. Not only did most of these meetings occur in the former Ullstein printing house, but Ullstein himself had recruited most of the prospective journalists: Paul Wiegler, the critic and former head of the literary division in the Ullstein Verlag; Rudolf Kurtz, an author of film books who now collaborated with Wiegler; and Ernst von der Decken. Ullstein was the youngest in this circle of sixty-year-olds. After several discussions, Mendelssohn noticed that Ullstein and his associates were more interested in a tabloid than in his plans for a serious newspaper. His eyes were opened to the journalistic ethos of the group by Rudolf Kurtz, who remarked with indifference that instead of a tabloid "something like the *Vossische Zeitung* could of course also be done, if that was Mendelssohn's intent."[10] The first round ended with Mendelssohn's

*In Mendelssohn's later account, several members of Information Control were "against the creation of a high-caliber 'intellectual' newspaper . . . and advocated a popular paper with the greatest possible mass impact" (*Zeitungsstadt Berlin,* 533). Though Mendelssohn never mentions it, it is also conceivable that the circles in Information Control still hoping for a quadripartite newspaper published in collaboration with the Russians were against setting up an American-licensed paper altogether.

recognition that the Weimar press, at least in its Ullstein incarnation, was not the shining model he had hoped for but "a journalistic tradition . . . dated, outmoded, and even discredited."[11] Their subsequent parting of the ways did not follow on such good terms as were later described by Mendelssohn and Ullstein in their memoirs. "Herr Ullstein," Mendelssohn reported to McClure in fall 1945, "was persuaded, after most difficult negotiations, to make way."[12]

While negotiating with Ullstein, Mendelssohn had contacted another interested party headed by the writer Hermann Dannenberger, known under the pen name Erik Reger. Born in 1893, Reger also belonged to the older generation of journalistic figures, but unlike Ullstein, Wiegler, and Kurtz, he did not come from the press milieu. In the 1920s and early 1930s he was an independent writer who occasionally contributed to the *Frankfurter Zeitung, Vossische Zeitung,* and *Berliner Tageblatt* without bowing to journalistic constraints and the routine of newspaper publishing. He had proven his independence with a 1931 novel that established his name in the literature of the late Weimar Republic. *Union der festen Hand* presented the economic and political power structure in the Ruhr industry but avoided the usual manner of moral and social critique. As one critic wrote, Reger's interest was the "sovereignty of the phrase," in all its uses, ramifications, and effects he had grown familiar with as a publicist for the Krupp Company. His novel was a "pathography of the journalistic existence . . . a tale of suffering between self-hate and melancholy, bouts of omnipotence and attacks of resignation."[13] Reger was awarded the prestigious Kleist Prize in 1931. One of his notable journalistic achievements before 1933 was the article series "A Natural History of National Socialism," published in the *Vossische Zeitung* in August and September 1931. After temporary exile in Switzerland (1934–36), he spent the Nazi period in Germany. In 1938 he joined the Deutscher Verlag (as the former Ullstein Verlag was renamed in 1937) as an editor and worked in the printing house in Tempelhof. Beginning in 1943 he lived in Mahlow, south of Berlin, and there he witnessed the war's end. His first encounter with the Russians, for which he armed himself with the Russian edition of his novel, ran smoothly.

Reger was among those writers who—motivated by both moral and material considerations—were determined after the war not simply to supply publications, newspapers, and magazines but to become publishers themselves. Only a few days after the Russians occupied Mahlow, on May 15, he sought out the local commandant to discuss the possibilities for implementing this plan.[14] The four-and-a-half-page "memo-

randum" he composed afterward, which he apparently understood as an application for a license, proposed the establishment of a "publishing company for journalism and literature." Its purview would be everything from journalistic daily events to literary book production. His declared overarching aim was the desire to contribute to the reeducation of the German people.[15] The project did not move beyond this stage, and the only trace of it, Reger's memo, is now lying in the Archiv der Akademie der Künste in Berlin.

In retrospect it is clear why Reger was not the right man for the Russians. He neither belonged to the KPD nor sympathized with it, had no contact with any of its members, and kept his distance from the other parties that received newspaper licenses from the Russians in the summer of 1945 (the SPD, CDU, and LDPD). He did not fit into the Russians' newspaper plans. American ideas of a liberal and independent press published by well-known Germans, on the other hand, seemed cut out for an independent mind of his sort.

So how did Peter de Mendelssohn and Erik Reger cross paths? Heinrich von Schweinichen, a wholesale paper merchant whom Reger had met during the war through the publisher Ernst Rowohlt, served as the catalyst. Schweinichen, a successful businessman and devout Christian, had used his connections during the war to siphon off large amounts of paper to print the works of his friend and Catholic philosopher Reinhold Schneider—a dangerous undertaking given the strict paper ban on religious publications. Even riskier was his collaboration with Fritz Kolbe ("George Wood"), the most important German agent in the OSS, the American secret service. Schweinichen passed along information through Kolbe and by means of his numerous business and personal trips to Switzerland (his wife, Nelly, was Swiss).[16] After the Americans arrived in Berlin, the OSS asked him to draw up a list of Germans not suspected of Nazi involvement and suitable for prominent positions. Presumably Reger's name was on the list, but it is unclear why it took so long for Mendelssohn to contact him. Either the OSS list did not end up in his hands, or he had overlooked Reger's name. In any case, the collaboration between Information Control and the OSS did not seem to be particularly good. It is conceivable that, for reasons of institutional jealousy, Information Control made a point of ignoring all suggestions originating from the OSS. The two accounts Mendelssohn later gave of his meeting with Reger support speculation of this sort.[17] However uncertain the details, it is clear that Heinrich von Schweinichen was responsible for introducing Erik Reger to Mendelssohn.

Reger had meanwhile elaborated upon the plans presented to the

Russians in his memo. The new proposal was thirteen typed pages in
length and carried the title "On the Reconstruction of the Press in Post-
Hitler Germany."[18] It must have provoked an intellectual coup de foudre
in Mendelssohn. As he later wrote, it showed "clear, courageous, un-
compromising thought and apparently came from someone fundamen-
tally engaged with the problem, joining boldness of thought with a
strong feeling of responsibility, imagination, and a sense of style with
practical knowledge and experience"[19]—in short, everything Mendels-
sohn had sought in vain from the Ullstein group.

As in his memorandum to the Russians, Reger again stated as his
principal goal the reeducation of the German people, but this time in a
more comprehensive way. He argued that Germany's disastrous course
in the twentieth century was the result of its misguided development
reaching back to the nineteenth century. His proposed newspaper would
have as its most important task enlightening and correcting those er-
rors and leading the Germans back to the path of Western culture. The
process would not be an externally imposed reeducation but a German
self-purification arising from within and leading to national maturity.

The *Tagesspiegel,* as the newspaper Reger received a license for was
named (certainly not without an allusion to the earlier *Tageblatt*), would
have been something like the Kulturbund's program for "democratic
revival" in newspaper form.

Their shared goals seemed to promise a sympathetic relationship in
which both would complement each other in the most harmonious way.
And indeed for the first three months, up until the controversy over the
KPD/SPD merger, this was the case. As Susanne Drechsler, a communist
editor who left the *Tagesspiegel* in February 1946, wrote, "There were
lengthy meetings every day, attended by all of the members of editorial
staff, including the volunteers and archive workers. Every political, eco-
nomic, and cultural issue would be discussed together and handled
according to a majority decision . . . the operative guideline was non-
partisanship, allowing equal say for all political orientations. In the fore-
front: educating the Germans to democracy. . . . There was particular
importance put on impeccable German style. All expressions that re-
called the phrases of the previous twelve years were forbidden."[20] Very
soon, however, the *Tagesspiegel* produced the first and sharpest cri-
tique of the Kulturbund, and conversely, from the circles around the Kul-
turbund emerged the sharpest rejection of the *Tagesspiegel.* At a time
when ideological and political oppositions were still contained within
relatively civilized discussions, there was no restraint when it came to

the *Tagesspiegel*. The communists called it a "reactionary mouthpiece" and a "forum for all underground fascist tendencies," claiming that the publication had "no right to exist" in the new Germany.[21] This reaction was understandable, as the *Tagesspiegel* for its part accused communist politics of Nazi methods. The *Tagesspiegel* contributed to the accelerating political polarization through its early and uncompromising identification of National Socialism with communism, a stance Reger had adopted even before 1933.[22] By calling events like the KPD/SPD merger and institutions like the Kulturbund totalitarian and comparable to Nazism, in the eyes of the communists the antifascist front was abandoned—and not only in their eyes. In late 1945 Ferdinand Friedensburg wrote to his friend Edwin Redslob, who had meanwhile become a copublisher of the *Tagesspiegel*: "You must certainly be aware or suspect that, whatever its isolated shining achievements, the *Tagesspiegel* is not exactly making friends among all those who, like me, have been actively yoked to the task of political and material reconstruction."[23] Surveys conducted by the American military government also revealed that many readers judged the newspaper's orientation too decisively Western and irreconcilable toward the East. "The American national observer," "one hundred percent American," "more papal than the Pope," the verdicts ran.[24] For adherents of East-West conciliation in Information Control, Reger's quarrelsome attitude also exceeded the allowable limit. They desired fewer "pin-prick attacks" against the other side and more substantive discussions with it.[25] Leftist liberal Americans also had reason to rank the founding of the *Tagesspiegel* a political defeat. For Peter de Mendelssohn was not the only American press officer who came to Berlin in the summer of 1945 to issue the first American license. While Mendelssohn had set about his task, Cedric Belfrage, who had already made a name for himself as the founder of the leftist *Frankfurter Rundschau*, turned up in Berlin to explore the possibilities for a paper like the *Rundschau*. In a meeting between Belfrage and Wilhelm Pieck, Erik Reger's name was mentioned as a possible candidate for publisher, which suggests just how unstable the journalistic situation still was.*

*The only trace of Belfrage's mission, a handwritten note of August 24, 1945, is in the Wilhelm Pieck estate of the former SED party archive. Belfrage and his collaborator Adler (it is not clear whether this was Ernst W. Adler or Eric J. Adler) are referred to not as officers from Information Control but as "American journalists." This may have been a misunderstanding, or an indication that the men were not on an official mission but on a secret one. As there is no record of this in the OMGUS files, the latter seems possible. It

Reger was unimpressed by both the communists' noisy polemic and the quiet criticism of several OMGUS officers. Moreover, he found new and reliable support in Mendelssohn's successor Bert Fielden, one of the anticommunists in Information Control. Reger pursued the three entrenched viewpoints of his political stance: strict antifascism coupled with equally strict anticommunism; the rejection of any suggestion in any form of continuing "Germany's special course"; and the consistent, complete, and unconditional identification with the West. The assertion that Reger continued on unflinchingly does require some qualification. He was the most important publisher of the *Tagesspiegel* but, according to American licensing practices, not the only one. Officially the three copublishers at his side shared equal power: Heinrich von Schweinichen, the art historian and former *Reichskunstwart** Edwin Redslob, and the journalist and critic Walther Karsch (who had also been Carl von Ossietzky's final collaborator on *Die Weltbühne*). After a short stint with the KPD in the summer and fall of 1945, Karsch had come round completely to Reger's ideological and political view. More interested in art and literature—that is, the feuilleton section—than in politics, he very gladly left that domain to Reger. From the very beginning, Edwin Redslob was only an ornamental honorary for the *Tagesspiegel*, being involved in entirely different projects (principally, estab-

is also conceivable that Belfrage and Adler represented circles in Information Control who advocated the idea of a quadripartite newspaper in Berlin. (See chap. 5 above.) The note states expressly that the new newspaper was to be "similar to the *Frankfurter Rundschau*." The other candidates for the position of publisher in addition to Reger were Walther Karsch, Stefan Heymann (KPD), Siegfried Nestripke (SPD), Otto Nuschke (CDU), and Georg Handke (KPD).

Herbert Sandberg's memoirs provide additional evidence that there were plans to set up an American-licensed "leftist" daily paper in the summer of 1945. While in the concentration camp in Buchenwald, Sandberg had met Emil Carlebach, a communist and later the copublisher of the *Frankfurter Rundschau*. Apparently Carlebach, accompanied by two American officers, sought out Sandberg in Berlin in the summer of 1945 and offered him a "license for the cultural editorship of the *Tagesspiegel*." Herbert Sandberg, *Spiegel eines Lebens* (East Berlin, 1988), 59. Since editorial posts were not licensed, this must be an error on Sandberg's part: either Carlebach offered him the cultural department of the *Frankfurter Rundschau*, or the two American officers who visited him in the summer of 1945 were Belfrage and Adler, trying to win him over for their proposed Berlin newspaper.

*The office of *Reichskunstwart* was created in 1919. Its task Edwin Redslob described as consisting of the "Formgebung des Reiches" (visual design of the Reich), roughly the equivalent of today's corporate-image making. In this function he selected the artists and designers for banknotes, coins, stamps, seals, posters, and so forth, as well as the architects for public buildings. Redslob, the only person to hold this office, was fired in 1933.

lishing the Free University). Heinrich von Schweinichen, the businessman whose skills had earned him responsibility for the financial side of the undertaking, seemed the least likely of the copublishers to offer competition or opposition. He had secured contractual assurance of editorial responsibility for "the cultivation of the religious sentiments of the German people" from his partners, but they regarded this dismissively as their business partner's private idiosyncrasy.[26] It was known that Schweinichen's devout Catholicism was the result of a personal crisis a few years before upon receiving a diagnosis of multiple sclerosis.[27] Reger, Redslob, and Karsch had even more reason to indulge their colleague in this small matter when he advanced all three the initial capital of five thousand reichsmarks each and defrayed the start-up costs from his own pocket.[28]

The first sixth months of the *Tagesspiegel*'s operation passed without any discord among the publishers, essentially because they had hardly any contact with one another. Reger, considered a difficult and even unpleasant person, was avoided by all and handed a carte blanche; Karsch focused on his theater reviews; and though the edifying articles by Schweinichen that appeared occasionally looked odd, they were not a serious bother to anyone.

Hence Information Control's decision in June 1946 to revoke Heinrich von Schweinichen's license, effective immediately, was that much more surprising. In and of itself, this was nothing unusual. Licenses were frequently revoked when their holders later turned out to have been involved with the Nazis or no longer fit into the political landscape of the commencing Cold War, like the leftist publisher of the *Frankfurter Rundschau*. Reger's partisanship in the debate over the KPD/SPD merger in 1946 had already exposed him to the threat of revocation by clashing with the reigning American policy of neutrality.[29] But what did the Americans find so dangerous about the upright businessman and devout Catholic Heinrich von Schweinichen that one day he was simply shown the door?

The official explanation cited no concrete grounds, merely stating that he had "acted in a completely irresponsible manner . . . [and] not only conspired against his co-licensees but . . . also endeavored to thwart the goals of the American military government. Driven by selfish motives, he let himself become a tool of foreign interests."[30] There was little indication of what these foreign interests might have been. Schweinichen had supposedly made himself "the spokesman for politically very active

rightist groups who sought to influence the *Tagesspiegel*'s standpoint."
Given the handful of articles Schweinichen had published in the *Tages-
spiegel* up to that point, this charge seems to have rested on as little
truth as the official explanation for Gustav von Wangenheim's later dis-
missal from the Deutsches Theater.

There has been no explanation of the Schweinichen case to this day.
His name is missing from the *Tagesspiegel*'s masthead, which includes
the names of the other founding publishers. The only evidence of his
presence in the *Tagesspiegel* archives is a few of his articles. Erik Re-
ger's papers make no mention of him at all apart from a remark in a
private letter that his case was "tragic."[31] There is also no trace in the
few papers left behind by Bert Fielden, the control officer for the *Ta-
gesspiegel*. The court records of the civil suit Schweinichen later filed
against his copublishers no longer exist, and with the exception of his
extensive correspondence with his friend and mentor Reinhold Schnei-
der (which contains no mention of his case), there is no archive of
Schweinichen's papers. Last but not least, the document that prompted
his fall no longer exists: a sixteen-page report on the *Tagesspiegel* writ-
ten by one Jasper Petersen. A few days after Schweinichen had passed
along the report (which he apparently identified with, though he later
denied this) to his colleagues, his license was revoked.

The few extant documents and information from other sources do
nevertheless offer an approximate reconstruction of how the man largely
responsible for Reger's successful move into newspaper publishing col-
lided with him and was probably booted out at Reger's bidding. The
head of Information Control in Berlin, Colonel Leonard, relayed the
contents of the Schweinichen-Petersen report with the following remark:
"It [i.e., the *Tagesspiegel*] should become more nationalistic and less
pro-American in its trend."[32] What was meant by Schweinichen's "na-
tionalism"? Was this the correct term for his ideological and political
outlook? Had a nationalistic wolf merely donned the guise of Christian
lamb for the Americans and Reger? The answer is that Heinrich von
Schweinichen was businessman, Catholic, and German patriot in equal
parts—a patriot not in a nationalist sense, but comparable to Ferdi-
nand Friedensburg in his views. Schweinichen believed that Germany,
and the newspaper he copublished, should ally itself with neither East
nor West but pursue its own independent course. Though he and Reger
agreed in their antifascist and anticommunist standpoint, he must have
realized that his views violated two of Reger's three unwritten rules. Re-
ger must also have known that his plans for renouncing all thoughts of

Germany's independence and promising unconditional alliance with the West would meet with opposition from Schweinichen, whose convictions were well known to Reger. Schweinichen came from the same circles of the Silesian nobility that had produced the Kreisauer Circle, and though not himself a member of this resistance group, he was close to prominent members like Hellmuth von Moltke[33] and must have shared their outlook on Germany. In Reger's view these German resistance fighters had been discredited as opportunists who served the Nazis as long as it benefited them and broke away in protest only once the situation ceased to work to their advantage. "We can't use these people," Reger wrote in his diary in the spring of 1945,[34] and this ultimately came to be his opinion of Heinrich von Schweinichen as well. From Reger's political perspective, whoever did not support strict identification with the West entertained the dangerous old vacillating political course that (as he had described in his memorandum) was responsible for everything and should be opposed in all forms by the means of the newspaper entrusted to him. In June 1946, Reger triumphed over his colleague and former patron. Ironically, only six months earlier it might have turned out just the opposite. With his objection at the time that the *Tagesspiegel* had abandoned its nonpartisan and objective position through its stance in the KPD/SPD controversy ("we have become a pamphlet for the SPD"),[35] Schweinichen then was toeing the American line of party neutrality much more loyally than Reger, who for this very reason had also nearly lost his license.

KURTZ

In 1945–46, failure to obtain a license from one Allied power did not mean remaining forever on the sidelines in the quadripartite city of Berlin. Unlike the zones of occupation, which were ruled by a single power, Berliners always had three alternatives and, operating like a collective Talleyrand (in Isaac Deutscher's terms), took full advantage of them.

After his first failed attempt, Heinz Ullstein did not even need to switch sectors. A few months later, apparently as a kind of consolation prize, he received an American license for a women's magazine (*Sie*) and could pursue his popular press concept without interference from intellectual puritans like Mendelssohn. Each member of the Ullstein group soon found a niche in the new media venues that cropped up between fall 1945 and spring 1946: at the French-licensed *Kurier* and the

British-licensed *Telegraf;* in the ever expanding Berliner Rundfunk; at the new American station DIAS/RIAS; in the Berlin branch of the British station NWDR; at the Berlin edition of the American *Neue Zeitung;* or at one of the numerous new magazines. Rudolf Kurtz, who had declared the group's accommodating stance if a revived *Vossische Zeitung* were preferred over a tabloid, also found his place in the fall of 1945.

At sixty-one Rudolf Kurtz, whom one colleague once called a "comic figure" and an "energetic simpleton,"[36] was a man long past his prime. "Discovered" shortly before World War I by Alfred Kerr, he was one of the young talents of the first years of Berlin's literary expressionism. He authored the editorial of the first issue of *Sturm* and, pursuing his early interest in film, wrote a book on the subject, *Expressionismus und Film* (1926). In the 1920s he became chief editor of the magazine *Lichtspielbühne,* and later turned his attention to writing comedies. He seems to have enacted his descent into the routine of established literary figures like an aging Brechtian Baal.

The newspaper that appeared for the first time on December 7, 1945, with Kurtz's name as chief editor, looked like the tabloid that he and Ullstein had wanted to create under Mendelssohn. The *Nacht-Express* was slick and superficial, a casual, frivolous, and entertaining newspaper that readers, as Kurtz supposedly once said, should be able to "buy at Alexanderplatz and toss away by Friedrichstrasse."[37] The sports section commanded considerable space, and the feuilleton section was disproportionately large for a newspaper of this type. The latter was edited by Paul Wiegler, Kurtz's friend in the Ullstein circle. Since the failure of that project, Wiegler had been busy in various positions, writing theater reviews for the *Allgemeine Zeitung,* editing the literary section of the Kulturbund's magazine *Aufbau,* and working as a manuscript reader for the Aufbau Verlag. He was apparently on such good terms with Johannes R. Becher that the two later in 1948 founded the magazine *Sinn und Form.*[38] When his work at the *Allgemeine Zeitung* ended with the paper's discontinuation in late 1945, Wiegler saw a welcome replacement in the *Nacht-Express,* recently founded by his friend Kurtz.

The feuilleton section of the *Nacht-Express* was a one-man show in the first year of the paper's publication. The only signed articles, mostly theater reviews, were by Wiegler. Everything else had been previously published: poems, short stories, and essays by well-known authors of the past. This changed slowly in the course of the following year. The *Nacht-Express*'s feuilleton grew more concerned with contemporary

events. New and younger colleagues joined the staff, none of whom, however, was able to achieve the prominence of Wolfgang Harich at the *Kurier* (later at the *Tägliche Rundschau*), Walther Karsch at the *Tagesspiegel,* and Friedrich Luft at the *Neue Zeitung.* The only person to represent the paper on the Berlin feuilleton scene remained Wiegler, a sixty-seven-year-old man long past his creative youth in the Wilhelmine period and ready for retirement, who now spent his days writing harmless feuilletons and well-wishing reviews with no bite.

In distinction to the omnipresence of Paul Wiegler in the feuilleton, contributions by chief editor Rudolf Kurtz were absent. Only the masthead indicated that this man held the position. This oddity had to do with the veiled operation of the tabloid. If political commentaries appeared at all, they were unsigned. But even if all articles had been signed, it would have been impossible to find Rudolf Kurtz's name among them. For the chief editor of this newspaper was the least enterprising of its journalists. His friend Klaus Poche offered (with no malicious intent) the following description of the *Nacht-Express*'s chief editor: "He spent the entire day in his pajamas. We had a large conference room. . . . Kurtz lived next door to this conference room. He read in there or dozed or fussed with his housekeeper. . . . When he came to visit us, he simply pulled on his suit over his pajamas." And regarding participation in daily editorial conferences: "Kurtz came from his room in his bathrobe. Kugler [local editor and chief of staff] said: 'All right, I can sum it up briefly. A fantastic issue. The format is right on, the weather is beautifully laid out, the local page is where it should be, the supplement as good as always. The masthead is correct.' Kurt took a brief look and said merely: 'Fantastic!'"[39]

How had this Oblomov landed the post of chief editor? And what allowed the *Nacht-Express* to function with Kurtz in this position? Berliners who picked up the first issue of this new evening paper on December 7, 1945, did not have an easy time making sense of it. Apart from being printed on Mohrenstrasse—that is, in the Russian sector—there was no indication of its origin or background. The lack of any kind of editorial commentary in the political section gave the impression of distanced objectivity. Representation of both Eastern and Western news agencies, with perhaps a slight leaning toward the Western side, added to this impression. When American Information Control surveyed opinions on the *Nacht-Express* in a poll in June 1946, only 23 percent of those asked considered it a Russian-controlled paper; the remaining 77 percent considered it an independent paper.[40]

The *Nacht-Express* was a Russian creation. Its four German pub-
lishers, including Rudolf Kurtz, received both their licenses and the
start-up capital from the SMAD.[41] The arrangement resembled that of
Defa with its blend of Russian capital and Russian control over a me-
dium made by Germans for Germans. But unlike Defa's boss, Alfred Lin-
demann, there was no dominating German figure at the *Nacht-Express*.
The position of chief editor, which Rudolf Kurtz occupied sleeping or
dozing, was in fact filled with great vigor by a Major Feldmann of the
SMAD, who had started up the undertaking, serving as its brains and
motor until his mysterious disappearance in 1949. As Eugenia Kazeva,
a colleague of his in the SMAD, recalls, Feldmann was one of the Jew-
ish intellectuals from Leningrad so numerous in the intelligence divi-
sion, a "small, round, mobile, and very clever man."[42] The Western press
speculated about his sudden disappearance, voicing suspicions that he
had fled to the West.[43] It is more likely that, like many of his Jewish col-
leagues, he fell victim to the Stalinist anti-Semitic campaign of the late
1940s. A German mistress may have served as the pretext for his arrest.
Feldmann established the paper's political standpoint with such a subtle
hand that its presence remained hidden to most readers. Presenting news
reports taken from Western agencies without commentary had the de-
sired effect of provoking readers' own reactions. The column "Voices of
the Press" took on an important function at the *Nacht-Express*. Con-
trary to usual practice, it appeared on the front page, selecting from
Western coverage of political events—from the *New York Times* to the
Daily Worker—everything that criticized Western politics and presented
Eastern politics in a favorable light.

Among themselves, the German editors who worked under Feld-
mann called the *Nacht-Express* the "evening edition of the *Tägliche
Rundschau*."[44] Though untrue in terms of personnel and financial mat-
ters, the comparison captured accurately the character and function of
Feldmann's paper. The *Nacht-Express* resembled less the SMAD's heavy-
handed official mouthpiece than the type of newspaper conceived by
Willi Münzenberg in the 1920s to break out of the KPD's journalis-
tic ghetto. The papers Münzenberg had created—*Welt am Abend, Ber-
lin am Morgen,* and *Neue Montagszeitung*—were at first glance tab-
loids: heavy doses of sports and entertainment, with political coverage
served up only on the side and indirectly. The readers of Ullstein and
Scherl's mass publications, whom these animated papers were supposed
to lure away, were as unaware of this strategy in the 1920s as the read-

ers surveyed by Information Control in 1946 who failed to recognize the subtle alignment of the *Nacht-Express*. The aim of Münzenberg's newspapers, "winning over indifferent readers" (Rolf Suhrmann),[45] was apparently also what the Russians attempted with the *Nacht-Express*. Alexander Dymschitz formulated it like this: "It is very important for us that if possible the majority of Berliners considers the *Nacht-Express* an American paper."[46]

And what about Rudolf Kurtz? The old bohemian had never shown an interest in politics, still less in communism, and was even reported as saying, "Marxism is nothing but rubbish."[47] When he entered Russian service after the American license failed to materialize, he was as indifferent to the change of sides as he had been earlier about the question of whether he produced for Mendelssohn a tabloid or a paper styled after the *Vossische Zeitung*. Concerns about involving himself with a Russian Trojan horse seem not to have occurred to him. But what motivated the SMAD to put a man notoriously that unsympathetic to their ideology in this position?[48] The duration of this strange relationship (lasting eight years, until the *Nacht-Express* ceased publication in 1953) belies the possibility of a mistake or oversight by the party. It was a partnership advantageous for both parties or, more precisely, a barter: for his name on the masthead Kurtz was guaranteed the comfort of his lounging pajama existence. His tenure at the *Nacht-Express* was an example—carried to the point of caricature—of what Sheila Fitzpatrick has described as the system of bartering interests between the party and intellectuals that had developed in the Soviet Union in the 1930s and, after the war, began to characterize the society and culture of the Russian zone in Germany.

DIE WELTBÜHNE

Among the intellectuals who roamed between the political spheres in Berlin in the years 1945–48, Erik Reger's copublisher Walther Karsch was one of the most agile. Early in the summer of 1945 he joined the newly founded KPD. Later that summer he became a copublisher of the *Tagesspiegel*, and when the newspaper's political stance became clear in the fall, he left the KPD again.[49] Who was this man whom the Eastern side henceforth labeled "Chameleon Karsch"?[50]

At the age of thirty-nine in 1945, Karsch belonged to the generation of intellectuals and literary figures who were about to enter public life

in 1933 when their careers were cut short by the Third Reich. Karsch's leftist tendencies had emerged early. While a student at Berlin University (where he studied German literature, history, and philosophy) he had joined the independent socialist Roter Studentenbund. From 1931 onward, he worked as the assistant to Carl von Ossietzky at *Die Weltbühne*. The period before the outbreak of the Third Reich was too brief for him to have made his name as a Nazi opponent and potential enemy of the state. Karsch spent the next twelve years renouncing all writing and journalistic activity—that is, in a strict sense, in inward emigration—at times unemployed, and occasionally working as a commercial representative.[51]

His inclination to consider the KPD his new political home after the war is as understandable as his effort to pick up where he had left off in 1933. Toward that end, regarding himself as the legitimate heir to the *Weltbühne*'s last editors Ossietzky and Tucholsky, he hoped to relaunch the flagship of Germany's independent leftist intelligentsia.

On July 3, 1945, he wrote to Johannes R. Becher ("Dear Comrade Becher"), the newly elected president of the Kulturbund, with his proposal. Explaining that he had worked "very closely with Carl von Ossietzky at the *Weltbühne* up until the day of his arrest," Karsch said that he now wanted "to revive the old *Weltbühne* in a new form, but entirely in the Ossietzky spirit. . . . I believe I have earned this right by renouncing the further pursuit of my literary career in 1933 and remaining silent for 12 years—in the conviction that for an activist writer from the left with a polemical disposition, any attempt to continue publishing under the Nazis must have ended unfailingly in intellectual corruption."[52] Karsch's request that Becher find "a few moments of time for the question of the *Weltbühne*"—that is, discuss the possibility of reestablishing the magazine—seems not to have been granted or at least not to have resulted in the support Karsch had hoped for. The only indication that Becher spoke with Karsch, thereby sustaining his hopes, is an article Karsch wrote about Ossietzky for *Aufbau,* the magazine Becher copublished. The piece made broad hints of Karsch's intent: "He [Ossietzky] demanded of us ultimate clarity, ultimate precision of expression, ultimate purity of thought. And that is precisely what we most have need of today after 12 years of intellectual and linguistic degeneration, when we undertake with the pen to do our part toward solving the immeasurable tasks of our time."[53]

By the time these lines appeared however, Karsch had already found his position at the *Tagesspiegel,* and the *Weltbühne* project was over for

him. Unbeknownst to him, in the summer of 1945 another figure from Carl von Ossietzky's life emerged with plans to revive the publication.

After caring for her husband until his death in 1938 in a hospital in Berlin, Maud von Ossietzky, née Woods, spent several months in a nerve clinic. Thrown off the track of an orderly bourgeois existence, she was shadowed and troubled by the Gestapo and led an unsteady life. Born the daughter of a British colonial officer in India in 1888, she had been a self-confident and independent suffragette in her youth. Her marriage to Ossietzky in 1913 and relocation to Germany had given her life a new focus. With Ossietzky's death she lost her greatest source of stability and became an alcoholic.[54]

One of the few people with whom she had contact after 1938 was Hans Leonard, a former salesman for a publishing house and now himself thrown from the bourgeois track by the Nazi racial legislation. After the war ended, the name Ossietzky, which at the order of the Gestapo Maud Woods was no longer allowed to use after 1938, acquired a new resonance, and their initially passing acquaintance altered. People showed interest in the widow of the mythical Ossietzky. According to Maud's (admittedly unreliable) memoirs, a swindler ("Jack a.k.a. Franz Krüger") tried to capitalize on it. Hans Wallenberg, formerly an editor at Ullstein and now the founder and chief editor of the *Allgemeine Zeitung,* apparently visited her to discuss the possibilities of a new *Weltbühne.*[55] There was a general interest in making Ossietzky's widow the starting point of a new *Weltbühne* project.

Employed as a civil servant in the Pankow district in the summer of 1945, Hans Leonard had long assisted Maud von Ossietzky in practical matters and now entertained similar thoughts. He was no intellectual, rather a salesman with leftist tendencies and cultural interests, both prompted by his family background. His father was Hugo Leonard (originally Lewysohn), a composer and conductor, and his parents had been friends of the Liebknecht family. Until 1933 Leonard had no express party affiliation, but after the war he declared a commitment "in spirit to. . . . the adherents of the USPD and later the KPD" in his curriculum vitae.[56] His career had led him through several of Berlin's music and theater publishers and included a job under Siegfried Jacobsohn, the publisher of the *Weltbühne.* Like Walther Karsch, Leonard survived the Nazi period as a commercial representative and joined the KPD at the about same time. He was forty-three years old when the war ended.[57]

At first Leonard pursued the *Weltbühne* project alongside his official position in Pankow. One of his first actions was to rid Maud von Ossietzky of the swindling "Jack a.k.a. Franz Krüger." Moreover, he saw to it that she received a spacious apartment at No. 10 Lützowplatz, large enough to house the planned editorial rooms as well. He drew up the application for a license, which Maud, who still possessed British citizenship, then submitted to British Information Control. And, once the granting of the license seemed assured and merely a question of time, he undertook the first practical business steps toward implementing the new magazine. Negotiations with the manager of the printing house in Tempelhof—where in these months the *Allgemeine Zeitung* was printed and the *Tagesspiegel* prepared—revealed that it was ready and technically in a position to accept a commission to print the new *Weltbühne*. The matter was pursued so quickly and optimistically that Leonard soon received the first offprints of the cover.

As 1945 drew to a close, everything suddenly came to a standstill. Although Maud von Ossietzky received the license applied for, it was revoked soon thereafter. The explanation given was a preexisting title on the name *Die Weltbühne*.[58] The name was the legal property of two émigrés living in New York, Hermann Budzislawski and Helene Reichenbach. They had read of plans for the *Weltbühne* in the New York newspaper *Aufbau* and immediately lodged a protest at British Information Control, stating that they had bought all the rights to the *Weltbühne* (published in exile in Prague after 1933) from Siegfried Jacobsohn's widow in 1934. The legal ghost of the *Weltbühne* name, which was to stir up confusion again in 1990, after the fall of the wall, made its first appearance in 1946.[59]

The protest from New York led to a hurried search for substitute titles back in Berlin. Versions like "Carl von Ossietzky's Weltbühne" and "Carl von Ossietzky—Welttribüne" were suggested, and their circumstantial subtitles proclaimed what thin copyright ice they were on. Two examples: "A Magazine for Politics, the Arts, and Science in the Spirit of the Founding of Siegfried Jacobsohn and His Successors Carl v. Ossietzky and Tucholsky, Published by Maud v. Ossietzky"; "A Magazine for Politics, Arts, and Economy. Dedicated to Carl v. Ossietzky, the Last Leader of the *Weltbühne*."[60]

While Hans Leonard debated the sense and nonsense of such formulations with British control officers, he realized that his own partnership with Maud von Ossietzky lacked all legal basis. His next step was to contractually formalize their common interests and respective ob-

ligations. The ten-year contract signed between Leonard and Ossietzky's widow on February 17, 1946, established that Maud would serve as publisher of "Carl v. Ossietzky's *Weltbühne*" and Hans Leonard as the magazine's executive editor (with a monthly salary of four hundred reichsmarks). A few months later, Leonard's functions were defined more precisely—"director, executive editor, designer"—by an additional agreement. The business shares in the new venture were fixed at 60 percent for Maud and 40 percent for Leonard.[61]

A look at the financial side of their undertaking, which Leonard had meanwhile also taken charge of, shows how much the personal friendship had become a business partnership. Unlike large licensed publications such as the *Tagesspiegel* and *Nacht-Express*, which received material support from their respective occupational powers, the *Weltbühne* was a private initiative pursued by two individuals who could expect nothing from the military government beyond a license. None of the Western powers were interested in financing the revival of an intellectual magazine from the Weimar period. The situation was different in the KPD, which granted its member Hans Leonard an interest-free loan of twenty thousand reichsmarks on January 15, 1946, for his project.[62] On March 9, Leonard transferred this sum to the recently established Maud von Ossietzky Verlag at an interest rate of 3 percent. It was stipulated by contract that this loan was made on the condition that Maud received the British license and would be canceled in the event she did not.

The first issue of the magazine, which came out in early June after all of these obstacles and delays, brought a further surprise—this time for British Information Control. As though there had been no protest from New York and no wearisome negotiations over a new name, the title appeared as it had in the original application: *Die Weltbühne*. And the license under which the magazine was published was not the British one applied for, but a Russian one. Hans Leonard later explained this sudden change of sides by claiming that the English had thwarted his plans in spring 1946 for political reasons. He also suspected the British and Americans of wanting to outmaneuver him and create a Western version of the *Weltbühne*.[63] Accordingly, nothing was more natural than to anticipate this development with his own tactical move. Given the dates, what occurred was more likely a matter of hasty scrambling than careful planning. On May 29, 1946, the British press officers received a written notice from Maud von Ossietzky "that I have decided . . . not to use . . . the license granted to me." The authorities who

had granted the new license were not named. A few days later, in early June, the first issue of the *Weltbühne* appeared. Given the production schedules of the time, the issue must have been put together and printed before May 29. Nor could the Russian license indicated in the masthead have been issued by the time of printing: it bore the date June 1 and was not received until days after the publication of the first issue on June 6.[64]

The circumstances of the revival of the *Weltbühne* and the circle of people who assisted in it suggest that the new version, despite the marks of identity (format, graphics, color), had little in common with its predecessor. Even the production site—in the building of the *Nacht-Express* on Mohrenstrasse—did not particularly evoke confidence in this respect. Was the *Weltbühne* supposed to function among intellectual magazines like the *Nacht-Express* in the tabloid press?

Walther Karsch's initial reaction shows that Hans Leonard's project was at first not seen as such even by critical contemporaries. His livelihood meanwhile secured as a publisher, Karsch followed Leonard's activities with a reaction of both indifference and goodwill; indifference because he was himself no longer involved, goodwill because it concerned the *Weltbühne*.

The only whiff of sour grapes after his unsuccessful approach to Becher was a declaration of disinterest in the new *Weltbühne* and a claim that "I had considered the whole idea completely preposterous."[65] Karsch was evidently still interested enough to keep himself updated on events at Lützowplatz through his friend and fellow critic Wolfgang Harich. Moreover, in February 1946 he wrote an article for the new *Weltbühne* about its predecessor, titled "Kantstrasse 152," the seat of Ossietzky's original publication.

Karsch's article never appeared. His authorship as copublisher of the *Tagesspiegel* had meanwhile become "intolerable"[66] for the KPD and hence also for Hans Leonard. What followed was open enmity. The *Weltbühne* ran articles that referred to Karsch as "Chameleon Karsch" and sought to ridicule his name and discredit him through the implication of dishonorable actions. Karsch revenged himself with a polemic, "On the Misuse of a Name," in which he reproached Leonard's *Weltbühne* for having abandoned the independence always maintained by Ossietzky and turning the magazine into an instrument of the SED.[67]

But such antagonism was the exception in the *Weltbühne*'s first year of publication. The majority of the contributors to the old *Weltbühne* hailed its reappearance as a significant event and the magazine as a se-

rious forum. As late as 1949 Leonard received assurances from Thomas Mann "that the *Weltbühne* under Jacobsohn and Ossietzky could have looked no different than it does under the present global circumstances."[68] A look at the authors published that first year gives the impression of an unorthodox publication composed of liberals and communists: Erich Weinert, Erich Kästner, Herbert Ihering, Axel Eggebrecht, Gert H. Theunissen, Karl Korn, Wolfgang Harich, Karl Schnog, Friedrich Luft, Curt Riess, Horst Lommer, Günther Brandt, Paul Rilla, Albert Norden, Günther Weisenborn, Paul Merker, Herbert Eulenberg, Egon Erwin Kisch, Fritz Erpenbeck, Kurt Hiller, Edgar Morin, Alfred Kantorowicz, Lion Feuchtwanger, Wolfgang Leonhard, Kurt R. Grossmann, Ralph Giordano, Walther Kiaulehn, Alexander Abusch.

In September 1946, as part of the run-up to the Magistrat elections, the *Weltbühne* published an article by SPD member Josef Grunner about SED/SPD relations. Thereafter it renounced discussion of explosive topics of this sort. In 1947 the pluralistic reservoir dried up more and more. One after the other, authors living in the West ended their collaboration, maintaining silence like Erich Kästner or protesting loudly like Kurt Hiller.

In Leonard's opinion, Hiller provided an important voucher for the continuity of the old *Weltbühne,* just as Maud von Ossietzky did as co-publisher. However, Hiller did not let himself be so easily used as Ossietzky's widow. When Leonard suggested that he write about "topics of a pacifist character" since he lived in London and would likely not be able "to take a timely stance on every issue of the day,"[69] Hiller refused and posted an ultimatum. Forewarned by Karsch, with whom he was in contact, Hiller made his continued collaboration contingent upon the fulfillment of two conditions Leonard could not meet: first, the *Weltbühne* was to apologize to Karsch for the libelous statements printed against him; and second, it was to print an open letter of Hiller's to Wilhelm Pieck "in which I suggest a pairing of liberal socialists and communists and other progressive groups, but first I declare it absolutely necessary to cleanse the party of a certain clique of Stalinists that has returned."[70]

This silencing of liberal and independent voices on the left corresponded to the ever-increasing presence of the SED. Günther Brandt, an independent leftist on the Berlin intellectual scene of 1945–48 forgotten today, was a regular commentator in the *Weltbühne*'s first year of operation, almost something like the paper's chief columnist. When he ended his involvement with the magazine, Alexander Abusch, the

official party censor of the *Weltbühne*, took his place in 1947 to provide supervision and commentaries.[71] However, before ranks closed completely, there was a final attempt to take seriously and revive the old *Weltbühne*'s tradition of independence, which Leonard from the very beginning had worn on his lapel like an ornamental badge. It was undertaken by a young man who like no other embodied the caprices and vicissitudes of Berlin's intelligentsia in the transition from the Third Reich to the Cold War.

HARICH

When the twenty-two-year old Wolfgang Harich entered the Kammer der Kunstschaffenden in June 1945 as Paul Wegener's personal assistant, it was the beginning of a career that was soon to make him one of the most influential public voices on culture in postwar Berlin. At Schlüterstrasse Harich became acquainted with Berlin's cultural scene and what had remained of its leading representatives. When the Kammer's end approached, he joined the French-licensed newspaper founded in the fall of 1945, *Der Kurier*. As a theater critic, he soon made his name as an *enfant terriblement intelligent* with his casual polemic and caustic style. He once accused Rudolf Pechel, publisher of the *Deutsche Rundschau*, of collaboration with the Nazis, although Pechel had been a concentration-camp prisoner during the Third Reich. Pechel revenged himself with a character sketch that appeared under the title "From Himmler to Harich" and referred to Harich as "a pure intellect on two legs, a kind of homunculus," continuing his description:

> No self-control, no inhibition, no reverence, intolerant to the last, no respect for human dignity, for other people's convictions and achievements, no self-discipline or self-criticism, no heart or emotional capacity. Looking for a fight for fight's sake, a manipulator of thoughts, protean, and of use everywhere since he has no convictions to change. Quick to make friends, quicker to make enemies. A cold flame, which emerges most painfully when he takes a stand on something: the phrases merely bubble from his mouth, he himself remains completely uninvolved. . . . Like everyone without substance he requires an opponent he can propel himself off of. . . . All in all of an amusing malevolence, an ingenious wunderkind who might be pardoned for much, even his own inner senility, and indulged like a court jester.[72]

Ernst Niekisch, who had no personal feud with Harich, called him "a mobile talent, but without true creative depth."[73] As the case of Gus-

tav von Wangenheim shows, his reviews seemed capable of destroying. Another of his victims, Käthe Dorsch, responded with a slap in the face delivered publicly in the club Die Möwe. The incident became the talk of the town and a part of the image in which Harich and Berlin's cultural public apparently all took pleasure. At any rate it was no exaggeration when Harich esteemed himself one of "the most popular journalists in Berlin" in 1946.[74] He was a friend of Friedrich Luft, his peer and colleague who also found quick success on the cultural scene. Harich later claimed that both were aware at the time that the fulfillment of their youthful dreams was due to the fact that the older critics who should have occupied such positions had emigrated or been murdered or discredited.

Like all young intellectuals not satisfied with earning their bread by writing feuilleton articles, Wolfgang Harich and Friedrich Luft also made plans to found a magazine. *Die Brücke* was meant to remain independent of the occupation powers and pursue a third way.[75] The critic Werner Fiedler, who had impressed both young men during the Nazi years as one of the few writing what Harich later characterized "reviews and not *Kunstbetrachtungen*,"*[76] was supposed to assume the journalistic leadership, and Fritz Hellwig, former publisher of the fashion magazine *Die Neue Linie,* to oversee the technical and organizational management of the project. According to Harich, the application for a license was submitted to the British.[77] In fall 1945, Harich and Luft were so certain of the outcome that Harich registered himself as the representative of *Die Brücke* on the attendance list for a press conference at the Kammer der Kulturschaffenden.[78]

When, however, for reasons that according to Harich were connected to the magazine's intended independent course, plans for *Die Brücke* came to nothing, he set his sights on—this time without Luft—Leonard's *Weltbühne* project as a replacement. His participation in discussions with Hans Leonard and Maud von Ossietzky from January 1946 onward was so regular that the three essentially formed a trio. For Leonard, who was not exactly familiar with Berlin's intellectual and literary scene, Harich seemed precisely what was missing. With his influence,

*Kunstbetrachtung, the term the Nazis substituted for *Kritik* (criticism), implied the absence of any element of what they referred to as "destructive intellectualism." Since works of art requiring fundamental opposition were (in the Nazi understanding) not supposed to enter the public realm anyway, everything that did enter was automatically entitled to the pacificity of *Kunstbetrachtung.* Literally, the word means "looking at art."

contacts, and good nose for the cultural zeitgeist, Harich could approach potential collaborators and serve as the magazine's necessary scout on the intellectual scene. The question was whether this spoiled salon intellectual, accustomed to equal success in Berlin-Mitte, Zehlendorf, and Karlshorst, would be satisfied with the role of scout as Leonard understood it.

After his own plans for *Die Brücke* sank, the temptation to jump aboard Leonard's *Weltbühne* was too great for Harich to resist. The project could offer everything *Die Brücke* had failed in securing: a license, financial backing, organization, even—to take Leonard at his word—the intention of continuing Ossietzky's independent path. And Harich took Leonard at his word. The KPD/SPD merger in 1946—particularly the role the KPD played in this—prompted Harich to present Leonard with his conception of the *Weltbühne*'s autonomy. His eight-page letter to Leonard of April 7, 1946, was a veritable declaration of independence. Harich favored the merger, but not through the methods of pressure, intimidation, and haste used by the KPD leadership and the SMAD. The errors of both sides—the KPD and SPD—should be censured. ("We will often have to deal out sharp criticism of both parties . . . and often even deride functionaries on both sides.") About the magazine's autonomous course he wrote:

> We have the task of creating a synthesis between bolshevism and Western, bourgeois liberal democracy. . . . The condition is that the proletarian mass movement converts to the fair playing rules of democracy *and* to radical socialism. . . . The *Weltbühne* has never been opportunistic. It must seize the chance here in Berlin, where the four world powers have come together, to unite the various currents into one living movement. . . . In this effort, neither the British license nor the receipt of orders in Berlin-Mitte [i.e., at KPD/SED headquarters] can be decisive, nor the fact that I live in Dahlem, that Weinert is returning from exile in Moscow, or that Karsch is a concessionaire at the *Tagesspiegel*.[79]

Perhaps Harich did not yet know at this point that the SED man Leonard could never accept such demands. Perhaps he wanted to see how far he could go before Karsch's lot caught up with him. In the spring of 1946 Leonard apparently still found Harich too indispensable to advise him of the situation or part ways with him. And since matters were still in an unbinding planning stage, Harich's statement of opinion was simply filed away without further ado.

The situation changed in June 1946, when the matter became con-

crete with the first issue of *Die Weltbühne* appearing under Russian license. Without repeating the plans for autonomy proclaimed two months earlier, Harich now requested for himself the position of executive editor "under your supervision and following your orders," as he assured Leonard. At the same time he also made clear that he regarded Leonard as responsible solely for the organizational aspects of publication and himself for conceptual and editorial concerns.[80] When Leonard issued him a flat refusal ("An editorial position is out of the question," he wrote to him, though, he added, he would "gladly . . . count you among our regular collaborators"),[81] Harich did not give up, but went all out, trying to achieve his aim via a detour to Karlshorst. Harich apparently had friends and patrons there, SMAD officers who valued him for his intelligence, amiability, and contacts to the Zehlendorf intelligentsia (including American control officers). Shortly after Leonard's refusal, Harich was summoned to Major Davidenko,[82] the officer responsible for the *Weltbühne* in the SMAD's propaganda division. A few weeks later Leonard described to his party friends what happened there, speaking of himself in the third person:

> Herr Harich and Comrade Leonard both appeared before Major Davidenko. Herr Major Davidenko disclosed to Comrade Leonard the SMAD's wish that, given the enormous significance of the *Weltbühne,* a large number of intellectually prominent collaborators should be carefully brought together, including Wolfgang Harich, considered very capable. Comrade Leonard replied that for months there had been extensive collaboration between the *Weltbühne* and Herr Harich, but in the course of the discussion Herr Major Davidenko seemed to stress closer collaboration.[83]

Davidenko decided that Harich should write and present Leonard with a proposal of his plans and demands. Harich had apparently already prepared such a report, and he appeared with it the following day in the editorial offices on Mohrenstrasse. As Leonard wrote in his report to the party, an "excited discussion" ensued. With the SMAD supposedly covering his back, Harich now demanded unlimited editorial control. His proposal did include an "advisory editorial board," but the editor—that is, Harich—was "to be absolutely independent in his work" and Leonard given no say in editorial decisions. ("Concerns himself only with the business side of the undertaking. . . . Apart from his seat on the advisory editorial board, Herr Leonard has no influence whatsoever on the editor in everyday editorial work.")[84]

Harich was probably unaware of the true power relations he attempted to influence in the summer of 1946, just as he would be ten years later when he delivered a report directed against the Ulbricht leadership to the Soviet ambassador to East Germany, Puschkin.[85] His protest in 1946 did not lead, as in 1956, to immediate arrest, but it provoked a chain of reaction similar to that later event. Leonard mobilized the SED leadership (Weinert, Ackermann) and presumably pulled strings in the SMAD far beyond and above Major Davidenko. The result was that at the next meeting Leonard and Harich were summoned to, Davidenko no longer insisted on increasing Harich's prominence at the magazine, but instead suggested that he be satisfied with the role of freelance collaborator.

Either this statement was too diplomatically worded or Harich was too deaf to note it. There is no other explanation for his again approaching Leonard four weeks later. He repeated his old demands, this time spiced with strong language and personal invectives. He called the previous editions of the *Weltbühne* "dilettantish muddling," a "miserable mess" produced "with a lot of phlegm and great internal uncertainty," and though Leonard himself was "a good publisher . . . I consider you completely incapable of any kind of editorial work. . . . Therefore in the interest of the *Weltbühne* it is urgent that you step down as chief editor and make way for another."[86] Given his lack of backing in Karlshorst, the move seemed a quixotic challenge or the harmless threat of a child. Informed of Harich's true lack of influence, Leonard could now assume the role of the discreet and forbearing adult, and simply ignore the young man's statements and demands. This was the quiet and anticlimactic end to the struggle for the *Weltbühne* that Wolfgang Harich had begun so stridently and dramatically. He continued to work for Leonard as a freelance feuilletonist, both men behaving as though a dispute had never occurred between them. Did this confirm Rudolf Pechel's judgment? Had the "manipulator of thoughts" so "quick to make friends and quicker to make enemies" quickly reconciled himself to the situation, swiftly forgetting the whole thing as nothing more than an escapade of the "ingenious wunderkind . . . indulged like a court jester"? The disapproval that Harich like a magnet continued to attract until his last days was surely based on his peculiar blend of seriousness and capricious youthful posturing. The scale of reactions stretched from the slap given to him by Käthe Dorsch to the prison sentence handed down by Walter Ulbricht in 1957. Harich's reaction to all this perhaps confirmed his childlike mentality. He endured his pun-

ishments with equanimity, and almost with a touch of satisfaction, as though he saw in them a confirmation that acknowledged and dignified his pranks.*

After Harich's attack was successfully countered, *Die Weltbühne* experienced a short-term upsurge beyond all expectations, only to sink again rapidly. In the second half of 1946 the net profit totaled 235,000 reichsmarks, but for the whole of the following year only 198,000 reichsmarks. The net profit of 52,000 reichsmarks in the first six months of 1948 dropped to 12,000 reichsmarks in the second half of the year.[87] The currency reform, a death knell for many magazines, explains the decline in 1948. But the decline in 1947 was due to the disappointment of many readers of the old *Weltbühne*. An eager welcome for the return of Ossietzky's magazine had resulted in the unexpectedly high circulation in the first year of publication. However, as one independent author after another ceased collaboration and the magazine's declared autonomy proved merely empty talk, the readership dissolved. What followed was predictable. When the decimated profits first became a loss in 1949, the SED once again stepped in to provide financial backing—but this time not as the provider of a loan. As Leonard explained in a later report to Zentrag, the holding company for all party firms: "The press was reclaimed by the party, Comrade Leonard confirmed as executor, director, and chief editor. The press was subordinated to Zentrag."[88]

The final remaining connection between the *Weltbühne* and the name Ossietzky was also dissolved with this overhaul by the party. Though

*Among Rudolf Pechel's papers is a document—setting aside the question of its authenticity—that bears on this point and deserves attention. A number of statements Harich supposedly made about himself were reported by a man named Willy Huhn, who introduced himself to Pechel as an old friend of Harich's. Making reference to Pechel's article "From Himmler to Harich," Huhn wrote a letter to Pechel on November 2, 1946, containing passages "for your personal information" from an autobiographical sketch made by Harich in 1944. The following are selections from the letter: "I am more a gossip than a philosopher! Without gossip and the morbid society that continually provides it with new material, I would rather not live. It is also terribly amusing. It is of psychological note that when caught up in amusing gossip the feeling of one's own amusing nature increases beyond all measure. . . . I will confess to a familiarity with chicanery and hysteria in my own nature. When in moments of depression, which is not unknown even to a blithe favorite of the gods like me, I see through myself, chicanery and hysteria open their arms to receive me. . . . Without chicanery I would never have gotten into the consulate, nor become Admiral N's secret council and MT's lover. I need chicanery to get to 'the right places' because I am still so young, but once there, I need it to be able to show what positive impact I am capable of, whether. . . . in the consulate, as a lover or as a philosophical student. . . . I would also like to bring to your attention Thomas Mann's *Bekenntnisse des Hochstaplers Felix Krull* published by Insel." Pechel Archive, vol. 42, Bundesarchiv Koblenz.

Maud von Ossietzky had never really been active as a publisher and had left everything to Hans Leonard (though complaining at times about this situation),[89] in 1950 she withdrew completely from the enterprise run in her name. For a monthly settlement of one thousand reichsmarks she renounced all rights to the magazine and Carl von Ossietzky's literary estate, and agreed to fashion "her planned memoirs only in harmony with the political course of the *Weltbühne* [and] the policies of the GDR" and have it published "by a GDR-licensed press."[90]

Epilogue

TIME CAPSULES
1933—1945—1989—2000

When the Third Reich collapsed in the spring of 1945 and the historical clock was set back to an assumed "hour zero," there was an optimistic feeling in Germany of being faced with a tabula rasa, an empty field inviting a totally new beginning. The fall of an empire, everybody seemed to be convinced, is like the collapse of a building: the old structure ruined, the lot becomes empty and ready for a new construction.

As there are neither zero hours nor immaculately new buildings, it follows that whatever is being constructed will to a degree be based on the rubble of its predecessor. As all the stories told in this book show, the recycling of materials followed the simple twofold design—avoiding what was bad in the previous building, and cultivating and fostering what was good.

There is yet another image to which the situation of collapse can be likened. Earlier in this book we spoke of the cultural situation in Berlin in the spring and summer of 1945 as something akin to the opening of a time capsule. The time capsule opened in 1945 was the cultural scene before its violent shutdown in 1933. After twelve years of suppression and freeze, Berlin culture resembled the newly awakened princess, rubbing her eyes, and feeling ready to pick up where sleep had overtaken her. Certainly, unlike the fairy-tale palace, the city had physically suffered in the meantime, her artistic and intellectual community exiled, murdered, and otherwise silenced and disciplined. But like the neurotic

who in the face of crisis easily protects himself by regressing into a previous—that is, unthreatened—stage of memory, those witnessing the collective collapse of 1945 regressed into the Berlin of January 29, 1933—that is, the day before Adolf Hitler became chancellor. Here they found consolation and direction; here they saw a point of reference. From here they could sort out how best to approach the task of rebuilding.

When forty-four years later the Berlin Wall came down and soon thereafter the empire of which it was the symbol and first bastion, the feeling that the historical clock had been set back was again universal. Few felt that the fall of the Wall brought us back into the year when it was built: 1961. In that year the Soviet Empire was at the zenith of its power. Now, with Communism's fall, most commentators agreed that the clock was set back to the time before the Soviet Empire had advanced into the heart of Europe—that is, before the world order of Yalta and Potsdam. But soon everybody concluded that the clock was not just set back to 1945. Since 1991, ever more distant time-encapsulated epochs have been discovered and opened. Today there is general agreement that, after the dissolution of the Soviet Union, the European order of the 1990s is closer to that of the Versailles Peace Conference of 1919 and to the world before the October Revolution than to that of the Cold War. In places like ex-Yugoslavia, these turns have meant opening a Pandora's box reaching back into the seventeenth century.

The two Berlins of 1945 and 1989 are strangely and intimately related. For in the years following 1989 it became ever more evident that though the scene reopened was 1945, it pointed backward toward 1933. In other words, the Communist collapse revived not only the Nazi collapse (more exactly, the memory of that collapse) but also that of the first German republic. The German mind after 1945 always had a hard time understanding the sequence of these collapses. In the short interregnum period between the end of World War II and the beginning of the Cold War there were attempts, as we have seen in the previous chapters, to work out and get an understanding of these two national traumas. But in the Cold War they froze into hostile ideologies. In East Germany the formula became state-sponsored "Antifascism," in West Germany "Freedom and Democracy." True, the new generation of the 1960s and 1970s slaughtered some of the ideological cows of their fathers. Over and over the "68ers" stated how ashamed they were about what their fathers had done, and that they were ashamed *for* their fathers. As sincerely as these confessions were meant, in the end they were in their way as unreal as the East German version of "Antifas-

cism" or, for that matter, as the contemporary sentimentality of West-
ern middle-class students toward the struggling Vietnamese people:
naïveté à la Marie Antoinette.

The reopening of German history in 1989–90 has put an end to this
kind of easy political morality. Germany is no longer a larger version of
Switzerland or Denmark, Berlin no more a slightly more populous Tri-
este, a sleepy island for draft evaders and other dropouts. It will again
be the capital of the most powerful nation in Europe. And in this regard
it will be closer to the city of January 29, 1933, or to the Berlin of the
immediate postwar years than to the East-West phenomenon of the Cold
War. Post-1990 Berlin brings us back to 1945–48 Berlin, and from there
we continue our travel to 1933.

All of this can be physically experienced in the central district of
Berlin-Mitte.

The center of Berlin, we remember, was the most thoroughly de-
stroyed part of the city. It was the dead "crater" around which the ur-
ban "circle" of the two postwar Berlins reconstituted itself. This center
remained a wasteland well into the 1960s. Most of the monumental
ruins that in 1945 had impressed Stephen Spender and others were
blown up and leveled in the 1950s. What before the war had been one
of the busiest square miles in Europe (Potsdamer Platz, Leipziger Platz)
continued as the desert it had become in 1945. And this character did
not change when in the 1970s and 1980s the East German regime put
up several nondescript shoebox containers for administrative and resi-
dential purposes. One might say that this space of defeat went from a
theater of Colosseum-like Nazi ruins through a 1950s wasteland (re-
sulting from their being dynamited) to an uninspired, flat, bureaucrati-
cally vapid architecture of a failed Socialism. Today this square mile is
Europe's largest construction site. It seems as if fifty years of immobility
and frozenness are being erased in an attempt to compensate for and re-
live the time lost. And while this battle of construction is going on (or
more exactly, before it began), the past has resurfaced. Wherever bull-
dozers began to dig up the terrain they hit upon foundations, cellars,
bunkers—such as the Gestapo-cellar on Prince-Albrecht-Strasse and a
forgotten section of Hitler's Chancellery bunker on Voss-Strasse. Walk-
ing the empty surfaces of Berlin-Mitte after 1989 felt like walking on
catacombs, or through a modern Valley of the Kings.

Simultaneously, claims of previous ownership surfaced. Properties
seized during the Third Reich whose owners had long ago been mur-
dered or died in exile were claimed by and often awarded to their heirs.

Old Berlin family names that in the past sixty years had become distant memories and that by now sounded more familiar in New York and Los Angeles suddenly were present again. Max Reinhardt's heirs claimed— and obtained—the building of the Deutsches Theater. Members of the Saloschin family claimed and got the Schiffbauerdamm-Theater—since 1949 home of the Brecht-Ensemble—and caused consternation when they handed the title over to a dubious enterprise set up by the play-wright Rolf Hochhuth (the long-ago and one-time celebrity of *Der Stell-vertreter*), who seems now to be trying to turn it into his personal play-ground. George L. Mosse, an American professor of history and heir to the Old Berlin publishing empire (*Berliner Tageblatt*), claimed and re-ceived the building on Jerusalemer Strasse, making sure of its restora-tion to its original design by Erich Mendelsohn. The Deutsche Bank and all the other corporate owners of palatial headquarters along Unter den Linden and its side streets had their properties restituted and are now renovating them into their future national headquarters. The Hotel Ad-lon, the Berlin version of the New York Plaza Hotel, has returned to its old site at Pariser Platz, opposite the lots where the American and the French embassies are being rebuilt. Friedrich Schinkel's Bauakademie at Werderscher Markt, blown up in the 1950s and replaced by the shoe-box building of the East German Foreign Ministry in the 1960s, is pres-ently being reconstructed (after the Foreign Ministry was demolished in its turn in 1995). The same sort of reconstruction-revenge is being dis-cussed regarding the Schloss. Blown up in 1950 and replaced in the 1970s by the nondescript Palast der Republik, the latter's fate has in the meantime been sealed: it will be demolished. The discussion now is only about whether to restore the Schloss in every detail, or to just follow its dimensions. The same goes for famous streets such as Wilhelmstrasse (the Berlin equivalent of Downing Street, Quai d'Orsay, and Pennsyl-vania Avenue) that in the forty years of Communist *anti-histoire* were stripped of their names and identities, and are now again what they were until 1945 and 1933, respectively. Sometimes one gets the feeling that the Berlin of the 1990s is becoming a replica of the Berlin of the 1920s. Or, perhaps more precisely, the result of a gigantic attempt to make it the museum of its own past, a museum not of originals but of *Blade Runner*–like replicated reality.

Until the year 1999, when according to schedule the German gov-ernment will officially move from Bonn to Berlin, "Mitte" will be a brand-new ghost town, not unlike the Brasilia of the late 1950s before the government transferred from Rio. There is no historical precedent

for such a determined rebirth-reconstruction of a national capital as re-united Germany is now undertaking. The whole enterprise may turn out to be highly ironic. Because the thoroughness, the expense, the luxury with which it is being conducted may belong to a period that ended, without anybody noticing, in exactly the year the decision was made to move the capital of the new Germany to Berlin. It may be that Berlin, as the capital of what has already been baptized the "Berlin Republic," in the year 2000 will be the true incarnation of the great global change of climate: an empty shell of luxury, subsequently filled, as the marble palaces of fifth-century Rome, by a decidely nonluxurious neobarbaric population. But then again, this is not so absolutely new an experience for Berlin. After all, in 1918 a similar thing happened when the collapse in World War I, the revolution, and subsequent civil war took over the opulent imperial city, and all resulted in the creative stimulation of Weimar Berlin.

Appendix

Archives

KOBLENZ

Bundesarchiv

MARBACH

Deutsches Literaturarchiv

MUNICH

Stadtbibliothek, Monacensia Collection
Private archive of Peter de Mendelssohn (Anita Naef)

HAMBURG

Staats- und Universitätsibiliothek, Manuscript Department

NUREMBERG

Germanisches Museum, Manuscript Department

KARLSRUHE

Badische Landesbibliothek, Manuscript Department

FRANCE

Archive of the Foreign Ministry (Paris)
Achives de l'Occupation d'Allemagne et d'Autriche (Colmar)

GREAT BRITAIN

Public Record Office (London)

RUSSIA

Center for the Preservation of Historical Documents, formerly Party Archive of
 the Communist Party of the Soviet Union (Moscow)
Central State Archive (Moscow)
Archive of the Foreign Ministry (Moscow)

UNITED STATES

National Archives (Washington, D.C., and Suitland, Md.)
Library of Congress, Manuscript Department (Washington)
University of Southern California, Manuscript Department (Los Angeles)
Harvard University, Houghton Library, School of Architecture and Design
Private archive of Erich and John Pommer (Camarillo, Calif.)
Private archive of Robert A. McClure (Chico, Calif.)

Interviews

Henry C. Alter (Dobbs Ferry, N.Y.)
Annemarie Auer (Berlin)
Boleslav Barlog (Berlin)
Günther Cwojdrak (Berlin)
Phillip Davison (Princeton)
Margot Derigs (Berlin)
Stefan Doernberg (Berlin)
Alexander Peter Eismann (Waldachtal bei Tübingen)
Wolfgang Geiseler (Berlin)
Arseni Gulyga (Berlin and Moscow)
Klaus Gysi (Berlin)
Wolfgang Harich (Berlin)
William Heimlich (Maryland, by telephone)
Kurt Hirsch (Los Angeles, by telephone)
Walter Janka (Klein-Machnow)
Eugenia Kazeva (Moscow)
Konrad Kellen (Pacific Palisades, Calif.)
Hans-Ulrich Kersten (Berlin)
Fritz Klein (Berlin)
Bernt von Kügelgen (Berlin)
Melvin Lasky (Berlin)
Ursula Madrasch-Groschopp (Klein-Machnow)
Kurt Maetzig (Wildkuhl bei Röbel, by letter and telephone)
Hans Mahle (Berlin)
Eric Pleskow (New York, by telephone)
Klaus Poche (Cologne, by telephone)
John Pommer (Camarillo, Calif.)
Jack Raymond (New York)
Rudolf Reinhardt (Frankfurt am Main, by telephone)

Christa Rotzoll (Berlin, by telephone)
Karl-Heinz Schulmeister (Berlin)
Nelly von Schweinichen (Künzell bei Fulda)
Inge von Wangenheim (Weimar)
Peter Wyden (New York)

Notes

CHAPTER 1. THE PRIZE

1. Volkmar Fichtner, *Die anthropogen bedingte Umwandlung des Reliefs durch Trümmeraufschüttungen in Berlin (West)* (Berlin, 1977). Fichtner's book also includes the figures on the amounts of rubble.

2. As cited in Johann Friedrich Geist and Klaus Kürvers, *Das Berliner Mietshaus, 1945–1989* (Munich, 1989), 124.

3. Clarissa Churchill, in *Horizon* (London, 1946), 188.

4. Albert Speer, *Spandau: The Secret Diaries,* trans. Richard and Clara Winston (New York, 1976), 66.

5. Stephen Spender, *European Witness* (London, 1946), 235.

6. Albert Speer, *Erinnerungen* (Berlin, 1970), 69.

7. William Shirer, *End of a Berlin Diary* (New York, 1947), 131.

8. Isaac Deutscher, *Reportagen aus Nachkriegsdeutschland* (Hamburg, 1980), 114. Deutscher offers, as an interesting variant of the "ancient ruin" analogy, the image of an excavated metropolis of ruins: "When the buildings lose their deceptive solid appearance, Berlin gives the impression of a strangely well-preserved ruin of the ancient world—like Pompeii or Ostia—of enormous dimension. This similarity to an excavated city is strengthened by the emptiness of many streets."

9. Wilhelm Hausenstein, *Europäische Hauptstädte* (Zurich and Leipzig, 1932), 372 ff.

10. Alfred Döblin, *Autobiographische Schriften und letzte Aufzeichnungen* (Olten and Freiburg, 1980), 397.

11. Joseph Goebbels, *Ein Kampf um Berlin* (Munich, 1934), 27, 46.

12. *Rote Fahne,* October 10, 1923.

13. As cited in U.S. Department of State Historical Office, "Foreign Relations of the United States: The Conferences at Cairo and Teheran, 1943," Dept. of State Publication 7187 (Washington, D.C., 1961), 254.

14. Winston S. Churchill, *Triumph and Tragedy*, vol. 6, *The Second World War* (Boston, 1953), 463–65.

15. Robert Murphy, *Diplomat among Warriors* (New York, 1964), 229.

16. John Maginnis, *Military Government Journal* (Boston, 1971), 261.

17. H. D. Schäfer in *Literaturmagazin* 7 (1977), 102.

18. Herbert Ihering, "Die getarnte Reaktion" (1930), in *Der Kampf ums Theater* (East Berlin, 1974), 364.

19. Schäfer in *Literaturmagazin*, 103.

20. Manuel Gasser, *Erinnerungen und Berichte* (Zurich, 1981), 113.

21. Walter Gropius to Ise Gropius, August 5, 1947, as cited in Reginald R. Isaacs, *Walter Gropius: Der Mensch und sein Werk*, vol. 2 (West Berlin, 1984), 953.

22. Martin Wagner in *Die Neue Zeitung*, April 18, 1947.

23. Martin Wagner, "Wenn ich Baumeister von Deutschland wäre," *Aufbau*, no. 3 (1946), 876.

24. In *Das neue Berlin* (Berlin, 1929), 28–29.

25. Ibid., 216.

26. As cited in Geist and Kürvers, *Das Berliner Mietshaus*, 286.

27. Peter de Mendelssohn to Hilde Spiel, July 15, 1945, Peter de Mendelssohn Archive, file "Briefe und Unterlagen, July/Sept.–Nov. 1945."

28. Johannes R. Becher, "Deutsches Bekenntnis," in *Publizistik*, vol. 2 (East Berlin and Weimar, 1978), 476 (originally published in *Aufbau*, no. 1 [September 1945]).

29. Claudine Chonet, "Souvenir de Berlin," *Les temps modernes*, January 1948, 1287. Curt Riess offers another good example of the surreal scenery in the description of a tea party in Grunewald:

> We climbed up a stairway standing out in the open to the upper floor. And then we entered a room furnished as though it were in an intact house, as though there had never been a war, as though the Russians had never marched in, as though there had never been a 20th century at all. It was a beautiful room, all in Biedermeier style, every chair and every table was a delicacy. The walls were covered in damask and full of valuable etchings. There were ten or twelve people sitting in the room, ladies and gentlemen, a few American officers, a British lieutenant, two French women. All of them, with the exception of the host, were wearing coats, because it was bitter cold. But they all acted as if they didn't notice. They made conversation, and drank tea from beautiful old cups.
>
> Curt Riess, *Berlin Berlin, 1945–1953* (West Berlin, n.d.), 67.

30. Shirer and Murphy as cited in Brewster S. Chamberlin, *Kultur auf Trümmern* (Stuttgart, 1979), 9–10.

31. Becher, "Deutsches Bekenntnis," 479.

32. Ernst Jünger, quoted in Manfred George, "The German Literary Scene," *New Republic*, May 27, 1946, 778.

33. Harry Graf Kessler, *Tagebücher, 1918–1937* (Frankfurt am Main, 1982), 94.

34. Ibid., 108.

35. Ibid., 97.

36. Ernst Troeltsch, *Spektatorbriefe* (1923; reprint 1966), 30.

37. Karla Höcker, *Beschreibung eines Jahres: Berliner Notizen, 1945* (West Berlin, 1984), 82.

38. Becher, "Deutsches Bekenntnis," 478.

39. Troeltsch, *Spektatorbriefe,* 69.

40. Klemens von Klemperer, *Germany's New Conservatism* (Princeton, 1957), 76.

41. Peter de Mendelssohn, "German Journal: A Midsummer Nightmare, June 1945 [should be July—W.S.]" (typescript), Mendelssohn Archive.

42. Richard Brett-Smith, *Berlin '45—The Grey City* (London, 1966), 103.

43. Churchill, in *Horizon,* 192.

44. Fritz Kortner, *Aller Tage Abend* (Munich, 1959), 560.

45. Suhrkamp to Hesse, November 13, 1946, as cited in *Peter Suhrkamp— Zur Biographie eines Verlegers* (Frankfurt am Main, 1975), 112.

46. Suhrkamp to Kracauer, January 30, 1946, as cited in *Als der Krieg zu Ende war—Literarisch-politische Publizistik, 1945–1950,* exhibition catalog of the Deutsches Literaturarchiv Marbach (1973), 130.

47. Furtwängler to Helmut Grohe, February 12, 1947, in Wilhelm Furtwängler, *Briefe* (Wiesbaden, 1965), 155.

48. Elisabeth Langgässer, *Briefe,* ed. Elisabeth Hoffmann (Düsseldorf, 1990), vol. 1, 537–38, 581; vol. 2, 700.

49. As cited in an article by Melvin Lasky in *Partisan Review,* January 1948, 62.

50. Herbert Ihering, "Nach zwei Jahren," *Aufbau,* no. 4 (1947), 332.

51. Suhrkamp to Hesse, April 6, 1946, in Hermann Hesse and Peter Suhrkamp, *Briefwechsel, 1945–59* (Frankfurt am Main, 1969), 29.

52. Gottfried Benn, "Ptolemäer," in *Sämtliche Werke,* vol. 5 (Stuttgart, 1991), 60–61.

53. Herbert Ihering in *Aufbau,* no. 3 (1946), 262.

54. Brett-Smith, *Berlin '45,* 146.

55. Ihering to Brecht, April 21, 1947, Herbert Ihering Archive, Archive of the Akademie der Künste (GDR), rep. 09 II ia, no. 214.

56. Kortner, *Aller Tage Abend,* 562.

57. "Irremediable" appears in a letter to Erwin Piscator, March 17, 1947, Friedrich Wolf Archive, Archive of the Akademie der Künste (GDR), file 304; "great potential" occurs in a letter to Wolfgang Langhoff, December 27, 1945, Wolf Archive, file 303.

58. *Sonntag,* December 14, 1947.

59. Jack Raymond (*New York Times* correspondent in Berlin), interview by author, New York, April 11, 1991.

60. *Observer,* October 13, 1946, retranslated from the German in Isaac Deutscher, *Reportagen aus Nachkriegsdeutschland* (Hamburg, 1980), 185–86. The population of Berlin was also able to play the collective Talleyrand because, as both contemporary observers and later historians testified, it was more cosmopolitan than that of any other Germany city. Submissive behavior toward the victors, which Allied officers in southern Germany and Austria frequently observed, occurred less in Berlin. The difference between Berlin and other parts of the country was repeatedly emphasized. When the head of American Information Control, Robert McClure, arrived in Berlin in July, he noted

in his diary: "The people are more cosmopolitan, sophisticated and better dressed than elsewhere in Germany." Robert McClure, diary, p. 11, Robert A. McClure Archive, Chico, Calif. In his account of Berlin's postwar politics, Harold Hurwitz says: "The cosmopolitan character of the city had changed, not been lost." Harold Hurwitz, *Die politische Kultur der Bevölkerung und der Neubeginn konservativer Politik* (Cologne, 1983), 94. Hurwitz cites the disproportionately low presence of Nazis (due to desertion) and high presence of non-Nazis and anti-Nazis as reasons. He argues that in Berlin, the capital of the resistance, the attitude of opposition, resistance, and combativeness was greater than elsewhere. Ibid., 47, 53. In connection with the description of the tea party in a half-destroyed villa in Grunewald cited in note 29 above, Curt Riess describes a scene evoking this atmosphere:

> Our host had been an official in the old, pre-Hitler foreign ministry and remained under Hitler, but belonged to those who had nothing but scorn for the foreign minister Ribbentrop. We talked for a while about the blunders Ribbentrop had committed as though we were speaking of the foreign minister of a country at the other end of the world, with the slightly weary irony of people whom it does not concern at all, and about the blunders of General Clay and Attlee now, and above all about the French, who apparently could do nothing right, at least not in the eyes of the guests at this tea party. I looked at them, one after the other. They were men and women who might have met like this in Paris, London, or Washington, who surely had met before somewhere, perhaps in Cairo, Rome, or Hong Kong. There were no victors and losers for these people, and the fact that our host wasn't even in position to buy a pound of butter, not to mention travel to New York or only to Paris, didn't matter a bit. In this room they knew that this would change too, they were too deep in politics for a few months or a few years to matter.
>
> Riess, *Berlin Berlin,* 67.

61. The description of the sofa is from an undated and untitled newspaper clipping in Robert McClure's estate; the guest book is part of McClure's estate. In a letter to his wife, Fritz Kortner mentions a trophy experience of a particular kind. He reports a party in the confiscated house of a "Nazi bigwig": "I first noticed a beautiful fireplace, which looked very un-Berlin. The Nazi had removed it from an apartment in Paris, as the current resident, a Jew, explained to me. Almost everything in the apartment came from another country. I sat there on a stolen Nazi chair, and it is hardly bearable how present the past still is." Letter of January 4, 1948, as cited in Klaus Völker, *Fritz Kortner* (West Berlin, 1987), 178.

62. Hilde Spiel, *Welche Welt ist meine Welt? Erinnerungen, 1946–1989* (Munich and Leipzig, 1990), 13.

63. Riess, *Berlin Berlin,* 64.

64. George F. Kennan, *Memoirs, 1925–1950* (Boston and Toronto, 1967), 428–29.

65. Cf. the essay collection *The Ideological Crisis of Expressionism: The Literary and Artistic German War Colony in Belgium, 1914–18* (Columbia, S.C., 1990). The magazine *Belfried,* distributed in both Belgium and Germany, published by Insel and edited by Flake and Schröder in Brussels, and printed in Belgium, was a cultural propaganda mouthpiece that appealed to the intellectual elite of Flemish Belgium.

66. As cited in Gilles Ragache and Jean-Robert Ragache, *Des écrivains et des artistes sous l'Occupation* (Paris, 1988), 53.

67. Gerhard Heller, *Un Allemand à Paris* (Paris, 1981), 165.

68. As cited in Manfred Flügge, *Paris ist schwer* (Berlin, 1992), 183.

69. Delbert Clark, *Again the Goose Step* (New York and Indianapolis, 1949), 186.

70. Simone de Beauvoir to Nelson Algren, January 31, 1948, Nelson Algren Archive, Ohio State University Library. The letter was written during her stay in Berlin with Sartre for the Berlin production of *Les mouches.*

71. The House of Culture of the Soviet Union followed in February 1947, the American Information Center (later America House) in May 1948, and the British Information Center in April 1948. In distinction to these public institutions, the Mission Culturelle worked primarily nonpublicly. The French version of the cultural center open to the public was the Centre Culturel Français, opened in October 1947.

72. Tarbé de Saint-Hardouin, July 11, 1946, Archive of the Foreign Ministry, Relations culturelles 1945–1959, Sous-série: années 1945–1947, vol. 44.

73. Felix Lusset, "Die französische Kulturmission in Deutschland—Die Berliner Jahre 1946/48" (unpublished fragment, property of Lusset's widow, Mme. Claude Lusset, Paris), 80.

74. Nicholas Pronay, *The Political Re-Education of Germany and Her Allies after World War II* (Totowa, N.J., 1985), 8.

75. Ibid., 10.

76. For background on the demand for unconditional surrender, see Anne Armstrong, *Unconditional Surrender: The Impact of the Casablanca Policy upon World War II* (New Brunswick, N.J., 1961), 12 ff. Pushing through this demand against the skeptical reservation, even resistance, of Churchill and Stalin, President Roosevelt cited General Grant's precedent at Appomattox, and in doing so made a characteristic mistake. Only once in the Civil War did Grant demand the unconditional *partial* capitulation of an army unit, at Fort Donelson in 1862. This soon assumed propagandistic dimensions in Northern public opinion and developed an almost mythological status that could not be reversed. As is so often the case in history, Roosevelt's decision in World War II was based on a historically inaccurate memory.

77. Carl J. Friedrich, *American Experiences in Military Government in World War II* (New York, 1948), 290. On American Information Control, he writes: "ICD with its subdivisions neatly replaced the Reich Chamber of Culture with its seven chambers of press, literature, radio, film, theater, music, and art" (288).

78. Clay to McClure, December 14, 1945, McClure Archive; for McClure on Clay, see file note, December 26, 1945, McClure Archive.

79. Robert McClure, report ("personal and confidential") to the deputy foreign minister William Benton, December 27, 1945, McClure Archive.

80. Mendelssohn, "German Journal."

81. Rudolf Reinhardt, *Zeitungen und Zeiten: Journalist in Berlin der Nachkriegszeit* (Cologne, 1988), 72–73.

82. I. S. Tulpanov, "Vom schweren Anfang," *Weimarer Beiträge* (1967/5), 731.

83. For example, Rüdiger Bernhardt and Gerd Dietrich. The latter wrote of the SMAD cultural officers: "They are now trying, beyond the reach of Soviet laws, in strange territory and as occupiers, to develop a prudent, generous, tolerant, and democratic cultural policy." Gerd Dietrich, *Politik und Kultur in der SBZ, 1945–49* (Bern, 1993), 14.

84. For Anna Hartmann and Jürgen Eggeling, interpretations like Bernhardt's and Dietrich's are "idealized evaluations" of a soberer reality: "Practically every decision, authorization, or ban came from Moscow; that is, decisions made on German soil always issued from the structures and forces of the Soviet system." Anna Hartmann and Jürgen Eggeling in *Text und Kritik,* no. 108 (October 1990), 28.

85. Werner G. Hahn, *Postwar Soviet Politics: The Fall of Zhdanov and the Defeat of Moderation, 1946–1953* (Ithaca and London, 1982), 10, 12.

86. Sheila Fitzpatrick, *The Cultural Front: Power and Culture in Revolutionary Russia* (Ithaca and London, 1992), 146.

87. All information is from the unpublished memoirs of Grigori Weiss (who shortened his name from Weispapier in 1949 because of the anti-Semitic campaign in the Soviet Union) in the Archiv des Instituts für die Geschichte der Arbeiterbewegung, Berlin (EA 1838).

88. "A very unfortunate instability would be thrown in the program if certain material were to be thrown out every time an author is charged by the Committee," Frank wrote to his superior on October 26, 1947. OMGUS 5/268–3/9.

89. Benno Frank to Robert McClure, memorandum, April 20, 1947, OMGUS 5/270–3/4.

90. Wolfgang Harich, interview by author, Berlin, August 3, 1993.

CHAPTER 2. KULTURKAMMER

1. Theodor Lehmann, *Nach dem Fall von Berlin: Bericht eines Schweizers in die Heimat* (Zurich, 1946), 7.

2. Wolfgang Leonhard, *Die Revolution entlässt ihre Kinder* (Cologne, 1990), 432.

3. Communicated to the author by Alexander Peter Eismann and Wolfgang Harich.

4. W. B. Staudinger to Dr. Stehr (adjutant to state commissioner Hans Hinkel), October 25, 1933, Bundesarchiv, Berlin Document Center, RKK Holdings, box 0095, file 19.

5. Protocol of the inaugural meeting of the Kammer der Kunstschaffenden, June 6, 1945, Landesarchiv Berlin/Stadtarchiv, rep. 120, no. 1399, p. 9.

6. "Abgesprochene Eingruppierung der Kunstschaffenden in die Lebensmittelgruppen," June 6, 1945, Landesarchiv Berlin/Stadtarchiv, rep. 102, no. 1399, p. 9.

7. Bundesarchiv, Zwischenarchiv Dahlwitz-Hoppegarten: ZC 13816, file 1; ZC 13945, file 10.

8. George C. Clare, *Before the Wall: Berlin Days, 1946–48* (New York, 1990), 141.

9. Leonhard, *Die Revolution*, 417.

10. Ibid., 414.

11. Major E. M. Lindsay, monthly report, November 30, 1945, Public Record Office [hereafter PRO], FO 1012/75.

12. As cited in Brewster S. Chamberlin, *Kultur auf Trümmern—Berliner Berichte der amerikanischen Information Control Section, Juli–Dezember 1945* (Stuttgart, 1979), 53.

13. Wolfgang Harich, interview by author, Berlin, November 28, 1991.

14. Kai Möller, *Paul Wegener* (Hamburg, 1954), 144.

15. As cited in Chamberlin, *Kultur auf Trümmern*, 40.

16. "Betr. Kammer der Kunstschaffenden," July 6, 1945, former FDGB-Archiv, Sassenbach-Stiftung, no. 201.132.

17. Landesarchiv Berlin/Stadtarchiv, rep. 120, no. 1339.

18. "Betr. Neugründung der GDBA/Verband für Bühne, Film, Musik," May 20, 1945, Sassenbach-Stiftung, no. 0132.

19. Richard Henneberg, Popular Education department, report on the Kammer der Kunstschaffenden, October 5, 1945, Landesarchiv Berlin/Stadtarchiv, rep. 120, no. 3231, p. 29.

20. Otto to the FDGB board, September 25, 1945, Sassenbach-Stiftung, no. 201.132.

21. Ibid.

22. Communicated to the author by Alexander Peter Eismann and Wolfgang Harich.

23. Gericke to Otto Winzer, August 6, 1945, OMGUS/Berlin, Landesarchiv Berlin, 4/8–2/1.

24. Richard Henneberg, report on a discussion with Wegener, November 9, 1945, Landesarchiv Berlin/Stadtarchiv, rep. 120, no. 3231, p. 25.

25. October 13, 1945, OMGUS/Berlin, Landesarchiv Berlin, 5/265–1/19.

26. Henry C. Alter, report of July 18, 1945, as cited in Chamberlin, *Kultur auf Trümmern*, 60–61.

27. Report of August 8, 1945, as cited in Chamberlin, *Kultur auf Trümmern*, 92.

28. Richard Henneberg, September 30, 1945, Landesarchiv Berlin/Stadtarchiv, rep. 120, no. 3131, p. 21.

29. Ibid.

30. Herbert Maisch to N. Nabokov, January 16, 1946, OMGUS/Berlin, Landesarchiv Berlin, 4/8–2/1.

31. Hilde Spiel, "Theater als Wirklichkeit," in Herbert Ihering, ed., *Theaterstadt Berlin* (Berlin, 1948), 111–12.

CHAPTER 3. THEATER BATTLES

1. Wolfgang Harich in *Der Kurier*, May 2, 1946, as cited in Edda Kühlken, *Die Klassiker-Inszenierungen von Gustav Gründgens* (Meisenheim am Glan, 1972), 16.

2. As cited in the exhibition catalog *Jürgen Fehling* (West Berlin, 1978), 150.

3. K. H. Ruppel in *Jürgen Fehling,* 173.

4. Communicated by Friedrich Luft, as cited in Hans Daiber, *Deutsches Theater seit 1945* (Stuttgart, 1976), 15.

5. Ihering, *Theaterstadt Berlin,* 11.

6. Ibid., 11–12.

7. Gustav von Wangenheim, "Bericht über meine Tätigkeit, 1945/46," Archive of the Akademie der Künste (GDR), Estate of Wangenheim, rep. 025, no. 1. There is a copy in the former SED Party Archive/Archiv des Instituts für die Geschichte der Arbeiterbewegung, NL 36/680.

8. Wolfgang Harich to Herbert Ihering, July 18, 1946, Ihering Archive, Archive of the Akademie der Künste (GDR), rep. 09 II. ib.

9. Maxim Vallentin, "Einleitende Bemerkung zur Ausarbeitung von Richtlinien: Besprechung bei Wilhelm Pieck, Moskau, 9/26/1944," Archiv des Instituts für die Geschichte der Arbeiterbewegung, Wilhelm Pieck Archive, NL 36/499; Kulturbund-Archiv, no. KB 98 Gv (3).

10. *Das Wort* (1938, no. 3), 89.

11. Reinhard Müller, ed., *Die Säuberung* (Reinbeck, 1991), 560–62.

12. Letter and memorandum to Pieck, May 6, 1945, Archiv des Instituts für die Geschichte der Arbeiterbewegung, Holdings: Alfred Kurella Office, IV, 2/2068/68.

13. "Gespräch mit Gustav von Wangenheim" (typescript), n.d. [July 1945], Wangenheim Archive, Archive of the Akademie der Künste (GDR), file 287.

14. Walther Karsch in *Der Tagesspiegel,* January 22, 1946. Reviewing the entire season, Karsch writes: "He [Wangenheim] displayed Reinhardt's magnificence and forgot his artistic precision, ignoring that Reinhardt gave his soul to the smallest of roles and thereby the role its soul." *Der Tagesspiegel,* August 11, 1946.

15. Wolfgang Harich in *Der Kurier,* May 31, 1946.

16. Wolfgang Harich in *Der Kurier,* July 16, 1946.

17. Harich to Ihering, July 18, 1946, Ihering Archive, rep. 09 II. ib. In answer to Ihering's (nonextant) response, in which he apparently protested against Harich's reproaches, Harich dropped the role of the youth admiring his older colleague and became personal and political: he accused Ihering of having compromised himself by working at Vienna's Burgtheater during the Nazi period and with his book on Emil Jannings, and said that he was now trying to put this behind him with an opportunistic change of political hue: "One of the most important theater critics in Germany makes an opportunistic kowtow before the Nazis, ruining his own civil courage with such success that the same man, after the Third Reich has been overcome, throws himself hastily into the arms of an antifascist raised above all suspicion." Harich to Ihering, August 31, 1946, Ihering Archive, rep. 09 II. ib.

18. *Der Tagesspiegel,* August 11, 1946.

19. Wangenheim to Pieck, August 19, 1946, Wangenheim Archive, rep. 025, no. 1.

20. Wangenheim to General Bokov, August 19, 1946, Archiv des Instituts für die Geschichte der Arbeiterbewegung, NL 182/1190.

21. Wangenheim to Bokov, August 24, 1946, Wangenheim Archive, rep. 025, no. 1.

22. Protocol no. 29 of the meeting of the central office on August 21, 1946. Archiv des Instituts für die Geschichte der Arbeiterbewegung, Holdings: Alfred Kurella, V, 2/2026/68.

23. Personal communication to the author from Wangenheim's son Friedel.

24. Arseni Gulyga, conversation with author, Berlin, July 14, 1993.

25. *Die Neue Zeitung,* June 1, 1946.

26. Wolfgang Harich in *Der Kurier,* May 31, 1946.

27. Enno Kind in *Neues Deutschland,* June 2, 1946.

28. *Tägliche Rundschau,* June 1, 1946.

29. Wangenheim, "Bericht über meine Tätigkeit."

30. Ibid.

31. *Theater in der Zeitenwende,* vol. 2 (East Berlin, 1972), 75. In the production of *Hamlet,* it was chiefly Horst Caspar, a star at the time, who played against Wangenheim's concept. "Horst Caspar, who tried to understand all of his roles from the inner subjectivity of his personality, was not able to follow Wangenheim's demand for a predominantly intellectually active Hamlet figure. . . . His internalized acting method, an extremely subjective manner of acting, frequently pushed aside the director's instructions." Ibid.

32. Angelica Hurwitz, as cited in Ihering, *Theaterstadt Berlin.*

33. As cited in Eberhard Spangenberg, *Karriere eines Romans* (Munich, 1982), 111.

34. The negotiations that led to his appointment were conducted by Langhoff's old friend Friedrich Wolf, who in December 1945 had already asked him to come to Berlin from Düsseldorf, where he headed the Städtisches Theater. Wolf to Langhoff, December 27, 1945, in Friedrich Wolf, *Briefe* (East Berlin and Weimar, 1969), 206–7. Max Burghardt, *Intendant* of NWDR in Cologne at the time and in contact with Langhoff, confirmed that Wolf came to Düsseldorf in May 1946 "on a secret mission" to bring Langhoff to the Deutsches Theater. *Sinn und Form,* 1976, 986. According to this, the search for Wangenheim's successor was started three months before his dismissal—that is, immediately after the premiere of *Stürmischer Lebensabend.* Langhoff, who apparently did not want to be considered a regicide, continually urged that the matter be handled as discretely as possible. "Gustav's agreement is of personal importance to me." Langhoff to Wolf, August 11, 1946, Friedrich Wolf Archive, Archive of the Akademie der Künste (GDR), 303/26. From the SMAD ranks, Officer Fradkin, responsible for theater affairs, acted as the official in charge, but it can be assumed that Tulpanov was also involved. He and Friedrich Wolf knew each other from shared time on the Stalingrad front. In Berlin, Wolf belonged, together with Willi Bredel and Erich Weinert, to the exiled intellectuals from whom Tulpanov regularly sought advice. S. Tulpanov, *Erinnerungen an deutsche Freunde und Genossen* (East Berlin and Weimar, 1984), 132–33. Langhoff's appointment was the result of a well-concerted collaboration of Russian-occupation intellectuals and German party intellectuals. The pressing question is whether this cooperation began after the Russians' decision to dismiss Wangenheim or whether his dismissal was one of its results.

35. Max Burghardt in *Sinn und Form* (1976), 976.

36. Herbert Ihering, as cited in Edith Krull, *Wolfgang Langhoff* (East Berlin, 1962), 11–12.

37. Langhoff's aesthetic-political views on the theater could be described as tending to the classics in Stanislavsky's method. For him it was no longer a matter of "serving up an old piece with a new sauce" but "staging the classics for an audience such that . . . they are as new and fresh as they were at their premieres." Langhoff, as cited in Krull, *Wolfgang Langhoff,* 15. Thus, in distinction to Wangenheim, he emphasized a concentration on the past—on the bourgeois and prebourgeois "heritage"—and a decisive renunciation of Marxist reinterpretations of the classics and contemporary political plays. Thus were avoided the conflicts and breaks that had occurred under Wangenheim. It may be said that in the 1950s there arose a counterpart to Gründgens's theatrical and artistic space of the 1930s.

CHAPTER 4. KULTURBUND

1. James Pool and Suzanne Pool, *Who Financed Hitler* (New York, 1978), 464; Gerhard Schulz, *Aufstieg des Nationalsozialismus* (Frankfurt, Berlin, and Vienna, 1975), 879.

2. On this delicate question, Magdalena Heider in her dissertation on the Kulturbund merely notes: "Whether this authorization actually preceded the application, or whether it was a question of an incorrect date, could not be answered." Magdalena Heider, Ph.D. diss. (Mannheim University, 1991), 41–42.

3. Johannes R. Becher, "Bemerkungen zu unseren Kulturaufgaben," in *Publizistik,* vol. 2 (East Berlin and Weimar, 1978), 362–63.

4. "Schaffung eines 'Kulturbund für die demokratische Erneuerung,'" a note of Pieck's from June 6, 1945, Archiv des Instituts für die Geschichte der Arbeiterbewegung, NL 36/734.

5. The seven program points or "guiding principles" were:

1. The elimination of Nazi ideology in all spheres of life and learning. Fight against the intellectual agents of Nazi crimes and war crimes. Fight against all reactionary, military views. Purge and purify public life. Collaboration with all ideologically democratic, religious, and clerical movements and groups.

2. Formation of a unified national front of German intellectual workers, creation of a steadfast unity between the intelligentsia and the people. Trusting in the endurance and capacity for change of our people: rebirth of the German spirit under the sign of a valiant democratic outlook.

3. Examination of the historical collective development of our people and, in connection with this, overview of the positive and negative forces as they were effective in all areas of our intellectual life.

4. Rediscovery and encouragement of the liberal, humanist, truly national tradition of our people.

5. Incorporation of the achievements of other peoples into the cultural rebuilding of Germany. Foster understanding of the cultures of other peoples. Regain the trust and respect of the world.

6. Dissemination of the truth. Regain objective standards and values.

7. Fight for the moral health of the people, particularly for influence on the intellectual care and control of the education of Germany's children and students. Vigorous encouragement of the youth and recognition of outstanding achievements through fellowships and prizes.

Zwei Jahre Kulturbund zur demokratischen Erneuerung Deutschlands (Berlin, 1947), 9–10.

6. David Pike, *Deutsche Schriftsteller im sowjetischen Exil, 1933–1945* (Frankfurt am Main, 1981), 158.

7. As cited in Heider's dissertation, 45.

8. General Bokov, as cited in David Pike, *The Politics of Culture in Soviet-Occupied Germany, 1945–1949* (Stanford, 1992), 84.

9. Dietrich, *Politik und Kultur,* 32.

10. Bruno Frei, *Der Papiersäbel* (Frankfurt am Main, 1972), 175.

11. Becher to Andersch, May 5, 1948, Alfred Andersch Archive, Deutsches Literaturarchiv, Marbach.

12. J. R. Becher, *Der gespaltene Dichter,* ed. Carsten Gansel (Berlin, 1991).

13. Ibid., 30.

14. Heinz Willmann, *Steine klopft man mit dem Kopf* (East Berlin, 1977), 276–77.

15. Hans Mayer, *Der Turm von Babel* (Frankfurt am Main, 1991), 110–11. "Traces of evil were unmistakable. He knew it, even cultivated it" (113).

16. Theodor Plivier, as cited in Harry Wilde, *Theodor Plivier: Nullpunkt der Freiheit* (Munich, Vienna, and Basel, 1965), 392–93.

17. Alfred Kantorowicz, *Deutsches Tagebuch,* vol. 1 (Munich, 1959), 255, 643–44. According to Kantorowicz, the phrase "Becher drained to the dregs" came from Brecht.

18. Noelle-Neumann to Becher, December 31, 1946, Archive of the Akademie der Künste (GDR), Johannes Becher Archive, no. 544.

19. Boss to Becher, n.d., Becher Archive, no. 188.

20. Initially, the plan seems to have been to stay in Dahlem/Zehlendorf. The district office had already promised a villa on the Wannsee for this purpose. Jost (director of Zehlendorf's office for popular education) to Mayor Wittgenstein, July 13, 1945, private archive of Franz Wallner-Basté.

21. Kulturbund-Archiv, no. 10/112.

22. Board protocol from September 17, 1947, Kulturbund-Archiv, no. 373/715.

23. Ferdinand von Friedensburg to Günther Birkenfeld, August 9, 1948, Bundesarchiv Koblenz, Estate of F. Friedensburg, NL 114, vol. 27, pp. 189–90.

24. The annual allocation, in addition to payments in kind, was approximately 200,000 reichsmarks. Cf. report of the Mecklenburg-Vorpommern regional organization to the central office, March 4, 1947, Kulturbund-Archiv, no. 530/776.

25. Becher to Weiskopf, May 23, 1947, Becher Archive, no. 1575.

26. Becher Archive, no. 255.

27. Becher Archive, no. 377.

28. Kulturbund-Archiv, no. 213.

29. Ludwig Marcuse, as cited in Willi Jasper, *Der Bruder* (Munich, 1992), 288.

30. Zweig to Mann, January 21, 1950, Heinrich Mann Archive, Archive of the Akademie der Künste (GDR), no. 2986.

31. Twelve years earlier, in the first year of emigration and before the KPD shifted to its popular-front politics, Becher had still regarded Mann with skepticism. He did recognize a certain closeness in his political antifascist position and was against "knocking him on the head, but on the other hand we cannot go so far as saying he is really ours, his work is a misunderstanding." Becher to Ernst Ottwalt, December 27, 1933, cited in Rolf Harder, "Die Entwicklung bündnispolitischer Vorstellungen Johannes R. Bechers, 1923–1945" (Ph.D. diss., Akademie der Wissenschaften der DDR, Forschungsbereich Gesellschaftswissenschaften, Institut für Literaturgeschichte).

32. Johannes R. Becher, *Briefe* (Berlin, 1993), 279, 283.

33. Becher in Ludwig Kunz, ed., *Gerhart Hauptmann und das junge Deutschland* (Berlin, 1932), 9.

34. Margarethe Hauptmann, notebook, August 5, 1945, in the manuscript "Kalendernotizen," Gerhart Hauptmann Archive, Staatsbibliothek Preussischer Kulturbesitz, Manuscript Dept., Berlin.

35. As cited in Gerhart Pohl, *Bin ich noch in meinem Haus? Die letzten Tage Gerhart Hauptmanns* (West Berlin, 1953), 70.

36. Plans for a move to Berlin were nonetheless made; for example, a villa in Müggelheim was reserved for him. Rudolf Reinhard, *Zeitungen und Zeiten* (Cologne, 1988), 59. After his death, his estate was temporarily lodged in a building in Müggelheim before reaching the vault of the city hall. For its planned Hauptmann memorial, the Berlin Magistrat proposed a villa in Dahlem (Rheinbabenallee 32–34) that externally resembled Wiesenstein House. Data in the file "G. Hauptmann-Archive," Landesarchiv Berlin.

37. F. C. Weiskopf to Friedrich Wolf, January 18, 1946, Wolf Archive, file 322a.

38. *Tägliche Rundschau*, October 11, 1945, as cited in J. R. Becher, *Über Kunst und Literatur* (East Berlin and Weimar, 1962), 862.

39. First published in *Neues Deutschland*, November 17, 1962, supp. 46.

40. As cited in Becher, *Der gespaltene Dichter*, 11.

41. Ibid., 207.

42. Leonore Krenzlin, "J. R. Bechers Suche nach Bündnismöglichkeiten mit konservativ-humanistischen Autoren nach 1945," in Simone Barck, ed., *Zum Verhältnis von Geist und Macht im Werk J. R. Bechers* (East Berlin, 1983), 126–30.

43. Lorbeer to Becher, "early December 1945," as cited in Harder, "Die Entwicklung," 188.

44. Huhn to Becher, September 2, 1945, as cited in Harder, "Die Entwicklung," 192.

45. As cited in Dietrich, *Politik und Kultur*, 93.

46. Ibid. Bredel gave Becher to understand that he considered that this criticism was "to a large degree justified."

47. Becher and the Kulturbund were not the only targets of such criticism

from the left. In October 1946, a "meeting of the artists in the SED of Greater Berlin" sent a similar written protest to the party leadership, the SMAD, and central administration for Popular Education, and the Office of the Arts in the Magistrat. ("We will move beyond artistic politics." As cited in Dietrich, *Politik und Kultur,* 260–71.) And in October 1947, in the name of a group of socialist writers, a certain Hermann Werner Kubsch approached the Soviet delegation arrived for the Congress of German Writers, from whom he expected more socialist sympathy than was apparently shown him from the SMAD:

> The representatives of the Soviet administration and headquarters support in large measure, both ideologically and materially, all bourgeois intellectuals, although, as it has proved, they receive little thanks. We understand this entirely and see that it is necessary to make the best elements of the bourgeois intelligentsia sympathizers of the Soviet Union, and we also know how best to do this through the stomachs of these gentlemen. But we do not understand how such assistance is denied our own young politically devout intellectual workers. . . . This is dangerous insofar as youthful forces, not yet entirely steadfast in political terms, develop the view that our Soviet friends have handouts only for famous people, and often say with a certain bitterness that it is much easier to be appreciated by the Russians not by toiling for socialist ideals but by trying via detours to bourgeois publishers to make one's name with bourgeois art.
>
> Cited in Anna Hartmann and Jürgen Eggeling, "Sowjetkultur und literarisches Leben in der DDR: Geschichte und Strukturen eines Spannungsverhältnisses" (unpaginated and unpublished typescript, made available by the friendly permission of the authors).

Becher's justification in the face of such attacks:

> When I returned, my chief responsibility was to collect and bind to us all those who were undecided as quickly as possible, everyone who could somehow end up in enemy hands again tomorrow or the next day, and, as far as it was possible, make them commit themselves to us. This "us" does not mean an "us" in the narrower sense, but an "us" in terms of a truly liberal development. Thus it happened that those who could be firmly relied upon, like you, were not so to speak the first in line, which must have unavoidably—I do understand—produced a bitterness in some.
>
> Becher to Hans Lorbeer, January 21, 1946, as cited in Harder, "Die Entwicklung," 190–91.

48. *Der Tagesspiegel,* October 2, 1945.
49. Protocol of the board meeting on January 9, 1946, Kulturbund-Archiv, no. 10/112.
50. Protocol of the board meeting on December 6, 1946, Alexander Abusch Archive, Archive of the Akademie der Künste (GDR), file "Präsidialrat."
51. Protocol of the board meeting on February 21, 1947, Kulturbund-Archiv, no. 373/715.
52. For example, Becher was present at a social evening in Friedensburg's house on November 17, 1946. Friedensburg Archive, Bundesarchiv Koblenz, vol. 27.
53. Heinz Willmann, interview by Karl-Heinz Schulmeister, June 10, 1971, Kulturbund-Archiv, no. 530/774.

54. Ibid.

55. Friedensburg to Deiters, March 10, 1948, Friedensburg Archive, vol. 27.

56. Landesarchiv Berlin/Stadtarchiv, rep. 120, no. 3252.

57. Bulletin no. 79/83 of the SMAD Office for Information, November 5, 1946, Former Party Archive of the Communist Party of the Soviet Union, RCChINDNI, fond 17, opis 128, delo 151. No less self-critical, Klaus Gysi said to the same audience: "In the past year and a half, we have had no great success in winning the sympathies of the intelligentsia. We have not succeeded in using to the required degree the willingness of German intellectuals to express such sympathies. This is closely related to many things, but particularly to the SED's dismissal of psychological factors. . . . The intelligentsia must be influenced differently than the rest of the population. The intelligentsia demands that something incomprehensible be explained to them, that their own point of view is respected, that they are given the chance for open discussion." Ibid.

58. Friedensburg to von Prittwitz and Gaffrons, January 11, 1947, Friedensburg Archive, vol. 27. The attempts by the SPD and KPD after 1945 to eliminate each other had a prehistory in the Weimar Republic, when the SPD had the say in the Berlin municipal administration, the unions, the Volksbühne movement, and so forth, and the KPD was shut out. Hence the communist sovereignty in the first eighteen months after the collapse, above all its attacks against the SPD, was a revenge for its former treatment by the Berlin SPD establishment: a self-consuming cycle.

59. Friedensburg in a meeting of the board on February 21, 1947, Kulturbund-Archiv, no. 373/715.

60. Protocol of the meeting of the Wilmersdorf operational unit of the Kulturbund on July 28, 1947, Kulturbund-Archiv, no. 16/220, 25–26.

61. As cited in the Telegraf, July 29, 1947.

62. Walther Karsch, "Zur demokratischen Erneuerung," Der Tagesspiegel, May 25, 1947.

63. "Bericht zum ersten Arbeitsjahr," n.d. [1946], Kulturbund-Archiv, no. 530/777. Strangely enough, this report seems not to have been addressed to the SED leadership and not only meant for the information of the Kulturbund's communist leadership, but probably went to the board. The reference to Ackermann and Winzer as "Messrs." in the text indicates that it was not an internal party report. Is it to be concluded that in the board, in the presence of its bourgeois members like Friedensburg, Birkenfeld, and Lemmer, the organization's close ties to the party were discussed openly?

64. Board protocol, May 31, 1947, Kulturbund-Archiv, no. 373/715.

65. Bundeskongress des Kulturbundes: 5/20–21/1947 (Berlin, 1947).

66. From January through October 1947 there were sixteen lectures by Americans, fifteen from the British, ten from the French, and thirteen from the Russians. "Ziffern und Fakten über die Vorträge von Vertretern der vier Besatzungsmächte in den Veranstaltungen der Landesleitung Berlin und der Berliner Wirkungsgruppen des Kulturbundes," October 31, 1947, Kulturbund-Archiv, no. 373/715.

67. OMGUS/Berlin, Landesarchiv Berlin, 4/8–3/1.

68. T. R. M. Creighton to Cecil Sprigg/Educational Branch, December 13, 1946, PRO, FO 1012/166.

69. Friedensburg's report to Wittgenstein of December 3, 1947, on a conversation with the American commandant Howley on November 1, 1947, regarding his political philosophy. Landesarchiv Berlin, LAZ no. 9086. An insight into Friedensburg's understanding at this time is offered in the confession he made to a party friend, Heinrich Krone, that he was a "deliberate Christian, passionate individualist, determined, and a proven democrat for 30 years and a fervent advocate of classical humanism, all characteristics that ideologically divide me irreconcilably from the world of bolshevism. But I think that perhaps precisely because of this inner inaccessibility for all Marxist ideas, more than many of my Social Democratic friends, I am able to create a practical relationship to the Eastern power." Friedensburg to Krone, September 30, 1949, Friedensburg Archive, vol. 26.

70. On the SED-controlled historiography, see Karl-Heinz Schulmeister, *Auf dem Weg zu einer neuen Kultur: Der Kulturbund in den Jahren 1945–1949* (East Berlin, 1977). In the Federal Republic, historiography close to the DKP adopted this version; see, for example, Henning Müller, "Das Exempel Kulturbund: Analyse eines Verbots," in *Zwischen Krieg und Frieden: Gegenständliche und realistische Tendenzen in der Kunst nach 1945* (Berlin, 1980), 175–82.

71. "Not desirable at this time" was the official judgment, the head of American Information Control in Berlin informed the Kulturbund; however, "no objections are interposed to the activities of the Kulturbund in the American sector of Berlin." Leonard to Harry Damrow (in the Kulturbund's Berlin chapter), June 17, 1946, OMGUS/Berlin, Landesarchiv Berlin, 4/127–2/1.

72. In *Neues Deutschland*, October 31, 1947.

73. Memorandum by Scott, November 3, 1947, PRO, FO 1012/166.

74. Board protocol on October 30, 1947, Kulturbund-Archiv, no. 16/220.

75. Willmann's discussion notes from a conversation with the Neukölln director Ihlow, November 10, 1947, Kulturbund-Archiv, no. 16/220.

76. File note, April 6, 1948, partial collection Friedensburg in the Preussisches Geheimes Staatsarchiv, rep. 92/72.

77. Former Party Archive of the Communist Party of the Soviet Union/RC-ChIDNI, fond 17, opis 128, delo 150 (ZK VKP [b] Foreign Policy Dept.).

78. RCChIDNI, f.17, o.128, d.149, as cited in Bernd Bonwetsch, Gennadij Bordjugov, and Norman Neimark, eds., "Die sowjetische Militäradministration in Deutschland: Die Verwaltung für Propaganda (Information) und S. I. Tulpanov" (Moscow, 1994; unpublished manuscript, made available by the editors' kind permission). In the same speech, Tulpanov addresses the role of Friedensburg, who assisted [the Soviets] as a "shrewd and clever politician" and "cardinal . . . to push through a more or less acceptable policy in the CDU, but is tied to capital. . . . It is impossible to keep him any longer. It was important for us to be able to control him so that all is now running well in our Soviet zone." Ibid.

79. "Mitteilung des Politischen Beraters beim Oberkommandierenden der SMAD V. Semenov über ein Gespräch mit dem Vorsitzenden des 'Kulturbundes' J. Becher am 13/11/1946," RCChIDNI, f. 17, p. 128, d. 147, cited in Bonwetsch, Bordjugov, and Neimark, "Die sowjetische Militäradministration."

80. A "bureaucratic internal wrangling" Bernd Bonwetsch and Gennadij Bordjugov call this mesh of behaviors and impediments among the groups competing for Stalin's attention. The attempts to get rid of Tulpanov, extending over several years and crowned with success in 1949, are a typical example. (See footnote on p. 34.)

81. This and the following statements from Behne and Friedensburg are in the board protocol of October 30, 1947, Kulturbund-Archiv, no. 16/220.

82. Memo, April 13, 1948, PRO, FO 1012/166.

83. All statements are in the board protocol of August 2, 1948. Kulturbund-Archiv, no. 211.

84. Friedensburg to Becher, September 11, 1948, Kulturbund-Archiv, no. 72. The date of this letter, three days *before* his expulsion, can be explained by Friedensburg's referring to an initial, unofficial notification of his expulsion.

85. Krummacher to Becher, September 20, 1948, Kulturbund-Archiv, no. 72.

86. Pike, *The Politics of Culture,* 562.

87. Ibid., 137.

88. Dietrich, *Politik und Kultur.*

89. Ibid., 97.

90. This is speculation based on statements from Friedel von Wangenheim, the son of Gustav von Wangenheim, made to the author in recollection of conversations with his father and other reimmigrants from Russia.

91. Pike, *The Politics of Culture,* 562.

92. Protocol of the Central Office conference on February 2, 1948, Kulturbund-Archiv, no. 527/825, 2.

93. Becher to the central office of the SED directorate, December 8, 1947, as cited in Becher, *Der gespaltene Dichter,* 42.

94. Undated handwritten note in the file "Ideologische Kommission" in the Estate of Alexander Abusch, Archive of the Akademie der Künste (GDR), sig. 4.

95. As cited in Gerd Dietrich, ed., *Um die Erneuerung der deutschen Kultur: Dokumente zur Kulturpolitik, 1945–49* (East Berlin, 1983), 209–11.

CHAPTER 5. RADIO

1. Cited in Bryan Thomas Van Sweringen, "Cabaretist of the Cold War Front: Günter Neumann and Political Cabaret in the Programming of Rias" (Ph.D. diss., Free University Berlin, 1985), 94. The original is in the library of the Institut für Publizistik at the Free University.

2. Ibid., 96. According to the same report, "The population of the American zone takes this Soviet propaganda at its face value and even expresses the wish to be under Russian control." Cited in Sweringen, "Cabaretist," 95.

3. Fritz Lothar Büttner, *Das Haus des Rundfunks in Berlin* (Berlin, 1965), 61. A Russian, Major Popov, under whose command the building was confiscated and set in operation, had supposedly been engaged as a technician from 1931 to 1933 at the Berliner Rundfunk. Ibid., 63. In addition to a thirty-man SS unit as a guard, the German occupation consisted of one Volkssturm unit

whose members were predominantly cultural (including radio) figures. Ibid., 61.

4. According to Wolfgang Leonhard, the Ulbricht Group actually consisted of two groups. One contained the true core of KPD functionaries, the other selected members of the National Committee for Free Germany. Leonhard, *Die Revolution entlässt ihre Kinder,* 421–22.

5. Ibid., 415. This openness was possibly the reason for Mahle's short tenure as *Intendant* at Radio Berlin. That at least is the explanation for his dismissal in early 1946 by the Russian officer Mulin in charge of radio affairs. Mahle supposedly could not handle the infiltration of Western agents and journalists and maintained "overfriendly" relations with British journalists. "He became for them too much of an acceptable figure." Former Party Archive of the Communist Party of the Soviet Union, RCChIDNI, fond 17, opis 128, delo 150, 93–94.

6. Hans Mahle, "So fing es an!" in *Erinnerungen sozialistischer Rundfunk-Pioniere* (East Berlin, 1985), 16 ff.

7. D. G. White, "Radio-Reorientation: U.S. Military Government in Germany, European Command, Historical Division" (copied typescript, 1950), 10, 30. (One copy is in the Archive of the Berlin-Projekt des Zentralinstituts 6 am Publizistischen Institut at the Free University.)

8. As cited in Markus Wolf, *Die Troika* (Düsseldorf, 1989), 176. On the use of the old station personnel, see also Leonhard, *Die Revolution,* 459.

9. A manuscript of memoirs from Mahle's assistant Ullrich Brurein states, concerning the use of announcers from the Reichsrundfunk, that "the particularly qualified announcers Siegfried Niemann and Horst Preusker, who used to be at the Nazi station," were able to continue on. N.d. [1967], archive of the former East German Radio, Berlin, Nalepastrasse.

10. White, "Radio-Reorientation," 10.

11. Harold Hurwitz, *Die Stunde Null in der deutschen Presse* (Cologne, 1972), 301 ff.; Harold Hurwitz, *Die Eintracht der Siegermächte und die Orientierungsnot der Deutschen, 1945–46,* vol. 3 of *Demokratie und Antikommunismus in Berlin nach 1945* (Cologne, 1984), 84 ff.

12. "The Russians . . . also ask for common control of Broadcasting House (Radio Berlin) which is in the British Zone (Sector)," it reads in the report on the first inter-Allied meeting on July 5, 1945. Cited in White, "Radio-Reorientation," 13.

13. Radio Control Officer Mulin to a representative of the party central in Moscow, stenogram, n.d. [September 1946], in the former Party Archive of the Communist Party of the Soviet Union, fond 17, opis 128, delo 150, 88.

14. "The Americans and British agree not to concern themselves with the operation of the studios and radio station in Tegel [i.e., Masurenallee]," reads the agreement of the commands of July 20, 1945. OMGUS/Berlin, Landesarchiv Berlin, 4/8–2/3. On the agreement over airtime, see White, "Radio-Reorientation," 14, 16.

15. Memorandum of the British Broadcasting Control Unit, April 24, 1946, PRO, FO 1056/13. At this time, in April 1946, the English division in

charge had given up these plans. The memo retrospectively describes American-English plans from the summer and fall of 1945.

16. Cited in White, "Radio-Reorientation," 78.

17. Telegram to the Foreign Ministry, November 11, 1946, PRO, FO 1056/13.

18. "The suggestion of Quadripartite Control of a zonal station had never been favored by Radio Section, since it became evident that occupational policies of the Allies were too divergent to make smooth operation likely." Memo of the Broadcasting Control Unit, PRO.

19. Charles S. Lewis to Robert McClure, March 13, 1946, OMGUS 5/270–1/14.

20. "Taking account of the paucity of its resources [RIAS] originally did not aim to conquer the general radio audience but conspicuously directed its program at the Berlin intellectuals." White, "Radio-Reorientation," 115. Audience numbers corresponded. Depending on the questions and group surveyed, the numbers at the end of 1946 fluctuated between 6 percent and 30 percent of the radio audience (i.e., the general population). Hurwitz, *Die Eintracht,* 133.

21. Statements to the author by Margot Derigs, Hans-Ulrich Kersten, and Wolfgang Geiseler.

22. *Der Kurier,* August 30, 1946, as cited in White, "Radio-Reorientation," 41.

23. Hermann Broch to Ruth Norden, January 4, 1946, Ruth Norden Collection, Deutsches Literaturarchiv Marbach.

24. Norden to Broch, February 21, 1946, Norden Collection.

25. Hermann Broch, *Briefe,* ed. Paul-Michael Lützeler (Frankfurt, 1981), no. 295.

26. Broch to Norden, July 21, 1946, Norden Collection.

27. Norden to Broch, February 21, 1946, Norden Collection.

28. Archive of Franz Wallner-Basté, property of Dr. Franz Wallner, Berlin.

29. The Drahtfunk period was one of great independence. DIAS was indeed founded by the Americans, but in the legal form of a German corporation that received its operational funds of 250,000 reichsmarks monthly from the Magistrat. With the conversion from wired to wireless, this amount was no longer sufficient, and the American military government had to take over RIAS—with all the consequences of a hyper-bureaucratization so catastrophic for the internal operation, as Wallner-Basté described it. (Figures are from the auditor's report of the "Kontinentale Treuhandgesellschaft GmbH" from June 28, 1947, OMGUS 4/12–2/13.) Ruth Norden said of the conditions in RIAS after the takeover by the military government: "The business machine has broken down completely . . . and conditions have been intolerable as a result." Memorandum to the Control Office, June 12, 1946, OMGUS 4/135–2/2. The American RIAS Control Officer Harry M. Frohman summarized the leading view among the German personnel and German contractors: "Rundfunk is bankrupt." Memorandum to Leonhard, March 26, 1947, OMGUS 4/12–2/13.

30. Franz Wallner-Basté, "A Conversation That Never Took Place" (manuscript), n.d. [August 1947], Wallner-Basté Archive.

31. Two of Wallner-Basté's letters to Ernst Reuter hint at his SPD member-

ship. On June 16, 1948, he speaks of "our comrade Leber" (referring to Anne-dore Leber), and on October 20, 1948, of "our party." Wallner-Basté Archive.

32. File note, November 6, 1946, as cited in Hurwitz, *Die Eintracht*, 137.

33. Memorandum by Hans Werner Kersten, June 21, 1948, OMGUS 4/12–2/13.

34. Cited in White, "Radio-Reorientation," 89. (The report followed in November 1947.)

35. Ibid., 89–90.

36. Wallner-Basté also described episodes that in his view illustrated Norden's political tendencies, like the visit of an American journalist who expressed her enthusiasm over the support of Hollywood figures like Chaplin and Katherine Hepburn for the American independent progressive presidential candidate Wallace. "Miss Norden: vain agreement . . . I object: whether it is right to offer an example with precisely these two names, since even many of us know what kind of politics the two are making propaganda for. Miss Norden does not actually contradict this, but freezes up." Franz Wallner-Basté, diary, July 20, 1947, Wallner-Basté Archive.

37. Lt. E. Schechter, "To whom it may concern," January 3, 1949, Wallner-Basté Archive.

38. Wallner-Basté, postscript to "A Conversation."

39. Harry Frohman (formerly Frommermann) had a prominent past. In 1928 he founded the cabaret singing group Comedian Harmonists, which soon became an institution in Berlin's entertainment industry. According to his wife, Marion Kiss, he was "a comic by nature" and "a rebel," not in a political sense but because "he never did what others wanted." Cited in Eberhard Fechner, *Die Comedian Harmonists* (Berlin, 1988). According to information from *Der Spiegel* (January 10, 1948), Gustave Mathieu was friendly with known leftists like Günther Weisenborn, Herbert Sandberg, Alfred Kantorowicz, and Wolfgang Harich, and had close contact to Radio Berlin. From there he brought a commentator, Eugen Hartmann, to RIAS. On February 7, 1948, a notice under the title "Regret" appeared in *Der Spiegel* offering an apology to Norden and Mathieu from the editors "for calumny due to false and malicious information." On February 3, 1948, Rudolf Augstein sent a personal letter of apology to Mathieu. (A copy was shown to the author by Mathieu.)

40. Wallner-Basté to Colonel Leven, October 12, 1948, Wallner-Basté Archive.

41. White, "Radio-Reorientation," 80 ff.

42. Hurwitz, *Die Eintracht*, 137–38. Hurwitz himself still showed this misperception in his study published in 1972. He writes of Norden and Mathieu: "The American leader of the new station and the press officer responsible for political broadcasts were both communists" (*Die Stunde Null*, 310).

43. "I don't feel we are accomplishing our goal with the occupation much as we would like to say we do. Loose talk of war is rampant and while here in Berlin the semblance of quadripartite working relations is maintained, there is a lot of unilateral action, suspicion of motives, breaches of confidence, etc. People like myself who would like to believe in the possibility of co-operation watch all the time how gentlemen's agreements are broken on the other side. And yet the

solution is not to stoop to the same practices, it would seem to me. . . . Here in Berlin particularly the anti-Russian feeling is at its height. People are scared to death of the Russians. . . . My job has grown in importance, but I am also much more exposed and vulnerable. I think it is generally accepted that I have done an excellent job, objectively speaking, but those are not the only considerations which count today and so I don't know what the developments will be." Norden to Broch, September 1, 1947, Norden Collection.

44. Cf. Barbara Mettler, *Demokratisierung und Kalter Krieg* (Berlin, 1975). Developments in the British zone were similar: in 1946, the NWDR *Indendant* Max Seydewitz and commentator Karl Eduard von Schnitzler were dismissed. Both moved to Radio Berlin, Seydewitz succeeding Mahle as the new *Intendant*.

45. Tom Wenner to Robert Murphy, August 8, 1947, POLAD 33/61.

46. Memorandum by Kersten, June 21, 1948, OMGUS 4/12–2/13.

47. Charles Leven was certain that Norden's exit was actually a dismissal, referring to "the removal of Miss Norden." Memorandum by Norden, March 17, 1948, OMGUS 4/136–2/10.

48. Mettler, *Demokratisierung*, 119.

49. William Heimlich, interview by Brewster Chamberlin and Jürgen Wetzel, 1981, Landesarchiv Berlin, Rep. 37, Acc. 3103, Nr. 88, p. 71.

50. Memorandum by Leven, March 7, 1948, and report by Leven, April 29, 1948, OMGUS 4/136–2/10.

51. Cited in Leven, report of April 29, 1948, p. 9.

52. Friedensburg, report to Colonel Textor, September 11, 1948, Friedensburg Archive, NL 114/26. Speaking to Ernst Reuter, Friedensburg called Shub "authoritarian, high-handed." February 3, 1949, Friedensburg Archive.

53. Annemarie Auer, interview by author, Berlin, August 13, 1991.

54. Leven, report of April, 29, 1948, pp. 4, 6.

55. Andreas Borst, "Rias und die US-amerikanische Kulturpolitik in Deutschland, 1945–49" (master's thesis, American Studies Department, Free University Berlin, 1990), 56.

56. The numbers Boris Shub indicated seem a self-serving exaggeration: according to his figures, 80 percent of listeners received RIAS, 15 percent Radio Berlin, and the rest NWDR-Berlin. Boris Shub, *The Choice* (New York, 1950), 104.

57. Cited in Sweringen, "Cabaretist," 123.

58. Herbert Graf in *Musikblätter,* July 1, 1948.

59. *Der Tagesspiegel,* April 20, 1948. The article was unsigned, but according to Herbert Graf (cf. note 58 above) came from copublisher Walther Karsch.

60. Cited in Gerhard Walther, *Der Rundfunk in der Sowjetischen Besatzungszone Deutschlands* (Bonn and Berlin, 1961), 15.

61. Cf. footnote on p. 113.

62. Cited in Walther, *Der Rundfunk,* 22. In fact, a discussion jointly organized by Radio Berlin and NWDR-Berlin did occur on June 11, 1948. Axel Eggebrecht served as monitor; participating from the Western side were Peter von Zahn, Eberhard Schütz, and Willy Fröster; from the Eastern side, Wolfgang Harich, Peter Steiniger, Herbert Gessner, and Karl-Eduard von Schnitzler.

CHAPTER 6. FILM

1. As cited in Chamberlin, *Kultur auf Trümmern*, 62.

2. Cf. a letter from Kollektivfilm, a film company that had received promises from Tobis's management that Tobis could not keep: "There seem to be severe difficulties in the collaboration between Tobis's central administration . . . and the gentlemen in Tobis's studios in Johannisthal. The gentlemen in Johannisthal, supported by the Red Army commandant in charge, disagree entirely with the orders of the central administration and have, so to say, declared themselves independent." Cited in Johannes Hauser, *Der Neuaufbau der westdeutschen Filmwirtschaft, 1945–55, und der Einfluss der amerikanischen Filmpolitik* (Pfaffenweiler, 1989), 392.

3. Berlin Document Center, RKK/Film Dept., File "Allgemeines T–Z."

4. Stiftung Deutsche Kinemathek, *Wolfgang Staudte* (Berlin, 1977), 184.

5. Hauser, *Der Neuaufbau*, 385; Berlin Document Center/RKK/Film Dept., File "Allgemeines T–Z."

6. Albert Wilkening, *Betriebsgeschichte der VEB Defa-Studio für Spielfilme/ Geschichte der Defa von 1946–1950* (n.p., n.d.), 13.

7. Cited in Chamberlin, *Kultur auf Trümmern*, 111.

8. Baensch's memo, July 30, 1945, Berlin Document Center/RKK/Film Dept., File "Baensch—Filmstelle des Magistrats."

9. Anton Ackermann, interview, 1966, as cited in Christiane Mückenberger, "Zur Geschichte der Defa bis 1949," in *Filmwissenschaftliche Beiträge*, Sonderband I (1981), 38.

10. Alfred Lindemann, "Die Entwicklung der Defa" (typescript), n.d. [ca. 1948], Bundesarchiv/Filmarchiv Berlin, Defa Collection, 573.

11. Mückenberger, "Zur Geschichte der Defa," 52.

12. Lindemann, "Die Entwicklung der Defa."

13. Lindemann's Gestapo file contains statements from collaborators at the Theater am Schiffbauerdamm, according to which Lindemann "[is] completely focused on a National Socialist state and . . . also expresses this in his professional activities. The ideal he always strove for was a Volksbühne like the National Socialist Theater am Schiffbauerdamm, as the accused truthfully confirmed." Bundesarchiv/Zwischenarchiv Berlin-Hoppegarten: ZC 13171, vol. 4, 788–89, 798. There is no evidence for Curt Riess's story that Lindemann was supposedly a concessionaire at the Theater am Schiffbauerdamm, had his license retracted after 1933, brought charges against Goebbels (i.e., the Ministry of Propaganda) and won the trial. Curt Riess, *Das gibt's nur einmal* (Hamburg, 1958), 37.

14. Lindemann, "Die Entwicklung der Defa."

15. Lindemann, "Die Interna der Defa" (memorandum), May 7, 1948, Bundesarchiv/Filmarchiv, Berlin, Defa Collection, 573, p. 3.

16. Ibid., pp. 9–10.

17. "Die Entwicklung der Defa in juristischer Beziehung " (typescript), n.d. [probably written by Lindemann in 1948], Bundesarchiv/Filmarchiv Berlin, Defa Collection, 573.

18. Chamberlin, *Kultur auf Trümmern*, 69.

19. A joint-stock company in Russian hands with a capital of 2 million reichsmarks was planned, according to Klering's report, dated October 30, 1945, of a meeting with Major Mogilev in Karlshorst. Bundesarchiv Potsdam, R-2/ 1025.

20. Hardly anything is known about the relations of these two organizations with one another. The SAGs belonged to the SMAD, just as each of its divisions was linked to the corresponding ministry in the Soviet Union. However, it is to be assumed that Tulpanov's information and propaganda division and especially its culture department under Dymschitz had a different relationship to German film production and other interests in it than the business ventures Sovexport and Sojusintorg.

21. Kurt Maetzig, for example. Archiv des Instituts für die Geschichte der Arbeiterbewegung, IV 2/906/206, p. 188.

22. "Sovexport repeatedly tried to influence our retail prices by exploiting their position as a monopoly." Lindemann, "Die Entwicklung der Defa," 5.

23. Bundesarchiv/Filmarchiv Berlin, Defa Collection, 397.

24. Lindemann, "Die Entwicklung der Defa," 8.

25. Archiv des Instituts für die Geschichte der Arbeiterbewegung, IV 2/906/-206.

26. Ibid.

27. *Der Telegraf,* May 3, 1947.

28. Lindemann, "Die Interna der Defa."

29. Jack Warner to Francis Harmon, August 10, 1945, OMGUS 5/263–3/19. Cf. Albert Norman, *Our German Policy: Propaganda and Culture* (New York, 1951), 62, where the author states that Hollywood "made serious efforts to convince occupation authorities that it be allowed to establish what would in effect have amounted to a monopoly of not only motion picture distribution, but of production and the ownership of the theaters as well."

30. Speech by Dr. Jacob at a conference with Mayor Scharnagel. Memo, March 28, 1946, Bundesarchiv/Filmarchiv Berlin, Defa Collection, 397.

31. As cited in Chamberlin, *Kultur auf Trümmern,* 102.

32. Heinz Roemheld, Information Control officer responsible for film, wrote to Preston Sturges on September 5, 1945, asking whether Sturges was interesting in coming to Germany at his own or his studio's expense to inquire into the possibilities of making a film: "Surely you will find material here of inestimable and lasting value to yourselves [sic]." OMGUS 10/17–3/5. In the 1940s Sturges was Hollywood's main satirist, as Wilder would become in the 1950s.

33. Annual report of the Motion Picture Export Association, March 25, 1946, 10. There is a copy of the printed report in the Butler Library, Columbia University.

34. Report of the Film-Theater-Music Division of Information Control, December 18, 1945, as cited in Chamberlin, *Kultur auf Trümmern,* 231.

35. As cited in Chamberlin, *Kultur auf Trümmern,* 232.

36. Heinz Roemheld to Eric [Erich] Pommer, September 14, 1945; Pommer to Roemheld, September 29, 1945; private archive of John Pommer, Camarillo, Calif.

37. Wolfgang Jacobsen, *Erich Pommer—Ein Produzent macht Filmgeschichte* (Berlin, 1989), 55.

38. Klaus Kreimeier, *The UFA Story*, trans. Robert and Rita Kimber (New York, 1996), 126.

39. On the Parufamet deal, see Jacobsen, *Erich Pommer*, 76–77, and Kreimeier, *The UFA Story*, 127 ff.

40. Jacobsen, *Erich Pommer*, 125, 133 ff.

41. Correspondence in the Erich Pommer Archive in the Manuscript Dept. of the University of Southern California at Los Angeles (hereafter USC), and in the private archive of John Pommer (hereafter PJP). The latter contains the extensive report of September 29, 1945, from Gertrud and Erich Pommer to John Pommer.

42. Letter of September 29, 1945, PJP.

43. Davidson Taylor (Roemheld's predecessor in Berlin) to Pommer, New York, October 7, 1945, PJP.

44. "We are convinced that the industry will do everything to kill the whole business. They will be dead opposed to it . . . Dad expects, if he gets the job, it will be a most difficult job to get Hollywood to fall in line." Gertrud Pommer to John Pommer, November 8, 1945, PJP.

45. Erich Pommer to John Pommer, October 22, 1945, PJP.

46. Undated document, PJP.

47. Erich Pommer to Gertrud and John Pommer, August 18, 1946, PJP.

48. *Die Neue Zeitung*, July 15, 1946.

49. Bünger to Bergmann, n.d. (date of receipt September 7, 1946), Bundesarchiv/Filmarchiv Berlin, Defa Collection, 397.

50. Pommer to Carl Winston, as cited in Ursula Hardt, "Erich Pommer" (Ph.D. diss., Dept. of German, University of Iowa, 1988), 199.

51. Lindemann's letter is cited in Riess, *Das gibt's nur einmal*, 84–85. Riess gives no source, and it is questionable how an American reporter in Berlin during the Cold War should have come into possession of such a document. On the other hand, in the late 1940s Riess was one of the best-informed figures on the Berlin press scene, and it is conceivable that the letter came to him by way of a refugee from the East or American officials interrogating refugees.

52. Kurt Maetzig, "Neuer Zug auf alten Gleisen," in *Das UFA-Buch* (n.p., 1992), 472.

53. Erich Pommer to Getrud and John Pommer, August 18, 1946, PJP.

54. Getrud Pommer to Erich Pommer, December 15, 1946, PJP.

55. *Süddeutsche Zeitung*, August 13, 1946.

56. In a letter to John Pommer dated July 19, 1947, Erich Pommer does not once mention Staudte's name but speaks of a "Russian production. . . . They do it in their usual primitive form . . . they always appear to be interested in reducing everything to a common denominator." PJP.

57. *Film Daily*, September 6, 1946.

58. Ibid., January 16, 1947.

59. Ibid., December 18, 1946.

60. Erich Pommer to Getrud and John Pommer, February 17, 1947, PJP.

61. Ibid.

62. Copy of a "personal and confidential" letter from Vining to Maas, February 9, 1947, Erich Pommer Archive, USC, file C.

63. In the early 1960s the MPEA archive was transferred from New York to Washington, D.C., and later destroyed. John Pommer provided the author with the following account of how the copy of the Vining brief ended up in Pommer's possession: "Irving A. Maas . . . gave it to Eric A. Johnston, President of the MPEA and MPAA [Motion Picture Association of America]. Johnston circulated it to the foreign distribution heads of the major companies. Joseph Seidelman (foreign distribution head of Universal) 'leaked' it to the press in late April. My father was called to Washington. In June 1947 he was given the letter by Assistant (or Under) Secretary of War Petersen."

64. As cited in the *Film Daily,* May 29, 1947. "There is nothing in this report," Pommer's explanation continues, "which accurately reflects a conversation between Mr. Vining and myself."

65. John Pommer to the author, June 17, 1991. In another letter to the author, of April 26, 1991, Pommer says: "There is not one sentence in the letter that sounds as if it could have been made by my father."

66. John Pommer to the author, April 26, 1991.

67. Memorandum by Nils C. Nilson, May 22, 1947, "Confidential," Pommer Archive, USC, file C.

68. As cited in the *New York Times,* April 29, 1947.

69. *Washington Evening Standard,* May 6, 1947; *Hollywood Reporter,* May 12, 1947.

70. Erich Pommer to Getrud and John Pommer, May 4, 1947, PJP.

71. Press release of the Public Information Office of OMGUS, Pommer Archive, USC, file C.

CHAPTER 7. WRITERS AT LARGE

1. Hurwitz, *Die Stunde Null,* 81.

2. Hilde Spiel, *Die hellen und die finsteren Zeiten* (Munich, 1989), 64 ff.

3. Mendelssohn to Hilde Spiel, July 29, 1945, Mendelssohn Archive (consulted with the permission of Anita Naef, Munich; the transfer of the archive to the Monacensia Collection of the Munich Stadtbibiliothek should have been completed in 1995).

4. Mendelssohn to Hilde Spiel, July 17, 1945, Mendelssohn Archive.

5. In distinction to the previous army newspapers, Habe seems only to have provided supervision for this project. Wallenberg, also an émigré and native Berliner, had worked in the editorial department of the *Vossische Zeitung* before 1933. See Hurwitz, *Die Stunde Null,* and Gesine Frohner, "Die Allgemeine Zeitung" (master's thesis, Institut für Publizistik, Free University Berlin, 1966).

6. Mendelssohn to Hilde Spiel, August 12, 1945, Mendelssohn Archive.

7. As cited in Peter de Mendelssohn, *Zeitungsstadt Berlin* (Frankfurt and Berlin, 1985), 533.

8. Mendelssohn, report, n.d., marked "Confidential," Mendelssohn Archive, file "Unterlagen zu Deutschland-Buch/Tagesspiegel."

9. The expropriation occurred under the label "Entziehung"—that is, as a forced sale.

10. Mendelssohn, *Zeitungsstadt Berlin*, 1959 ed., 465.

11. Mendelssohn, "Confidential" report (see note 8 above). A similar evaluation was offered by Margaret Boveri, who had also been invited to the meetings but declined with thanks: "Apparently it will be a newspaper done by the same old people, all routine and pure opportunism, without any of them having any idea of who they are working for." Margaret Boveri, *Tage des Überlebens* (Munich, 1968), 296.

12. Mendelssohn, "Confidential" report.

13. Erhard Schütz, *Romane der Weimarer Republik* (Munich, 1986), 146.

14. Klaus Jans, "Die Anfänge des Tagesspiegels" (master's thesis, Fachbereich Kommunikationswissenschaften, Free University Berlin, 1986), 71.

15. Erik Reger Archive, Archive of the Akademie der Künste (West Berlin), file 333.

16. Peter de Mendelssohn, "Information on Herr von Schweinichen," August 25, 1945, OMGUS 5/240–2/9. See also Schweinichen's questionnaire with the accompanying statement of the OSS Berlin office: "George Wood . . . who has worked with von Schweinichen confirms the essential facts. . . . Both Wood and myself consider him very reliable and trustworthy." OMGUS 5/240–2/9.

17. In his book Mendelssohn describes Schweinichen walking right into his office with a manuscript of Reger's. Mendelssohn, *Zeitungsstadt Berlin*, 542. In a "Memorandum über die Gründung und Lizenzierung des Tagesspiegel" Mendelssohn names his OMGUS colleague Fred Bleistein as the person who brought Schweinichen to his attention. Mendelssohn Archive, file "Unterlagen zu Deutschland-Buch/Tagesspiegel."

18. The only complete copy is in the Louis Lochner Collection (box 2) in the archives of the Hoover Institution, Stanford University, and bears this title. There is only a fragment in the Reger Archive. Mendelssohn is responsible for the title "Grundsätzliche Gedanken zum Wiederaufbau der deutschen Presse." The document is signed by Reger and Kurt Zentner, who was a journalist in the Deutscher Verlag until 1945. Presumably this is how he met Reger. He was apparently a personal friend of Schweinichen's, since they addressed each other informally. Susanne Drechsler, April 19, 1946, Susanne Drechsler Papers (unordered and unlabeled, consulted in the spring of 1990), archive of the former GDR Staatlicher Rundfunk, Berlin (Nalepastrasse). Accordingly Zentner might have approached Reger as a journalistic representative of the businessman Schweinichen. He later became the chief of staff at the *Tagesspiegel,* until his dismissal in early 1946 because of undeclared Nazi membership. As he never appeared in any programmatic fashion, his coauthorship seems to have been a formality.

19. Mendelssohn, *Zeitungsstadt Berlin*, 542. See also his manuscript "Memorandum": "The memorandum sketched out in an excellent manner precisely the goals I had in mind for the paper to be created."

20. Susanne Drechsler, "Bericht über die Zeitung *Der Tagesspiegel*," April 19, 1946, Drechsler Papers. Drechsler seems to have spied at the *Tagesspiegel* for the KPD/SED. Her reports began in the fall of 1945 and ended some time

after she left the editorial staff (of the local-news section). It is not clear from the copies in her papers who the immediate addressee was. It might have been Wilhelm Pieck, for a drafted memoir from 1974 states that she worked "at the *Tagesspiegel* after consulting with Wilhelm Pieck." Manuscript of November 13, 1974, Drechsler Papers.

21. Cf. chap. 5 above.

22. During disagreements within the Berlin chapter of the Schriftstellerverband in 1931 (see chap. 1 above), Reger was one of the few prominent liberal authors who supported the board of directors against the leftist liberal majority. See *Der Schriftsteller* (the magazine of the Schutzgemeinschaft Deutscher Schriftsteller), no. 19 (1931), 9–12.

23. Friedensburg to Redslob, December 30, 1945, Edwin Redslob Archive, Germanisches Museum, Nuremberg, I, C, 10.

24. Reger Archive, file 334.

25. Memorandum to McClure, January 24, 1946, OMGUS 5/240–3/12.

26. As cited in Jans, "Die Anfänge des Tagesspiegels," 99. Schweinichen wrote a Christian preamble to the business contract. It states that the undersigned certified the contract "led by the belief that at the start of any revival stands the ordering word and in the absolute inner obligation to the holy and incomprehensible being above." There is also mention of "a fraternal relation" and "a devotion to the task upheld by humility and faith." "Präambel des Gesellschaftsvetrags," n.d., made available to the author by Nelly von Schweinichen.

27. Reported by Nelly von Schweinichen.

28. File note by Schweinichen, October 14, 1948, National Archives Suitland, Reg. 260 7/53/18/5, box 215.

29. Harold Hurwitz, *Demokratie und Antikommunismus* (Cologne, 1990), vol. 4, pt. 2, 896–97.

30. *Die Neue Zeitung,* November 22, 1947. The late date (eighteen months after Schweinichen was fired) is due to a lengthy article in the *Tägliche Rundschau* that made Schweinichen's fate public.

31. Reger Archive, file 274 (undated).

32. June 18, 1946—that is, six days before Schweinichen was notified of the license revocation. OMGUS 4/11–2/1.

33. Reported by Nelly von Schweinichen.

34. Reger Archive, file 250b. He elaborated on this thesis, which also resonated with many of his lead articles, in a long article entitled "Improvisierter Widerstand." *Der Tagesspiegel,* December 22, 1946.

35. The citation is from the article in the *Tägliche Rundschau* about the Schweinichen case mentioned above, and as such its authenticity is of course dubious. However, the article does contain so much authentic material that it can be regarded as one of the few reliable sources for the Schweinichen case. Statements in the *Tagesspiegel* and the officious American *Neue Zeitung* did *not* contradict the decisive passages. The Americans believed that Schweinichen himself was an informant for the *Tägliche Rundschau,* which, given that the information could not have been accessible to an outsider, makes sense. Schweinichen denied this by hinting at his well-known anticommunist views.

36. George Zivier to Peter de Mendelssohn, October 20, 1969, Mendelssohn Archive. The letter was written in response to Mendelssohn's request for Zivier's recollections of events in 1945.

37. Klaus Poche, former editor of the *Nacht-Express* and a friend of Kurtz's, as cited in Jan-Thomas Goetze, "Zur Rekonstruktion der Geschichte des Nacht-Express, 1945–1953" (master's thesis, Fachbereich Kommunikationswissenschaft, Institut für Publizistik, Free University Berlin, 1991), 130.

38. Paul Wiegler Archive, Archive of the former Akademie der Künste (GDR), no. 396/2, first file.

39. As cited in Goetze, "Zur Rekonstruktion," 126–27.

40. Hurwitz, *Die Eintracht,* 98.

41. The account given in a well-informed SPD publication from the 1950s (*Sopade,* 1954), possibly based on information from one of its copublishers (Kilver) who had fled to the West, reads:

> In November 1945 the Soviet Major Feldmann revealed to Rudolf Kurtz, formerly a journalist for film publications at Ullstein, Herbert Kilver, editor of the *Tägliche Rundschau,* and two other Germans that he had made them partners in the "Express-Verlag Inc." he had established. Kurtz and Kilver, earmarked as the licensees, received "shares" of 4,800 RM (24%) and 10,400 RM (52%) respectively, while the other two Germans were given 2,400 RM each (24% total), without any of the "partners" having brought a penny to the publishing house that was supposed to put out the *Nacht-Express.* All four were instructed to go to a notary to sign the contract, which Feldmann had already prepared in duplicate, and to see to the registration according to commercial laws at the office in Berlin-Mitte afterward.
>
> As cited in Barbara Baerns, "Deutsch-Deutsche Gedächtnislücken: Zur Medienforschung über die Besatzungszeit." In *Publizistik und Journalismus in der DDR,* ed. Rolf Geserick and Arnulf Kutsch (Munich, 1988), 65.

According to a contract dated November 28, 1945, the other two German partners were Ursula Lampe and Karl Grünberg. Landesarchiv Berlin.

42. Eugenia Kazeva, interview by author, Moscow, July 21, 1993. Jan Foitzik termed Feldmann "above all the censor of the paper, but he was supposed to also be its actual editor in chief as well." Jan Foitzik, *SBZ-Handbuch* (Munich, 1990), 37.

43. Hartmann and Eggeling (in *Text und Kritik,* no. 108) offer an overview of the press reports and speculations.

44. Goetze, "Zur Rekonstruktion," 129.

45. Rolf Suhrmann, *Die Münzenberg-Legende* (Cologne, 1983), 190.

46. Former Party Archive of the Communist Party of the Soviet Union, RCChIDNI, fond 17, opis 128, delo 150, 89. There was also a notable inversion or reversion of this deception: after 1950, editions of the *Nacht-Express* counterfeited by the West with anticommunist propaganda were smuggled into the Eastern sector.

47. Goetze, "Zur Rekonstruktion," 128.

48. It can only be guessed how this connection came about. Paul Wiegler

may have presented Kurtz to Johannes R. Becher, who then passed him along
to the Russians. It is unclear who—whether Kurtz or the SMAD—took the
initiative.

49. It is unclear whether Karsch left the party of his own accord or was ex-
pelled from it. In a letter to *Die Weltbühne* (no. 122 [1947], p. 544), the SED
district group in Zehlendorf stated:

> After Herr Karsch received the license for the *Tagesspiegel,* he did not simply behave
> indifferently but declared that he "of course" wanted to remain in the KPD; how-
> ever, it would not be advisable for him to belong to the organization in Zehlendorf.
> All documents referring to his membership should be removed from Zehlendorf and
> he should be made a member directly through the central Berlin office. He wanted
> to take these measures in order to avoid difficulties with the American occupation
> authorities. After the *Tagesspiegel*'s policy approached a reactionary ideal, we re-
> quested Herr Karsch's presence at a meeting one day and asked him whether he per-
> sonally identified with this policy. He answered affirmatively, and his continued pres-
> ence in the KPD was of course no longer possible. He was immediately expelled.

In support of this version is the similar case of the copublisher of the *Frank-
furter Rundschau,* KPD member Arno Rudert, who was expelled by the party
when he followed the paper's changed tack after the license of his copublishers
Gerst and Carlebach was revoked. Hurwitz, *Die Stunde Null,* 321. There is no
mention of Karsch in the former SED Central Party Archive.

50. Hans Leonard, "Chamäleon Karsch," *Die Weltbühne,* no. 7 (1946),
204.

51. As cited in Jans, "Die Anfänge des Tagesspiegels," 73.

52. Manfred Harder, ed., *Briefe an J. R. Becher* (Berlin, 1993), 167–69.

53. *Aufbau* 1, no. 3 (1945), 223.

54. As cited in Ursula Madrasch-Groschopp, *Die Weltbühne—Porträt einer
Zeitschrift* (Königstein and Taunus, 1983), as well as Madrasch-Groschopp's
personal statements. Maud von Ossietzky's memoirs, *Maud von Ossietzky er-
zählt* (East Berlin, 1988), should be used with caution. See also the biographical
note about Maud von Ossietzky in *Bibliographische Kalenderblätter der Ber-
liner Stadtbibliothek,* May 1975, 7.

55. In a letter to Hans Leonard of August 15, 1945, Maud von Ossietzky
asked: "Did you see Herr Wallenberg? I am anxious to hear his attitude and
views about our shared matter." Archiv Weltbühne/Madrasch, Rep. 200, Acc.
4288, file 59, Landesarchiv Berlin.

56. Curriculum vitae of October 29, 1947, Archiv Weltbühne/Madrasch.

57. As cited in Madrasch-Groschopp, *Die Weltbühne,* and personal state-
ments from Madrasch-Groschopp.

58. According to Madrasch-Groschopp the license was issued on November
21, 1945, for the title "Carl von Ossietzkys Weltbühne" and the cancellation
occurred on February 15, 1946. Madrasch-Groschopp, *Die Weltbühne,* and Ar-
chiv Weltbühne/Madrasch, file 55.

59. The Budzislawski heir Thomas A. Eckert has written—certainly not in
an unbiased way, but still drawing on many sources available only to him—
about the history of the financing of *Die Weltbühne* published in exile. See
Thomas A. Eckert, "Die Neue Weltbühne unter der Leitung von Hermann

Budzislawski—'Im Fahrwasser der KPD'?" in Michael Grunewald and Frithjof Trapp, eds., *Autour du Front Populaire Allemand Einheitsfront—Volksfront* (Bern, 1990), and Eckert's foreword to the reprint of *Neue Weltbühne* (Munich, New York, and Paris, 1992), vol. 1. The most informative sources of gossip are the articles by Andreas Juhnke in *Transatlantik*, no. 12 (1990) and *Manager Magazin*, no. 3 (1993).

60. There are facsimiles of these in Madrasch-Groschopp, *Die Weltbühne*.

61. Contracts and agreements are in the Archiv Weltbühne/Madrasch, file 58.

62. Leonard's negotiating partner in the KPD was Fred Oelsner, head of the "Agitation and Propaganda" division. Archiv Weltbühne/Madrasch, file 55.

63. In acting like this, Leonard relied on reports from Wolfgang Harich, who for his part, as Leonard would soon find out, had personal aspirations for the *Weltbühne*. Harich recounted a discussion with the British press officer Steward. When questioned as to "whether Harich had any particular information as to whether the English or Americans intended to publish the *Weltbühne* without the Ossietzky Verlag, Harich replied that he did have specific information about it, that he was close to Walther Karsch at the *Tagesspiegel,* and that the Americans did in fact intend to publish a magazine of this sort with one of the former colleagues of the *Weltbühne,* possibly with Karsch." "Aussagen von Herrn Wolfgang Harich," June 7, 1946, Archiv Weltbühne/Madrasch, file 67/H.

64. Hans Leonard to Maud von Ossietzky, June 5, 1946, Archiv Weltbühne/ Madrasch, file 59.

65. Walther Karsch to Axel Eggebrecht, March 25, 1946, Eggebrecht Archive, unlabeled correspondence file, Manuscript Department, Hamburg Staats- und Universitätsbibliothek.

66. Erich Weinert to Hans Leonard, as cited in Leonard's memo of June 7, 1946, Archiv Weltbühne/Madrasch, file 67/H.

67. In *Sie,* May 4, 1947.

68. Photocopy of the original document in the Archiv Weltbühne/Madrasch, file 73.

69. Leonard to Hiller, January 29, 1947, Archiv Weltbühne/Madrasch, file 67/H.

70. Hiller to Leonard, February 27, 1947, Archiv Weltbühne/Madrasch, file 67/H.

71. Alexander Abusch, *Mit offenem Visier* (East Berlin, 1986), 172. Referring to a discussion with Major Davidovitch, the Russian control officer in charge of the *Weltbühne,* Abusch writes that Davidovitch offered to him that the magazine "would not be censored if I was prepared to supervise the political coverage. . . . Comrade Davidovitch never interfered with my work. It was an unspoken understanding that the responsibility [for the *Weltbühne*] was left to the responsible branch of the party."

72. *Deutsche Rundschau,* September 1946, 176.

73. Ernst Niekisch, *Erinnerungen eines deutschen Revolutionärs: Gegen den Strom* (Cologne, 1974), 266–67.

74. Harich to Hans Leonard, July 23, 1946, Archiv Weltbühne/Madrasch, file 67/H.

75. In an interview with the author in Berlin in August 1993, Harich described *Die Brücke* as one of "several projects" at the time, adding that it was to be "leftist, but read in all zones, whether independent or at least claiming so."

76. Ibid.

77. There is no mention of this project in the Public Record Office—which does not necessarily mean that Harich's memory is inaccurate, for there is also no trace in the PRO of other projects and activities undoubtedly going on in the British sector.

78. Attendance list of the press conference, October 25, 1945, Sassenbach-Stiftung, no. 201.132.

79. Archiv Weltbühne/Madrasch, file 67/H.

80. Harich to Leonard, June 6, 1946, Archiv Weltbühne/Madrasch, file 67/H.

81. Leonard to Harich, June 14, 1946, Archiv Weltbühne/Madrasch, file 67/H.

82. According to Abusch the name was Davidovitch (see note 71 above).

83. Hans Leonard, report "Betr. Wolfgang Harich," July 9, 1946, Archiv Weltbühne/Madrasch, file 67/H.

84. "Die Weltbühne: Exposé und Programm" (typescript), n.d., Archiv Weltbühne/Madrasch, file 67/H.

85. See Harich's account of his actions in 1956 in *Keine Schwierigkeiten mit der Wahrheit* (Berlin, 1993), 42–43.

86. Harich to Leonard, July 23, 1946, Archiv Weltbühne/Madrasch, file 67/H.

87. Archiv Weltbühne/Madrasch, file 58/4.

88. Leonard, "Anlage zur Verlagsdokumentation," July 27, 1966, Archive of ZENTRAG, Berlin.

89. "You don't like seeing me in the office," Ossietzky wrote to Leonard on May 29, 1947, in one of her complaining letters. "You treat me as though I were there for a courtesy call. . . . You keep everything from me and I know no one and nothing, from time to time I am merely trotted out as a show horse." Archiv Weltbühne/Madrasch, file 59. Dealing with Ossietzky's widow was not easy for Leonard and became more difficult as her alcoholism worsened. Disagreements arose when Maud claimed funds in excess of her share. A modus vivendi was established finally when the press practically assumed trusteeship over Maud. It looked after all her material needs (apartment, telephone, heating, alcohol, cigarettes, vacations on the Baltic), and she renounced all further participation in editorial activities.

90. Paragraph 7 of the agreement of December 22, 1950, Archiv Weltbühne/Madrasch, file 58/3.

Index of Names

Compositor:	Prestige Typography
Text:	10/13 Sabon
Display:	Sabon
Printer:	Data Reproductions
Binder:	Dekker